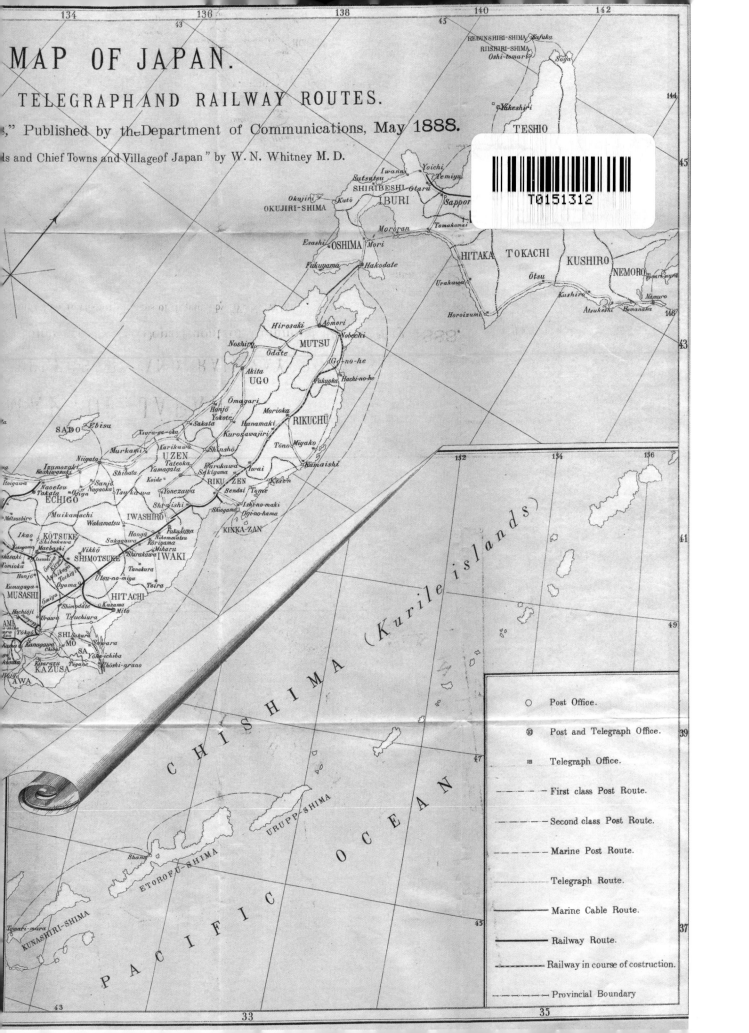

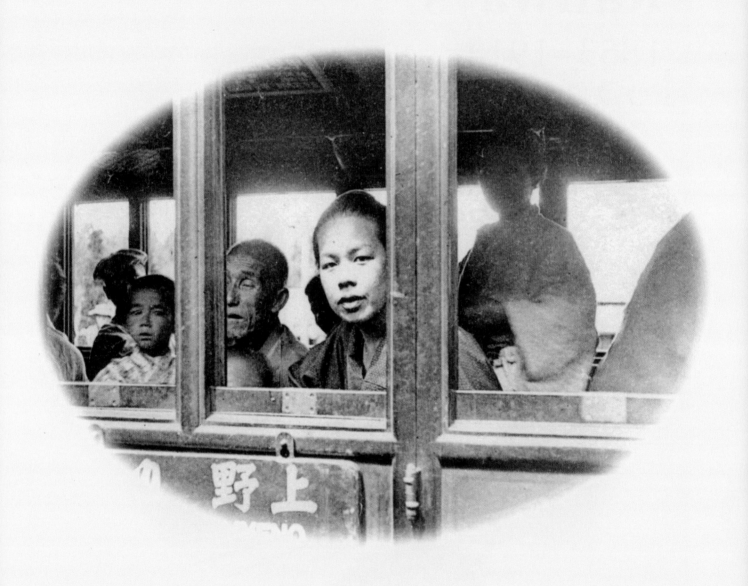

Early Japanese Railways 1853–1914

Engineering Triumphs That Transformed Meiji-era Japan

Dan Free

TUTTLE PUBLISHING
Tokyo • Rutland, Vermont • Singapore

DEDICATION

To my parents, R. B. and M. A. Free, with love, deep respect, and much gratitude.

Published by Tuttle Publishing, an imprint of Periplus Editions (HK) Ltd., with editorial offices at 364 Innovation Drive, North Clarendon, Vermont 05759 U.S.A.

Library of Congress Cataloging-in-Publication Data

Free, Dan.
 Early Japanese railways, 1853-1914 : engineering triumphs that transformed Meiji-era Japan / Dan Free.
 p. cm.
 Includes bibliographical references and index.
 ISBN 978-4-8053-1006-9 (hardcover)
 1. Railroads--Japan--History--19th century. 2. Railroads--Japan--History--20th century. I. Title.
 HE3358.F74 2008
 385.0952'09034--dc22

 2008030225

Distributed by

North America, Latin America & Europe
Tuttle Publishing
364 Innovation Drive, North Clarendon, VT 05759-9436 U.S.A.
Tel: 1 (802) 773-8930; Fax: 1 (802) 773-6993
info@tuttlepublishing.com
www.tuttlepublishing.com

Japan
Tuttle Publishing
Yaekari Building, 3rd Floor, 5-4-12 Osaki, Shinagawa-ku, Tokyo 141 0032
Tel: (81) 3 5437-0171; Fax: (81) 3 5437-0755
tuttle-sales@gol.com

Asia Pacific
Berkeley Books Pte. Ltd.
61 Tai Seng Avenue #02-12, Singapore 534167
Tel: (65) 6280-1330; Fax: (65) 6280-6290
inquiries@periplus.com.sg
www.periplus.com

First edition
13 12 11 10 09 5 4 3 2 1

Printed in Singapore

TUTTLE PUBLISHING® is a registered trademark of Tuttle Publishing, a division of Periplus Editions (HK) Ltd.

(page 1)
A view of an IJGR express train making its final approach to Sannomiya Station in the vicinity of Kōbe with a mixed lot of coaching stock in the earlier times when the right-of-way crossties or sleepers were kept covered in ballast.

(page 2)
Ueno-bound railway carriage passengers, titled "En Wagon," photog. André Chéradame from the series Un Voyage Autour du Monde, Editions de l'Energie Française, c. 1900.

進行中の�車

CONTENTS

PREFACE

In 1904, Kashima Shosuke was a railway economics student attending Keiogijuku (present day Keio) University in Tōkyō. Before returning to his native Ōsaka for summer vacation, he sent two letters and a hand-written report, along with packets of material, to the London-based editor of *The Locomotive Magazine*, a leading railway periodical of its day. He sought to better acquaint English-speaking readers with the railways of Japan, and also to make a little pocket change out of his submission. The contents of those packets were meticulously scaled mechanical drawings of the newest sleeping car in Japan, recently imported from England, hand-drawn, colorful pen-and-ink maps of the Japanese railway system, watercolor paintings of recently built locomotives and a group of photographs showing railway operations. Each of the two letters that accompanied those materials gave a brief description of the railway system in Japan at the time, a bit of its history, and explanations of the photographs and drawings. *The Locomotive Magazine* unfortunately was not able to use his materials given the demands of higher-priority subjects about which to write.

About eighty years later, *The Locomotive Magazine* was no more—its files and archives had been long since dispersed—but I had the good fortune to purchase Kashima Shosuke's letters and cache of photos and drawings from a lover of railwayana who had obtained some of the files from the defunct magazine's archives and was willing to part with the Kashima materials. Thus began on my part what has turned into a quarter-century learning process focused on the railway system of Japan in its earliest days. Almost immediately, I was confronted by the lack of good English language sources from which to learn anything more than the most basic, condensed history of Japanese railways, and what little was available tended to focus more on the technological marvels of the famed Shinkansen, or so-called "Bullet Train," network than with its venerable antecedents.

The piecing together of bits and scraps of early Japanese railway history from spotty and often contradictory sources led to the taking of notes. Taking notes eventually led to the need to organize them. Organizing them led to neatened entries on my computer, and all the while the musings that stirred Kashima Shosuke to write letters to London in the steamy Tōkyō summer gradually took hold in my head. Kashima's century-old musings became mine. I became dissatisfied with the available materials, and began to consider the idea of putting pen to paper. The collection had grown to a respectable size, and I was starting to run across historical data that I hadn't found in other sources. As I prepared to do the proper research that would enable me to write a book, I estimated that the research and writing would be tasks that could be completed in four or five months. As is often the case, my estimates weren't as accurate as I had hoped. Four years of research, correspondence, field trips, re-writes, and the occasional momentary flashes of renewed inspiration have coalesced to put me at the point where I'm writing this preface. My hopes are not all that different from Kashima Shosuke's: that through this book non-Japanese-speaking readers might become better acquainted with the early history of Japanese railways, and in the process with the fascinating country where they were built.

It has been my privilege, in researching this book, to see remarkable international parallels emerge. For much of the 19th century, Japan and America were both playing industrial and developmental catch-up to that titan of 19th Century industrial development, the United Kingdom. How they dealt with that development, in ways paradoxically divergent but similar, demonstrates the commonality of our shared existence.

That such similarities could exist in two cultures so profoundly different is, in itself, heartening. That others may come to appreciate this common ground is perhaps the closest thing to be offered as a purpose for this effort, other than an informative restatement of the narrative, hopefully with a few new items of interest interwoven.

Shosuke, here is your article, admittedly one hundred years late, and considerably expanded. I'm sorry, but there's nothing I can do about the pocket change.

Dan Free
New York City
March 12, 2008

(page 5)
Higashi Kanagawa (East Kanagawa) station, shown here shortly after inauguration, was situated where the Yokohama Tetsudō departed the Tokaidō mainline on it's route to the other terminal at Hachioji. It opened in 1908. The line was leased to the IJGR in 1910 and nationalized in 1917.

(page 6)
Locomotive number 6164 of a group of 18 members of the IJGR's 6150 class is shown at the head of a passenger train. As it appears to be on a double- track segment of line, which was relatively scarce, the location is probably along the IJGR Tōkaidō line. The class was built by Baldwin and imported starting in 1897. The number it carries dates the photograph to after 1909.

(opposite)
An unidentified coastal location, perhaps on the Atami line during construction, as presumably a contractor's temporary narrow gauge (762mm) line is visible to the right while construction baulks and scaffolding are still visible at the curtained mouth of the new tunnel shaft just seen to the left of the smokebox door. The locomotive seen is a D-9 class member, designated the 6270 class and built by Dubs, soon to be the North British Locomotive Works. The running number on the smokebox door dates the photograph to after 1909 when IJGR changed its numbering scheme.

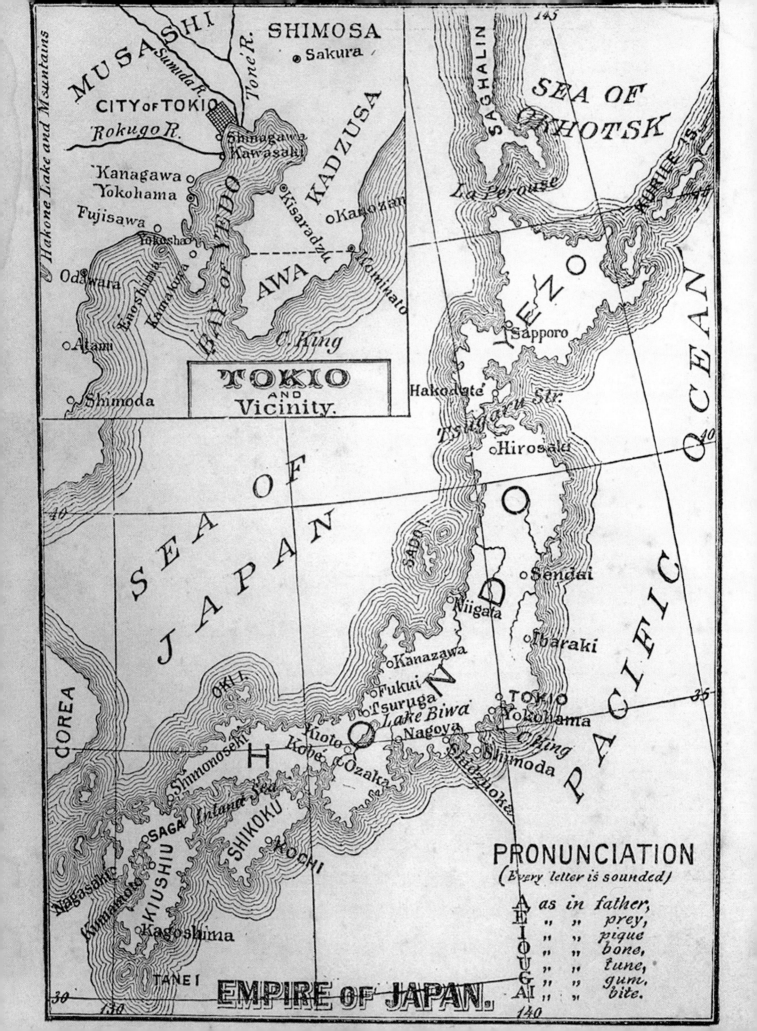

PROLOGUE
Japan Before 1853

Prior to 1543, the only contact between Japan and the Western World was indirect, via second-hand sources, such as the reports of Marco Polo, who relayed what he had learned of those islands from hearsay during his sojourn in China at the court of Kublai Khan. Polo used the name *Gipangu*, from which we derive Japan. *Gipangu* is itself an Italicized version of the Chinese pronunciation *Jih-pŭn*, which had been settled upon as the term used in communications between the two respective Emperors of Japan and China. The Chinese characters *Jih-pŭn* 日本 mean respectively *sun* and *origins*, as from the ancient point of view it was the eastern-most known land in the world: the land *where the sun rises*. The ancient Japanese called their land *Yamato*, but when they adopted the Chinese writing system for their spoken language (the two languages are otherwise unrelated) in the 3rd century BCE, they began to use the same two written characters they had adopted for the name of their country in the diplomatic correspondence between the two Emperors. But they pronounced those two characters using native Japanese words. As the word for 日 sun is pronounced *ni* in Japanese and 本 *origins* is pronounced *hon* or *pon*, they eventually came to call their land Nippon or Nihon. The Japanese may have settled *Yamato*, but so far as concerns the rest of the world, the Chinese pronunciation was the one by which it became known. As a result of the way their writing system developed, the Japanese can pronounce any Chinese-derived ideograph, to this day, in two ways: the "Chinese style" pronunciation or the native Japanese. Thus 山 (*mountain*) can be pronounced *in Japanese* using the Chinese pronunciation *San* or the Japanese pronunciation *Yama*. Westerners are most familiar with this from references to *Fuji-yama* and *Fuji-san*.

Travel in Japan changed little during the millennium stretching from the 8th Century to the 19th Century when Japan made the decision to modernize. In the 8th Century, Buddhist monks, most notably the legendary monk Gyoki, instituted Japan's first notable public works program, developing a system of communication with new roads, canals, and bridges to enable public access to the great temples of the day. In that century as well, the first system of post stations and inns (restricted to the use of only government officials) were established, being staged approximately 30 *ri* (about 75 miles)[1] apart. Transportation technology was little improved over the course of centuries intervening between the age of the engineer-monk Gyoki and the 19th Century. The dis-

tance between stages had been reduced to anywhere from four to ten miles, but as road building and road maintenance were the responsibility of the village or locale through which they ran, there was a great variance in traveling conditions throughout the realm. Travel was either on foot or horseback, by ox-cart (for nobility) or palanquin, a type of sedan chair known in Japanese as *kagō* or *koshi*, depending on its configuration.

The average load for a packhorse was 250–350 pounds. Under the best conditions, a traveler could travel 25 miles in a day; usually however, the average was around 18. This continued to be the average rate of travel up until the 1870s. Rivers formed a natural highway network for travel along so much of their length as was navigable, but interposed barriers to travel routes that crossed their courses. At some rivers, it took travelers up to half a day simply to accomplish a crossing. Because some rivers, such as the Ōigawa, formed domain boundaries, boats of any kind were forbidden on them as a defensive measure, necessitating detours of many miles in a route to a point where they could be forded. (The well-to-do would hire *kataguruma*, coolies stripped to a *fundoshi*, to carry them on their backs across at this point.) Many rivers were unbridged simply because bridging strong enough to withstand the severe seasonal flooding so prevalent among Japanese

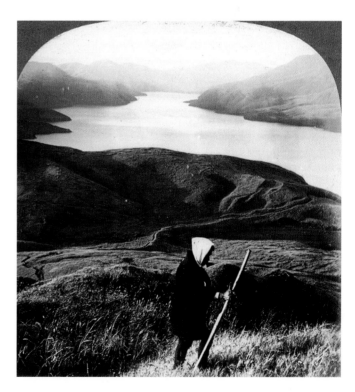

(opposite)
Tanegashima (Tane Island), where Westerners first set foot on Japanese soil, is located at the very southern tip of the Japanese archipelago. It is visible on this vintage map, listed as Tane I off the southern coast of Kyūshū.

(right)
This view of Lake Ashino near Mt. Hakone shows what was by far the most common mode of travel in Japan from ancient times well into the 1890s. Few but the relatively well-off could afford to travel on anything but foot even into the 1870s in Japan.

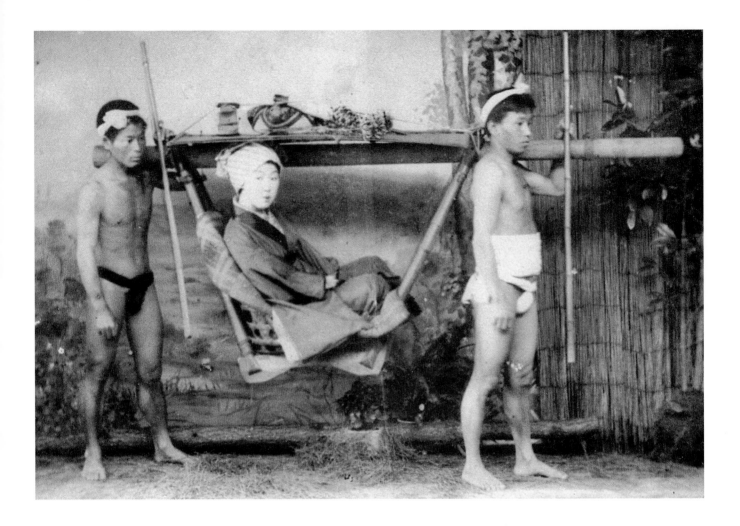

rivers could not be devised. Due to the relative lack of bridging, a scattered flotilla of small craft not much larger than a typical rowboat flourished at the various permissible crossing points and served as ferries between the shores. Even on the major roads, there were frequent gates, meant to keep the peasants of one fief from traveling freely to the next. Due to the fact that Japan is an archipelago, there was naturally a great emphasis in coastal shipping, but because of shipping restrictions, the largest ships (the *Sengokubune*) were by law limited to a burthen of 1,000 *koku* (a unit of measure defined as the amount of rice necessary to feed one person for one year: approximately 5 bushels), although by the first half of the 19th century the law was not as strictly enforced and some ships of larger burthen had come into service.

The year 1543, a mere 21 years after Magellan's crew had completed the first successful recorded circumnavigation of the world, marks the first recorded direct contact between Japan and Western civilization, in the form of three Portuguese sailor-adventurers, Fernão Mendez Pinto, Christopho Borrello, and Diego Zeimoto. Pinto left a chronicle of his voyage that reads like the script of an action-adventure film. According to Pinto, by a long chain of events, the three found themselves stranded on an island where Portuguese ships rarely put in, believed to have been located somewhere near present-day Macao. After weeks of waiting for a ship to call in port to no avail, the Portuguese were beginning to despair when a squadron of pirates (probably Chinese) sailed into port and dropped anchor. As the appearance of other ships was

unlikely for quite some time, the three agreed to enlist as sailors with the pirates, hoping to work their way along their route, as part of the crew, until the pirates would reach Malacca (what is now the area of Singapore), the straits of which were a strategic bottleneck for shipping through which ships from the Far East bound for Europe would have to pass, where the three could take their leave and find passage home. The three set off with the

(above)
For centuries, the more fortunate in Japan could travel in a kagō, a sort of sedan chair as is shown here. While the Japanese became quite accustomed to it over the course of centuries of use, the first Westerners in Japan could not acclimate themselves to the cramped position of being seated cross-legged for long hours of slow travel.

(opposite above)
Although this view was obviously taken after the introduction of photography in Japan, there is little to distinquish it from a scene centuries earlier. A typical example of one of the ferries that existed in Japan by the tens of thousands is seen with a full host of passengers. Boats such as these were the typical short-haul ferries of Japan well into the years of the Meiji reign.

(opposite below)
With the introduction of Western breeding stock beginning in the 1860s, the horse population of Japan gradually grew. Native Japanese horses (such as seen at left) were closer to the Western pony and were notoriously bad-tempered. By the 1870s, a series of relay houses had been established in Japan, where theoretically a horse could be rented for the road ahead to the next post station. This was initially a very unreliable service. Shown here is what a Western traveler weary from a day's travel on foot would have gladly paid premium price for in the 1870s: two pack horses (one on which to ride with baggage, and the other for baggage and accompanying guide) available for hire at the post house.

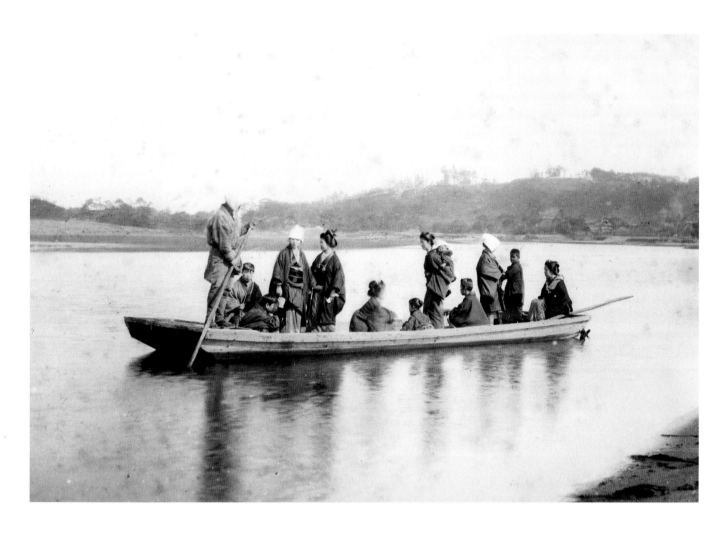

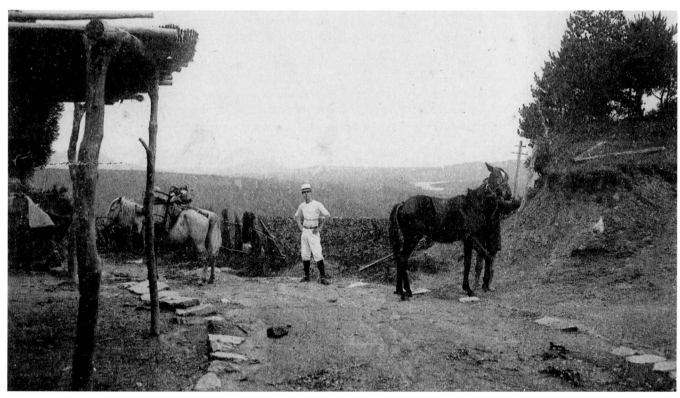

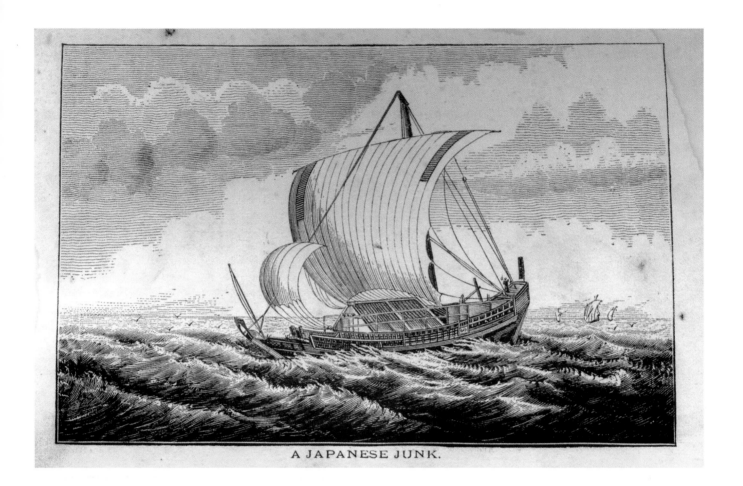

A JAPANESE JUNK.

Japanese ship design changed little in the three centuries between the visit of the first Western sailors to Tanegashima in 1543 and the opening of Japan by Matthew Calbraith Perry in 1853. Shown in this 19th century woodcut is a fairly representative version of one of the largest Japanese ships that would have been seen in the centuries that preceded the modernization introduced in the Meiji era.

pirates in a squadron of junks only to be attacked at sea by a rival pirate band. Although the junk on which the three were in service escaped pursuit, the sails of their junk had been damaged during the battle such that it lacked full sailing capacity and was thereafter blown off course during a storm that followed the battle. In an attempt to find the closest friendly land where they could repair their ship without fear of apprehension by the Chinese authorities, the pirates attempted to sail to the Okinawan Islands, but spotted land fortuitously and took safe harbor at the small island of Tanegashima, in southern Japan off the coast of Kyūshū, the southernmost of Japan's four major islands.

By coincidence of history, these three Portuguese came ashore in Japan at a time when the realm was in political turmoil. Since as early as 1192 at the conclusion of the decisive Taira-Minamoto Civil War, it had been established political custom in Japan that the Emperor (the *Tennō* or, as the Victorians liked to called him, the *Mikado*) was a figurehead sovereign who, to borrow the common axiom, "reigned, but didn't rule." True political and military power was vested in a nobleman or *daimyō* holding what by force of arms and custom had become the hereditary title of *Seii Tai Shōgun*, or "Barbarian-quelling Supreme Commander." Shōguns (as they came to be called) and their dynasties, the Shōgunates, came and went in typical feudal fashion: rebellion and overthrow

by force at critical moments, but always the institution of the Imperial Dynasty had been maintained. Unlike neighboring China's changing dynasties, new Shōgunal dynasties never took the title of Emperor, but were content to keep the Emperor in place with titular powers and assume the title of Shōgun. The only fundamental question at the fall of any Shōgunal dynasty was which influential *daimyō* would capture the title of Shōgun for himself and his descendants. In the early 1540s, those first Portuguese mariners sailed unknowingly into just such a situation.

By this date, the Ashikaga or "Muromachi" Shōgunate, in place since 1333, had lost political and military control of the country and had largely collapsed by the end of the Ōnin Wars in 1477. A scramble for the title of Shōgun had been festering in the land ever since—a period of intermittent civil wars between jockeying *daimyō* to determine who would succeed as Shōgun now known as the Sengoku period. By stroke of good fortune for those first three Portuguese, the hold of the pirate junk was stocked with plunder, which the pirates starting trading with the locals, so the ships stayed in port for a few weeks, and were visited by the local *daimyō*, who was amazed to find three men with beards and faces the likes of which he had never before seen and who aroused a great curiosity in him. The pirates had plenty with which to busy themselves in their ship repairs and setting up a smuggler's bazaar at which to haggle over the prices to be gained from their booty, but the three Portuguese were at loose ends until the voyage resumed, and contented themselves to play tourist and go hunting with their trusty arquebuses. In Japan at that time, firearms and firearm technology were virtually unknown. Diego Zeimoto was a

particularly good shot, and bagged twenty-six fowl in one day with his arquebus, much to the amazement of the locals as he returned to town. News traveled quickly to the local *daimyō*, who requested a demonstration. The *daimyō* was so impressed that he accorded Zeimoto unusually great honors and was exceedingly eager to acquire firearms and to adopt the new technology. The desirability of such technology in times such as Japan was then experiencing is self-evident. By the time the pirate junk weighed anchor and set sail, the three Portuguese on board had come to the realization that here was a market ripe for exploitation. They lost no time in promoting the idea on their return to Lisbon.

A brisk but intermittent trade gradually developed as quickly as ships of the day could sail. Within three years, the first Portuguese vessel had come to Kyūshū (remarkably fast contact given the rate of change and travel in those ages). By 1549, Francis Xavier had established a mission in Kyūshū and the Portuguese were attempting to be the first Western nation to forge regularized trade relations with Japan. The first cannon were purchased and brought ashore two years later. The Portuguese found one of the bays at the base of a long cape in western Kyūshū to have a natural harbor well suited for a port, and requested permission of the local *daimyō* to anchor there, which was agreeable. The locals had named the small fishing village situated at the anchorage "Long Cape" (*Naga-saki* in Japanese). By 1571, the first *regular* trade ships from Portugal anchored in its waters and Nagasaki was on its way to becoming a trade center. The local *daimyō* were quick to send their best swordsmiths to learn gunsmithing from the Portuguese and to establish manufactories at the local arsenals that each domain was required to maintain as a part of its national defense obligations. Firearms proliferated rapidly from that small foothold in Kyūshū, and within years the use of firearms had spread throughout the realm. Henceforth, the transfer of Western technology to Japan would become a notable aspect of Japan's interaction with Western civilization: small initially, but accelerating at an amazing pace during the Meiji period.

The Portuguese were only too happy to provide firearms to the local *daimyō* and teach them gunsmithing in exchange for the products of technologies understood in Japan that the West had not at that point mastered (such as lacquer ware) which naturally would be in higher demand and produce a higher profit margin. Later, after an abortive invasion of Korea in the 1590s, Korean potters were brought back to Kyūshū bearing new technological knowledge and skills that proved instrumental in making improvements to the local earthenware industries. They brought with them the secret that kaolin was necessary to manufacture porcelain (a technology that Europe wasn't able to duplicate until the eighteenth century), and the skills to fire it. The discovery of suitable kaolin deposits in Kyūshū soon resulted in the first Japanese porcelain kiln located at Arita, a name ever after synonymous with porcelain in Japan. Arita ware was quickly added to the holds of Portuguese caravels as a trade commodity. By that time the Portuguese had also learned that there was a ready market in Japan for an agricultural product discovered in the newly found western hemisphere called tobacco. Technology and tobacco, cannons and cannons may have seemed promising enough to insure future commercial success to the Portuguese. But matters were not that simple. Because of the mere coincidence of having first landed in Kyūshū, the Portuguese trade and missionary pursuits were centered there. They were on good terms with the local *daimyō*, the powerful Shimazu clan of Satsuma, and Portuguese influence grew locally as many of the populace, and indeed certain *daimyō* were converted to Christianity. Unfortunately for the Portuguese, the Shimazu had taken a position antagonistic to the formidable Toyotomi Hideyoshi.[2]

By the closing years of the 16th century, the political-military contenders for the title of Shōgun had reduced down to only a few, of which Hideyoshi was one. Hideyoshi eventually gained the upper hand in the Sengoku struggles (it was he who was responsible for the ill-fated Korean invasion so felicitous to Japan's porcelain industry), and by the time he landed in Kyūshū to deal a blow to the Shizamu clan, was near the height of his power. Naturally, the Shimazu used all the resources available to them, among which were the Portuguese; specifically their firearms and the cannon on any of the Portuguese ships that happened to be in port and available to render a service to friends in need. The Age of the Conquistador was then in full flower, and the Portuguese were too tempted to emulate the successes of their Spanish cousins. Of course, Hideyoshi viewed this as what we would today label foreign intervention, was not at all pleased by the unwelcome complications Portuguese fire-power had injected into his campaign against the Shimazu clan, and viewed everything about the Portuguese, from ships to cannon to religion, as a potential threat to his power base. He was one of the samurai who had served under Oda Nobunaga at the Battle of Nagashino in 1575. Nagashino is said by some to have been the world's first use of rapid-volley firing on a large-scale basis by roughly 1,000 musketeers firing *en masse*; a tactic pioneered by Nobunaga. It is said to have preceded European use of this tactic by some 25 years and was instrumental in victory. Hideyoshi knew first-hand the effectiveness of this new Western technology and feared it. He prevailed in his campaign against the Shimazu, and one of the outcomes of his victory was the issuance of edicts putting foreign trade (and with it, foreign ideas) under centralized control, as his observation of the growing Portuguese power and influence while he was in Kyūshū convinced him that it was a danger to political stability. Hideyoshi's former mentor Oda Nobunaga had experienced problems with religious groups and had started the process of issuing edicts regulating them: Hideyoshi followed his former leader's policies. His edicts at first tended to be circumvented or ignored, but as his power grew, were ultimately heeded. For good measure, Hideyoshi outlawed the wearing of swords by anyone except members of the samurai class and barred their possession with his celebrated *Katanagari* ("Search for Swords") purge of 1588, which required that firearms too be surrendered—a means of weakening the ability for armed resistance and curtailing the spread of firearm technology in hopes that Nagashinos and Shizamu campaigns would never happen again, or at least that future clashes would not be complicated by firearms.

Hideyoshi died in 1598 leaving a five-year-old son, Hideyori, as his heir, with several of his most loyal vassals charged with Hideyori's protection. One of those vassals, however, saw an opportunity in the power vacuum created by the untimely demise of Hideyoshi and moved quickly to usurp his former master's position. Although he was relatively modestly born, Hideyoshi's former ally and subordinate not only possessed tact, acumen, and military prowess, but equally importantly a great deal of luck and good sense of timing. He was named Tokugawa Ieyasu, and he succeeded in seizing power from the defenders of the young boy he was pledged to protect and in building on Hideyoshi's achievements before Hideyoshi's enemies could undo them. Naturally there were more battles, but Ieyasu effectively settled matters, reunifying Japan in 1600 at the decisive battle of Sekigahara, a name

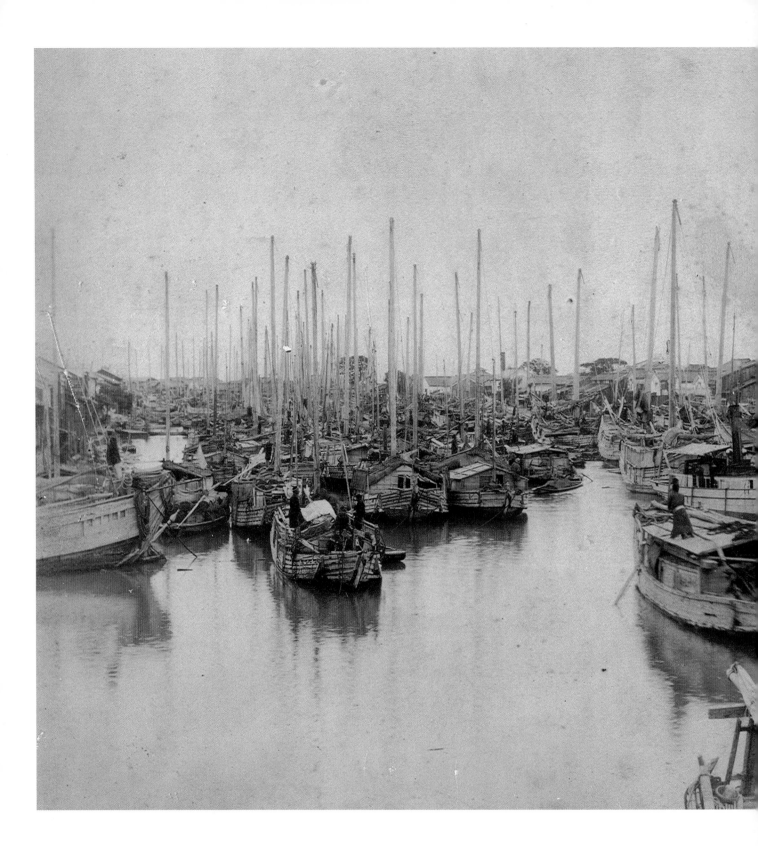

Although this photograph was probably taken in the 1890s, most of the ships seen in this photograph are of the type traditionally seen in Japan for centuries. More modern steamships would gradually appear in Japanese ports after the decision was made to modernize. The location is Ōsaka.

that rings in the ears of the Japanese much as Hastings does to an Englishman, Poitiers to a Frenchman, or Gettysburg to an American. Ieyasu's legacy was the Tokugawa Shōgunate, lasting from 1603 to 1868.

Ieyasu was a bold, capable, and cunning field commander, but he was not the model of a progressive political leader. On his ac-

transliteration of the Japanese language) which centuries later, at the end of the dynasty he founded, grew to be the most populous city in the realm. Ieyasu too was present at Nagashino and undoubtedly he remembered vividly the trouble firearms had caused Hideyoshi, with whom he had been then allied, in the Shimazu campaign. He undoubtedly shared with Hideyoshi the view that the adventurism the Portuguese had demonstrated was a threat to political stability in Japan, and by extension, to his rule. Being all too cognizant of the challenges that can arise when a unifier like Hideyoshi passes from the scene, and undoubtedly wishing to avoid similar consequences for his successors, he reigned as Shōgun for only some three years and thereafter made a point of "retiring" in favor of his son Hidetada, using the rest of his days as a power behind the throne in order to assist and prepare his son for continuation of the dynasty, while acclimating the rest of the country to the notion that Hidetada was their ruler. To Ieyasu, the notion of contact and trade with Europe was still largely an unknown element with an exceedingly bad track record at that point; not to be highly regarded based on his past experience. By this point in time, the Dutch had found their way to Japan in the form of the Dutch East India Company, as had a sole Englishman in Dutch employ by the name of Will Adams, who in fact served informally as an advisor to Ieyasu. By 1611, through Hidetada, Ieyasu had granted his first audience to a Spanish envoy and by 1613 to an envoy from King James I of the political entity that just eight years earlier had become known as Great Britain. As a result of these missions both nations were permitted to establish trade relations. The English thereupon established a porcelain factory in the Kyūshū town of Hirado. The Spanish and English relations must have been nothing more than a provisional experiment in the minds of Ieyasu and his son Hidetada. Ieyasu was by then an old man approaching the end of his life and was acutely aware of the need to solidify and legitimize his régime, the power of which was subject to challenge by virtue of its newness if for no other reason. Among his last acts, through Hidetada, Ieyasu, apparently disapproving of the course foreign trade was taking, moved to rein in what he perceived as growing Western influence and put in place prohibitory edicts in 1612 and 1614. In 1615, Toyotomi Hideyori, the son of Ieyasu's former master, challenged him one last time in battle, was defeated, and was forced to commit suicide leaving no heir. With that defeat, all effective opposition vanished. Ieyasu could breathe a sigh of relief. A year later, in 1616, he died—the same year that saw William Shakespeare pass from the world scene.

Careful to pursue the course of further consolidation of the new régime's power, which was still at best untested and at worse tentative, Hidetada and his son, Iemitsu, lost no time following the great Ieyasu's lead with edicts designed further to reduce Western influence; restricting all foreign ships and trade to the two Kyūshū ports of Hirado and Nagasaki in 1616 (still later only to Nagasaki) and prohibiting Spanish trade outright in 1622–1624 (the Spanish experiment had proven troublesome—problems again with religion and the Conquistador Mentality). By this time, the English trade venture only recently established in Hirado had closed as it was not commercially viable. With further edicts in 1635 and 1636, all Japanese were prohibited from foreign travel and all Japanese who found themselves abroad were deemed exiled and forever barred from returning home. It was decreed illegal for any Japanese to own a ship with more than a single mast or exceeding fifty tons displacement, effectively an outright ban on ownership of ocean-going vessels.

cession to the title of Shōgun, Ieyasu put Japan on a thoroughly traditional and sedentary political course. He left the Emperor undisturbed to reign at the capital in Kyōto and established his Shōgunal capital within his domain at a small provincial castle town known as Edō (sometimes written Iedo, Yedo, or Jeddo, as Western scholars had yet to arrive at a standardized system of

As restrictions against Western influence mounted, those local Japanese in Kyūshū who had converted to Christianity bore some of the burden and became resentful. In 1637 an ill-fated Christian revolt, the Shimabara Rebellion, broke out near Nagasaki, aided in part by the Portuguese. The locals again resorted to Portuguese firearms, long since banished under the *Katanagari*, which further convinced the new regime that foreign influence and technology were a threat. As a result, in 1639 the Portuguese (along with their meddlesome missionaries and gunrunners) were outright barred from entry anywhere in Japan. The remaining Dutch East India Company, which kept strictly to business and did not import religion, fared better, but was no longer allowed to freely occupy sites in the Nagasaki environs. Starting around 1641, the number of Dutch ships were curtailed and severely controlled, only being allowed to anchor in port at certain periods, not allowed to come and go freely, and all Dutch trading entrepôts, factories, and residences were required to be moved and thereafter confined to a small island just off shore in Nagasaki harbor called the *Deshima* that was ordered to be enlarged artificially to the size of about one hectare. Housing, warehouses, and other necessary buildings for the conduct of trade were built there, the entire island surrounded by a high fence, and a bridge was built that connected it to the town proper, with a guard post manned by the local police and gates that were barred year-round. The Dutch traders were not allowed to leave the island, except the *Opperhoofd* ("chief," lit. *Overhead*) of the trading post who was required to make a yearly report to the Shōgun in Edo called a *Fusetsu-sho*, and was allowed to leave the Deshima for this purpose. Otherwise the Dutch might as well have been politely treated hostages. No Japanese men were allowed on the island unless they were employees of the company. No Japanese women were allowed at all, unless they were courtesans. The trade ships were allowed to arrive in summer, usually July, and were required to turn over their sails, arms, and ammunition to the local authorities to prevent any adventurism during their stay. Any Dutch ships in port were required to leave by no later than the end of September; even delay caused by the worst of sailing weather being unacceptable. As the time approached, their sails, arms and ammunition would be returned, the ships would be refitted, provisioned, and loaded with a year's accumulation of stock in trade, and when all was well, set sail.

There must have been a very lonely and desolate feeling on the tiny islet each October, when the last Dutch ships had left and the *Opperhoofd* and the ten or twenty Dutch resident employees who remained in isolation set about preparing for winter and the return of Dutch ships the next summer. But the pattern had been set. Like a larger Deshima whose last ships had sailed, for the next two hundred years Japan settled into a period of profound isolation.

Hiroshige, one of Japan's masters of the woodblock print, created this scene titled **Evening at Takanawa**, one of the finest works of his series *Tōto Meisho*, probably around 1840. The scene is a classic depiction of the methods of transport available in Japan before the introduction of Western technologies and shows a representative sampling of the kinds of traffic to be encountered on the Tokaidō, Japan's largest and busiest highway at the time. An ox-cart, kagō, ships, and pedestrian traffic are all seen in the vicinity of a local tea-house at the side of the pre-Meiji era's premier superhighway, where the hostess is greeting pedestrian wayfarers. Note the Japanese custom of riding atop of a rented packhorse, along with one's baggage. Roughly three decades after the scene depicted in this print was drawn, Takanawa would be the focal point of a struggle between the new government and reactionary elements in the Japanese military, who were obstructing building of the first railway in Japan. Eventually, the ageless calm of evenings at Takanawa such as the one shown here would be interrupted by the high-pitched shriek of British-made steam whistles and the sounds of occasionally passing trains.

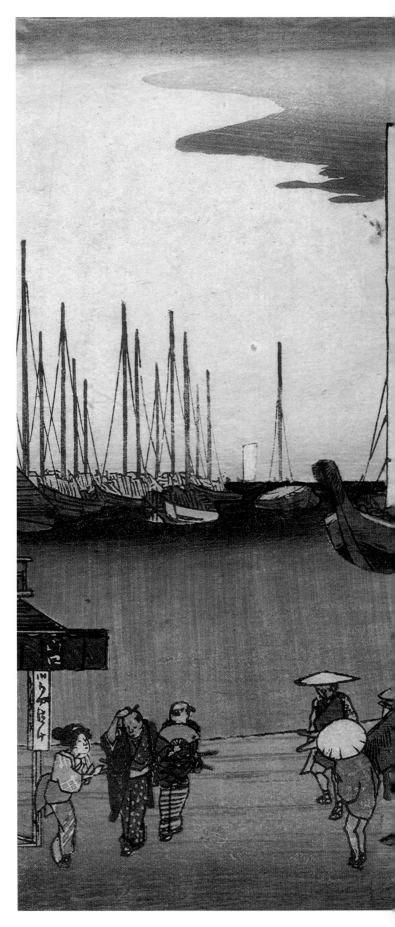

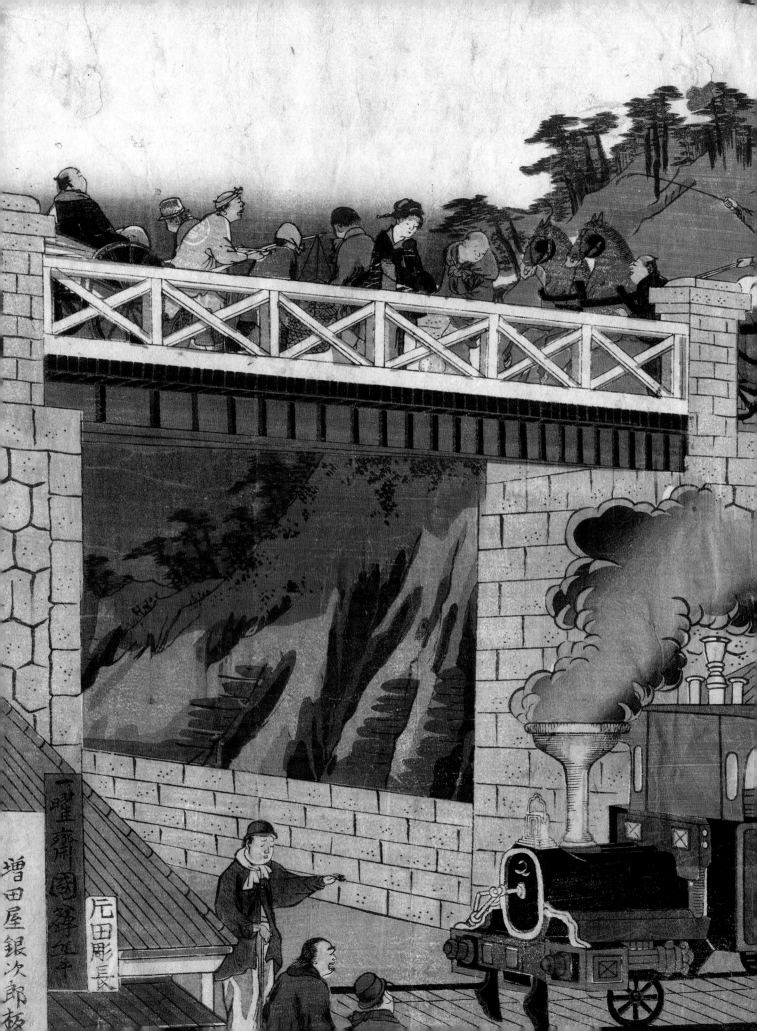

Chapter 1: 1853–1868

Introduction of Railway Technology, the Shōgunal Railway Proposal, and the First Railway Concession

Compared to 1643, the Western world had changed quite a bit by 1820, while, relatively speaking, Japan had changed but little. Britain was well on the way to creating its Empire, having recently secured a position of primacy in India, which would serve as the principal base from which further Asian trade and colonial expansion would be conducted. The political institutions and boundaries of Europe had just been revised by the convulsions of the Napoleonic Wars and the settlement issuing from the Congress of Vienna, which ceded to Britain small Dutch colonial holdings in the Cape of Good Hope at the southern tip of Africa, a very necessary re-supply point on any ocean voyage from Europe to the Far East. Thus, Britain found her position to trade with Asia markedly improved. Russia was a rising power that was just starting to expand development of the far eastern reaches of its territories, and in the western hemisphere the United States was a fledgling nation that had yet to prove itself capable of being, much less gaining acceptance as, a world power. The first effects of the industrial revolution were being felt, spurred in part by the technology of stationary steam engines used in England starting in the 1790s to power mine hoists, mine pumping stations, and textile machinery. Success in these areas gave rise to the application of the reciprocating steam engine to naval propulsion and in the UK to hitherto horse-drawn mine-car rail technology, starting in 1803 to1808 with the world's first two railway locomotives constructed by the Cornishman Richard Trevithick. The success of the primitive and inefficient locomotive was at least such that, for a brief period when the Napoleonic Wars and failed crops (due to the volcanic ash-dimmed "year without a summer," courtesy of Indonesia's Mount Tambora) increased the price of feedstock for horses, the fledgling engines proved to be more cost-effective than horsepower. In other spheres, the economic benefits to be gained from industrialization were starting to be appreciated on a mass level, as were the economic benefits to be gained from trade in the products of this new industrialization.

As early as the 16th century, mining enterprises in the German principalities had started to use wooden rails to guide flange-wheeled mine carts hand-pushed by miners, but the technology's greatest application occurred in the coal mines around Newcastle in the United Kingdom commencing in the latter half of the 17th century. The mine tracks built were crude affairs only a few miles long—just long enough to transport coal from the pithead to the closest navigable waterway where it could be loaded onto ships. Operation was by horse and gravity. By 1825, the two technologies of rail-borne transport and steam power had converged and had matured to the point that Great Britain gave the world the first commercial common-carrier railway to undertake a scheduled passenger service (not just coal traffic) when the Stockton and Darlington Railway in northern England was opened.

Passengers were a bit of an experimental venture and were hauled daily in horse-drawn stagecoaches or omnibus under arrangement with several independent operators, unlike a railway as we have come to know it. In theory, anyone owning a team of horses and one or more flanged-wheeled wagons conforming to the railway's gauge was allowed, through arrangements with the company, to "train their waggons" over the line on payment of a fee much like a toll fee on a turnpike; as canal boat owners of the day were allowed to use a canal. In practice few took advantage of this, except for a number of businesses along the line for their freight needs and stagecoach owners for passenger service. This gave rise to traffic congestion (the Stockton and Darlington operated much like a common toll-road, not attempting to regulate traffic movement) since the trains of carts couldn't pull over to the side of the road or pass, as could be done on regular roads, and as drivers not employed by the company did not always coordinate their movements to correspond with places on the line where passing sidings had been installed. This problem was not lost on the innovators of the day. Indeed, one of the company records indicates, "The Committee [Board of Directors] found great inconvenience by Carriages traveling on the Railway at different speeds, and being convinced of the necessity of adopting one uniform rate of traveling, have had *several interviews* with the Merchandise Carriers for the purpose of inducing them to adopt the leading of Merchandise by [the company's] locomotive engines instead of horses as heretofore." [Emphasis supplied]

Five years later saw the birth of what was the first full-fledged railway in the modern sense of the term. Horse traction would not be used: steam locomotive propulsion was to be employed from inception. The only trains permitted on the line were those operated by the railway company itself, subject to traffic control under direction of the company. By that time, George and Robert Stephenson had built an efficient steam locomotive, the design of which differed from modern steam locomotives arguably in only three or four major technical aspects. The line was the Liverpool and Manchester Railway, opened on September 15, 1830 by the Prime Minister, the Duke of Wellington, the celebrated "Iron Duke," not by virtue of his railway advocacy, nor victory at Waterloo, but due to his unpopularity that required he shield his windows with iron shutters. Despite a long preceding and gradual development, it can still be said generally that the inauguration of the Liverpool and Manchester on that September 15th marks the birth, not of railways *per se*, but of the *Railway Age*, for after the success of the Liverpool and Manchester, railways were no longer an unproven experimental technology, but were thenceforth increasingly accepted as "proven and profitable."

Meanwhile back in Japan, Dutch trading ships in strictly regulated quotas continued to come and go from the Nagasaki *Deshima*. Trade and trade ships had improved in the interceding

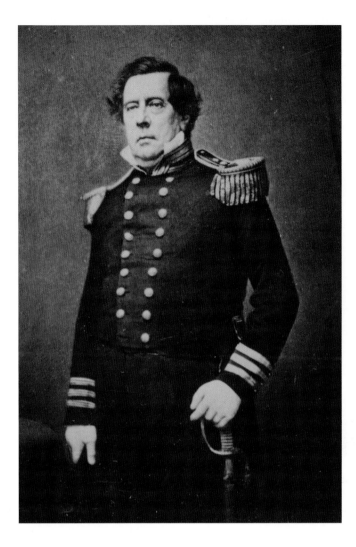

Matthew Calbraith Perry successfully accomplished the "opening of Japan," in large part through threat of force, during his two visits to Japan in 1853 and 1854, thereafter forever altering the course of its history.

principal from the Shōgunal Government to establish trade relations, which resulted in a provisional treaty; the so-called "Kanagawa Treaty," soon to be followed by a more formalized treaty thereafter negotiated and concluded by the first diplomatic envoy to Japan from any Western power, the American Townsend Harris. The "Harris Treaty" of 1856 was the first of many trade treaties to follow as every Western trading power of the day followed suit, demanding a similar status to that which the US had obtained. At the time, Western knowledge of Japanese political affairs was so unsophisticated that the exact nature and nuances of the relationship between Shōgun and Emperor were not widely understood. The *Bakufu* itself was at a loss to come upon a term that would suitably express the Shōgun's stature to the foreigners. Eventually, all concerned borrowed a term which had lately been employed by the British in several treaties recently concluded with China in the aftermath of one of the Opium Wars, and the Shōgun took to styling himself the "Great Prince" or *Tai-kun-shu* 大君主. The Westerners first arriving on the shores of Japan generally abbreviated this name and Anglicized its spelling, thereafter often referring to the Shōgun in shorthand fashion as the *Tycoon*.

Japan had been coerced under threat of armed intervention to open its doors, but initially, trade was confined to certain ports only (towns like Yokohama, Kōbe, Hakodate, and Nagasaki, which came to be known as "Treaty Ports") and foreigners were required to have a special passport to travel to the interior of the country anywhere outside the confines of the Treaty Ports.

* * * * * * * * *

There is little historic record of railway activities for the next ten years in Japanese history but by 1865 enough rails, flanged wheels, and railway hardware had been imported that Japan's first railway that accomplished a commercial purpose was in operation. This was a short mining railway that was constructed to move coal from the mines of newly discovered coal deposits at a locale known as Kayanuma in Hokkaidō to a navigable transshipment point. The venture came to be known as the Kayanuma Tankō Tetsudō 茅沼炭坑鉄道 (*tankō* means coal mine and *tetsudō*, literally "iron way," means railway). Little is known of the line or its workings, save for the fact that it was worked on a "horse and gravity" principle, in the time-honored tradition of the first coal mine rail lines around Newcastle 200 years before.

Nagasaki in 1865 was quite a different town than it had been ten years before. Foreigners were no longer Dutch and Chinese only and were no longer confined to the Deshima. A newly arrived Scottish trader by the name of Thomas Blake Glover founded the firm T. B. Glover and Co., which is said to have imported from Great Britain a small 762mm (2' 6") gauge steam locomotive and to have demonstrated it on a test track along the Nagasaki Bund (as the waterfronts in Far Eastern treaty ports were becoming known) between Lot numbers 1 and 10 in the foreign resident's quarters in hopes of inspiring "railway fever" to Glover's profit among the Japanese. Some authorities question this, but if the reports are to be believed, this was the first locomotive in Japan that was not a model and was capable of actual commercial activity, despite the fact that there is no confirmation that it ever performed *revenue earning service*. Again, very little is known about this demonstration railway, but fittingly the first fully-functional locomotive in Japan was named the *Iron Duke* and, if reports are to be believed, then the Iron Duke inaugurated the Railway Age to Japan, a symbolism perhaps not lost on Glover. There is brief mention of this event in *The Railway News of London*, July 22, 1865, "A railway, with locomotive engine and tender, is in operation on the Bund at Nagasaki, and excites a great deal of attention among the Japanese, who come from far and near to see it." Thomas Glover's house still stands in what is now a park in Nagasaki and is in fact the oldest Western-style residence in Japan, but what became of the *Iron Duke* is not known. There is, however, a small, tantalizing reference to Glover & Co. having conveyed a steam engine as part of the equipment package sold to the Japanese Government when it commenced construction of its first modern Imperial Mint in Ōsaka shortly thereafter. Whether this was a stationary engine to power the mint machinery or the elusive locomotive is not known, although it *is* known that in the very earliest days of the Ōsaka Mint's operation, there was a small "tramway" line that was laid between the mint proper and Ōsaka station. There is one tantalizing further reference to this locomotive to be found in a 1922 French article, which relates that the locomotive was "Vendue, dit-on, à des marchands d'Osaka." ("*Sold, they say, to Ōsaka merchants.*")

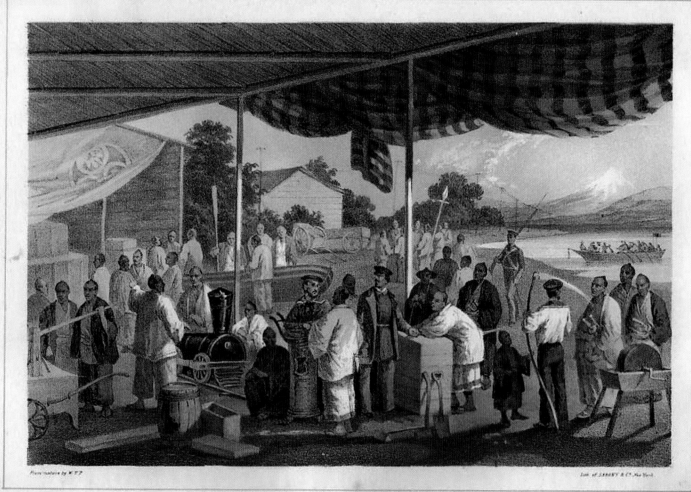

DELIVERING OF THE AMERICAN PRESENTS AT YOKUHAMA.

By the time Glover was demonstrating the *Iron Duke* in Nagasaki, Shōgunal power had deteriorated almost completely and change was taking hold. By dint of sheer military power, Western nations had succeeded in forcing a series of decidedly unequal treaties upon the Japanese Government that the *Bakufu* did not have the military power to resist, an example of which were the notoriously exploitative extra-territoriality clauses exempting foreign nationals from Japanese law when on Japanese soil (subjecting them instead to "consular courts" in the treaty ports presided over by foreign consuls or judges), but providing no reciprocal exemptions to Japanese citizens abroad. Superficially the strategy of the Shōgunate, then nominally in the hands of a mere teenager, Tokugawa Iemochi, whose reign was destined to be among the more inept of the Tokugawa line, seemed to be a policy of sufferance and containment, while taking the first tentative steps toward modernization and adoption of Western technologies. Discontent with the régime was widespread. Reactionary *daimyō* advocated outright expulsion of all foreigners and a return to Japan's isolationist policy. More farsighted and progressive *daimyō* argued that radical industrialization and commensurate strengthening of Japan was the only viable chance Japan had to escape annexation and colonization by European powers who were making just such moves across the Yellow Sea on the Asian mainland at that very time, in what has

Within sight of Mt. Fuji, the miniature Norris locomotive brought by Commodore Perry's Expedition in 1854 as a gift of the United States is unloaded among the other gifts brought ashore on the beach of Mississippi Bay, just south of Yokohama. The scene is more likely an arranged composition from the hands of the Perry Expedition's artist than an actual depiction.

come to be known as the Opium Wars and the French Indo-Chinese Wars. Unhappy with the Shōgunate's perceived and actual weakness via-à-vis Western nations and for other reasons, the other *daimyō* began to put pressure on the Tokugawa Shōgunate, which found itself caught between polarized *daimyō* and Western Powers on its doorstep in the heyday of colonization, with little room to maneuver.

To the forefront of the anti-Tokugawa cause came the Chōshū domain, at the southwestern-most tip of Honshū, across the straits of Shimonoseki from Kyūshū. (Chōshū was the Sinicized name of Nagato province, roughly the western half of today's Yamaguchi prefecture, a domain historically antagonistic to the Tokugawa régime.) Resentful of Western encroachments decidedly to the disadvantage of the Japanese people, the Chōshū domain started militating against foreign presence in Japan and in favor of restoration of political power to the Emperor. In 1863 it orchestrated a series of anti-Western and anti-Shōgunal confrontations, not without tacit encouragement from the Imperial court at Kyōto. As a result of attacks on British ships in 1863, for which

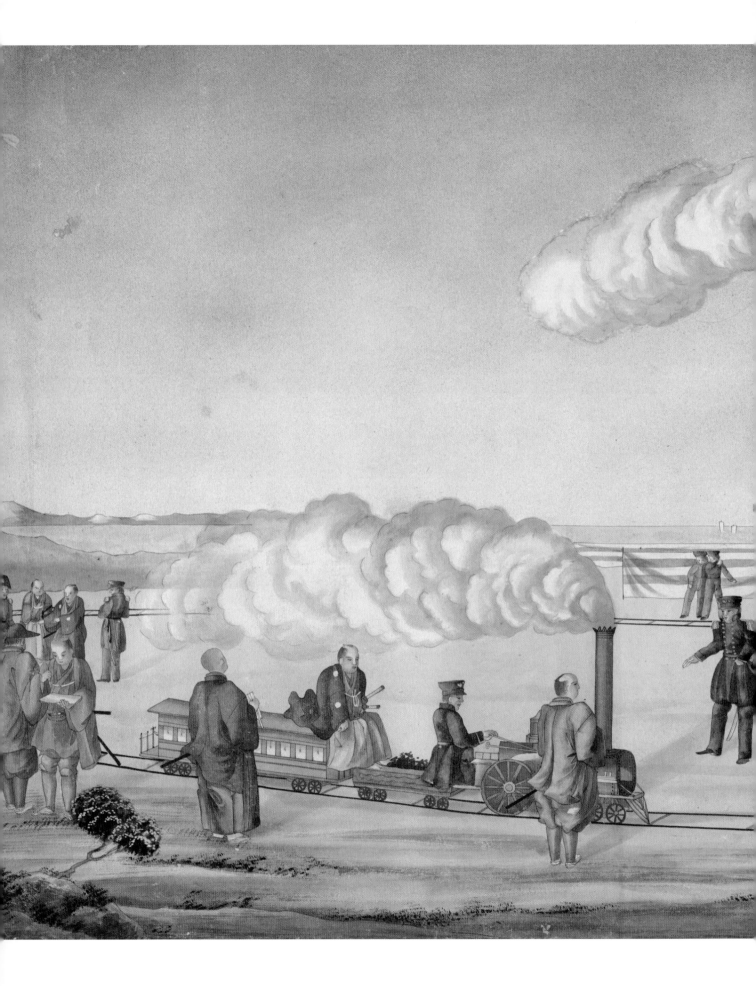

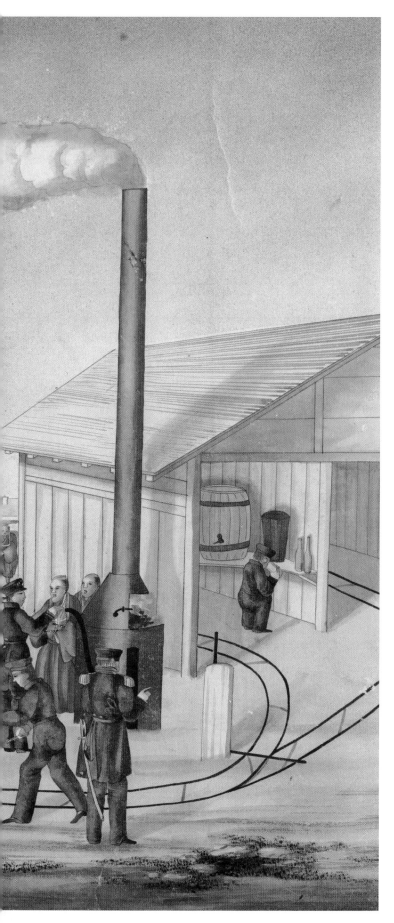

attacks the Chōshū domain was unilaterally punished by a British Royal Navy bombardment and destruction of Chōshū forts at Shimonoseki the following year, the Japanese Government was saddled with an Indemnity of $3,000,000 Mexican Dollars, known as the Shimonoseki Indemnity.[3] After a coup attempt in 1863, and an uprising in the capital staged in 1864, the Emperor felt *obliged* to call on the Shōgun to restore order to the realm in 1864 by mounting an expedition to put down the unruly Chōshū *daimyō*. To the surprise of some, the results were not altogether successful for the Shōgunate, such that 1866 saw the powerful Kyūshū *daimyō* fiefdom of Satsuma (another domain with historic antagonism toward the Tokugawa Shōgunate since the days of its defeat at the hands of Hideyoshi) joining its neighbor Chōshū in an alliance, again using the restoration of political power to the Emperor and total expulsion of foreigners (the so-called *sonno jōi* movement) as a rallying point.

For a brief period, in 1865–1866, a proposal for construction of a railway to run between the Imperial Capital of Kyōto and Ōsaka was pressed by the *daimyō* and future leading industrialist Godai Tomoatsu of Satsuma (although an acquaintance of Glover, Tomoatsu made his proposal with Belgian backing) as a means of being able to speed troops from the Chōshū and Satsuma domains in the south in the event of an emergency to "defend" the Emperor from colonizing foreigners, first via steamer to Ōsaka and thence by rail to Kyōto. Understanding all too well that rallying to defend a *threatened* Emperor from foreigners was not fundamentally different from rallying to defend an *unruly* Emperor from the *Bakufu* itself, the Tokugawa régime was not favorably disposed in respect of this proposal and it came to naught. The *Bakufu* itself was considering a different railway scheme that would have enabled it to rush troops from its seat of power in Edō to Kyōto if things got out of hand.

In late 1866, the American Legation was confidentially advised that the Shōgunate had resolved to build a railway from Kyōto to Edō, along an inland route. This would have run through tea growing districts, then a major source of Japanese foreign trade revenue, and also would have avoided coastal areas prone to foreign bombardment (as had occurred at Shimonoseki) and colonial occupation of the line. The Tokugawa scheme reported in a later official dispatch to the US State Department also called for a northern extension to the silk districts, probably those in the Takasaki/Maebashi vicinity, which also would have a secondary purpose of linking close-by Nikko, where the ancestral tombs of notable Tokugawa Shōguns were found and rich copper deposits could be exploited, with Edō. This would have formed a great central trunk line through Japan, connecting Edō and the north with the populous Kansai plain on which Kyōto and Ōsaka are located, and thus have joined the two capitals of the Shōgun and the Emperor. According to US diplomatic correspondence, the Tokugawa railway proposal had progressed at least to the point where a preliminary "though hasty" route survey had been made, and young Tokugawa functionaries had been sent to Europe to study railway building and earn engineering degrees, with more expected to do the same in the United States.

This painting is one panel from a scroll by an unknown (presumably Japanese) artist depicting the demonstration of the Norris locomotive that Commodore Perry brought as one of his gifts. The train, with a Japanese dignitary aboard, approaches a turnout with a lever-operated switchstand controlling the route between the main loop and apparently a storage siding leading into the building, beside which a gift forge has been erected for demonstrations of Amerian smithing technology. A high ranking American officer appears wearing a cocked hat at far left. The scroll was at one time in the collection of Wang Zhiben, a Chinese art scholar who taught in Japan in the Meiji era.

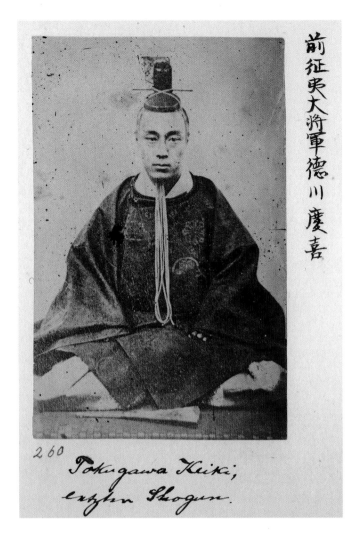

前征夷大将軍德川慶喜

260

Tokugawa Keiki,
eighth Shōgun.

Japan's last Shōgun was Tokugawa Yoshinobu, shown here in traditional court attire. Also known by the sobriquet Keiki, the last Shōgun was not initially considered to be among the leading candidates for the position. Among the last major foreign policy actions of his régime was the issuing of Japan's first railway grant to Anton L. C. Portman, the American Legation's Chargé d'Affaires, only days before the start of the Boshin War that would sweep the 250 year old dynasty of his ancestors from power.

Unfortunately for the Tokugawa Shōgunate at this time, both the financial and political situations were highly uncertain, and the Tokugawa railway proposal was postponed indefinitely. Foreign ministers at the head of their respective legations did the best they could to assess the likely outcome of the political unrest. The French minister, Léon Roches arrived in Japan in April 1864 and quickly set about ingratiating himself with the *Bakufu*, with notable success. In eminently reasonable Cartesian terms, Roches concluded that as the *Bakufu* was the legitimately recognized government of Japan as a matter of international law, he should treat with the *Bakufu* and not with the Imperial Court in Kyōto. Thereafter the French favored the Tokugawa régime. Roches became a favorite of the *Bakufu*, which had started slowly to modernize and adopt Western technology, and won for French interests the awarding of contracts to build a naval base, docks, repair facility, and arsenal for a planned modern navy at Yokosaka (south of Yokohama on the Miura peninsula), to build silk textile factories, to furnish technical advisors to assist in modernizing the

Army, and to build and equip a modern mint. Roches submitted his own railway proposal, again made in 1866, for a railway from Edō to Kyōto with French technical and financial assistance, which would have been as useful to the *Bakufu* in maintaining primacy in Kyōto as a railway from Ōsaka to Kyōto would have been for the Chōshū-Satsuma Alliance, but the *Bakufu* was determined to build it solely using Japanese funding and labor. By the end of 1867 the *Bakufu* had taken the steps of proposing a program that would have restructured the existing government and financed national development through taxes on the *daimyō* for projects such as military, educational, telegraphic, navigational, and railway development. The *daimyō* were not inclined to agree to such a drastic tax on their income, and the proposal was abandoned.

The newly installed head of the British legation, Sir Harry Smith Parkes, landed in Nagasaki in 1865 and met Glover. Perhaps because Glover had introduced him to high ranking Chōshū-Satsuma Alliance members (who Glover had befriended) before Parkes departed for Yokohama, and thereby afforded him the chance to form an opinion as to their competency, military might, morale, and motivation, Parkes took an altogether different view of the events of the day, and was inclined to bide his time, believing that the Chōshū-Satsuma Alliance and gathering backers of the Emperor had a better chance of success than might otherwise have been thought. Before not too long a time, Sir Harry had become more and more sympathetically disposed to the cause of restoring power to the Emperor.

Parkes was, to say the least, a colorful, strong, and forceful character, at a time when British diplomats in the Far East (and elsewhere) were not in the least afraid to be forceful. He was completely his own master and had learned quite well how to maintain a resolute character in the face of adversity, having been orphaned in the year 1833 at age five and sent to live with an uncle, who died in 1837, obliging him to set sail for China in 1841, to live with a cousin who lived in Macao. He had served in the British diplomatic corps in a lower rank in China since 1842 at age 14. As such, he had participated in the diplomatic maneuverings necessitated by the Opium Wars and had been hardened and tempered by his own experiences forged in adversity and cast from the crucible of China. Parkes was appointed Consul of Canton in 1856 at age 28 and stood down the Chinese Commissioner Yeh over his seizing the British lorcha *Arrow*, which incident sparked the so-called "Arrow War." Hostilities between Britain and China flared up again in 1860, and Parkes was sent to Tungchow, near Beijing, as part of the British diplomatic team at the conclusion to negotiate settlement terms. On arrival, Parkes found his diplomatic immunity disregarded by the Chinese and himself taken captive and made prisoner for several weeks. (Parkes' imprisonment and mistreatment is said to have been part of the justification for the British sacking and burning the Summer Palace in Beijing in punishment for what they viewed as a flagrant disregard of the principle of diplomatic immunity.) By the time Parkes was appointed the United Kingdom's Minister to Japan in 1865, he was self-assured, worldly wise, and could be quite obdurate. And while undoubtedly he could be quite tactful and charming when it served his purposes, likewise he could bully, intimidate, and be a martinet when it behooved him. The story is told that despite the fact that he was by one year Roches' junior in terms of diplomatic standing, he succeeded on one occasion in forcing his way in to a private meeting between Roches and the Shōgun himself on grounds of equal treatment for Her Britannic Majesty's Minister. Another example of his forcefulness is found in the December 29, 1873 issue

Typical Large Railway Station in Japan

of the New York Times, where it was reported that at one State Dinner in the presence of the Emperor, Parkes, who then held senior status among Tōkyō Ministers, rose to give a toast to the Emperor "accompanied by a neat little speech," but when it came time for the American Minister's toast, Parkes literally shushed him at mid-point of the first sentence and told him to sit down; shouting him down with the abrupt words "No more." Parkes' objection? The American Minister's grave offense lay in the formula used in his toast, which had wished "Prosperity, happiness and progress to the Sovereign and People of Japan" and, according to Sir Harry, mentioning the People of Japan in the same breath as the Emperor was "superfluous" and out of order as unduly political. As John Black, the man responsible for introduction of modern journalism to Japan and editor of one of its first English language newspapers put it, "The Japanese officials who were brought into communications with them [foreign ministers], complained sadly of the brusque manner in which they were frequently treated by the plain-speaking strangers. Especially was this the case with regard to Sir Harry Parkes, on whose absolute outbursts of wrath and excited action, they are never tired of dilating."

By 1867, the US Minister was Robert Van Valkenburgh, a New Yorker who had served in the US Congress, and who along with Roches, also tended to sympathize with the *Bakufu*. Shortly after Roches' railway proposal, and a competing proposal by one Carle L. Westwood, an American named Anton L. C. Portman met with *Bakufu* officials and made yet a third proposal to build a line from Edō to Yokohama in the form of a *concession* (i.e. the line would not have been built for the Japanese Government, but was to have been financed with American capital and to have remained American-owned under the control of its American owners).

Portman, a naturalized American who had been born in Holland, had been attached to the Perry expedition as a mere clerk, but when the attempts to communicate with the Japanese using Chinese proved to be such a shambles that the Japanese refused to negotiate in that language, Dutch was hurriedly substituted,[4] and Portman, who spoke Dutch, proved invaluable and was pressed into service. (Congress later resolved to increase his pay to three times the original sum in view of his contribution to the success of the Perry Expedition.) By 1867, he had risen to become the Secretary, what today would be the Deputy Chief of Mission; second in command of the US Legation in Japan. When he learned of the Tokugawa project to build a railway from Edō to Kyōto in 1866 he saw an opportunity. During the course of 1867, he devoted increasing portions of his time to obtaining for American interests the right to participate in the first railway building. He undoubtedly pointed out that Americans had an enviable record of railway building and were well along in the process of building the World's first transcontinental railroad and likely reminded the *Bakufu* that the French and the English had been awarded contracts for building all the major public works projects then underway and that it was unfair to exclude Americans from such undertakings. He inquired of his counterparts in the *Bakufu* why there was no provision in the new Tokugawa railway project for a branch to Yokohama, Japan's most important port, less than two dozen miles away from Edō. His counterparts at the Ministry for Foreign Affairs replied that due to the increasing anti-foreign *sonno jōi* political sentiment then prevailing in Japan, it was felt that allowing anyone other than Japanese to build the railway would have aroused contrary public opinion to an unmanageable level. Portman then skillfully proposed to build only a branch railway of

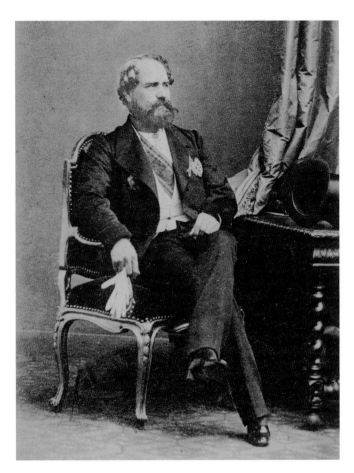

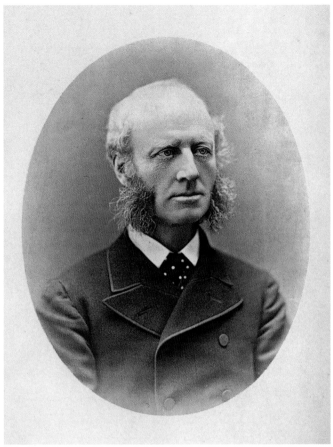

Léon Roches, Minister Plenipotential and Envoy Extraordinary of Napoléon III, Emperor of the French, to Japan, 1864–1868.

Sir Harry Parkes, Her Brittanic Majesty's Minister Plenipotential and Envoy Extraordinary to Japan from 1865 to 1882, in a photograph taken around 1879.

the Tokugawa grand trunk line: a section between Edō and Yokohama, astutely pointing out that the Yokohama line did not even have to be physically connected to the Tokugawa Grand Trunk Line, and that the building by Americans of a short line of railway could only serve to underscore the importance and nationalistic character of the achievement of the projected Grand Trunk Line. He succeeded where others had failed in concluding negotiations with the *Bakufu* for a railway concession in part due to timing. By late 1867, relations with anti-Tokugawa *daimyō* had turned so sour that there was little political disadvantage in risking arousing them on smaller subsidiary issues. The *Bakufu* felt that while, given the impending struggle it could foresee, it could ill-afford to budget domestic funds for its projected grand trunk line, there was little reason why foreign money couldn't be put to use on the smaller Yokohama line, which at least would be helpful in the logistical support and supplying of troops and material likely to be needed to be sent from Edō. Accordingly, Portman was granted a concession to build the line from Edō to Yokohama by the Foreign Minister; an official then honored with the title of Ogasawara Iki no Kami, on January 16th, 1868 (December 23rd of the preceding year by the Japanese lunar calendar) in what was to be one of the last major foreign policy actions of the Shōgunate. In a later diplomatic dispatch, it was said that the two men, who had grown over the course of their years of interaction to be longstanding friends, had an understanding to keep the existence of

the grant confidential for as long as feasible, so as not to cause further problems for the *Bakufu* in difficult times or to arouse the sensibilities of the British or French Ministers.

The grant itself was fairly succinct; a one-sentence paragraph in the original translation, the only notable aspect of which allowed Portman to designate persons to undertake actual construction and financing. As a government official, as it was later quite correctly observed, Portman was by US law "strictly debarred from seeking profit" on the grant, and it is clear from the correspondence surrounding the grant that Portman intended to seek financial and technical backers from America rather than attempt to construct the line himself. Simple though the grant was, it was accompanied by a comprehensive, though broad, statement of 14 conditions,[5] which served as the "rules and regulations" governing the grant: The deadline for starting construction was five years from the date of the grant, and once started, the deadline for completion was three years from the start date. The line was forbidden to interfere with the Tokaidō, the main road between Edō and Kyōto, and was required for safety to be fenced. If it ran through rice fields, it would not be permitted to interfere with drainage or irrigation. Rates were capped at a maximum of 25% above prevailing British and American rates, with Japanese Government officials granted a 50% discount in travel rates. [Shipment of troops, materiel, freight, or mail by the Japanese Government was not addressed.] The government reserved the right to regulate and en-

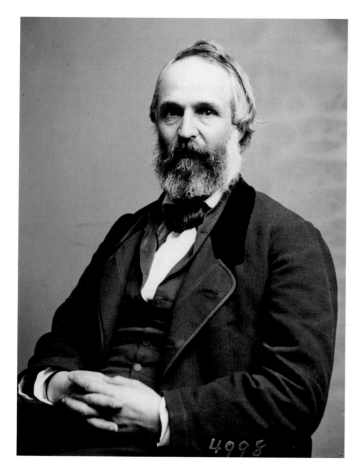

Robert Van Valkenburgh, the American Minister Resident to Japan, 1866–1869. As mere Minister Resident, the senior American diplomat in Japan was inferior in diplomatic rank to his British and French counterparts.

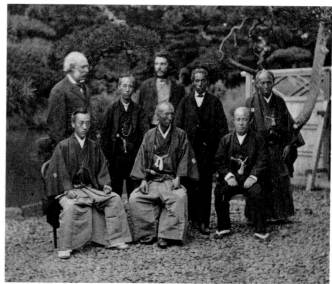

This rare view shows US Minister Resident Van Valkenburgh standing at the left of a group of Tokugawa Bakufu dignitaries. Among them is Katsu Kaishi (seated, far left), captain of the first Japanese steamship that traveled to the United States in 1860, bringing with it the first Japanese mission to the United States. The Tokugawa military reformer and modernizer Ōzeki Masuhiro is identified as seated at far right. But most intriguing is the Westerner standing in the center. It is highly likely that this is Anton L. C. Portman, who negotiated the first railway concession with the Bakufu. The photograph was taken on September 22, 1867—around the time Portman was negotiating (or beginning to negotiate) that concession with the Shōgunate. Within roughly three months from the time this photograph was taken, the railway concession would be granted to him, while all the Bakufu officials pictured would be undergoing the process of being swept out of power. The photo was taken in the gardens of the Hama-Goten (lit. Beach Palace) of the Shōgun. It would be renamed the Hama-Rikyu after the Meiji restoration and was the location of the official reception and festivities that were held after the opening of the first railway.

force safety and engineering inspection oversight and undertook to facilitate surveying and construction contract letting with local contractors, to insure faithful and punctual performance of such contracts, and to undertake and complete the necessary land acquisition for the line within 6 months of receiving the final survey. Annual ground rents for the land acquired were set and a rudimentary payment schedule was established. The government required a full accounting of the cost of the line upon completion, annual reporting of receipts and expenditures thereafter, and reserved the right to purchase the railway at any time at a premium of 50% over its "cost price." Finally, the government guaranteed that Japanese nationals would be free to travel on the line and to buy and own shares of stock in the enterprise free of taxation, and that the government would not interfere with actual management and operation.

In all, the conditions of the Portman grant demonstrates that it had been the subject of considered deliberation by the *Bakufu* and but for the excessively favorable rate caps, the simplistic formula of the purchase option, and the failure to foresee the advantage of requiring a favorable governmental rate for shipment of troops, materiel, freight, and mail, the document was on whole a very creditable first step into the railway building and regulation arena.

During the time Portman was conducting his negotiations, the domains of Chōshū and Satsuma had continued their remon-

strances: an abortive punitive expedition against the so-called "Southern *Daimyō*" by the Shōgunate in 1866 had only served to underscore the military ineffectiveness of the *Bakufu* Government. The struggling and inept fourteenth Shōgun, Tokugawa Iemochi, died during the course of that expedition at age 20, and his death was used as a face-saving measure to cease pursuit until his successor Tokugawa Keiki (more commonly known in the West as Tokugawa Yoshinobu) was installed. Taking advantage of this, sensing the weakness of the *Bakufu* armies, seizing on the relative inexperience of the new Shōgun, and exploiting the potential for transitional difficulties they hoped would be a natural result in the Tokugawa administrative structure and in its chain of command, the Chōshū-Satsuma Alliance grew and the year 1867 saw it increasing pressure on the Shōgun to step aside. As the stage had been set for a final Chōshū-Satsuma/Tokugawa rivalry, so too was it set for a Anglo-French-American diplomatic rivalry for *entrée* and influence, with Roches whole-heartedly embracing the Tokugawa régime, the Americans trying to remain aloof, but preferring the known quantity of the Tokugawa régime to the unknown and avowedly anti-foreign *sonno jōi* hotheads of the so-called "Imperial Cause" which was the label preferred by the Chōshū-Satsuma Alliance, and the British becoming increasingly sympathetic to the Emperor (as an institution of real political power) and his Chōshū-Satsuma backers.

The year 1868 was the watershed. Armed conflict began only a few days after Ogasawara Iki no Kami had issued the railway grant

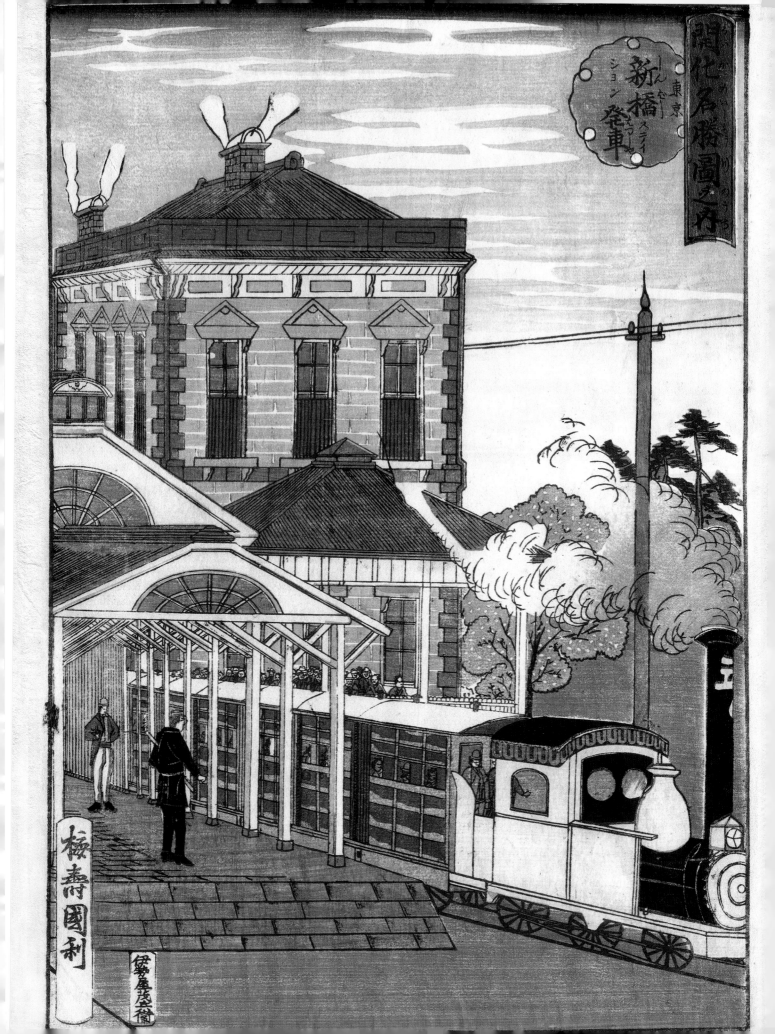

Chapter 2: 1869–1870
Intrigue, Influence, and Incompetence as Railway Planning Begins in Earnest

On March 8, 1869, the *Stonewall* was at last delivered to the new Imperial Government. She was promptly rechristened the *Kotetsu* (甲鉄) meaning "Ironclad," and upon her commissioning became undisputedly the most formidable ship of either fleet. The Chōshū-Satsuma Imperial Cause lost no time in putting the newly christened warship into service, bound for Hakodate. According to Van Valkenburgh, after some delays brought on by the accidental sinking of one of the squadron's most serviceable ships due to an on-board explosion caused by an inexperienced crew member during target practice, and an abortive start thwarted by heavy seas, the squadron left Uraga at the entrance to Edō Bay, where it had put in to wait out the squalls, on April 21st. Only a few days later, the crew of *Kotetsu* saw their first real action, repulsing an attack from the rebel fleet's flagship *Kaiten* (a paddlewheel steamer formerly known as the *Eagle*) on her way to the final Battle of Hakodate, where she was the backbone of the new Imperial fleet consisting of eight ships. The battle was the first victory for the modern Imperial Japanese Navy by the time it had finished, sealing the fate of the remaining Tokugawa loyalists on land, which by then had dwindled to between 800 to 2,000 men according to Van Valkenburgh's dispatches. Within a short time, the remaining Tokugawa commander Enomoto Takeaki and the remnants of the Tokugawa army in Hakodate surrendered. They were allowed to march out of their last redoubt at Kameda, on the outskirts of Hakodate, with military honors, the recently deceased Komei Emperor's 17 year old son and designated heir to the throne, Mutsuhito, who had more likely than not grown up being prepared for a lifetime of cooperation with or quiet, tactful passive opposition to the Tokugawa régime by turn of fate found himself undisputed Emperor of Japan and *sitting at the head of government*. His coronation in 1868 thus came officially to mark the beginning of a reign that was given the title of "Meiji," meaning "Enlightened Government" in Japanese, and he posthumously came to be referred to by his *reign name*.

To mark the momentous import of the Imperial restoration and to put himself closer to what had become the nation's *de facto* capital in the eyes of the populace, the Emperor moved his permanent residence eastward from Kyōto to the former Shōgun's castle in Edō soon after it had fallen in 1868. As if to underscore the beginning of an entirely new era, Edō was renamed Tōkyō, meaning "Eastern Capital." While many might argue that, in large part, the "reigns but does not rule" axiom was never *entirely* abandoned, few would argue that there was not a distinct increase in the prestige, prerogatives, and the political power of the Emperor over the course of his reign. Instead of doing business in the manner his predecessor the Kōmei Emperor had done, putting a mere imprimatur on Tokugawa edicts, the Meiji Emperor sat at the head of a government council, later a cabinet, advised by ministers who had replaced the Shōgun, not altogether unlike the manner in which a European monarch sat at the head of his or her ministers who advised and executed the functions of government.

Once faced with the hard reality of governing, the Chōshū-Satsuma *clique* quickly realized that the foreigners could not be expelled, as the more radical elements of the faction had desired and it gradually became more pro-reform and pro-Western (at

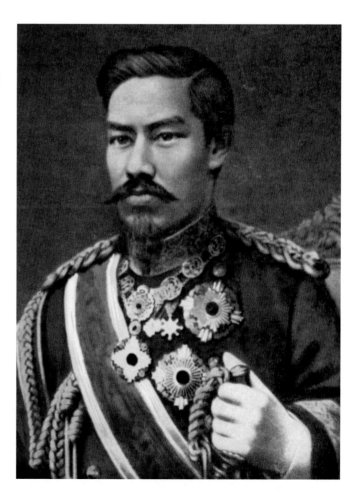

(opposite)
The artist Utagawa Kunitoshi has depicted a Yokohama-bound train headed by one of the Avonside locomotives departing Shimbashi station, while a crowd watches the departure from behind the ticketing wicket.

(right)
Probably only around a half-dozen known photographs were permitted to be taken of the Meiji Emperor, Mutsuhito, during his life. This accounts for the many photomechanically reproduced (what we would today think of as "digitally altered") images of him such as this, showing him around the 1880s or 1890s.

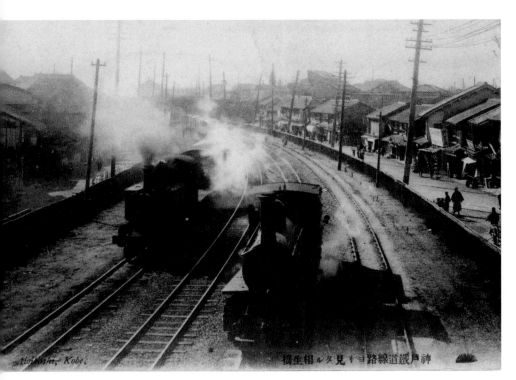

Meiji Government in respect of industrial development occurred with the erection of the first telegraph line in the realm. In a radical change of course from the policies of the preceding 200 years, the Imperial Government unabashedly began retaining Western advisors to help modernize the nation. It has been observed that technological change is a political process, and while this certainly is often the case, in Meiji Japan, the inverse could be argued: political change was a technological process. By the time the realm had absorbed needed Western technology, it had become acclimated enough to Westerners that the political agenda of the Chōshū-Satsuma oligarchy had been changed to the point that complete expulsion of foreigners was no longer a goal.

Initially, Japanese of all political stripes could agree that the planned naval base and a navy were an absolute necessity to defend the homeland against foreign aggression or intervention, so the essence of the Yokosuka agreement with the French was re-affirmed by the new government. In an effort to avoid reliance too much on any one power, which could too easily lead to dependence (and in those times in Asia, dependence was never far removed from annexation and colonization), the new government exercised a delicate balancing act, retaining different nations to accomplish different areas of reform and to be used as models to approximate, while the new régime strove not to become too reliant on any one power. The Tokugawa régime had asked the French to assist in modernization of the army, which they did up to their defeat in the Franco-Prussian War, when the Germans replaced them as a model. The régime leaned on British advisors for the navy, while the Dutch were retained for civil engineering projects involving land reclamation and river and harbor improvements. Later, the German legal system was emulated and the American educational and agricultural systems were studied; all according to areas where, in the conventional wisdom of the time, the particular country chosen as a model had demonstrated notable success.

Not surprisingly the newly formed government that surround-

least insofar as adopting technology to strengthen the realm was concerned); progressive ministers emerged as most influential and elected to set the country upon a radical course of rapid modernization. The decision that the Tokugawa Shōgunate had made to build a lighthouse system to aid in shipping and navigation was ratified.[1] In 1869 the old edicts outlawing ocean-going ships would be rescinded. That same year, another significant act of the

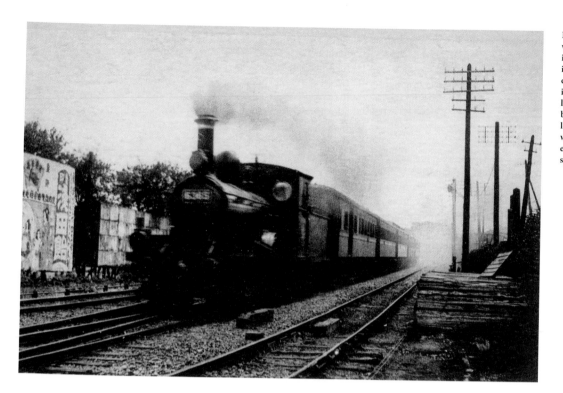

Railway travelers in Meiji Japan were no more immune from being bombarded with advertising imagery than are their present-day descendents, as this photograph illustrates. In this view a 6300 class locomotive draws a train past a bank of billboards at an unknown location. Note the curious short wooden platform at the right, the exact purpose of which is open to speculation.

ed the Emperor consisted mainly of men picked from the cream of the Chōshū-Satsuma Alliance. There are more than a few coincidences in the history of Japanese railway development that occur during this period, one of which is found in Thomas Glover's assisting five youths from Chōshū to slip secretly out of Nagasaki (on June 27, 1863 when travel abroad was still forbidden to all Japanese) on board the ship *Chelswick* bound for Shanghai, sent to study in England on a stipend from the Chōshū domain. These five young men were Endo Kinsuke, Inoue Kaoru, Inoue Masaru, Itō Hirobumi and Yamao Yozo. Once on the mainland they were split into two groups and aboard the ships *White Adder* and *Pegasus* they were soon bound for England, where they landed in early November. In July 1864 they enrolled at the University College of London. By this time Inoue Masaru, then known by his adoptive name of Nomura Yakichi (he had been adopted by another samurai family, which was a manner of networking common to Tokugawa Japan), had acquired the sobriquet of *Wild Drinker* and his enrollment records reflect a sense of humor and of 'putting one over' on his hosts, as he managed to be officially enrolled using the name of *Nomuran*; Japanese for "Wild Drinker." Itō and Inoue Kaoru only stayed half a year before returning, but Inoue Masaru stayed among the longest and became the most proficient in English. He focused most on railway studies among the Five, and with Yozo was the last to return in 1868, when he reverted to his Inoue family name. The Chōshū Five formed an *old boys network* that their English benefactors profited from more than once, and while studying in England, collectively came away deeply impressed with its technology, social structure, financial institutions, and of course, railways. All were destined to go on to greatness in Japan; three of them played pivotal roles in the railway history of Japan.

First and foremost to the fledgling government was the necessity of continuing incipient Tokugawa programs of development (with such modifications as were deemed fitting), of building a modern economy, a modern army, a navy and adequate naval facilities, and commensurate navigational facilities to protect the navy and commercial shipping, which was a key to foreign trade revenues; all as cajoled by Parkes. Warships continued to be ordered from the shipyards of Europe and the US, to supplement the first squadrons of the Imperial Japanese Navy that had seen action at Hakodate. Parkes was successful in obtaining appointment of a British subject to act as the first customs commissioner for the government, and the Ōsaka mint project was resurrected and awarded to British interests, later built and equipped with machinery purchased through Glover & Co. (Endo Kinsuke, one of the "Chōshū Five," became the Ōsaka Mint's first head.) Parkes had already volunteered the good offices of the Royal Navy to survey and recommend the appropriate sites on which to construct a comprehensive system of lighthouses at critical points throughout Japan (undoubtedly coming to be viewed by the new government as a necessity to safeguard its precious new warships).

The man chosen to implement Japan's lighthouse network was Richard Henry Brunton, a Scot with a receding hairline, mustache, and mutton-chop sideburns. Henry Brunton was every bit as obdurate as Sir Harry Parkes, but evidently lacked his charm. At a time when, on departing Japan at the end of their service, the first foreign technical advisors employed by the Japanese Government were customarily given an audience with the Emperor as a fitting farewell, routinely given an extra sum of money—not infrequently a lifelong pension—and decorated with an order of merit and medal in appreciation, by contrast, it is reported that at his farewell audience, Brunton was simply given £500 and a gracious verbal "thank you" from the Emperor. His prior training and experience, by his own admission, was not in the area of lighthouses, but in *railways*. Accordingly, he spent several months in the UK bringing himself current with the engineering issues peculiar to lighthouse design, construction, and operation before departing Southampton on June 13, 1868. After a voyage that took just five

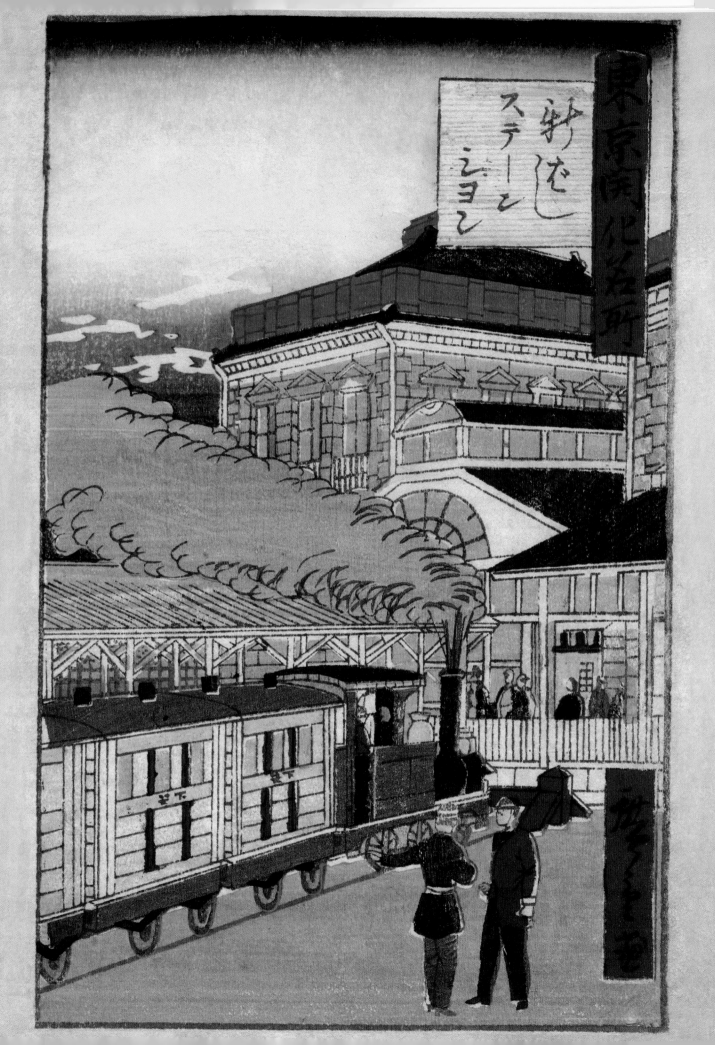

Chapter 3: 1870–1872
Building the First Railway

As the fledgling government's treasury was already reeling from the Shimonoseki Indemnity, the Boshin War, the costs of warships, naval yards, lighthouse construction and modern armaments procurement, it was obvious that a source of funding for the proposed railway network, however modest, would be the first matter of business to be considered. Before word of the government's decision had spread very far, numerous enterprising foreigners came forward with financing proposals, as one might expect. Initially, the government assigned the railway project to the Ministry of Civil Affairs and Finance. Itō was given authority to raise money for the project. Parkes had initially recommended that "Japanese merchants" be used to raise the money (a long history of the government "putting the squeeze" on the merchant princes of Ōsaka stretched far back into the Tokugawa Shōgunate). This idea was floated, but came to naught. One commentator relates that the government had turned to the industrial house of Mitsui, which had recently established one of the first modern banks, and asked it to raise the funds for construction, to the tenor of ¥700,000, agreeing to guarantee a return of 7% and a share of half the profits in excess of 7%. (The offering failed for lack of subscribers despite Mitsui's best efforts.) If this was the case, the effort must have occurred well in advance of Parkes' meeting on December 7th, as alternative measures had been put in place only a week after that meeting: seizing the opportunity for British interests, Parkes introduced Itō and Ōkuma to Horatio Nelson Lay, *Companion of the Most Honorable Order of the Bath*, a British subject who was formerly the Inspector General of Maritime Customs for the Imperial Chinese Government and had recently come to Japan, purportedly seeking interested borrowers for some £3,000,000 he said he had been asked to place by London venture capitalists for whom he was acting as a partially disclosed agent; preferring to keep their identities secret. Exactly one week later, on December 14th, according to subsequently published notices, "His Imperial Majesty the Tennō of Japan" had issued an Edict enabling the floating of a loan and appointing Lay an Agent of the Japanese Government. That all the documentation appointing Lay a government commissioner, setting out his commission, and authorizing his fundraising activities had been cobbled together within the space of only one week does not speak well of the legal attention the new government functionaries were giving to the matter, and that lack of oversight would soon come back to haunt them.

At best, history has judged Lay to be a controversial figure. He was the son of George Lay, a naturalist and would-be missionary who had parlayed himself into a position with the British diplomatic service in China due to his ability to speak Chinese but who died before his family could join him in China. Lay's widowed mother cajoled the Foreign Office to find a position for the young Horatio, which they did out of a sense of obligation, recalling that they had taken similar steps for Harry Parkes. Horatio was sent out to Hong Kong and was placed in the home of Dr. Charles Gützlaff, who had mentored Parkes. He set about learning Chinese, officially entered the British Superintendency in 1849, and was eventually posted to Shanghai, due to a lack of qualified candidates in the Foreign Service. Thereafter he quickly became appointed Vice Consul, raising hackles of some, and earning him the derisive nickname of the "Boy Consul." This was at a time when there was a rebellion brewing in Shanghai. While official British policy was one of neutrality, due to career considerations it was advantageous for Lay to be sympathetic to the Ch'ing Government, and ever the opportunist, Lay did so. In so doing, he aroused yet more of what was to become an ever-growing hostility of the foreign resident community in China towards him.

At the end of the Shanghai rebellion in November–December 1854, Lay was so bent on ingratiating himself with the Imperial Government that when the rebels were surrounded, and the only means of escape was through the foreign settlement, the foreign community was inclined on humanitarian grounds to allow the escape. Lay however commandeered a group of Royal Marines and Imperial Soldiers and chased the rebels down, which only earned him further contempt for intermeddling in the internal affairs of China, but obviously curried favor with the Ch'ing Government. By this time, Lay had earned the reputation of being

(opposite)
Edging to the buffer stops at Shimbashi around 1874 is a train headed by one of the Sharp-Stewart locomotives that had gained the reputation of being the most reliable among the initial IJGR fleet. The livery of the train seen here is perhaps the closest approximation of the manner in which the first trains in Japan were painted.

(left)
Horatio Nelson Lay, the British subject who was former Inspector General of Maritime Customs for the Imperial Chinese Government.

too aggressive in his official conduct. Nevertheless, the Chinese found him useful, and asked him to enter the Chinese Customs Service in Shanghai, from which he quickly rose to be in charge of customs for the whole Chinese Empire. In a small sense, Lay became a bit of a known double-agent who played in the netherworld at the intersection between Chinese and British interests and served usefully for a while as a sounding board of both, through which trial proposals were floated. But his position as a dual agent would prove to be too tempting for this aggressive and brash young man bent on making a name for himself. It was in his position at the Customs Service of Imperial China that Lay launched a scheme that would be his undoing.

In 1856, he saw the need for a flotilla of gunboats to suppress coastal piracy that was impacting negatively on trade and customs revenues and began on his own initiative to press that proposal. Chinese merchants believed this might reduce their casualty losses attributable to piracy and provided a large part of the seed money. This was in the midst of a period of wars between China and Great Britain, and the proposal to arm the Chinese Government with a flotilla of gunboats was met with vehement opposition by some British residents in China. Undaunted, Lay pressed on with his scheme, enlisting Captain Sherard Osborne, R.N., to serve as the proposed flotilla's commander and managed to cajole out of his Chinese employers an approval merely to investigate the possibility of purchasing a flotilla. Lay promptly returned to London to rally support for his project, and made a number of enemies by virtue of the representations he made while he was there. He misrepresented as outright his authority to acquire the gunboats, and reportedly exercised "unremitting pressure" on the Queen's Government during the negotiations to receive a "Queen's License" to acquire the armaments and to enlist English officers to serve as the Flotilla's command structure under the directions of a potentially hostile foreign government. At the same time, Lay saw fit to promote his own candidacy to a knighthood in the Order of the Bath (which was granted) at a time when such direct self-promotion was much less prevalent. Lay parlayed his way through London with promises of funding from China, and eventually convinced shipyards to accept his authority as a Chinese Government commissioner *on credit* and ordered a small fleet consisting of eight gunboats.

Gunboats began arriving on the Yangtze in August 1862 while Lay, who supposed that he had accomplished a *fait accompli* with which his Chinese employers would be obliged to agree, was in Beijing where he "cajoled, argued, and stormed" at members of the Chinese Foreign Ministry to accept delivery of the "Lay-Osborn Flotilla," as it had come to be known. But the Ch'ing Government stood fast and the whole scheme started to unravel. The government would not agree to foreign nationals being in command of the Flotilla, and refused to pay for the balance due on the gunboats, which Lay had assumed it would do to make good the shortfall. Over the next year and a half, scheme turned into a scandal, and Lay was removed from his position by his Chinese employers, who also set about purging all of his appointees and hires from the Customs Service as the reverberations spread. This upset the delicate balance of the Sino-British relations, which were then at an all-time low and were only slowly being restored in the aftermath of the recent hostilities. Naturally the matter caused considerable embarrassment to the British Government at a time when they did not wish to see further complications in Sino-British relations. The taint of the débâcle was so strong that Lay was deemed *persona non grata* in the British

Foreign Service. Where once he had been a double agent whose star was on the rise, Lay soon found himself to be a masterless servant and was, according to one source, "totally isolated." According to the same source, after his dismissal by the Chinese Government, "… Lay continued to believe that he had a role to play in China, but no one else of any consequence did."

Stanley F. Wright summed it up succinctly in his history of the Imperial Chinese Customs Service:

> "For Lay dismissal was inevitable, although he does not seem to have thought so. But the wound he had inflicted on China's pride was too deep for easy forgiveness. He had tried to usurp powers which no self-respecting sovereign State could possible [sic] delegate to a paid foreign employee: not only did he wish to direct the operations of the fleet, but he also wished to control the disposal of the Customs revenue, — a double jurisdiction of such scope and power as would have enabled him, in the opinion of the Yamen, to dictate State policy. In his pathway to the control of the disposal of the Customs revenue stood the two high Chinese officials, the Peiyang and the Nanyang Ta Chên—both of them powerful Viceroys. These two offices, which had been created by the Imperial Decree of 20th January, 1861, establishing the Tsungli Yamen, Lay wished to have abolished. He had increased the Yamen's apprehensions by his proposal that he should be given a foo to live in, such as was then allowed only to princes of the Royal family, by his assumption of equality with the high ministers of the Yamen holding himself as responsible only to Prince Kung—the Vice Regent, by his overbearing manner, and by his dilatoriness in presenting accounts for the money expended on the fleet. The Ministers of the Yamen had lost confidence in him, and so once more they turned to Mr. Burlingame, where they knew they would get helpful and disinterested advice. He was of the opinion that it was a matter entirely for the Chinese Government to deal with, but agreed to consult his colleagues. They unanimously concurred in his opinion. Bruce co-operated with Burlingame, and both of them directed their efforts in such a way as to do the Chinese and Lay the least injury. With this support the Yamen carried out its intention and dismissed Lay on 15th November, 1863, according him at the same time exceptionally generous financial treatment, viz. Tls. 3,000 a month for five months to cover the expenses of his establishment at Peking, Tls. 2,000 a month as salary from 1st May, 1863, to 15th March, 1864, and a special parting gratuity of Tls. 6,000 in all Tls. 42,000 (= £14,000)."

It was with this track record that the aggressive and scheming Mr. Lay washed up on the shores of Japan, plotting his 'come-back.'

Incredibly, the new Japanese Government was apparently totally ignorant of the circumstances surrounding Lay's unauthorized dealings and subsequent dismissal from the Chinese Customs Service, even though the troubles had been picked up by and reported in the British and American press; the *New York Times* published a special report on the matter as early as January 30, 1864. It is said in several sources that Itō and Ōkuma naively assumed from his name and chivalric title that Lay was a relative of Lord Horatio Nelson of Trafalgar fame, and they placed greater confidence in him than they otherwise would have had his true social standing been known. Whatever the cause, Lay was given the opportunity to raise financing for the projected new railway.

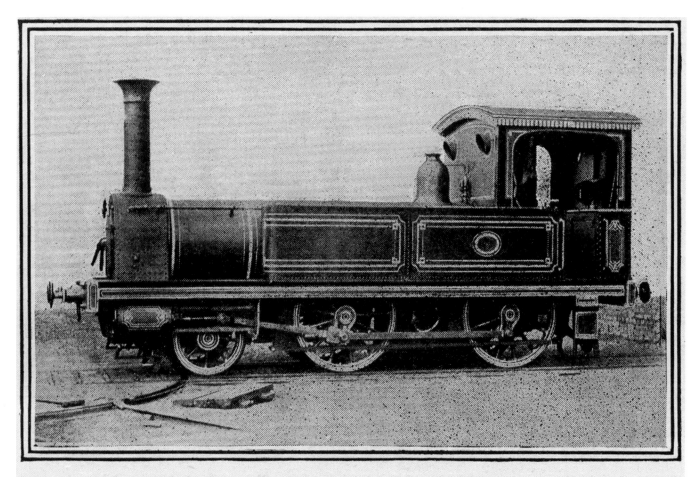

THE FIRST LOCOMOTIVE TO RUN IN JAPAN, 1871.

Commissioner of Railways at age 29 and was put in charge of the newly formed Railway Bureau in August of that year. The *Kōbushō* was headed by another of the Chōshū Five, Yamao Yozo. Inoue set about his newfound commission with a great amount of energy, and would brook no contest: soon *Wild Drinker* would come to be known as *Old Thunder*. His combination of zeal and willfulness was precisely what was needed. Inoue would go on to serve well and faithfully as head of the Railway Bureau for many years, by the end of which he had truly earned his reputation as father of the Japanese railway system.

At some point during the four month period between Harry Parkes' meeting in December 1869 and an article appearing in the April first, 1870 issue of *The Engineer*, one of the pre-eminent engineering journals of the day, an issue which would forever flavor and bedevil the Japanese railway system was apparently decided: the adoption of 1067mm (3' 6") gauge (the distance between the insides of the rails) as Japan's *de facto* standard. Of course, most nations of the world use 1435mm (4' 8½"), which is accordingly often called "Standard Gauge." Exactly how this decision was reached is not known, and remains one of the great, unanswered questions of Japanese railway history. It is not unreasonable to surmise that as neither Parkes, Lay, Itō, Ōkuma, nor any of the other men who were in a position to affect this decision felt any strong or particular expertise in this area, and that it was left be resolved at other levels. It is doubtful that Yamao or Inoue had

The Vulcan Foundry of Newton-le-Willows had only been in business for a little over five years when it received an order for one of Japan's initial ten locomotives from George Preston White, the initial resident consulting engineer in London who had been retained to handle technical specifications and orders on behalf of the Japanese Government. Vulcan built and shipped this neat little engine first, winning the honor of having built the first locomotive in Japan ever to be used in revenue earning service. The polished brass steam dome and copper-capped chimney were typical of British locomotives of that period. The elaborate pin striping of the black livery would soon give way to a more somber unlined black. The locomotive was reboilered in the 1890s at which time it received a larger diameter boiler that was placed higher on the frames, a steam dome in the middle of the boiler, and new side tanks, smokebox, chimney and cab. It has been kept in this later state for preservation and today is one of the most important items in the collection of the Railway Museum in Ōmiya.

much input, as the decision was certainly made before the *Kōbushō* and Railway Bureau were even in existence, and their involvement in railway affairs at the time the final decision was made would have been only informal and unofficial. Writing in 1909, shortly before his death, and many years after the event, Inoue indicated that he was part of the deliberation over gauge, militated in favor of the narrower gauge and took credit for its introduction, but it is unlikely that he had much *official* input in the ultimate decision, as it had to have been made well before August 1871 when he was appointed head of the Railway Bureau, and his statement rings a bit self-serving with an eye to burnishing his reputation as Father of Japanese Railways. Mention in the April 1, 1870 issue of *The Engineer* of the fact that 1067mm gauge had

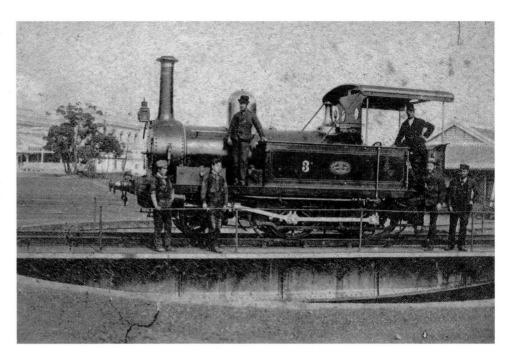

A rare view of the single Yorkshire "A Class" locomotive that was among the initial batch of ten locomotives ordered for the first railway in Japan, pictured here on the Ransomes & Rapier turntable at the Tōkyō terminus with Shimbashi station in the left background. As this locomotive originally bore running number 10, but was renumbered with running number 3 in 1874, the photograph must date from after that time. The rather large expanse of vacant land between the turntable and the station (later to be filled with sidings) together with the English driver in the cab and the two Japanese firemen standing on the left would seem to indicate that the photo may have been taken before Japanese drivers began replacing English drivers starting in 1879. In 1887 the side tanks were enlarged and by the 1890s, the cab, whose design was more suited to the heat of colonial India, had been remodeled to afford its crew more protection against the cold of Japanese winters. The locomotive garnered the dubious distinction of being the least reliable of the initial ten imported. It was unceremoniously turned into a cut-away static display in the 1920s, but has since been cosmetically "restored" and can still be seen at the Ōme Railway Park in the Tōkyō environs.

been adopted likewise would preclude Morel from any hand in the process, as the article proves the decision had tentatively been made and was known in London even before the date of Morel's arrival on the scene in Japan. The April first article also tends to support the inference that the matter probably had been discussed in Japan in only the most cursory manner, if at all, before Lay departed for London, and was intended to be left to the sound judgment of the consulting engineer he was to hire. Given that it took on average two months for a letter to reach London from Japan at that time, and given that telegraphic communication between Japan (or even China on the continent) had yet to be established with London, it would simply not have been an efficient use of time to have engaged in any meaningful deliberation by mail between London and Japan on that issue. Necessity dictated that Lay set sail for London either with the matter of gauge tentatively resolved, or with full authority to resolve it according to his best judgment. Another article in *The Engineer,* two months later in June, mentions that the gauge decision was not certain, but was *probable,* which is evidence that Lay probably left Japan with the tacit understanding that he would leave the question of gauge to the final judgment of the consulting engineer who was to be retained. That consulting engineer was George Preston White. It is also known that the initial locomotives for the new railway were made to White's design specifications and that he assisted in placing the orders for the initial twelve, by which time of course it would have been an absolute necessity that the gauge had been irrevocably established. One *yatoi,* who was employed by the *Kobushō* noted that, "In their choice of a 3 feet 6 inch gauge the Japanese have been influenced by considerations which had weight with the engineers of Indian railways…",[3] which of course also tends to implicate George Preston White. The fact that the decision was made in the course of a brief four month period when there were no knowledgeable civil or mechanical engineer except for White known to have been employed and when there were few people knowledgeable in engineering matters in a decision-making position in Tōkyō (all of whom were presumably more preoc-

cupied with ramifications of the Lay débacle) suggests that, in all probability, the final decision on this issue was left to George Preston White in London or that his recommendation on the matter was summarily endorsed. (Dr. Pole, writing at a time by which it had become painfully obvious that the decision to adopt the narrow gauge had proven to be a mistake, went to some length to disavow any part in the process and was at pains to note that the decision had been made before his services were retained).

The orders for locomotives to White's specifications came at a time when the idea of building railroads to a "narrow gauge" was in great currency. Worldwide however, "Standard Gauge" predominated: it prevailed throughout Great Britain (except for the Great Western Railway at 7' 0" and Ireland using 5' 3"), Continental Europe (except Spain 5' 6" and Russia 5' 0"), the United States, Canada, parts of Australia, and in most of South America. But in the early 1860s, commencing with the successful operation of several such railways in Wales and later Norway, a growing school of thought in engineering circles was vociferously advocating building railways to a narrower gauge. Chief among its proponents was the Englishman Robert F. Fairlie, who maintained a spirited defense of narrow gauge lines in the technical press of the day with which any contemporary railway engineer worth his salt was conversant, as it was one of the "hot issues" of the day. Fairlie published his *magnum opus,* the book *Railways or No Railways* in 1872 which did much to popularize the fad. He had something of a vested interest in the subject, as he was the inventor and patent holder of a locomotive particularly well suited for narrow gauge working. The chief advantage of a narrow gauge railway was its cost. Tunnels could be made smaller, less land bought for right-of-way, and the locomotives and cars were smaller and thus marginally cheaper due to the result of savings in the materials that went in to constructing them. This was enough to command attention of the engineering world: Tunnels were, per foot, the single most expensive component of railway construction which, along with bridges (probably the second most expensive component after land acquisition itself) any good engi-

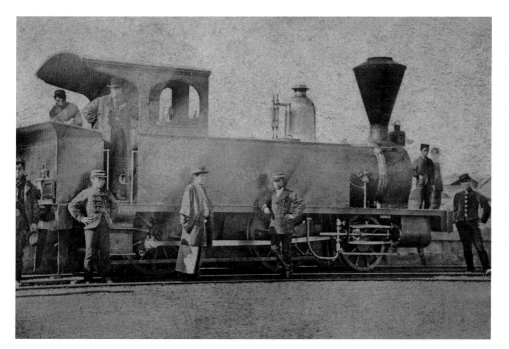

One of the two Avonside locomotives from the first ten imported from Britain to Japan is shown here along an unidentified platform location in this early photo. One of the Avonside locomotives was the fifth to be imported to Japan. They were instantly recognizable by their distinctive cab and coal bunker configuration and their side tanks, cab, and bunker may have been painted a light brown, ochre, or tan, as many surviving woodblock prints show the Avonside tanks in shades of yellow to brown, with a black boiler. The funnel stack (a spark arresting device for wood fired boilers) was later replaced with a proper British copper-capped chimney, as coal was the fuel used in Japan. These locomotives were exported to Taiwan in the aftermath of Japan's acquiring the island as a fruit of the Sino-Japanese War, and one is preserved there today. The photo is an excellent record of the earliest IJGR uniforms.

neer would always seek to avoid if an equally good alternate route could be found. Indeed engineers often opted for a somewhat longer route that avoided tunneling and bridging if the same ruling gradients and curvatures could be maintained.

As the very title of his book illustrates, Fairlie and his partisans initially trumpeted the suitability of narrow gauge railways for lightly populated areas with less revenue and traffic generating potential than would have been economically practical for the building of a standard gauge railway; i.e., as a "feeder" line in conjunction with a standard gauge main line system, where short-to-modest distances and slow-to-moderate speeds were all that was required. (Narrow gauge trains were more likely to derail going around curves at high speed than were more stable, wider gauged trains, hence the speed restrictions.) While this made sense, the narrow gauge was often seized upon as a cheap expedient "competitor line" scheme (particularly in the US) to break the monopoly a standard gauge line had in a particular geographic region, which made less sense. Any one could see that at the end of any narrow gauge line, passengers who supposedly didn't mind the slower speeds (in exchange for cheaper fares) would also supposedly not mind having to change trains. That assumption made even less sense when one considered that freight, of course, would have to be off-loaded and reloaded onto waiting standard gauge trains, but proponents argued that shippers supposedly would be paying at lower rates, and so wouldn't mind the attendant shipping delays and additional costs entailed by the labor of off-loading and reloading. The freight transshipment cost problem ultimately is what rendered the concept ill-fated, for over a long period of time, these costs gave a Standard Gauge line (where at the end of a run, cars were simply coupled on to the locomotive of the next Standard Gauge railroad) a permanent operational and implicit competitive edge.

Fairlie also seized upon the cheaper initial construction costs to argue that here was a system particularly well suited for mountainous regions, which naturally required considerably more tunneling and bridging than did lines through flat lands. But because narrow gauge freight cars and passenger cars are smaller (there's a mathematical limit to how wide the overhang of car width can be relative to the width of the track gauge before it becomes unstable, unsafe, and prone to tip-over) and *had to be smaller* in order to pass through those desirable cheaper, narrower tunnels, common sense dictates that for any given amount of cargo or number of passengers, a narrow gauge line operating at theoretical peak traffic capacity cannot not carry as much *payload* as a comparable Standard Gauge line operating at theoretical peak traffic capacity, requiring more cars to carry the same amount of traffic. The cost of having to maintain a larger car fleet to carry the same volume of traffic could be a hidden cost for a line operating near full capacity, which precious few narrow gauge lines did. Running extra trains was a false solution, as this just meant an increase in fuel costs. In the end, it came to be said that the only area where the narrow gauge was more desirable than standard gauge was in the extraction of *easily transshipped* bulk natural resources such as oil, coal, or mineral ores from areas so geographically remote or inaccessible that the cost of building, maintaining, and operating a standard gauge line would have exceeded the value of the resources to be extracted. By the beginnings of the 1880s the drawbacks had been noted. Isolated lines that were not connected in any way to the existing rail network of the region where they were located naturally fared better, as they had a monopoly position in their service territory. As to those that were so connected, the first half of the 1880s saw the beginnings among the more profitable lines of spending the additional money necessary to convert to standard gauge if they could afford it.[4] One wonders if this sometimes ended up amounting to more capital outlay at the end of the day than would have been required if the lines had been built to standard gauge in the first place. For those lines that couldn't afford the cost of conversion, the next 20 years saw a troubling trend in increasing bankruptcies and receiverships among narrow gauge lines. By 1900, except in countries that had adopted narrow gauge as a nationwide standard and except for railways purpose-built to extract inaccessible natural resources, narrow gauge rail-

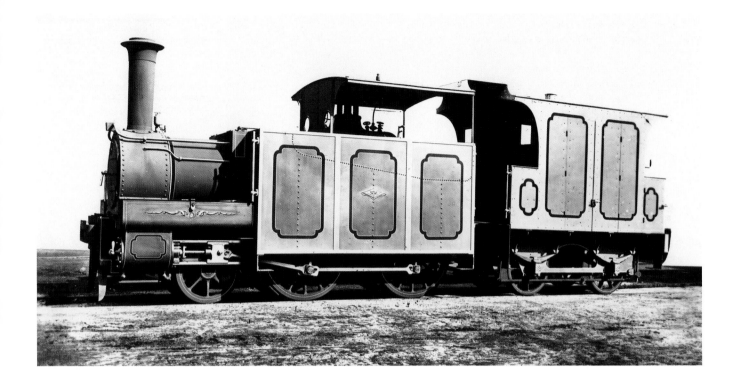

This builder's photograph shows one of the two Dubs locomotives that were among the ten original locomotives imported to Japan, along with the special brake-van that was necessary to be coupled between the locomotive and any train when the two units were not twinned back-to-back. There was little need ever to use them in tandem formation initially. As a pair, they were the most unconventional, and the most ungainly in appearance, of all the locomotives initially imported.

way building worldwide had for practical purposes ceased and the fad was all but over.

None of this was immediately appreciated in 1868, least of all by the likes of Iwakura, Itō, Ōkuma, and Parkes. In fact it wasn't appreciated by some of the leading engineers of the day. Success stories of operations of the Festiniog and Tal-y-lyn railways in Wales were well known, news from Norway was promising. Still later the Denver and Rio Grande Railroad in Colorado would be built to narrow gauge and be heralded in the US and there would be trumpeted schemes for narrow gauge railways in the Andes. In New Zealand, where Morel had worked before going to Australia, there had been a start made building standard gauge railways, but on grounds of economy (to greatly simplify the story) the government had decided to build all future railways to the narrow gauge and to convert standard gauge lines accordingly.

The decision to build the Tōkyō–Yokohama line to a gauge of 1067mm stuck. Had rail building in Japan been started in the 1850s or 1890s, a gauge of 1067mm might not have been chosen, for the decision to build was made just before the high water mark of "narrow gauge fever." Indeed, by the 1890s, when railway building began in earnest in China, standard gauge would be chosen and the Chinese railway system built to that gauge. It is true that the mountainous nature of the Japanese archipelago and the impecunious conditions of state finances at the time made building to a narrow gauge doubly attractive. The speed restriction downside was a non-issue in 1868 Japan. The average rate of travel in Japan in 1869, for a good day, was 20 miles per *day*; the average speed one could expect to maintain *routinely* on a well-maintained

narrow gauge line at that time whose track, locomotives and rolling stock were in top condition was in the neighborhood of 20 to 35 miles per *hour*. Morel's New Zealand experiences that preceded his Australian work would undoubtedly have rendered the idea entirely acceptable to him, as New Zealand is about the same size as Japan, having similar distances between cities that its railways had to connect, and had the same mountainous topography. Equally undoubtedly, the practical considerations just experienced in New Zealand, which had started building railways to standard gauge but had switched to narrow gauge on cost grounds, along with the similar experience in India would not have been lost on Morel, nor on his employers, whose treasury was struggling to answer the question of how the country was going to pay for the costs of all the sudden modernization programs upon which it was embarking. Thus was created a point of contention for the Japanese railway system from that time forth until the late 1950s, when the decision to build all future Shinkansen or so-called "bullet train" rail lines to standard gauge settled matters somewhat.

For the first locomotives, George Preston White had specified ten 2-4-0T tank locomotives and two 0-4-2 tender locomotives, which were ordered from five firms. All the work orders for these initial locomotives appear on the order books of their respective builders in the year 1871 and judging by the completion of the first of the batch, must have been placed sometime immediately after New Year's Day. They ranged in weight between 14 to 22 tons and even by the standards of the day would have been viewed merely as small branch line locomotives (the two tender locomotives were ordered in anticipation of the longer Kōbe–Ōsaka–Kyōto line, the second segment of railway planned to be built). This was considered adequate given the short running distances anticipated for the near future and as they would have been cheapest in terms of purchase costs. As longer lines of railway were opened, requiring larger tender locomotives with a longer refueling range, these first locomotives were expected to find ser-

vice on local or short-haul services, on branch lines or in rail yards as yard engines; marshalling cars to make up trains. The orders were spread among those five British locomotive builders to speed delivery time: Avonside received two orders (Works Order 834 & 835), Dubs was given an order for two (Works Order 436 & 437), Sharp Stewart four (Works Order 2101-04) and later, an additional two (Works Order 2141 & 2142) that were the tender engines, Vulcan Foundry was handed an order for one (Works Order 614), and Yorkshire Engine likewise was asked to construct one (Works Order 164). Vulcan won the distinction of having completed and shipped what was to become the first locomotive for Japan's first railway in February 1871.

The two Dubs locomotives were among the most freakish English locomotives ever produced in terms of appearance. Dubs held a patent for a particular type of coupling resembling a scissor mechanism that was fitted to the rear drawbar of each, and permitted them to be coupled together, back to back, to form one "twinned" unit, not unlike a typical Fairlie locomotive in appearance. White must have specified the patent coupling so that the locos could be used if train-weight demands were unexpectedly greater than had originally been anticipated. While this foresight was laudable, the locomotives' unsightly appearance was only heightened by this, as no coal bunker could be situated on the back end so that an unobstructed cab back would exist when they were coupled in formation. The resultant grotesquely over-sized water-tank-and-coal-bunker side housings extended well over the boiler top and down almost to the centerline of the driving axles. The ungainly appearance was made worse by the fact that there were originally no cab sides to the locomotives, but simply a canopy roof. To this add two appearance-spoiling toolboxes on the footplate in front of the tanks over the cylinders that extended all the way to the very front edge of the smoke-box, adorned with a foliate paint scheme only serving to draw attention to their poor proportions. There were in fact no buffer-beams or buffers on these locomotives as built nor were the couplings on the front of the locomotives the conventional British screw-link couplings that had been fitted on all the other locomotives imported: rather they were of a configuration similar to the soon-to-be archaic American "link and pin" pocket drawbar-type coupler, more often encountered in British usage on small industrial or mining railways. As a *coup de grace* there were originally no brakes other than water brakes with no brake shoes fitted to the locomotives and due to this, each locomotive came supplied with a brake van with hand brakes in the event the two ran separately. All these features combined to achieve locomotives that were, for want of a better term, *patently ugly*: an utter deviation from the design standards of a nation that, over any other nation, proudly and consistently produced the most beautiful locomotives in the world. Their legacy continues to this day: the first Japanese artists who drew them for the popular woodblock print market generally did a fairly creditable job depicting these two freaks. Their appearance was so ungainly however, that later authorities on the subject of Japanese woodblock prints of that era have assumed the images of the two utterly unconventional Dubs locomotives that appear in the prints of the day were brazen flights of fantasy on the part of the artists and consequently generalized that all early Japanese railway prints are not in any way reliable depictions, which is not necessarily so.

Of course once the orders for the locomotives were underway, White also placed orders for rolling stock. The suppliers of the first passenger cars and goods wagons were Gloucestershire's Oldbury Railway Carriage and Wagon Company and the Metropolitan Railway Carriage and Wagon Company's Saltley Works near Birmingham. The initial roster of rolling stock for the fledgling line consisted of 50 short-wheelbase 4 wheel passenger carriages 22 feet in length to the platform ends, (10 first class and 40 second class), 8 brake vans and 75 assorted "opens and vans" (gondolas and box cars to an American). The passenger cars were very similar to the contemporary "D Class" passenger carriages ubiquitous in New Zealand, built along American lines, with a central gangway aisle and a door at each end of the car opening on what a passenger who rode on them described as an all-too-narrow end platform, rather than the prevailing European design of separate compartments with no corridor and side-doors. They were 6' 8" wide inside, with seats being 1' 10" wide. First class carriages were divided into three compartments per car, each seating six persons with sliding doors between them and were upholstered in red leather, but second class carriages had no such partitions and were less luxuriously upholstered. Third class seating consisted of bare wooden boards. Remarkably, the passenger carriages were fitted with an early attempt at air conditioning: each was built with a double roof (a design the British had hit upon in the 1850s when building carriages for the Indian railway system) with an open space of a few inches between. The upper-most roof thus served as shade for the lower roof, and air would quite naturally circulate between the two roofs as the train moved, cooling the effects of the baking sun.

The goods wagons consisted of "three-plank" wagons (with sides two feet high), "four-plank" sided mineral wagons, ballast wagons, rail trucks (flat cars), timber trucks (bolster cars) and brake vans or cabooses. To conserve on cost, freight cars had one screw coupling on one end (a sort of three link chain with a screw turnbuckle mechanism as the middle of the links which allowed the cars to be drawn snugly together to the point where their buffers touched) but plain chain couplings on the other end (this of course meant sharp jerks on starting as the slack in the chains were taken up). Apparently, the rational was that there would be a 75% chance of always having a screw coupling available to serve as the coupling between freight cars. Passenger cars, on which it naturally was highly desirable to minimize any jerks on acceleration and slamming on deceleration, were not subject to this economization and were equipped with screw couplers on both ends. Incredulously, one of the surviving drawings, prominently marked "I.R.J. Drawing No. 5" is for a *carriage truck*, a flatcar fitted with guard-rail sides, ramps extending over the buffers, and crossbar restraints, that was intended to be used for transporting buggies and horse-drawn carriages. Buying such a vehicle seems unnecessarily extravagant for a land where (in 1870) there were so few horses, and very, very few people even owned a horse-drawn carriage. Perhaps the real reason for such a far-fetched order was the possibility of its inclusion in the Imperial Train to accommodate the horse-drawn State Carriage in which the Emperor rode.[5] Naturally, its existence presupposes that a corresponding *horse box* (horse transport car) was ordered for any teams of horses likely to be accompanying.

The gauge issue thus having been settled and orders for the first locomotives and rolling stock made, efforts could turn to construction in earnest. With the surveys complete and finalized, with the line staked insofar as possible, the Yokohama land reclamation underway, the recalcitrant Satsuma daimyo matter proceeding apace, and with rails and supplies expected soon to start arriving at Yokohama, it was actually time to build. Demolition of buildings started as needed. Grading and excavation began along

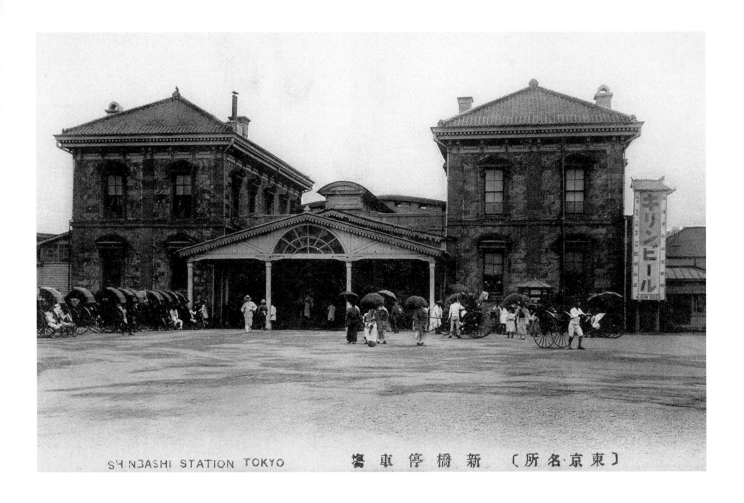

SHINBASHI STATION TOKYO　　寫車停橋新　〔所名京東〕

A closer view of Shimbashi in the 1890s. Rickshaws are lined up at the left, and Kirin Beer is prominently advertised at the right, dating this photograph to after 1888 when the brand was first introduced. The station and its sister station in Yokohama were the work of the American architect, R. P. Bridgens.

the line. Construction commenced both at Shimbashi and at Yokohama. Nearly duplicate passenger stations, neat little brick structures given stone facing to make them appear a bit grander, were designed by R. P. Bridgens, an American architect practicing in Yokohama. They are said to have been vaguely inspired by and based upon Paris' Gare de l'Est, although this was a loose inspiration at best: they were tiny in comparison. A brick locomotive shed in Yokohama was started and a brick roundhouse in Shimabashi, in anticipation of delivery of Ransomes & Rapier turntables from the UK, as were outbuildings, repair shops, and freight depots. Nothing remains of the original Yokohama station, which stood on the site now occupied by Sakuragicho station, except the High Victorian British cast-iron ornamental fountain that later stood in the forecourt. It was moved and now can be seen at the Yokohama Nishiyama Waterworks.

Like it's twin sister, Shimabashi station was destroyed in the Great Kantō Earthquake of 1923. Unlike it's twin, the plot of ground on which it stood was subsequently converted to a freight yard. Rail service to that site was abandoned by the 1980s, and when it was given over to urban redevelopment in 1997, the foundations of the original station were discovered, and a replica of the original station has recently been completed on those foundations. One of the original Shimbashi Works shop buildings has

been moved and preserved at the Meiji Mura historical village outside Nagoya.

For Morel, there were many tasks requiring attention. "Coolies" had to be taught how to make cuttings or embankments in conformity with the necessary line profile. Graders had to be shown the proper way to prepare a roadbed, with its necessary drainage slopes and ditches. The Japanese track gangs had to be taught the basics of track laying, alignment, and ballasting, not to mention how to curve rails without kinks and build turnouts and crossings. On days when inclement weather had stopped work, Morel would take the Japanese workers into his own home and lecture them on engineering and surveying. The rails on the Shimbashi line and the earliest railways in Japan were the typical British bullhead (double-headed) rail, weighing 60 lbs. to the yard (quite a creditable weight for the time given the train weights envisioned) in 8 yard lengths, set in proper chairs, on cypress wood sleepers or crossties, but by the turn of the century, American style flat-bottom rails spiked directly to the crossties was in universal use. Initially, it had been proposed to import cast iron crossties from the UK for the line on the theory that wooden ties wouldn't withstand the climate. This would have entailed a significant expense; just one example of the needlessly inflated costs of the line that came to be laid at the feet of the British consultants by later critics. Morel protested that there was no shortage of cheap timber in Japan and prevailed in saving his hosts not only the cost of the sleepers themselves, but also import duties and shipping costs.

Along the line, there were four intermediate stations to build with yards and passing sidings where trains going opposite direc-

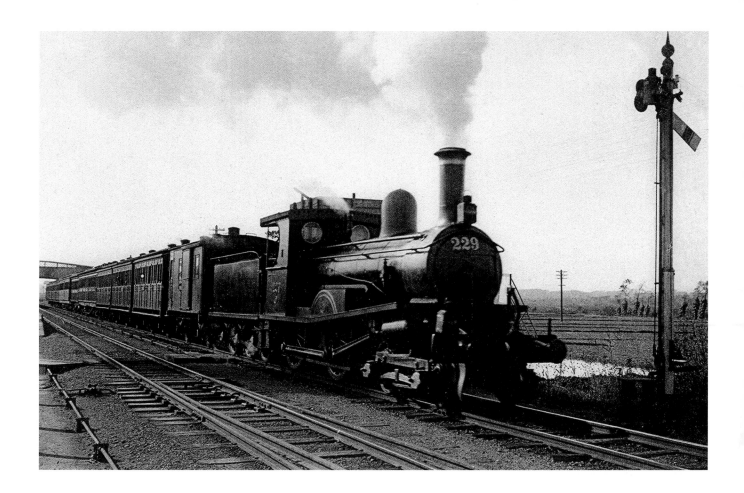

tions on the single-track line could meet and pass each other, or as traffic density developed, where a slow moving freight train could be pulled over to allow a faster passenger train to pass. From north to south, those stations were: Shinagawa, Kawasaki, Tsurumi and Kanagawa. (Later, Omori station would be added between Shinagawa and Kawasaki.) There were of course the usual number of small bridges and culverts to be built, but no great bridging problems. The largest bridge needed was one at the mouth of the Tama river known as the Rokugogawa bridge, 530 yards long. (*Kawa* or *gawa* means "river." Traditionally, Japanese rivers can be known by differing names along the length of their courses. The Tamagawa was known at that point as the Rokugogawa.)

Apparently, all along the new line there were scenes of more than average confusion, as English engineers and surveyors, Japanese laborers, and Japanese bureaucrats, all of who could be stubborn when it suited, learned how to make a go of it together *as a team*. As it was feared that reactionary elements in the country might stir the populace into violence against the *yatoi* workers in reaction to perceived foreign encroachments, it was initially ordered that each locality through which the line was being built would be responsible for providing bodyguards for each foreign worker, at a ratio of four bodyguards for each *yatoi*. But still work muddled on, with Morel not only proving himself to be a tireless worker, but one who seemed to get along exceedingly well with the Japanese and who won their respect and admiration, in part because he never tired of teaching his Japanese assistants the hows-and-whys of a task and zealously advocated training them for the day when Japan would be self-sufficient as a rail building

Seen departing from what is believed to be Omori station (opened 1876) is a typical Tōkyō region IJGR express train of the 1890s, drawn by a British built Neilson 4-4-0 D9 (6200 Class under the 1909 scheme) locomotive, number 229. The signal is off, and the locomotive is making a lively time of it judging from the chimney exhaust. Japanese railways adopted the British practice of running on the left hand side of a double track line and of indicating the type of train by marker lamps that were positioned in various combinations along the buffer beam or at the base of the chimney. Note the short 4-wheel baggage or parcel van behind the tender.

nation. As one contemporary writer put it, "Many difficulties that at first seemed great, vanished altogether as the native workmen and the engineer came to understand each other: many mistakes occurred, but a remarkably good feeling always existed between the native and foreign officials." But despite good feelings and Morel's best doings, things were apparently chaotic and disorganized to the point of considerable waste: Inoue himself remarked that the British engineers rejected rough-hewn wooden sleepers if they were not properly square and simply threw them away[6] and required stonemasons to finish all sides of stone block when only the sides being mortared were truly necessary: evidence of undue attention to appearances at a time when it was common knowledge that funds were short and that concerns over appearances should take a back-seat to concerns over economy. As many of the higher-paid British *yatoi* were diplomaed engineers and their Japanese hosts had no formal education in the field, it was often not feasible to stand down the British on technical disagreements or in the making of judgment calls as to necessity, and so considerable *gilding of the lily* crept in to the entire undertaking. Moreover, some unthinkable blunders by today's construction

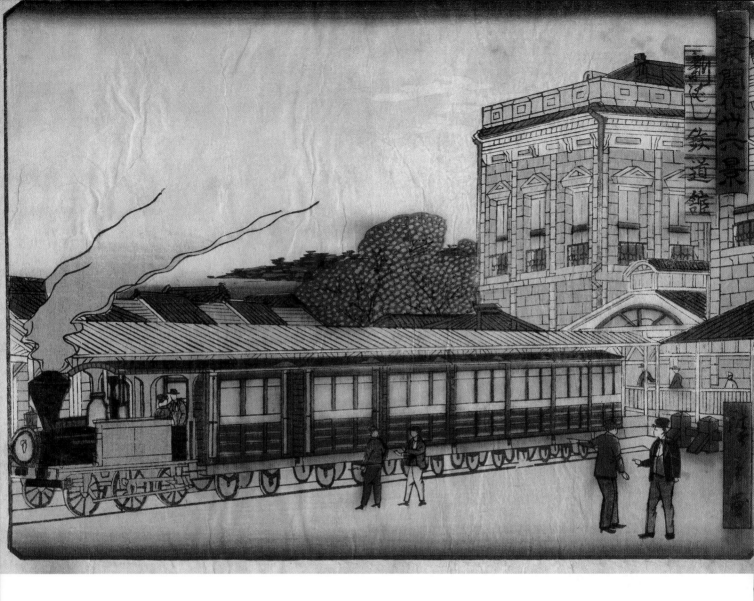

The artist Hiroshige III captures a train piloted by probably one of the Sharp-Stewart tank locomotives departing from Shimbashi station in early spring during cherry-blossom season. The scene is fairly early, as most of the railway staffers appear to be Westerners.

standards were made. Brunton comments, "The construction of this line… was… attended by a series of the most unfortunate mischances and mistakes. Buildings were erected, pulled down and re-erected in other places: numerous diversions were made; bridges were strengthened after completion; rails were twisted in every conceivable form and laid in such a way that it seemed impossible for a train to run over them." Brunton, in his usual jingoist and condescending way, points a finger at Cargill for "supinely permitt[ing] the interference of the native officials with their operations" and the "self-willed, self-satisfied, and over-bearing" nature of the Japanese. (For their part, the Japanese could have used almost exactly the same words in their descriptions of Brunton, Parkes, and Lay.) Brunton's antipathy for the undertaking is perhaps a reaction to the fact that Morel, a relative novice who had no formal degree, had been selected for the post of Chief Engineer, when Brunton had many years of railway service to his credit. Brunton was first and foremost a railway man, both by degree and by training, after all. One would almost be disposed to discount Brunton's account as so much "I told you so" self-indulgence were it not for the fact that, in its essentials, it has been confirmed by other sources.

In an article in one of the engineering journals of the day, it is noted that while the roadbed had been built to a width to allow for double-tracking of the line in the future, the initial line was laid right down the center, which meant the entire existing trackage had to be taken up and moved to one side of the roadbed when the decision was made to double-track; this undoubtedly the most unthinkable blunder of all, and probably evidences official interference on the part of short-sighted Japanese functionaries who opted for neat appearances over common-sense engineering reason. No engineer of any worth would have permitted such a blatant misstep. The article also notes that the trackage in the yards was arranged so poorly at Yokohama and Tōkyō that they were essentially taken up, redesigned, and re-laid. Even allowing for some self-congratulating jingoistic commentary, and discounting accordingly, the clear message is that all was not well on the Shimbashi line. Lay himself must have had some misgivings as to Morel's abilities, as he had written to the government, before the parting of ways, that "his [Morel's] technical skills may prove

A rather rare photograph, probably by Kusakabe Kimbei, shows the Shimbashi line and Shinagawa station shortly after opening. The scene is taken looking roughly northward from the vantage point of the bridge that carries the Tokaidō Highway over the line, at the point where the railway curves inland on its way south to Yokohama after having left the Takanawa Causeway. The station proper is seen to the left of the line, with its water tower. A railway shed is to the right of the line. This spot was a favorite of woodblock print makers of the day. Compare this with the triptych woodblock of Shinagawa shown on pages 24 and 25 and the nocturnal view on page 75 to get some idea how accurately some of the woodblock prints of the day portrayed reality.

not adequate for the task."

Edmund Gregory Holtham was another British engineer who was shipped out to Japan among the second wave of "new hires." As such he arrived too late to become involved in the building of the Shimbashi line, but on arrival in Yokohama in 1873 he was immediately struck by the poor workmanship evident in the line, and records that fact prominently in his memoirs. Holtham wrote,

> "This little piece of railway of eighteen miles, the first constructed in the country, was a model almost of what things should not be, from the rotting wooden drains to the ambitious terminal stations, that always suggested by their arrangement the idea that they had been cast, from some

region under heaven, with a pitchfork into the places where they were now visible."

Perhaps this is fitting of the first railway in Japan; Holtham's description bears an uncanny and remarkable parallel to Japan's creation myth, for according to the most ancient Japanese beliefs, the Japanese archipelago itself was created in a similar fashion. The Kojiki (the "Records of Ancient Matters"), an 8th century Japanese text meant to record its earliest history, recounts that the god and goddess Izanagi and Izanami (who are to the Japanese as Adam and Eve are to Christendom) were given a jeweled spear by the deities of the heavens, who commanded them to create the earth and bade them go. While they stood on the Floating Bridge of Heaven, which lay between the heavens and earth, they saw that the world had not yet condensed and was still a sea of primeval ooze. Perplexed, Inazagi suggested they test the waters with the spear, and when he drew the spear back out from the brine, the droplets that fell helter-skelter off its jeweled tip immediately coagulated into the first of the islands that are now Japan as they randomly hit the sea. Had Holtham been more conversant with Japanese cultural history, he would have perhaps seen the ancient parallel to his own assessment with deeper appre-

ciation, and perhaps would have attributed the pitchfork work to the hand of Izanagi.

One contemporary writer gives us a further insight into some of the reasons for disorganization, specifically the tasks that were laid before the first engineers in training the Japanese laborers who were often opposed to abandoning their traditional construction methods in favor of what the British saw as more efficient Western techniques. At a time when the steam-shovel excavator was only a few years old as an invention in the West, there were precious few to be found in Europe or American, let alone Japan, where there were none. Excavation had to be done by hand, and the Japanese "coolies" initially refused to use wheelbarrows to haul away the spoil, insisting instead on using two baskets slung on each end of a bamboo shoulder pole in the time honored Japanese way of doing the job. Another story is told that the first proud Japanese surveyors, taken for training from the better educated samurai class, initially refused to remove the two swords always carried by samurai as a badge of class distinction, despite the fact that the steel of the sword blades interfered with the survey instruments and caused faulty readings. (The carrying of swords by the samurai class had not yet been outlawed.) Time had to be taken out from the project to negotiate a compromise whereby the samurai would temporarily put aside their swords when using the instruments, and take them back up on resumption of other duties.

The evident lack of concern as to the proper laying out of railway facilities continued in a lackadaisical manner. Yards and turnout patterns were poorly laid out, with turnouts placed in a manner to impede smooth running. Even by 1894, when the desire for increased speeds should have resulted in more concern being paid to track alignment in stations, *yatoi* IJGR employee, Francis Trevithick, noted "if the line through the stations was constructed for through running, and devoid of curves on approaching the facing points, a speed of 35 miles per hour could be maintained without any difficulty… the points and signal arrangements are of the most primitive methods, and are a good many years behind the Railway Age."

In addition to all the other difficulties, much sadness was occasioned by the fact that during construction, the well-respected Morel contracted either tuberculosis or pneumonia, depending on the source. It was a time when health concerns were not to be taken lightly among the *yatoi*: of the 19 *yatoi* employed in those first days of railway building, four of them died and three returned home due to health issues. The government was obliged to hire an English surgeon, one Theobald Purcell, as its Chief Medical Officer in an attempt to keep their costly *yatoi* in good health and productive. Purcell was a bit of a romantic who also found time to write numerous weekly features for the *Japan Weekly Mail* describing daily life in his neighborhood that were posthumously collected into a book. At a time when foreign residents were divided into lovers of *Old Japan* and promoters of *New Japan,* Purcell was definitely one of the former, and he had a keen eye for observation. One of his observations did not bode well for Morel's pulmonary problems: "It is damp [here in Tōkyō], even in the summer time; fungi sprout luxuriantly, and it is here that moss lies thickest on the roofs." In the end, Morel's health continued to decline and there was little Dr. Purcell could do for him. The government granted him leave to travel to a healthier climate to recuperate, but by that time he was too ill to travel and he was given over to the care of his wife. According to the folklore that has grown in the years following his death, his wife was a Japanese woman known as *Ume (Plum Blossom)*, but two modern authori-

ties, one British and one Japanese, both have refuted this and produced proof that she was actually a British subject named Harriett. After taking ill, he doggedly soldiered on for a while, but by November 1871 his health was such that he could no longer perform his duties, and he took to his bed and his wife's care, only to die that same month without having lived to see completion of the line. Some commentators state that his wife, presumably having contracted his illness, followed him by only a few hours, some state she survived by only a day, and one states that she lived long enough to see completion of his work, but it is more likely that she too died very shortly after her husband. Their graves in the old Foreign Cemetery of Yokohama have been appreciatively marked with a monument to Morel's significant and historic contribution to the modernization of Japan.

Another Englishman, R. Vicars Boyle, C.S.I., who had considerable prior experience building railways in India, took Morel's place, and work plodded on. In the event, it took *two and one half years* to build the 18-mile stretch of single-track railway. At the end of construction, the initial million pound loan (which initially had been assumed to be sufficient to build the larger portion of the entire projected network from Tōkyō all the way to Ōsaka and Kōbe) had been almost entirely exhausted. Granted, approximately two thirds of it had been diverted by the government to pay other pressing needs of modernization, but of the £300,000 actually allotted to rail building, all that was accomplished (at a time when a top quality British-built locomotive could be purchased new for about £1,500) was the Shimbashi line and a *fraction* of preliminary works on the Ōsaka to Kōbe section that had been chosen as the next phase (and the *entire* Kōbe–Ōsaka section was only some twenty miles in length).

Despite the various obstacles, it is still difficult to justify why Morel, Boyle, their crews, and the Railway Bureau were as slow as they were building a *single track* line of railway only 18 miles long on the flatland of an alluvial plain, with no tunnels, in an area where there was no shortage of cheap labor from a populous workforce, with only one bridge worthy of mention, and where any urban demolition necessary would have almost entirely consisted of smallish wooden houses or other wooden structures that were easily torn down. Moreover, one reads no-where of any serious shipping delay that disrupted the supply line of equipment and materials being shipped out from the UK. Of course, track laying work is accomplished at a far quicker rate of progress than the civil engineering works that precede it, which are undoubtedly one of the prime suspects for the delay, since one has to assume that if the roadbed and bridges—the civil engineering works—had been ready, the entire trackage, including station yards and sidings, could *easily* have been laid in a month, including proper ballasting.

By way of comparison, when the Central Pacific Railroad broke ground for the western portion of the US Transcontinental Railroad on January 8, 1863, it did so largely with new crews of workers unaccustomed to railway building who had to learn railway construction techniques and who used the same tools and technologies as were used in Japan. Bridges on both lines were to be made of wood. Furthermore, the Central Pacific was not managed by seasoned professional railroad executives, but by a group of Sacramento shopkeepers, assisted by a small group of professional engineers, not too different from the administrative structure that existed in Japan. Similar to the Shimbashi line, Central Pacific was building a single-track railway, but through much more rugged terrain. The two lines were not that much different in respect of equipment and materials acquisition and shipping

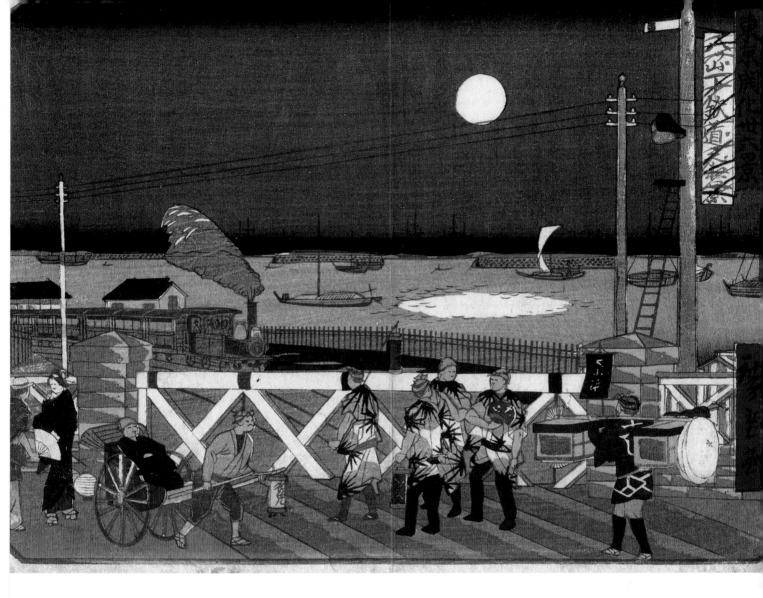

This woodblock print by the artist Hiroshige III shows Shingawa at night, standing in the middle of the Tokaidō Highway overpass bridge. A Sharp-Stewart tank locomotive brings a southbound train for Yokohama out of the station. Note the signal at far right and the two paper lanterns hanging from the rickshaw-headlamp and taillight respectively.

costs. All rails, locomotives, rolling stock, and many tools and specialized supplies for the Central Pacific had to be shipped from the Eastern US (there were no railway equipment factories *per se* then in California and only one foundry of any note) either around South America and Cape Horn which took months, or to Panama and off-loaded to cross the isthmus by rail or mule team, then back aboard ship for transit on to California… a supply situation similar to the one facing the builders of the Shimbashi line. Later, after the first Chinese work crews had been hired in 1865, the Central Pacific faced the same linguistic and cultural challenges that the British engineers faced in Japan. In fact, except in matters of terrain, the relative initial situations of the two undertakings were notably similar. Nevertheless, the Central Pacific had completed all its surveys, made its gradings, fills and cuts, built its bridging, finished its roadbed, laid its first rail (Oct. 26, 1863), and reached Roseville, California, where the foothills end and the Sierra Nevada mountains begin, (126 ft. in elevation above their start point) by February 29, 1864. The distance of the line to Roseville was 18 miles, exactly the length of the Shimbashi line. It took the Central Pacific Railroad only thirteen months (over more difficult terrain as a start-up enterprise with new crews and inexperienced management) to build the exact same length of

line that would take 2½ years to build along the shores of Tōkyō Bay: less than half the time. In fact, by 2½ years after groundbreaking, the Central Pacific had succeeded in opening 43 miles of operating railway line through *mountain* terrain to Clipper Gap, California, elevation 1766 feet, a full one-quarter of the way to the line's summit, up the steeper face of the Sierra Nevada mountain range; ample proof of what could be accomplished by motivated contemporaries with the same basic tools. In fact, when its construction crews were fine-tuned to the peak of their performance in 1869, the Chinese track crews of the Central Pacific laid over ten miles of track (admittedly on pre-readied roadbed) on the mere whim of a bet in *less than twelve hours*.

Even assuming the fact that the English built railways initially to a higher standard of engineering permanency than their backwoods American cousins, e.g. proper iron bridges in place of the rickety wooden trestles one sees in photos of the Wild West

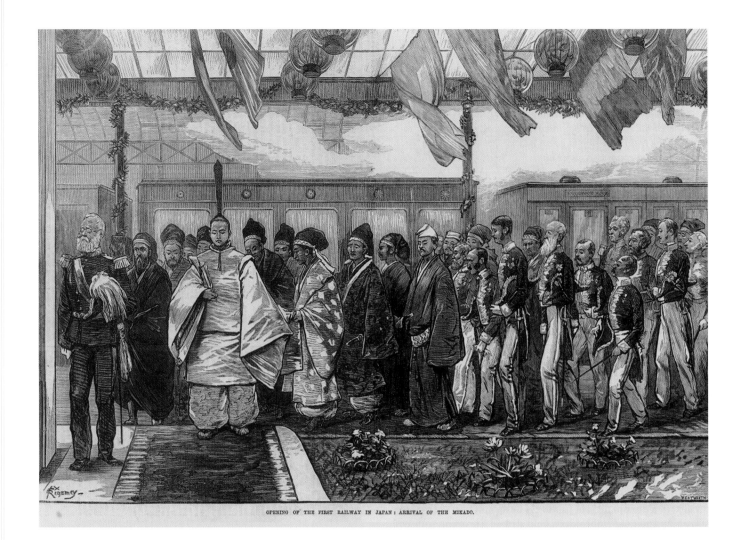

OPENING OF THE FIRST RAILWAY IN JAPAN : ARRIVAL OF THE MIKADO.

The Emperor leading the procession of court officials followed by the foreign diplomatic community upon arrival at Yokohama. The artist's version of the imperial carriage is directly behind him, marked by chrysanthemum badges over each window, although the actual carriage was of slightly different appearance. Out of deference to the Imperial Person, the artist has drawn him as one of the tallest of the participants: Meiji actually stood 5' 4" tall.

Thereupon, the Emperor arrived at the station decked out in red and white streaming banners emblazoned with the sun and moon (allusions to the first character of the word Meiji, formed by combining the kanji for the words sun and moon and which can mean *enlightenment*), a uniquely fitting way to underscore the fact that everyone under the moon and sun was witnessing an enlightening, momentous event in the history of Japan. He was met by Prince Sanjo, Inoue Masaru, the Minister of the Kōbushō Yamao Yozo, and other government officials. Prince Sanjo presented him with a congratulatory address on behalf of all and he greeted them with a short address of thanks. To the assembled throng within hearing distance, one source recorded his address as being:

> "We open the railway service between Tōkyō and Yokohama with our personal presence and express a desire that hereafter all of you will avail yourselves of the facilities offered through this railway whereby commerce will prosper and millions of people will obtain wealth and prosperity."

Inoue presented the Emperor with a hand-drawn plan of the line upon which he was about to embark, whereupon he entered into the specially built Imperial Car of the little nine-car train that awaited him. Wirgman's narrative continues:

> "I also followed the crowd to the railway station, where it became dense; and I was nearly crushed before I reached the gate, which they would not open until the first batch of passengers were seated in the train. When they opened it, the crowd poured in like a flood. A stand was erected in front of the train, and was filled with lookers-on who had tickets. I climbed up the platform, and, showing my pass, got into the state train with my colleagues of the newspaper press. They were smoking vigorously, and were much pleased. The station was decorated with flags and flowers by a European hand, but evidently not a Parisian. The Mikado was in the train when I arrived; and several Japanese in court dress were moving about. Pavilions were erected at the station; and on the left was a representation of the mountain Fuji-yama, made out of a tree, with its leaves and white flowers representing the snow on the top.
> The steam-whistle sounded, and we moved off, leaving the flags of the pavilion fluttering in the wind. We passed along that part of Jeddo facing the sea. The people stared at the

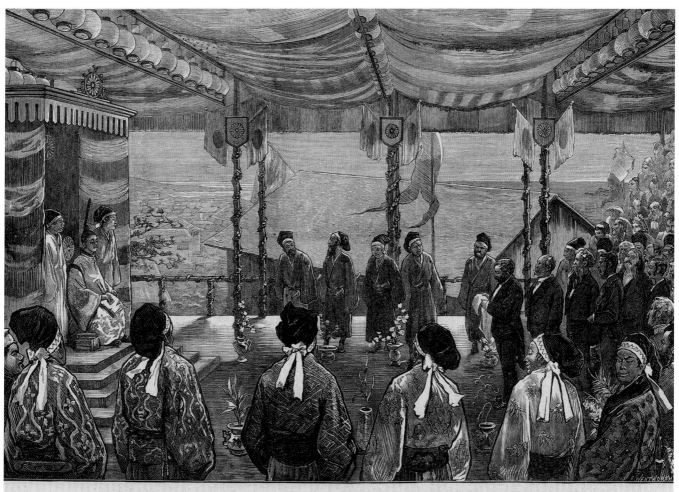

OPENING OF THE FIRST RAILWAY IN JAPAN: MR. MARSHALL READING THE ADDRESS OF THE LEADING MERCHANTS OF YOKOHAMA TO THE MIKADO.

train, without ceremony, and continued whatever work they were doing as soon as it had passed. But at the intermediate stations, on each side of the line, groups of men, women, and children were kneeling down.

As we neared Yokohama, the ships in harbour began firing salutes. The station here was decorated like the Jeddo station. We arrived at eleven o'clock a.m. I went opposite the Imperial carriage and saw the Mikado get out. His court bowed to him, and, after little pause, he began moving slowly forward, looking neither to the right nor to the left, with nobles and Ministers, some proceeding and some following him; the foreign representatives bringing up the rear, all in full dress. This is the subject of one of the sketches I send you. His Imperial Majesty went through the hall, to the sound of Japanese music, played by musicians in court dress. He entered the pavilion erected to receive him, and sat down in a chair under a dais. When he stood up to read a speech the pavilion was occupied by his Court, the foreign representatives, the German railway banker, and a deputation of the leading merchants, in evening dress. Mr. W. Marshall then read an address to the Mikado, after which the chief of the Yokohama Government made a speech. The Mikado moved away in slow time, to the tune of 'Voici le Sabre, Oui, le

The representative of the resident foreign community in Yokohama, Mr. Marshall, giving a congratulatory address to the Emperor in the Yokohama pavilion. After the orations, the railway was declared open and the invited guests returned to Tōkyō for a reception at the Enryokan palace adjacent to Shimbashi Station.

Sabre, Le Sabre, Le Sabre de Mon Pere!' played by a naval band.[10] He went into the hall and upstairs. The visitors partook of refreshment when the Mikado came down again; at noon the train went back, with much the same ceremony as it came. At Jeddo, the railroad was declared opened by the Mikado. The proceedings finished with the collation offered to a party of guests at Enrio Kan.[11] The streets of Yokohama were decorated with flags and lanterns. It was a general festival, and in the evening the town was illuminated."[12]

William Elliot Griffis, one of the professors at what would later be called the Imperial University of Tokio (Tōkyō University) described the significance of the event in rather florid prose,

"The 14th of October was a day of matchless autumnal beauty and ineffable influence. The sun rose cloudlessly on the Sunrise Land. Fuji blushed at dawn out of the roseate deeps of space, and on stainless blue printed its white magnificence all day long, and in the mystic twilight sunk

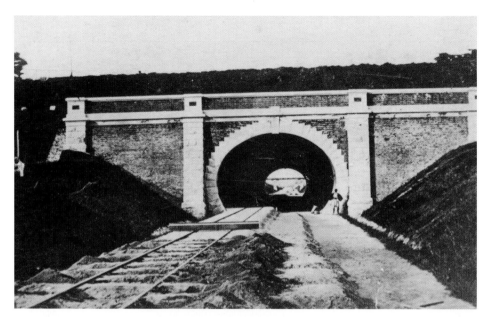

This photograph shows the Ashiya-gawa tunnel near Sumiyoshi that was built under the course of the Ashiya River, which had risen, over the course of centuries of silting and levee building in a chronic cycle, to the level shown. The photograph dates to the period before the Kōbe–Ōsaka line was opened in May, 1874, as very clearly the line is in the midst of final grading and ballasting in this image, giving an excellent view of the line's earthen floor, sub-base of coarse ballast, and finer top layer with a ballast spreader left laying across the line at the point where finishing efforts had been concluded. Note the gentleman standing at the tunnel mouth at the right, giving an idea of the scale of the structure: is this the same samurai in his Mitsu-aoi crested haori with his back to the camera who appears in the Ōsaka station photograph on page 91? Of the three tunnels in this stretch of line, this tunnel was the only one built to accommodate double tracks. A bridge is barely visible in the distance, but can be seen, viewed from the other side, in the *Illustrated London News* drawing shown on page 86.

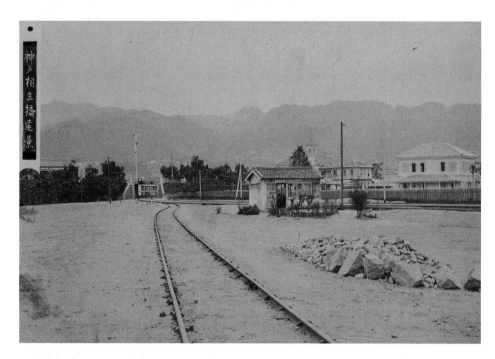

The start of Japan's second railway line is shown in this view, taken from the Kōbe station yards, looking along the line as it departs roughly northeasterly on its run to Ōsaka. Adequate ground has been reserved for future expansion of the yards, although apparently not all the rubble remaining from construction has been cleared. The bridge seen at mid-ground is the "Aioi-bashi," which is the vantage point where three photos shown in later pages were taken. The view probably dates from the first years of operation, around 1875.

nate, as this came during the time of the inordinate disorganization seen on the Shimbashi line. Some of the disorganization evidently spilled over, for when Holtham arrived at Kōbe, he was disgusted to see that of the three tunnels; one had been built wide enough for a double line, while two had been built only wide enough for a single line, yet another example of the waste and poor planning that occurred in the starting days of railway building.

The line started at a completely new wrought iron pier which the Railway Bureau built at Kōbe as part of the line, extending out into the water some 450 feet and 40 feet wide, enough breadth to accommodate three rail lines, and equipped with a traverser at the end (a type of sliding deck with track on it, onto which cars could be rolled, slid sideways to another track, and then rolled off). This configuration permitted two ships on either side of the dock to be loaded or off-loaded directly to or from railway cars without interruption. Thus in the case of off-loading, empty cars were pushed onto the dock from land and as they became loaded were rolled out to the end of the pier, shifted to the center track, and pushed or pulled back onto land without having to interfere with the loading or off-loading operations taking place simultaneously on either side. (The freight cars of the day were small, squarish British-style 4-wheel cars of an 8-foot wheelbase that could easily be pulled by a good draught horse, or pushed by three or four men.) For many years this was one of the best docks at Kōbe, and it was strictly reserved for government ships or ships on official business only. Not even Yokohama, the premier port of the realm, could claim to have as modern a port facility at the time. Its first landing pier of comparable stature there was not constructed until 1889.

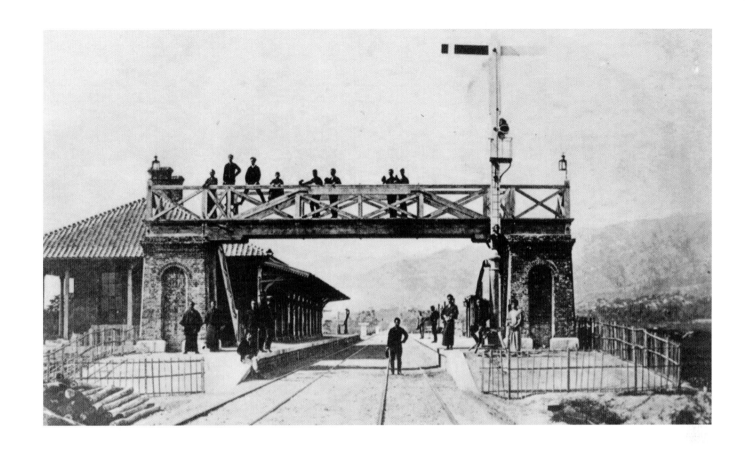

A detail-laden view of one of the original Kōbe–Ōsaka line intermediate stations, Kanzaki, known today as Amagasaki. The station took its name from the nearby Kanzaki river and initially consisted of nothing more than a passing siding configuration, but was substantially provided with a neat brick station building and a charming footbridge built to rather high standards with ornate brick piers on an ogee-carved stone foundation at a time when funds were short and a simple all-wood structure would have been more economical; evidence of the British desire to build to a high standard ab initio. The view offers up a wealth of detail, from the water column in the foreground just under the finial-topped signal, to the very interesting signal itself, the two-tone tile pattern making a border around the rooflines, and the footbridge lanterns. One would like to think that some of 21 the individuals seen posing are the proud yatoi, engineering cadets from the Kōbudaigakkō, and local workmen who had a hand in building the line.

While the dock undoubtedly was the pride of the new terminal and went a great way towards expediting supply logistics, again it took an inordinate amount of time to complete the line, specifically the tunnels and bridging. The three tunnels *combined* only amounted to 250 yards. Advantage of the summer dry season was taken (when each of the rivers had dried to the size of an easily manageable stream) to divert the course of each river, make a large excavation or "cut" across the bed, build the section of tunnel lining with brick, encase it with generous amounts of cement, and cover the dirt back to form the riverbank before the rains started again. This "cut and cover" method was being pioneered right about that time to build the world's first subway system in London, where streets where cut up, a tunnel dug below and bricked in, then the cut was covered back over with the spoils of excavation to the proper grade and paved. Meanwhile, in Japan, women and children were employed to remove the spoil of excavation, being paid on a ticket system. They were handed a ticket by a foreman for every two baskets of spoil deposited (as with the Shimbashi line, the local Japanese resisted excavating with wheel-

barrows, and insisted on carrying away the spoil in two baskets, balanced over a shoulder pole, in time-honored Asian custom). At the end of the day, each worker was paid in accordance with the number of tickets he or she had accumulated. Also along this 20 mile stretch were no less than 208 bridges and culverts, the longest of which was over the Mukogawa, which was 1,190 feet long. It was on this section that the first wrought iron bridges were built.

The line was rather a straightforward run inland from the pier to a point beyond the foreign settlement, where it made a northeasterly curve toward Ōsaka, and then ran parallel along the coastline to its end in Ōsaka. There were initially four intermediate stations: Sannomiya, Sumiyoshi, Nishinomiya, and Kanzaki. In addition, near the Ōsaka station, a 1¾ mile branch to the Aji River [Aji-gawa] was laid down. The Ajigawa was the access point to the network of many canals and rivers used for transport in the area, so the Ajigawa branch railhead served as a point where goods from the outlying region brought in by canal boat could be transferred onto rail to be taken down to Kōbe where they could be loaded onto ocean-going vessels. It was intended to be nothing more than an expedient until a proper canal could be dug to the projected Ōsaka rail yards, where a docking basin would be excavated and facilities built. The branch was said to have operated at a loss. It was apparently a constant operational thorn in the side of the railway. It was closed on November 30, 1877 and pulled up after only 2½ years of operation—unquestionably the first abandoned railway line in Japan—by which point the canal, docking basin, and transshipment complex had been opened adjacent to the rail yard. This small branch and the Ōsaka Mint's tramway both ended at Ōsaka station.

A station was put in place at Ōsaka that was a thoroughly English-inspired design. After four years of struggle the tunnels

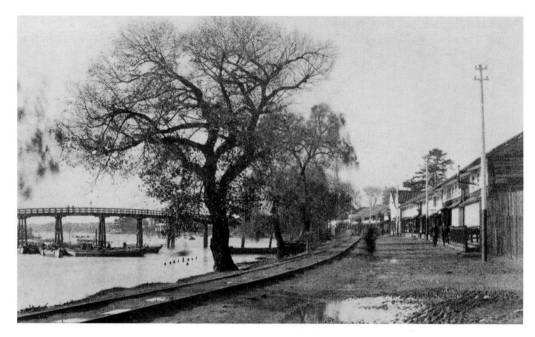

This rare view is believed to show the first line of railway ever abandoned in Japan and is one of a group of photographs from the UK, probably brought back by one of the yatoi who worked on the building of the Kōbe–Ōsaka line. Some of the photos are stamped "Miyazu, Kitaji, Naniwa" (Naniwa is an archaic name for Ōsaka) thus presumably Miyazu in the Kitaji neighborhood was the photographer. The photos all appear to date from around the time the Kōbe–Ōsaka line was opened. It is believed that this photograph shows the short lived Aji-gawa branch, which ran along the course of the Sonezaki river for part of its route prior to its terminus on the north bank of the Aji-gawa. The branch was cheaply built and never properly maintained as evidenced by the total lack of ballast seen here. It was envisioned as a temporary line and the tracks were taken up in 1877.

and bridges were completed. As these were the first railway tunnels in Japan the occasion called for a photographic commemoration, and one was duly made of the Ashiya-gawa tunnel, before trackage had been laid through it, showing the staff, crew, various of the laborers, and probably more than a few locals posed proudly at the mouth, along the cutting, atop the portals, and all along the riverbank above. While matters were progressing and the year turned to 1874, the Kōbushō was given the power to regulate rate changes in January, while luggage regulations were established in November. By spring of that year, the line was completed and was opened to Ōsaka for passenger traffic on May 11th. As Ōsaka was the largest center of commerce in Japan at that time, it was assumed from the start that freight service would be an integral part of operations of the new line. Parcel and freight traffic business started at the end of the year on December 1st. By year's end, the bookkeepers reported that 505,733 passengers had been carried in seven months and twenty days of operation, while for the single month of December, 15,771 parcels had been carried along with 1,981 piculs (roughly 132 tons) of goods.

Again, English motive power and rolling stock were purchased for the line. Larger locomotives were ordered, due to the longer distances that expected when the line was completed to Kyōto—four 0-6-0 tender engines from Kitson and two 0-6-0T tanks from Manning-Wardle, which joined the two 0-4-2 tender locomotives previously ordered from Sharp Stewart. Around the same time orders were placed for four 2-4-0T tank engines from Stephenson similar to the ones used on the Shimbashi line and for additional Sharp 2-4-0Ts, which had proven themselves to be the best of the various original 2-4-0T types to be found on the nascent Government Railways. In 1871 and 1872 Brown & Marshall Britannia Works (perhaps also Saltley Works) had been called upon to provide passenger rolling stock for the line, and provided a range of compartment carriages much more typical of English designs of the period, with side-doors and three compartments rather than end doors and a central gangway. Rather surprisingly, they were built on an eight-foot wheelbase with an overall length of only 15 feet—tiny even by English standards of the day—possi-

bly because such a small size would allow them to be moved about yards and sidings by a team of 3 or 4 men without need of locomotives. The surviving drawing of the First Class salon carriages ordered indicates that they were upholstered in blue Morocco leather, with silk lace trim and a wool fringe around the legs, subfloored with patterned oil-cloth and carpeted over with Brussels carpet and were so tiny they seated only 12 passengers per car. Quaint 15 foot 4-wheel "birdcage roof passenger brake vans," as they were called (in American terminology, baggage cars with cupolas) were likewise ordered. Goods stock appears to have been eight-foot wheel base standard stock with brakes on only two wheels, while the "brake vans" (cabooses) ordered were built on a 7' 6" wheelbase, only 13' 2½" long, and were essentially boxcars with a very truncated covered veranda at one end where the brakeman rode, exposed to the elements save for the roof. Probably in anticipation of the special shipments that the new mint at Ōsaka would create, a special "Bullion Van" had been ordered, which varied little in external appearance from the standard goods train brake van except for being fitted with sliding doors rather than a pair of hinged doors and for being 15' 6" long, on a standard 8-foot wheelbase.

An Englishman who traveled to Ōsaka in the brief period during which it was the terminus left this account:

> "Along with an American professor I had arrived in Kōbe by steamer through a rather tempestuous sea, sick, dirty, and miserable, amid a pallid crowd of woe-begone Japanese fellow-passengers, if possible more sick and miserable than ourselves. The rain was pouring in torrents and a piercing wind chilled our very marrows as we landed. After a good hot bath, a sound sleep, and a very hearty mid-day breakfast, we walked round the settlement, which had been thoroughly washed down by the rain. … Close by is Hiogo, a characteristic old native town, where there is now the spacious terminus of a well-laid railway which runs to Ōsaka and [is projected beyond to] Kioto, and will yet, it is hoped, soon reach

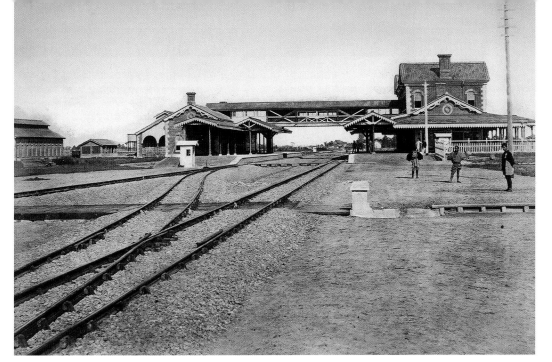

The original Ōsaka station from trackside on or shortly after its opening in 1874, giving a good view of the original configuration. The locomotive shed, water tank, and other subsidiary buildings are seen to the left. Notable is the fine trackwork and proper ballasting, again thanks to the high British engineering standards of the day, which included a proper pedestrian over-bridge at a time when traffic would not have justified its expense. Seen leaning against the platform canopy upright is an unidentified yatoi. A samurai proudly turns his back to the camera, probably for the purpose of exhibiting the ka-mon or family crest on the back of his haori; the three hollyhock leaf (Mitsu-Aoi) motif of which identifies him as possibly connected with the Tokugawa clan. The station itself would not have been out of place in the English Midlands.

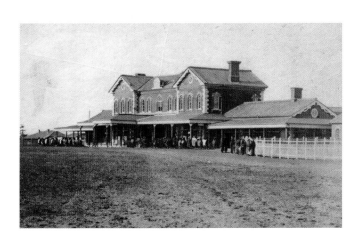

This early photograph shows the façade of the original Ōsaka station. The site chosen for the station and yards was an expanse of sunken rice paddies then on the edge of Ōsaka that were filled in and leveled to grade. The local residents took to calling the area Umeda, 埋田, meaning "buried fields." Later, the way Umeda was written was changed to the more euphemistic sounding and identically pronounced 梅田 (Plum-fields), as the original character combination could also be read as "burying fields."

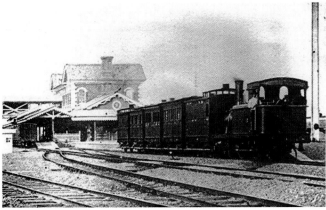

Another view of Ōsaka Station, early in its operation, probably the late 1870s, by which time a station bay track had been added on which the short trains stands. That train of three passenger cars and two brake vans is, judging by the orientation of the crewman seen leaning out the cab, departing the station bay on its way to Kōbe running bunker first, while another train stands at the main platform. Note the neat birdcage or cupola lookouts on the brake van roofs, to permit the guard to observe the train while underway for signs of axle boxes overheating or other mishaps. The locomotive is one of the Sharp Stewart specimens that would be classified as Class 120 in 1909.

> *Tokio. … After drifting about the settlement in rather an aimless manner, we took tickets for Ōsaka, which was then the temporary terminus of the railway.*
>
> *The railway crosses at a high level a spur of the range that encloses Kōbe and then darts down towards Ōsaka, straight as an arrow, by a series of alternating slopes and levels which had rather a striking appearance from the top of the incline. The traffic even then was very good, and seemed to bid fair for the ultimate success of railways in Japan…."*

Most of the shop and maintenance buildings were located in Kōbe, and were chiefly built of corrugated iron to save cost and time. In 1875, a wagon building works supplemental to the one also constructed at Shimbashi was completed and brought "on line" in Kōbe so that the rolling stock of passenger and freight cars could be built in Japan without having to import rolling stock from the UK, as had been done initially. Walter McKersie Smith was the first Works Superintendent. Steel parts such as wheels, axles, and buffing and draw gear were still imported from England, as Japan had no steel mills yet. But the Japanese have a long history of carpentry and skilled joinery and soon were turning out a very good product, even by the exacting standards of the British commentators of the day. Holtham, who was a frequent visitor to Kōbe at this time, recalls how this was the time when many of the old castles of the local *daimyō* had been ordered torn down by

government decree. He goes on to recount that the Kōbe works "turned some seasoned timbers from pulled-down feudal castles into railway carriages." In both the Kōbe and Shimbashi carshops, the underframe timbers of both passenger and goods cars were usually *keyaki* (Japanese Elm) while the floors, sides, and roof were made of *hinoki* (similar to red pine). Initially hinoki, kiou, or matsu (pine) was used for the crossties of the railway, but by 1907 *kuri*, similar to chestnut, was in almost universal use according to the Nippon Railway's Superintendent of Way that year, S.Sugiura. On the Hokkaidō Tanko Tetsudō, the Chief Engineer Ōmura Takuichi reported that chestnut, oak, elm, spruce and *yatitamo* (similar to elm) were used by his line that same year. As creosote was not at that time manufactured in Japan, and as the cost of importing it was prohibitive, due to its highly flammable nature rendering it a shipping hazard, ties on the initial lines were not treated until domestic creosote production came into being. Progress in attaining self-sufficiency in car building was such that as early as 1885, a British diplomatic report mentions that Japan was producing her own rolling stock and largely was no longer importing it from England, only being dependent on foreign builders for locomotives. In fact, the shops at Shimbashi and Kōbe met not only the needs of the government railways, but built all the rolling stock for such soon-to-be formed early private lines as the Nippon Tetsudō, Ryomo Tetsudō, and Kōbu Tetsudō.

There was no noticeable break in construction operations at any time between the Kōbe–Ōsaka segment and the building of the Ōsaka–Kyōto segment: as soon as crews were not needed on the former section, they were sent to the latter. Interestingly, at about this time, in 1873, when there were only 40 miles of railway built in the entire realm, the Railway Bureau briefly considered adopting 1435mm/4' 8½" as the standard gauge for all future railway building and re-gauging the existing lines, but the decision was made against re-gauging. This became the first of many occasions that followed in the future when the feasibility of re-gauging to 1435mm was considered, but would ultimately be rejected because of the prohibitive costs entailed. 1873 would henceforth always be recalled as a momentous lost chance in Japanese railway development. Inoue Masaru, writing in 1909, gainsaid the enormity of the task of converting the entirety of the national system to 4' 8½" gauge in a gloss, making (without any support whatsoever) the glib conclusion that "an alteration of gauge can easily be effected whenever such a step be judged necessary in the public interest." He should have known better. Francis Trevithick, the grandson of railway pioneer Richard Trevithick who with his brother Richard had joined the IJGR, did as early as 1894, when he voiced the conclusion that, "… it is too late … and for people to talk seriously about an alteration of gauge at the present time is foolish, and at the same time only showing their ignorance of the question." Trevithick of course was right, but the mistake of adopting the narrow gauge came to be widely regretted. Nonetheless, more than a few futile man-hours would be devoted to studying the feasibility of re-gauging up to the point when Japan's increasingly costly involvement in the coming world conflicts of the 1930s rendered such notions unthinkable from a fiscal standpoint.

The line to be built from Ōsaka to Kyōto was 27 miles in length, with five intermediate stations: Suita, Ibaraki, Takatsuki, Yamasaki, and Mukomachi; small brick structures for the most part, as brick was starting to become available from newly formed Japanese brickyards. There were five major river crossing (as compared to the size of the river crossings previously made): the Yushogawa, Kanasakigawa, Ibarakigawa, Odagawa, and Katsuragawa.

Holtham, who had been sent to do initial surveys of the line that was to run north from Lake Biwa to the Japan Sea at Tsuruga and eastwardly to Tōkyō was re-assigned to build a segment of the Ōsaka–Kyōto line on the completion of his initial survey. He was given the last construction segment, ending at Kyōto and containing the bridge over the Katsura River, from which we have a flavor of what construction was like.

While building that bridge, he complained that only one diving suit was available, which had to be shared with the crew building another bridge on the adjacent segment of line. Sinking the foundation wells, as he called them… structures sunk and lodged in the riverbed from which rose the uprights that supported the deck of the bridge… to form the foundation was a problem due to the character of the river bed which consisted of alternating harder and softer strata. The wells were floated out to position and were sunk to the river bottom easily enough, but as the riverbed material was being excavated from under the bottom lip to the desired depth for solidity, they would often be caught on a boulder or snag on a layer of the harder material that would impede their descent, sometimes causing them to lean to one side. Then as excavation was concentrated around the point of the problem, the underlying obstruction would give way, sometimes causing them to cant or list suddenly in a different direction. Keeping the wells to a true vertical as they were being sunk was the major problem. When obstructions were met, if it had been not borrowed and was not on-hand already, the diving suit would have to be sent for, and a Japanese diver would then suit up and be sent down to examine area around the wells and manually dislodge any boulders, stones, or obstructions found. This must have made for some excruciatingly slow going.

Work proceeded through small annoyances (heavy mosquito infestation) and large: one typical work day, Holtham was at his bridge when he looked over to the nearby thatched-roof storage canopy which had been built over his stack of timber balks to be used in bracing the bridge or as cross ties, to see the thatch going up in flame. He yelled to his head assistant Musha,[1] work stopped immediately, and the entire crew scrambled to form a bucket brigade from the nearby river to save the supply. Time after that had to be spent bandaging those burnt putting out the fire, then back to the matter of building the bridge. Larger still were the annoyances caused by numerous *jishin,*[2] sudden governmental re-organizations that were frequently taking place about that time and which, for a while, threatened him with premature termination of his employment contract, as they were often used as a technique to clean house of unaffordable, underperforming, or unwanted *yatoi.*

When the bridge was finally complete sometime in late summer of 1876, it was tested by bringing "two of the largest tender engines along with a train of heavy girders," (two out of the *only eight* in the land, it might be added—these would have been taken either from the small Kitson 0-6-0 tender goods locomotives imported in 1873–1874 for freight service on the Kōbe–Kyōto line, two members of which were later rebuilt into 4-4-0 tender locomotives, or the diminutive Sharp Stewart 0-4-2 tender engines from the initial order) placing them both on the bridge, and marking any deflection against a pole that had been set with a witness mark previously. One smiles today at the thought that two of those tiny Kitson or Sharp-Stewart locomotives were the "heavyweights" of the day for bridge testing.

The Katsura was the last river barring the approach to Kyōto. Once all bridges were in place the entire length to Ōsaka, there was no obstruction to reaching the old Imperial capital. But things

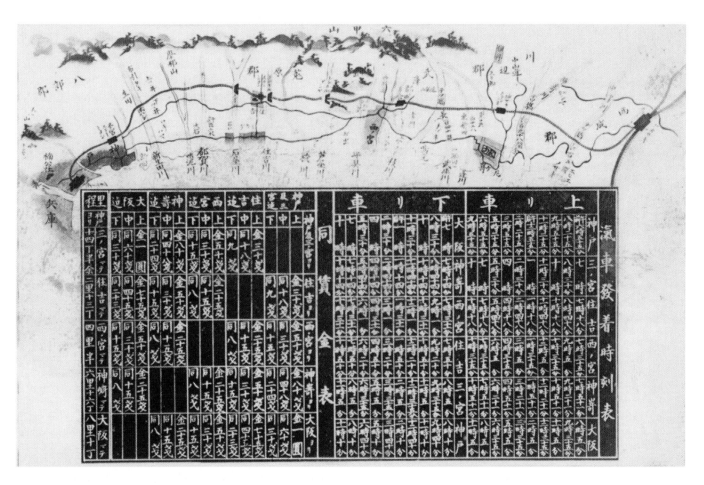

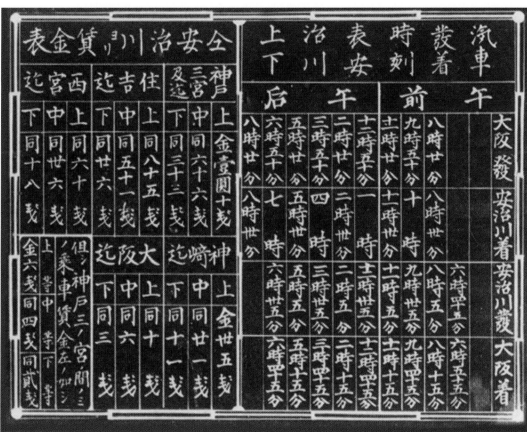

The first of these two photographs includes a hand-drawn map showing the route of the Kōbe–Ōsaka line, indicating the rivers under which it passed and the locations of intermediate stations. The second photo shows an early (if not the first) timetable for the line, with train departure times, and the fares for Upper 上, Middle 中, and Lower 下 Class passage, at a time before this had been changed to a more euphemistic "1st," "2nd" and "3rd" Class.

were not to be quite so easy. The plans for the Kyōto Station and other buildings had only been forthcoming from Kōbe headquarters in April 1876, so the buildings were in no state of readiness. Water towers, turntables and engine sheds were also lacking at Kyōto. When the plans for the station did finally arrive in April, they called for a granite-trimmed brick station with an entrance archway and small central clock tower almost certainly inspired by and notably similar to the clock tower at King's Cross station in London. Holtham experienced more than the usual amount of difficulty finding suitable materials, specifically adequate amounts of granite stone of a uniform color for the clock tower and entrance. He was eventually forced to apply an expedient measure by saving the most uniform colored granite for the clock tower and central entrance arches, while using the inferior granite for the trim elsewhere on the building. For the time being, traffic was opened on the line on September 5, 1876 to a temporary station at Tōji (just south of the present day Umekoji Steam Museum).

About the time Holtham was focused on finishing the Kyōto station, arguing with quarry suppliers, and wondering how steam locomotives could be run into Kyōto without a means of replenishing the low water in their boilers, two momentous events took place: 1) the Railway Bureau ran out of money and 2) the unrest eventually leading to the Satsuma Rebellion reared its head in the south of Japan.

The Ministry of Finance and the Railway Bureau had been scraping together funds in a financial juggling act ever since the initial Oriental Bank loan proceeds had been consumed, and had struggled along, as least insofar as railway building is concerned by a variety of methods, not the least of which was the time-honored method of "cutting corners" of which Holtham's shared diving suit is but one example. This was an era of frequent and recurrent *jishin*, Holtham's dreaded government restructuring, and one could never be quite sure what to expect. By this point, the initial surveys for the line from Kyōto to Ōtsu, from Tsuruga south to

Lake Biwa, and indeed beyond had been completed; a survey had started off from the projected Tsuruga line eastwards around Maibara on the shore of Lake Biwa, through the Sekigahara Gap (where Tokugawa Ieyasu had reunited Japan over two hundred and fifty years before) and forged on towards Gifu along the proposed initial route that had been envisioned toward Tōkyō. Because funding was close to exhaustion, an immediate stop work order went out for all activities except the completion of the Kyōto extension.

More troubling were the first rumblings of the Satsuma Rebellion, which were breaking out in Kyūshū, the southernmost of the four main Japanese islands. There had been a few minor rebellions since the restoration, but none serious. This was quite different, however. The Satsuma domains were among of the most powerful military powers in Japan, and their armed forces more seasoned than the fledgling Imperial Army. There are a number of causes of this rebellion; enough to account for why the Satsuma domains, which just ten years before had championed the Emperor's authority, would now challenge it. Part of it was *sonno jōi* unhappiness with the sudden influx of foreign influence, and unhappiness over the government's perceived inability to revise the extra-territoriality treaties and expel all foreigners. Part of it was sheer knee-jerk reactionary conservatism. Part of it also has to do with the government's political, economic and social reforms that were deeply disadvantageous to the samurai class. For purposes of this narrative, one can perhaps be excused for grossly over-generalizing with the statement that the Meiji Government was systematically taking steps to eliminate the underpinnings of the samurai class' socio-economic power.

In feudal Japan, the Samurai were a warrior caste, historically of the lower classes of Japanese aristocracy, who were used as the professional army by the higher-level aristocrats of Imperial rank. Their fundamental purpose as a class was to serve as professional soldiers. Strange as it may seem to modern minds, commoners—

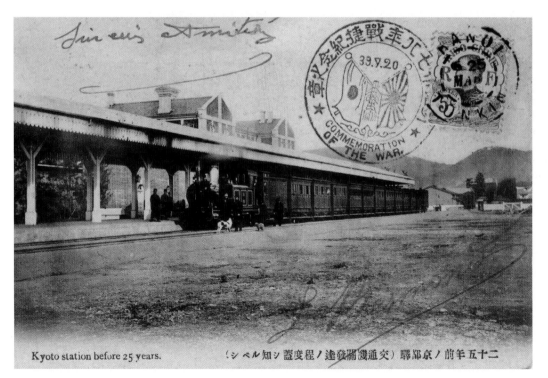

Kyoto station before 25 years.　（シベル知シ蓋度程ノ達發彌（畿通交）驛部京ノ前年五十二）

This turn-of-the-century postcard shows Kyōto station in its very earliest days of operation, when the railway terminated literally at the station's end, and there were only a single platform track and parallel siding to be found there. A 13 car train consisting of the tiny 15 foot long passenger carriages and a brake-van (baggage car) at each end stands ready to depart for the run to Ōsaka and on to Kōbe. The locomotive bears number 38 on its chimney, indicating it is one of the Sharp 2-4-0T tank engines ordered for the line that would eventually become known as the '130' class under the 1909 numbering scheme. Note the lined livery and prominent polished brass steam dome. The photo dates from the period after official inauguration on February 5, 1877 but before start of construction of the extension to Ōtsu in 1879, which began at the far end of the station.

peasants, landed farmers, merchants, and artisans—did not serve any large military role in traditional Japan. Warcraft was mainly the province of the samurai, in exchange for which they received a guaranteed annual hereditary government stipend, measured in *koku* of rice (A *koku* equals about 5 bushels). By the end of the Tokugawa dynasty, the *Bakufu* had come to pay these stipends in the monetary equivalent of the market value of a *koku*. A fiefdom was said to be worth *x* thousands of *koku* in income, and *daimyō* status and prestige was gauged by these amounts.[3] By the waning days of the Tokugawa Shogunate, with over 200 years having passed without serious armed conflict, most of the samurai had become a sedentary class of petty aristocracy who had little or no real military acumen, and as a class were largely unproductive. (However, this was not necessarily the case with the Shimazu clan of Satsuma and their supporters.) With the arrival of Western military might in the treaty ports, it became painfully obvious that relying on the samurai class in defense of the realm in the event of foreign invasion or intervention would not have been wise. One only had to look to the recent events in China or the British Navy's bombardment of the Chōshū forts at Shimonoseki as an example of that futility. In 1873, the new government adopted the advice of their French military advisors for military reform and adopted the policy of universal conscription as the basis for the new army, which would henceforth also be composed of *heimin*, as the commoners of the day were called. This was a direct affront to the samurai as a class, and it was the handwriting on the wall. In 1869, all the various grade distinctions of samurai were streamlined into just two. In 1871 the government had taken the first tentative step to outlaw the carrying of swords by the samurai, who, as mentioned before, previously had been the only class allowed to wear swords, and who were told to cut off their top-knot hairstyles (another badge of class distinction) and to adopt Western dress. In that same year the commoners were informed that they no longer were required (as a matter of law as opposed to politesse) to kneel before samurai. The old restrictions against samurai farming, owning a trade or business, or making a living being anything other than a samurai were abolished. To a samurai, the clear message was: "You're now no different than a well-dressed commoner." Further moves by the central government around the same time were a decree that all castles of samurai be demolished (to deprive the samurai of their military power base) and the old provinces, over which a samurai *daimyō* ruled, were abolished; replaced by redrawn prefectures headed by a governor appointed by the central government, a Western political import, which of course deprived the samurai of their political base. Then there was the matter of taxation. The government was finding it increasingly difficult to maintain the cost of all the sudden modernization programs that it had set in place. Long-needed land tax reforms had just been made, but this benefited the farmer and peasant classes who were in sore need of relief. While, in the long run this proved to be a wise move, staving off mass discontent among those classes, it had the immediate effect of further reducing the inflow to state coffers. In the early 1870s, the annual stipends to samurai and subsidized domain debts consumed most of the government's revenues, which was simply an unacceptable drain to state finances, given that the class had outlived its purpose. The government eventually decided it was time to take matters into hand and effect a settlement with the samurai in respect of the annual stipend payments, originally paid in exchange for the samurai's defense obligations but which under the new system with a new army, were an utter waste. The government proposed

a one time, final-settlement payment to the samurai, in the form of bonds to be given, following a formula. Naturally, many of the samurai were seething, particularly those in Satsuma, who were among the wealthiest domain holders, and stood to lose the most by being superannuated. In 1876 the government made acceptance of the bonds mandatory. Add to this a sense of betrayal by the very government many of them had worked to put in power and a festering resentment of the government's inability to renegotiate the extraterritoriality treaties, and it is not difficult to see why matters were moving toward armed conflict.

The coming rebellion became visible late in 1876, but armed action didn't occur until early in 1877 in Kyūshū; where the Satsuma forces besieged the local government garrisons (Satsuma province is in southern Kyūshū around the town of Kagoshima), at about the time the final works on the Ōsaka–Kyōto extension were nearing completion. At this point, the nation was in a high state of anxiety as to the outcome. The new *heimin* army was only a few years old and, other than a (successful) brief punitive expedition in 1874 to obliterate some villages in Taiwan in retaliation for their having captured and killed some stray Japanese fishermen, was utterly untested. It was being called upon to disassemble arguably the best-armed of the traditional fighting forces then known in the land, whose training and command structures were well-established. Moreover, the bulk of the naval officers corps were Satsuma men to the point that men from the Satsuma domains dominated the new Imperial Navy. No one was certain that the navy could be trusted to remain loyal. To add to the uncertainty, no one could be sure whether any of the foreign powers would maintain strict neutrality (as they did for America during the American Civil War) or would intervene on behalf of one of the disputants (as they did for China during the Chinese Taiping Rebellion). Around this time, foreign engineers assigned to the survey crews that were in the field surveying routes in remote villages started a routine practice of inquiring periodically of headquarters in Kōbe if the government was still in power and whether there was any imminent threat to foreigners that would require them to evacuate promptly back to the relative safety of the foreign settlement at Kōbe, as there was a strong anti-Western flavor to the Rebellion.[4]

The approaching completion of the Kyōto extension didn't come at a good time for the government. The Emperor was expected to open the line. It was, after all, the line leading to the *Imperial capital*—and it would be a homecoming for him. To cancel the planned gala opening would have signaled a weakness on the part of the government, and might have encouraged more domains to ally themselves with their Satsuma peers. To go on would have meant taking the Emperor away from the government's power base in Tōkyō and moving him to the Kōbe/Ōsaka/Kyōto area at the northern edge of southern Japan, that much closer to rebel hands. Plus, there was the matter of the trip itself. Traveling overland via the Tokaidō would have taken over a month and would have required countless ceremonies and expense along the way. The route by steamship from Yokohama to Kōbe was about a 36 hour trip; clearly a preferable alternative, but the Emperor's ship would have to be escorted by ships of the new navy, manned with large crew contingents of Satsuma men, of questionable loyalty.

It was a time when people speculated as to whether *heimin* could hold their own against *samurai*; whether the Emperor would make a show of it, or whether a face-saving reason for the line 'not to be ready' would be floated. At the new Kōbe car shops, work continued on the private Imperial car (described by contem-

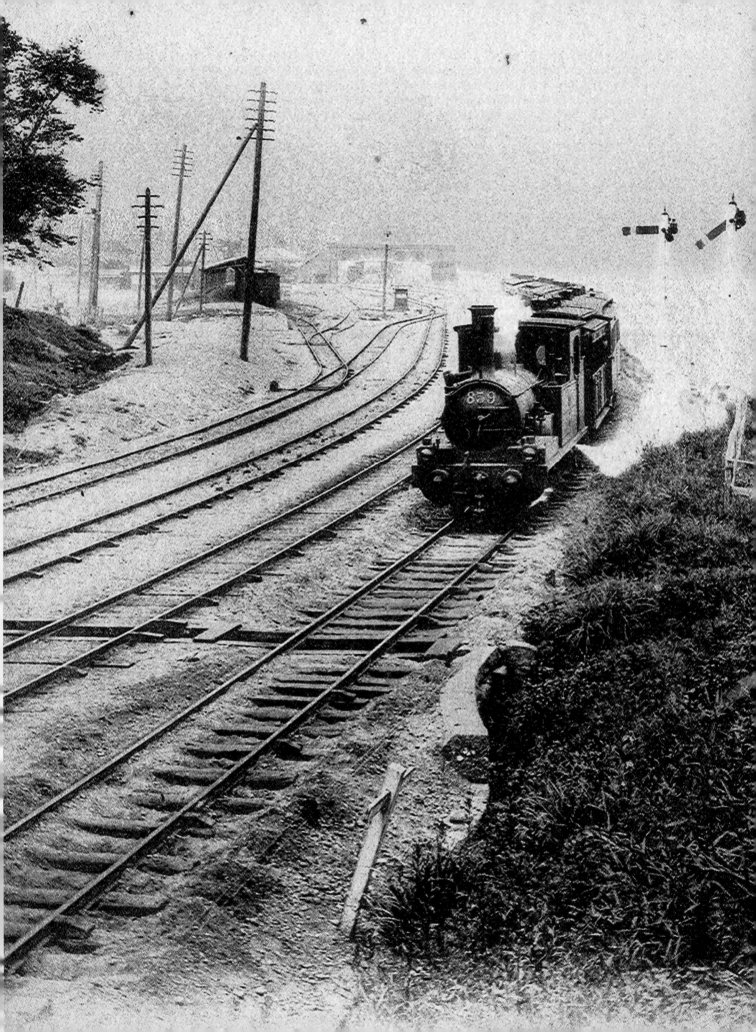

Chapter 5: 1877–1884
Ōtsu, Tsuruga, Nagahama, and East to the Nōbi Plain

Soon after the Emperor departed Kyōto, the staff of the fledgling Imperial Japanese Government Railway, IJGR as it came to be known, turned its energies to improving existing lines and operations instead of expanding the network. In 1877, the Railway Bureau was reformulated as the Railway Commission, again with Inoue Masaru as Commissioner. The continuation of the stop-work order was a telltale indication of the tight financial straits that the civil war in Kyūshū had imposed on the government, which had yet to realize the savings from the *daimyō* stipend settlement emplaced the year before. A mere month after the Emperor had presided over the festivities along the Kōbe–Kyōto route, for the first time in Japanese history, a railway was being used in support of military operations; needless to say a point of patriotic pride for the IJGR, coming only five years after it had commenced operations. Troops had been sent down the Kyōto line to Kōbe almost as soon as hostilities began in February. Only a month later, Holtham, who'd been assigned duties in Ōsaka, noted the first of many movements of special trains in the opposite direction, carrying wounded soldiers back from Kōbe, where they had been landed by government troop ships,[1] to Ōsaka where one of the newest military hospitals had just been built. He describes them as "poor fellows… in no state to be moved… numbers died on the voyage, some in the train, and some even on the platform of Ōsaka station. Two or three times a week a [notice of a special] train of wounded would be telegraphed [from Kōbe]; and then the station was cleared, and the wagons brought alongside the platform, a number of coolies with litters coming in and carrying off the soldiers in sad procession through the streets to the castle…" It must have been a sobering time during those bleak March days compared to the festivities just a month before. He noted that most of the injuries were sword cuts from close quarter combat or shot wounds to the head or neck from combat at a longer range—the government was making use of trench warfare, so injuries below the neck were less frequent. Ordinary passenger cars, and in a shortage, freight cars were pressed into service as makeshift ambulance cars. He remarked upon and was favorably impressed by the great degree of care that was given by the new government towards the injured who were transported through to Ōsaka. The scenes around Ōsaka and Kōbe must have been a busy ones—for not only were there unexpected trains to be run with the utmost of urgency on the oft-unannounced arrival of a troop ship bearing wounded and special trains had to be scheduled for

A Tōkyō–Yokohama down train departing from Shinagawa station, headed by A8 class 2-4-2T Tank locomotive, running number 859, probably in the 1890s. The steam seen escaping under the cab is from the injector, indicating that the driver is in the process of adding water to the boiler. British style semaphore signals were adopted from the earliest days. A string of empty cars sit alongside a canopied platform, while an up train is barely visible under the passenger footbridge at the station in the far distance.

troops being dispatched to the front, but also supply and munitions specials from the new Ōsaka Arsenal to waiting ships at Kōbe pier. Holtham noted that while the ambulance trains were Ōsaka-bound, "we had crowds of troops coming in for transport to the front, some of the regiments being apparently composed of raw lads just taken from the hoe and manure-pail, and evoking pity by their evident clumsiness with the weapons supplied to them." In the event, they were quick to learn, for by early fall, the rebellious Satsuma forces, consisting of perhaps the best organized, trained, and equipped force of all the samurai domains, had been decisively beaten by the new *heimin* army before further rebellion had spread. People breathed a collective sigh of relief and went back about their business. The staff of the IJGR hoped that the Kyōto "stop work" order would soon be lifted. This was not to happen as promptly as had been hoped. While the new government would never again be seriously challenged, the cost of the Satsuma Rebellion had so impacted state finances that it would be almost a year before any authorization for extension of the rail system would be forthcoming. One final outcome of the Rebellion was that the military became completely convinced of the utility of having a good transportation system at its disposal. By the end of the rebellion, Japan had expanded a standing army of 30,000 to one more than three times that size, in the short space of 8 months. During the course of the rebellion, the Shimbashi line had transported 26,000 troops to waiting ships at Yokohama, almost the size of the entire standing army at the start of hostilities. Quoted figures were not found for February to June 1877, but from July 1877 to June 1878, the Kyōto–Kōbe line carried just less than 32,000 troops and officers. In short, the rail system had transported a number of troops easily exceeding more than two-thirds the number of the entire expanded army by the Rebellion's end. The military never again posed any major objection or obstacle to rail building as it had in Tōkyō in 1870–1871. In fact, it became an ardent supporter of further extension of the network, particularly the Tōkyō–Kyōto mainline.

It was in the midst of the busyness caused by the Satsuma Rebellion that Japan's first serious railway accident occurred, which again underscores the relatively lax manner in which rail operations were conducted in those days. The accident was caused by one of the English locomotive drivers on the night of September 30–October 1, 1877. With the return of troops from the front as the Rebellion was winding down, extra trains were again being run to accommodate them. This was accomplished by a common traffic management technique whereby regularly scheduled trains would be run *in duplicate* as two train "sections" (or "extras" in American parlance) of the same "scheduled train" at the scheduled time; the *special* train being run ahead of the *regular* train; thus two trains bound in the same direction ran a safe distance apart as divided units of one "scheduled train." Normally

to the pound—an *enormous* wage for an assistant engineer. Given the native cost of labor, it is understandable that the Railway Bureau realized all too well that an easy cost-cutting target was to be found in the *yatoi* salaries, and after the first domestically-educated engineers started to be graduated in 1879 and a pool of domestically trained potential locomotive drivers grew from the corps of native firemen, it was only a matter of time until the *yatoi* would be phased out completely. On April 14th of that same year on the Shimbashi line a notable change took place when three of such native firemen were promoted to engine drivers: the first in Japan. Their fellow countrymen followed them on the Kōbe–Ōsaka line on August 7th, when the first native engine drivers began service there. The move was not received enthusiastically among the more jingoistic foreign residents of the time. Holtham notes that some of the more bigoted were in the habit of inquiring at the ticketing offices which trains were still being driven by Europeans, and one blustering foreign ex-pat was heard to pontificate, "… it would all be very well so long as the train was on a straight line, but he doubted if any Japanese could be trusted to *steer* the engine round the curves." After an initial period of accustomization, Holtham was able to record that the Japanese drivers were found to be "steady and wide awake, as we knew beforehand, but also economical in the use of coal, oil, etc.—to say nothing of their lower wages, about one-sixth of those paid to foreigners."

By this time, the foreigner commentators who actually traveled along the new Ōtsu line would praise native efforts. Said one,

> "At five p. m. we took [from Kyōto] the train for Ōtsu… This extension of the Kōbe line was only opened a few months ago, and, though but seven or eight miles in length, reflects great credit on the Japanese engineers by whom it was constructed. To cross the mountain pass between Kioto and Lake Biwa heavy grading and tunneling were necessary, and these difficulties have been overcome in the most workmanlike manner. The scenery along the line is really very fine. Winding up and down pretty valleys, extensively cultivated with the tea-shrub and sheltered by rocky hills covered with lovely foliage, the train at last dashes through a tunnel and emerges near the placid blue waters of Lake Biwa…"

The line's construction without foreign assistance was not only gaining foreign praise, but was the source of awakening pride in native technical abilities. In the November 12, 1879 issue of the *Tōkyō Akebono Shimbun* an article pointedly observed that the Ōtsu extension had been completed without foreign help and at half the cost of prior lines, despite the terrain being more difficult. The *yatoi,* from its perspective, only wasted time and money due to their high wages, language problems, relative inexperience with Japanese conditions, and frequent insensitivity to native desires to economize. It sounded the call for them to be phased out; a call that would come to be heard with increasing frequency.

As the window-diving Mr. Gaspar was suffering the consequences flowing from his ill-advised conduct and the work on the Ōtsu branch was winding down, Inoue and his staff in Tōkyō were focusing their attention to the final link to the Japan Sea at Tsuruga. The funds remaining from the initial grant for the Kyōto–Ōtsu segment were tapped. (About this time, the government also had printed excess amounts of paper currency, which of course lead to later rampant inflation with its attendant financial woes and would wreak havoc as to future financing of govern-

ment-sponsored railway lines.) Almost as if the Ōtsu extension had convinced Japan that she could indeed build her own railways, the government approved the most ambitious segment of line yet put in hand. There were several projected routes considered, and the deliberation actually went as high as a ministerial meeting in the presence of the Emperor, where it was decided to run a line from Tsuruga on the Sea of Japan coastline to Shiōtsu, the closest point on Lake Biwa, to complete the rail-lake steamer transverse link that would bisect Honshū— a route which had already been preliminarily surveyed by *yatoi* in 1871–1872 and re-surveyed by Holtham and other *yatoi* during 1873–1874. Inoue presented the final proposal in January 1880, and rather than build the line from Tsuruga to the northernmost town on Biwa, Shiōtsu, a distance of roughly 15 miles, he recommended constructing the line down the eastern side of Lake Biwa, southward along its shore to Nagahama, which afforded a superior natural harbor. This was granted.

Work was started almost immediately on April 6, 1880 under the superintendence of Iida Toshinori. The Yanagase Tunnel, which stood between Biwa and the seacoast to the north, the most difficult work on the line at roughly 1,400 meters in length, was commenced on June 11th. The tunnel was more than double the length of the Osakayama tunnel, just under a mile long. Work commenced simultaneously at each tunnel portal with two opposing borings working to the center and simultaneously two rail segments were started on either side of the tunnel.

Work proceeded on the segments of the line at either end of the tunnel such that, by March 10, 1881 (less than a year from start of construction), the line had been open from Nagahama on the shores of Lake Biwa (where a lake steamer-rail transfer station was built that still stands today and is perhaps the best remaining example of stations of that era) running north to the southern portal of the Yanagase Tunnel. On the same day, the line from the northern end of the tunnel was opened to Tsuruga and the actual port station beyond, Kanagasaki. The distance from Tsuruga to Nagahama was just short of 26½ miles.

Work on the tunnel initially progressed at a rate of 3 to 4 lineal feet per day for the first hundred feet or so until solid rock was hit. At this point, the undertaking faced its first true difficulties. The only means of boring shafts in the rock for the dynamite (an improvement by then starting to become routine compared to the former blasting powder) was by hammer and chisel. Ventilation in the tunnel had become so bad that there wasn't adequate oxygen for the workers' miner's lamps to burn at the excavation headings, let alone for breathing. A fan worked by a water wheel forcing air through ventilation tubes was tried, but was not adequate. By August of 1882, the problem had become so severe that it resulted in a suspension of work. Ameliorative measures had to be taken. The concept of a water-powered turbine to drive an air compressor was suggested and Holtham was tasked with its initial design. Those initial designs were sent from Tōkyō (where he had been transferred to oversee doubling of the Shimbashi line) to the Kōbe shops of the IJGR where Benjamin Wright oversaw the working drawings made by native draftsmen, the casting and forging of the materials and the machining and fitting and final assembly of the device. It is a great credit to the existing skills of the Japanese workmen at Kōbe shops that a mere decade after the introduction of Western casting and machine tool technologies, they were able successfully to make a casting as complicated as a turbine wheel, no mean feat, and the cylinders of an air compressor, and to machine and assemble them into a functional ma-

chine. (As the cylinders and crankshafts of a turbine-actuated air compressor are not notably different from those of a reciprocating steam locomotive, the exercise proved to be a useful drill against the day when Kōbe shops might be called upon to build a locomotive.) The device took little time to build, considering its novelty and relative intricacy, and was ready to be shipped in October. As the tunnel portals were in a remote locale, the turbine-compressor was purpose-built to be disassembled into smaller pieces, which were shipped to the worksite and reassembled that same month. Once erected on-site, it proved to be a notable success and at 40 rpm and a working pressure of 60 psi, provided not only enough compressed air to ventilate the tunnel, but also to power pneumatic rock drills, which had again been designed, cast, machined, and built—this time by the Akabane Works in Tōkyō, an all-purpose factory the government had established in what was then the suburbs of Tōkyō. This time the work crews (unlike at Ōsakayama) readily adapted the them: seeing the value of Western technology when tunnel lengths in the order of magnitude of Yanagase were faced. The turbine not only permitted tunnel construction to resume, but speeded the rate of progress in conjunction with the two pneumatic rock drills.

By March of 1882, Inoue had received governmental authorization to extend the line from Nagahama around the shores of Lake Biwa to Shunjō (north of Maihara), thence striking out eastwardly to the Sekigahara gap, a further 14 miles. Finally, in August of 1883, Inoue obtained permission to build another 8½ miles beyond Sekigahara to a temporary terminus at Ōgaki, a distance of some 49 miles from Tsuruga—the longest stretch of railway yet attempted in one building régime. There were 16 stations in all along this line. Ōgaki was chosen as the temporary terminus primarily because it was the closest point for the railhead to make a connection to the system of canals and rivers that reached to Kuwana and Yokkaichi and radiated from the important regional city of Nagoya as well, thus forming a rail-lake steamer-canal system between the Kansai and the Nōbi Plain—the largest expanse of non-mountainous land between Tōkyō and Kyōto. In reaching Ōgaki, the railhead would have succeeded in passing through the mountain range separating the Kansai plain, on which Kyōto and Ōsaka are located, from the Nōbi plain and Nagoya. At Ōgaki, the end of the line would have been about 100 km. away from Nagoya to the southwest and would only have been about 35 km. west of Gifu and the Kiso River, the valley of which formed a natural path whose course could be followed north easterly and serve as the intended route to Tōkyō. In due course, on April 16, 1884, the Yanagase Tunnel was completed and the projected rail-steamer link to the Japan Sea coast became a reality.

Eleven months before the Yanagase Tunnel was completed, on May 1, 1883, the section from Nagahama to Sekigahara had opened and the Nōbi Plain lay before the eastern railhead. One month after the tunnel opened, on May 25th, 1884, the final leg to Ōgaki was complete and the line officially finished. Beside the nat-

ural strategic military value, the Tsuruga–Biwa–Ōtsu route provided the added benefit of facilitating rice shipments, and went a long way to allaying fears of another great famine.

With this native-built line, the IJGR had succeeded in linking the opposite coasts of Japan via Lake Biwa, putting the cities Kōbe, Ōsaka, and Kyōto in communication with Nagoya, and positioning itself at the western entrance to the Nōbi Plain where further extension could be undertaken without costly tunneling for a considerable distance. With this one section, the total railway route-mileage of the IJGR had increased by a factor of about two-thirds. To add to the sweetness, the line came in under-budget. It cost some ¥2,895,462, which was ¥522,669, or roughly 18%, below the estimates. All eyes turned eastward towards Tōkyō.

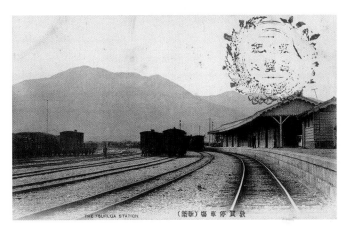

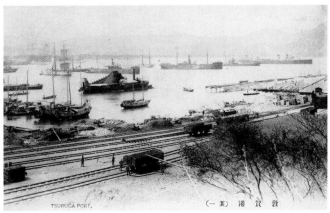

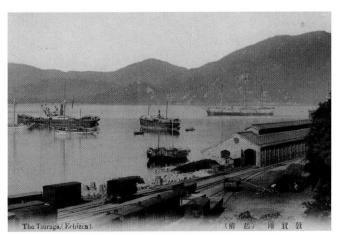

Tsuruga station and its harbor station of Kanagasaki served as the terminal of Japan's first railway line to transverse Honshū. As such, they were built with above-average freight yards and shore facilities intended to handle the traffic that was generated by transfer from the coastal shipping originating from points along the Sea of Japan coast destined for the markets of Kyōto, Ōsaka, and points beyond. The freight traffic that this route engendered is evidenced by the standing freight cars and the long freight depot in the final view. These three views probably date from around 1890-1900, by which time a second transversal line, the Shin'etsu, had been built from Tōkyō to Naoetsu, which then joined Tsuruga as a transfer point of rail-coastal shipping on the Sea of Japan Coast. The oddly shaped ship slightly left of center in mid-harbor in the second photo is a dredging rig making harbor improvements.

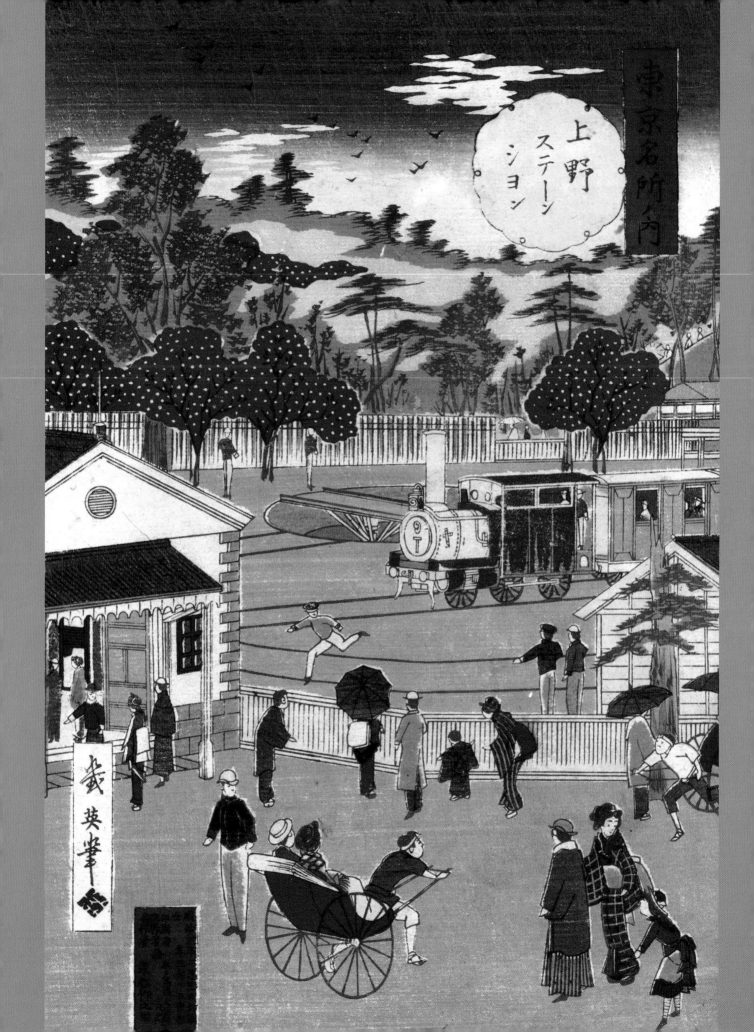

Chapter 6: 1880–1895
Extending and Integrating the System

From about the time that the various sections of the Tsuruga–Ōgaki line were in full course of construction, it had become apparent to Inoue and the Railway Bureau that Japan would, in the not too distant future, be approaching a level of engineering and construction capability as would allow the nation to construct its own lines of railway on a reasonably grand scale without need of foreign assistance. Not only had the Government realized this, but the Japanese public had as well, from numerous self-congratulatory articles appearing in the press trumpeting the successes of such feats as the Ōsakayama Tunnel. Certain writers of the British engineering press clucked jadedly at the naïveté of the Japanese Press for effusing over the completion of a mere 650 meter tunnel as if it were a marvelous engineering accomplishment when such a event would scarcely have merited mention in a small-town newspaper in the UK by that point, and was similarly dismissive of the media's hype surrounding the fact that when the two tunnel bores met at center, they were out of alignment only by a matter of a few inches, but only some 40 years hence, that had been the same posture adopted by the British press when the first engineering feats were being accomplished by the Stephensons, Locke, Brunel, and other pioneering railway builders. Undeterred, the exuberant nation heralded its accomplishments in a way that seemed at odds with its significance in the annals of world engineering: the Japanese had surpassed their own engineering benchmarks, and that was reason enough for jubilation. Perhaps the reason for the slightly begrudging tone some of the articles in the British engineering press of the day is explainable: The handwriting was on the wall, and the point at which British technical assistance would no longer be necessary had dimly appeared on the far horizon. From about this point onward, the British engineering journals of the day again and again adopt a cautious tone, advising that British interests in providing equipment and technical advisors to Japan's railways needed to be carefully watched and aggressively promoted. When speaking of Japan, the self-assured attitude of *railway colonialism* that had infused the earlier articles began to disappear. Henceforth, the British engineering press seemed to realize that the question of further British involvement in railway development in Japan had reached the point where it probably not would be expected to contribute to colonization (as it would, at the hands of various powers, in places like Rhodesia, Burma, Indonesia, the Congo, and Vietnam.) This was not the proper subject of speculation for engineering journals, of course, but in an age of aggressive British colonization, such considerations were never far below the surface of the commentary. Instead, the rallying-call that ensued

would largely couch the issue as one of remunerative trade opportunities for British interests, and the tone of the publications shifts to that of encouraging British consultants and equipment manufacturers to become competitive in face of the challenges.

The Japanese of course were all too aware of the dangers of reliance on a foreign power for technological assistance insofar as political dependency was concerned and were doing their level best to avoid it. They were quite transparent about their intentions to use foreign technical advisors and financing only for so long as was absolutely necessary. Nonetheless, the Japanese hadn't reached a level of total self-sufficiency at this point, and certainly hadn't reached the level where the native labor pool could furnish an adequate supply of qualified Japanese engineers to staff the building of lines that were about to be projected.

Delivering a paper before the Japan Society of London in 1899, Kadono Chōkyūrō (1867–1958), a *Kōbudaigakkō* graduate who had gone to America to work for four years on the Pennsylvania Railroad and on his return to Japan had served as an engineer on the San'yo Tetsudō, succinctly summarized the development of railways up to this point,

> "[The Shimbashi, Kōbe–Kyōto–Ōtsu, and Tsuruga–Ōgaki] lines were undertaken by the Government and served as an experiment to prove to the people and country that railways are one of the most efficient means of transportation. The years following the completion of these lines were given to the study of all the details of the workings of railways, and railwaymen were being educated and fitted for other lines in contemplation."

The first lines of course had proven to be quite successful, the anti-foreign sentiments that were feared might arise in the populace and be taken out on the *yatoi* had failed to materialize, and on the whole, the population in the areas affected were wholeheartedly embracing railways and were starting to call for extension, as was the military, having appreciated their usefulness during the Satsuma Rebellion. The successful completion of the Tsuruga–Ōgaki line had likewise given credence to Inoue's hypothesis that the British *yatoi* were, as a class, as much a part of the problem on some levels as they were a part of the solution and were best used only for tasks the Japanese hadn't yet mastered. The stage was set for expansion of the network. While Kadono's observation would have the reader believe that the decision to slow the pace of building was deliberate, the truth of the matter was that the aftermath of the Satsuma Rebellion had seen the government printing large amounts of currency to finance the costs of quelling the rebellion, which in turn had quite a negative impact on the already-strained state coffers. By the late 1870s and early 1880s the effects were being felt in the inflation that gripped

Little is known about the artist Giei. This is one of his prints, showing one of the Dubs-built members of the original ten IJGR locomotives, bearing running number 9, entering Ueno station, around 1885 after the Akabane line had connected the Shimbashi line with the new Nippon Tetsudō and that locomotive could reach the new station via the rail link.

the nation, and there simply were not adequate funds available for rapid and extensive expansion of the two fledgling regional railway systems into a national network, absent resort to foreign borrowing. Nonetheless, the demand for further expansion was growing and the need was to all self-evident. What was required was a solution that would permit of its undertaking in view of the straitened condition of state finances at that time.

While it was easy enough to decide to build an 18 mile railway from Yokohama to Tōkyō as an experiment, and it was simple enough to decide to build a similar line from the deep water port of Kōbe to link the nation's pre-eminent commercial center of Ōsaka and extend it on to the Imperial capital at Kyōto, there comes a point when experimentation must give way to concerted planning, and the concerns of railway planning in Japan in 1880 were no different from those that obtained elsewhere in the world at that time.

Inoue and his contemporaries at the Railway Commission had to allocate meager resources at best. As they looked forward to plan the next lines, that planning would be guided by several factors, the primary one of which was the overall utility of the line to development of Japan as a modern nation. Of course, that overarching principle could come to be applied in various guises, which began to manifest themselves as themes recurrently encountered in subsequent planning: projected lines would be slated for construction based upon their strategic military usefulness in defending the realm, some would be chosen by virtue of their usefulness in fostering and stimulating industrial or agricultural development, others would be chosen due to their usefulness in development of geographically inaccessible or sparsely inhabited parts of the realm (together with all the potential for exploitation of the natural resources found in such regions that is therein entailed) or in order to consolidate governmental power and promote national unity in remote areas, while still others would be chosen simply by virtue of their providing a quick means of transportation and communication between and among major population centers. The new undertakings that arose reflect each and every one of these themes in application.

It was a foregone conclusion by anyone in the nation who had an opinion on the subject that the three disparate lines should be linked, so that Tōkyō, Kyōto, and Ōsaka, the three most important cities of the realm, would have integrated rail communication. Of necessity, such a line would pass closely enough to the regional centers of Nagoya and Shizuoka that branches to each could be constructed, bringing five important cities and two of her best, most modern ports (Kōbe and Yokohama) into contiguous communication; the benefit to the nation and to its trade would have been immeasurable, but the project was stopped cold by the Satsuma Rebellion. About the time of the completion of the Ōgaki line, the government began to realize in earnest the importance of railway development, and as the route of the proposed new lines was under consideration, the newly-formed Army, lead by its head Prince Yamagata (later to serve as Prime Minister) was vociferous in championing the absolute necessity of connecting Tōkyō, *via* Takasaki, with Ōgaki. Yamagata was insistent upon a route that would stay well inland of the shores, far from the range of foreign naval bombardment, and be much more easily defensible: the Japanese Army had its hands full for the time being simply defending the nation from rebellion and the threat of Western imperialism. Already stretched thin, it did not need to take on the task of defending roughly 375 miles of railway line exposed along a coastline between Tōkyō and Ōsaka if it could avoid it. A rival route along the eastern seaboard of Honshū would have been cheaper, though not as direct, but to its credit the cities of Nagoya and Shizuoka would have been fallen conveniently right in the path of the route, avoiding branches to each of these important cities. The question of which route was preferable was one of the issues that nagged both Boyle and Inoue. By as early as 1877 enough data was in hand to permit Boyle to report favorably on the central route, and a fairly extensive summarization proposed route appears in the May 25, 1877 issue of *The Engineer*. National security concerns had won the day, and the route selected approximated that of the old Nakasendō ("Through the mountains") road, which roughly followed the central axis of Honshū. The government financed the project by means of a 7% ¥20,000,000 loan, the Nakasendō Tetsudō Kosai, which it raised domestically.

As can be seen from the accompanying 1885 map on page 51, building from Ōgaki would not have presented any serious difficulties, but for the fact that three rivers with bad, muddy bottoms, the Ibigawa, Nagaragawa, and Kisogawa would require considerably complicated bridging. As the erection of suitably permanent bridging in this area would take considerable amounts of time on leaving Ōgaki, given the equipment and construction methods available to the Railway Bureau at the time, Inoue hit upon an alternative method to speed construction: the line would commence eastward from Ōgaki, and the slow task of bridging would proceed, but simultaneously a feeder line would be built from Handa or Kamezaki on the coast to Nagoya, up which materials and supplies could be brought for building the segment of line up the Kiso valley beyond the segments requiring the most complicated bridging. In the event, it was found that Handa harbor didn't have as suitable a depth of water, and that Taketoyo was better suited, so the line was set to be constructed from there. The main line would thereafter follow the route of the Kiso river north-easterly (again, roughly approximating the "Kisokaidō" segment of the Nakasendō) as it started its ascent into the Japan Alps to the Usui Pass and thence towards the Kantō Plain beyond.

From Tōkyō, Inoue found that the southwesterly approach was likewise not so straightforward, as mountains were encountered very quickly. How best to supply the construction efforts in a highly mountainous terrain (a feat that had never been undertaken in Japan before) to enable the bringing in of supplies and removing spoil during tunneling, grading, and cutting was also a major issue. The route the new line would follow leaving Tōkyō would be northwesterly, towards Takasaki and then commence its ascent towards what even in those times was a fashionable mountain resort for Japanese and foreign well-to-do alike, Karuizawa, and onwards towards a junction. It was feared that this line would be inadequate for supply purposes at the higher elevations and using an identical strategy, Inoue decided that another feeder line would be constructed from Naoetsu, a navigable coastal port (by standards of the day) on the Sea of Japan side of Honshū, southward to Ueda to link with the Tōkyō–Takasaki–Karuizawa line and from there to a junction with the line coming up from Ōgaki through the Kiso River valley, permitting supplies to reach the remote mountainous area where construction would be in progress, and permitting the spoil of excavation to be disposed of more easily. While the Naoetsu–Ueda line was primarily built as a "construction feeder," it would also, on completion, serve the useful function of providing the second line to cross Honshū from Tōkyō, much as the Tsuruga–Lake Biwa–Ōtsu link did for Kyōto and Ōsaka. When the link was finally made between Naoetsu and Takasaki, the line was at first commonly known as the *Usui Line*,

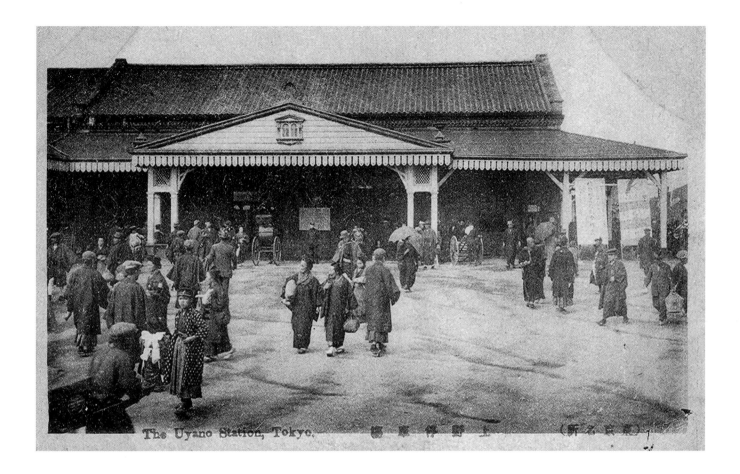

The Uyeno Station, Tokyo.　上野停車場　(新名所之内)

but eventually settled into it's official name: *Shin'etsu Line*, from the first two kanji characters of the former feudal provinces of Shinano (present day Nagano Prefecture) and Echigo (present day Niigata Prefecture), which it connected. Construction of the Naoetsu–Ueda line was authorized in March 1885 and as it would operate as a non-contiguous line for some time, small shop facilities were built at Nagano, where the rolling stock for the line would be built, and where locomotives could be repaired. The Taketoyo line was authorized two months later in June.

While Inoue and the Government were grappling with these logistical difficulties and engrossed in planning, other forces had come into play. First was the inflation that arose from the Government policy of printing of large amounts of paper money mentioned earlier, and the ensuing financial weakness of the Treasury, a situation only compounded by the payments to pension of the samurai that has been mentioned. Eventually, austerity measures instituted by Finance Minister Matsukata Masayoshi would put the nation on a more stable fiscal path, but the effects of his reforms were still years away. During this critical period before those results had been felt, and felicitously for the future of railway construction, a second force took advantage of the situation.

As early as 1869, the irrepressible entrepreneur Takashima was pressing the government for subsidization of a proposed railway-building scheme to be undertaken by private enterprise, which he was proposing to form. As mentioned, his request was rebuffed. Only a year after the completion of the Shimbashi line, the *daimyōs* of the houses of Date, Ikeda, Hosokawa, Kamei, Mori, Matsudaira, and Yamanouchi had petitioned the government for the right to build a railroad from Tōkyō northward to Aomori,

the most prominent town at the northern-most tip of Honshū. That petition was not granted, but the government did go so far as to construe it, reportedly at Inoue's initiative, as a request to purchase the existing Yokohama–Tōkyō line and entered into sales discussions with the group. An association styled the Tōkyō Tetsudō Kaisha (Tōkyō Railway Company) was formed, and an actual contract of sale was executed, calling for installment payments. For a brief moment, around 1873, it appeared that the Japanese government might be considering getting out of the railway business. But the company was never able to make any payments beyond the second, the purchase accordingly failed, and the company was disbanded in 1878, despite the best efforts to effectuate what we would today call a "rescue" on the part of the legendary Shibusawa Eiichi, then a budding entrepreneur-industrialist-philanthropist who would go on to be involved in numerous railway ventures (among which were the Nippon Tetsudō, the Gan'etsu Tetsudō, the Hoku'etsu Tetsudō, and the Seoul–Pusan Railway) and ultimately would achieve in Japan the stature similar to that accorded to Henry Ford or Andrew Carnegie in America.

In the period following the Satsuma Rebellion, various nobles

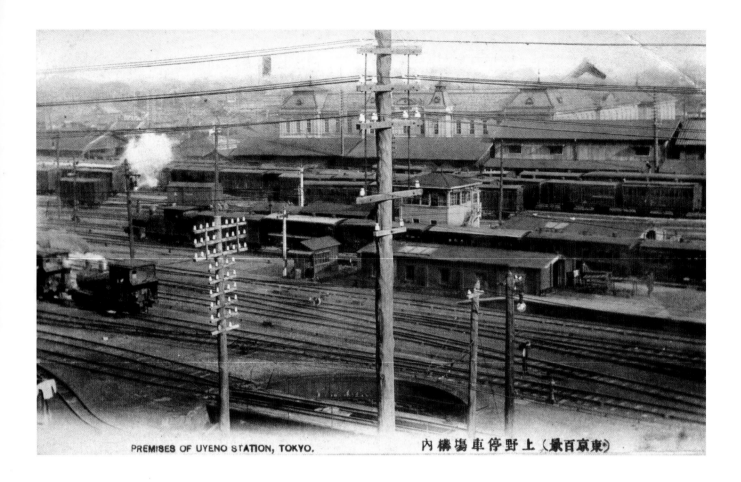

PREMISES OF UYENO STATION, TOKYO.　　　上野停車場構内（東京百景）

An interesting view of the yards of Ueno Station as a train of short passenger stock behind a brass-domed A8 type 2-4-2T tank locomotive departs, taken around the time of Nationalization. Four-wheel passengers cars predominate in this scene, at a time when more modern passenger stock had become much more commonplace on the IJGR and other of the "Big Five." Out of the roughly forty vehicles in the view, only one appears to be mounted on trucks. Note the modest diameter turntable that could probably accommodate no locomotive larger than a mogul and the 1040 Class 0-6-0T shunter (built at the Nippon's Ōmiya shops) in the left foreground, introduced in 1904 and easily identifiable by its steam dome mounted twin safety valves, rectangular cab spectacles, and curious lid-covered coal bunker.

loyal to the government had also pressed for a charter to construct a railway. Reeling under the debt of the Satsuma Rebellion, painfully aware of the need to keep the still-powerful *daimyō* satisfied and complacent, and astutely realizing that the heavy treasury expenditures from the *daimyō* financial settlement could in effect be "re-captured" and put to work constructing the railways that were still, after all, a government policy goal, albeit with the political downside of being privately-owned and controlled, gradually the government came to see the authorization of privately-owned railways as an expedient by which it could extricate itself from the current difficulties it faced as to how to find the means to finance further railway expansion. So it came to pass that in 1881, imperial assent was given to the charter of a corporation that had ambitiously been styled the Nippon Tetsudō Kaisha ("Japan Railway Company") by the nobles of the Imperial Court and former samurai who were promoting the scheme. Looking back on its formation, Inoue also mentions the paternal government motive toward the samurai investors: that by providing a guaranteed investment outlet, the government in effect would prevent some *daimyō* from making bad investments leading to

bankruptcy and further class alienation, and keep those investors actively engaged, with a stake in the economic well-being of the nation. The route of the proposed line ran from Tōkyō northward to Aomori at the northern tip of Honshū, serving the triple purpose of developing the Tōhoku region, connecting it with the Kantō plain, further cementing Hokkaidō to the political comity of the realm so that no future *Republics of Yezo* would occur, and providing a bulwark against potential Russian colonial encroachments from the direction of Vladivostok and the Sakhalin Islands. By this time, Inoue had become a staunch believer that the railway system should be state-owned, but ever the pragmatist, was obliged to yield to the exigencies of the day. As with the first government lines, the decision was made without any serious traffic studies, profitability or cost projections, or other due diligence being made; the whole venture again being premised upon educated conjecture. However, given that there were no serious forms of land transportation against which to compete, given that capital was likely to be scarce and therefore unlikely to be invested in *competitive* ventures, and given the government's unfavorable policy toward permitting construction of competing lines, in hindsight it is not surprising that many *daimyō* did indeed invest a sizable amount of the proceeds of their government settlement into the Nippon Tetsudō (and as it developed, into other future privately-owned railways). In a financial sense, the decision to allow the formation of joint-stock publicly-traded corporations to construct and operate railways in Japan made a good deal of common sense at the time. Nevertheless, subsequent private railway companies were not destined to receive as advantageous a set of subsidies and guarantees as did the Nippon.

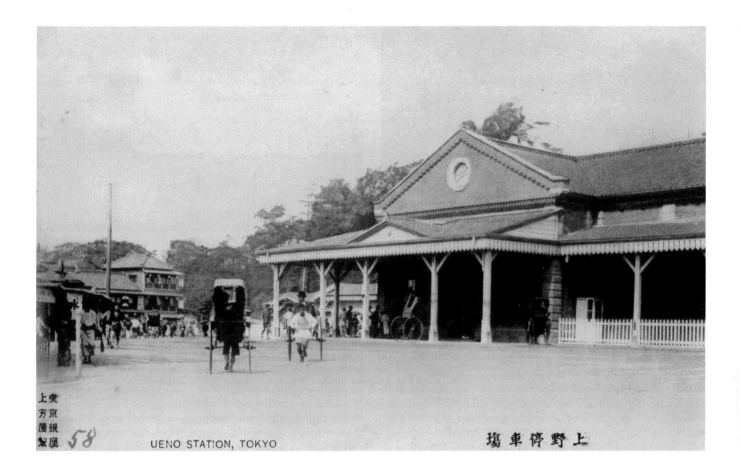

UENO STATION, TOKYO　　　　　　　　　上野停車塲

The corporate charter of the Nippon Tetsudō was quite generous and can be found set forth in whole in the appendix. Not only were there financial guarantees of return, but the charter arrangements and understandings provided that construction of the line itself was to be undertaken by the IJGR Railway Bureau under Inoue's supervision, neatly serving the dual purpose of keeping Inoue's staff gainfully employed and intact while relieving the management of the Nippon Tetsudō of the necessity of finding and hiring engineering talent, dealing with surveys, construction difficulties, materials and equipment acquisition, defaulting contractors, unforeseen calamities, and labor problems. All management had to do was to finance construction and, on completion, commence operation of a railway the government had agreed to build for them. Inoue contentedly shifted his engineers, skilled work crews, and construction operations from the Sekigahara pass environs to the region north of Tōkyō.

Kadono Chōkyūrō's narrative continues:

"... the first charter was not granted to a private railway company until 1881, about ten years after the experiment was first installed by the Government. The year 1881 may be termed an epoch in the history of Japanese railways. The comparative inactivity for about ten years after [the lines initially planned in] 1870 cannot entirely be attributed to an intentional check for the purpose of training and study. There may have been other causes necessitating the inactivity during that period. Whatever was the case, as we look back upon it now, the country was nonetheless benefited by the slowness of progress in railways in their first stage. Time was

Rickshaws are the only vehicles in sight in this 1890s view of Ueno terminal taken of the side of the terminal that was parallel to the tracks. The Nippon Tetsudō's rail line would have been visible just to the right of this building. The one-story brick structure successfully withstood the Great Kantō Earthquake of 1923 only to be consumed in the ensuing fires, which left nothing more than an empty shell of untoppled masonry.

allowed for study of the railway policy of the country as well as the details connected with construction, equipment, and management. Dating, then, from 1881, both the Government and private companies have been engaged in active work all over the country. ... The mileage began to augment steadily year after year ... but... the Government was careful in studying each project before a charter for it was granted... The Government does not sanction the construction of competing lines. This policy seems a salutary one for the country. The disastrous waste of none too-plentiful capital has thus been avoided. The work of the Government Railway Department in surveying and reporting upon all feasible lines and classifying them according to their respective merits, whether commercial or strategic, and thus affording a guidance, so to speak, for railways to be constructed in future, was welcome and wise. 'The official programme' of projected railways, thus formulated, was sanctioned by the Diet, and governs the construction of important lines in the future. This seemingly conservative aspect in our railways at their first stage cannot be regretted. Subsequent steady development has vindicated the wisdom of these cautious steps."

Here was a fundamental feature of the future pattern for railway development once the government allowed formation of private

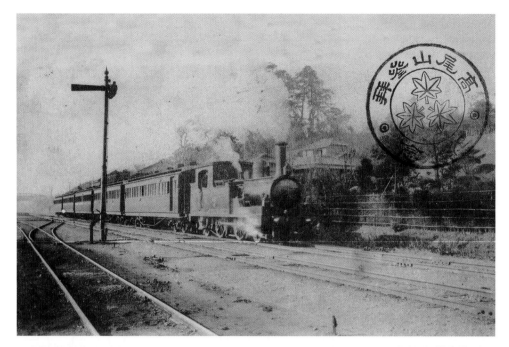

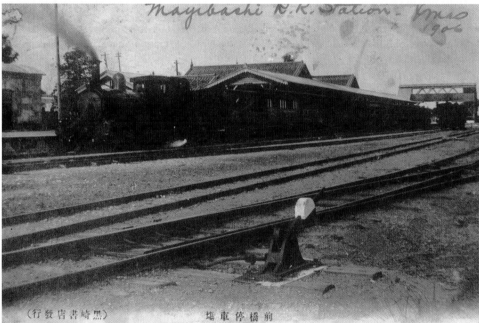

(行發店書崎黒)　　　　　場車停橋前

(left above)
Little remembered today, the A8 class 2-4-2T locomotives with Joy's valve gear and radial front axles were at one time widespread. They were built by Naysmith Wilson (107 units), Dubs (61), Vulcan (18 units), Brooks (4 units), and Kraus (2 units). In addition, 44 class members were domestically built. They handled all types of traffic, from crack express trains to the lowly freight and many served well into the 20th Century, some lasting into the post WWII period. A8 class locomotives could be seen operating on the IJGR and the following lines: the Nippon, Kobu, Sobu, Kyōto, Bōso, Hokkaidō, Kansai, Sangu, Kyūsushū, Bisai, Narita and San'yo railways. This view from the 1890s shows an A8 piloting a five-car passenger train of bogie stock along a double tracked right-of-way: proof that the locomotives were still quite capable of being assigned mainline duties, even though 4-4-0 tender engines from Britain had by then become commonplace and larger 2-6-2 tank locomotives from America were starting to be imported.

(left below)
Maebashi was an important provincial town that was located on what was initially the terminus of the northwestern branch of the original phase of the Nippon Tetsudō that the IJGR was retained to build. This view of the station just before nationalization shows a Nippon Tetsudō passenger train at rest at the platform, by which time the line had been extended and the station was no longer a terminus.

(opposite)
Difficult as it may be to believe today, this pocket card contains essentially the condensed schedule of all passenger trains for the northern half of Honshū, including Tōkyō and Yokohama, as of March 16th, 1886. The fastest train speeds between Shimbashi and Yokohama compare creditably with the time required for the same trip between the corresponding points today. As is seen from the schedule, at this time, the Nippon Tetsudō was operating two passenger trains a day in each direction along its mainline north. Note also that compartment carriages were assured as a first class luxury on the Maebashi trains, perhaps a Victorian reflection of Management's British-influenced aversion to American-style center aisle carriages as being a bit too republican.

centrations of high-grade iron ore had been discovered in the area of Ōhashi, 20 miles inland from Kamaishi. A scheme was quickly put forth to develop these deposits with mines, smelters, reverberatory furnaces and to that end the government contracted with British interests in 1875 to build a steel mill at Ōhashi, where the deposits lay. As Ōhashi was inland and a large output was anticipated, it was decided to build a railway between the there and the closest good harbor in order to facilitate the enterprise. The gauge chosen for the line was 2' 9" (838 mm), basically a small gauge used for light industry. By happenstance, the brother of the same Dr. Theobald Purcell who was unable to cure Edmund Morel, Gervaise Purcell, one of the English *yatoi* who had been engaged as a civil engineer on the Ōsaka–Kyōto segment, was without any

pressing assignment at the time. He agreed to be transferred to the Bureau of Engineering, Mining Department in 1875 and was put in charge of surveying, laying out, and building the line from Ōhashi to Kamaishi, where he arrived in early July. Gervaise Purcell left a terse diary that records his time at Kamaishi.

The Kamaishi project and its little railway were ill-fated almost from the inception. Subsequent writers have remarked in hindsight that the technical advisors who had been retained recommended building furnaces that were unsuited to function on the lower grade local charcoal that was produced in the region to fuel them. Purcell, according to his diary entries, had only been in Kamaishi less than a month when he ran into difficulties with his supervisors that were apparently to last throughout the course of

The Revised Time-Table of Trains, Running between the Capital and Yokohama.

[REVISED FROM THE 16TH MARCH, 1886.]

Gratis to Subscribers of the "Japan Gazette."

M	Stations.	Down Trains.														
		A.M.	A.M.	A.M.	A.M.	A.M.	P.M.	P.M.	P.M.	P.M.	P.M.	P.M.	P.M.	P.M.	P.M.	P.M.
...	Shinbashi ...d.	6.35	8. 0	9.15	9.45	11. 0	12.15	1.30	2.45	4. 0	4.45	6. 0	7.15	8.30	9.45	11. 0
3¼	Shinagawa.. ,,	6.44	8. 9	9.24	9.54	11. 9	12.24	1.39	2.54	4. 9	4.54	6. 9	7.24	8.39	9.54	11. 9
6	Omori,,	6.53	8.18	...	10. 3	11.18	12.33	1.48	3. 3	4.18	...	6.18	7.33	8.48	10. 3	...
10¼	Kawasaki ... ,,	7. 5	8.30	...	10.15	11.30	12.45	2. 0	3.15	4.30	...	6.30	7.45	9. 0	10.15	11.28
12½	Tsurumi ... ,,	7.13	8.38	...	10.23	11.38	12.53	2. 8	3.23	4.38	...	6.38	7.53	9. 8	10.23	...
16½	Kanagawa .. ,,	7.25	8.50	9.55	10.35	11.50	1. 5	2.20	3.35	4.50	5.25	6.50	8. 5	9.20	10.35	11.46
18	Yokohama .. a.	7.30	8.55	10. 0	10.40	11.55	1.10	2.25	3.40	4.55	5.30	6.55	8.10	9.25	10.40	11.51

M	Stations.	Up Trains.														
		A.M.	A.M.	A.M.	A.M.	A.M.	P.M.	P.M.	P.M.	P.M.	P.M.	P.M.	P.M.	P.M.	P.M.	P.M.
...	Yokohama.. d.	6.35	8. 0	8.50	9.45	11. 0	12.15	1.30	2.45	4. 0	4.45	6. 0	7.15	8.30	9.45	11. 0
1½	Kanagawa .. ,,	6.41	8. 6	8.56	9.51	11. 6	12.21	1.36	2.51	4. 6	4.51	6. 6	7.21	8.36	9.51	11. 6
5½	Tsurumi ... ,,	6.53	8.18	...	10. 3	11.18	12.33	1.48	3. 3	4.18	...	6.18	7.33	8.48	10. 3	...
7¾	Kawasaki ... ,,	7.01	8.26	...	10.11	11.26	12 41	1.56	3.11	4.26	...	6.26	7.41	8.56	10.11	11.23
12	Omori,,	7.13	8.38	...	10.23	11.38	12.53	2. 8	3.23	4.38	...	6.38	7.53	9. 8	10.23	...
14¾	Shinagawa .. ,,	7.21	8 46	9.26	10.31	11.46	1. 1	2.16	3.31	4.46	5.21	6.46	8. 1	9.16	10.31	11.42
18	Shinbashi ... a.	7.30	8.55	9.35	10.40	11.55	1.10	2.25	3.40	4.55	5.30	6.55	8.10	9.25	10.40	11.51

RAILWAY TIME TABLES.

Uyeno-Mayebashi Line.

TRAINS LEAVE UYENO (Tokyo) at 5.15, 8.00 and 11.00 a.m., and 2.15 and 4.50 p.m.; and MAYEBASHI at 7.50 and 11.10 a.m., and 2 20 and 5.05 p.m.

FARES—First-class (Separate Compartment), *yen* 3,88; Second-class, *yen* 2.28; Third-class, *yen* 1.14.

Uyeno-Utsunomiya Line.

TRAINS LEAVE UYENO at 8.00 a.m. and 4.15 p.m.; and UTSUNOMIYA at 8.25 a.m. and 4.40 p.m.

FARES—First-class, *yen* 2.45; Second-class, *yen* 1.44; Third-class, *sen* 72.

Shimbashi-Akabane Line.

TRAINS LEAVE SHIMBASHI at 7.20 and 10.25 a.m., and 1.20, 4.10, and 7.25 p.m.; SHINAGAWA 7.29 and 10.34 a.m., and 1.29, 4.19 and 7.34 p.m.; and AKABANE 9.07 and 11.30 a.m., and 2.50, 6,05, and 8.40 p.m.

FARES—First-class, *sen* 70; Second-class, *sen* 46; Third-class, *sen* 23.

Yokosuka Steamers.

LEAVE THE ENGLISH HATOBA, YOKOHAMA, 8.15 a.m., 10.45 a.m., 1.30 p.m., 4.30 p.m.

LEAVE YOKOSUKA, 6.50 a.m., 10.50 a.m. 1.45 p.m , 4.15 p.m.

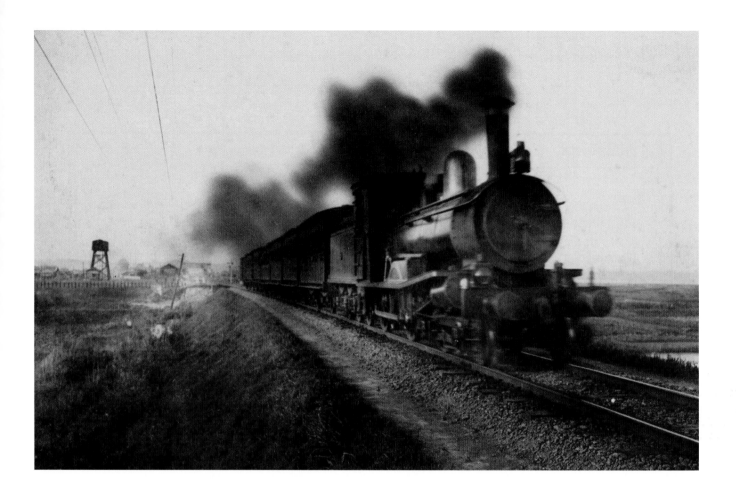

The lack of running number on the smokebox door and the small corporate *mon* on the side of the tender identify the locomotive heading this express as a Nippon Tetsudō 4-4-0. It is possibly a Beyer-Peacock product judging from the maker's plate over the splasher, although it is difficult to discern whether this is a member of what would become IJGR 5300 or 5500 class upon nationalization. The view is at an unidentified location along one of the Nippon Tetsudō's lines.

his employment there. Purcell was left in the dark as to many details, even as to whether the line would use horse or steam motive power, but was advised rather vaguely to build a line with bridges that could support the weight of a 20 ton locomotive. (He began work at least by the end of August.) Such was the nature of working on the early projects in the first years of Meiji, when projects launched with less than rigorous study and planning, and revisions were often the order of the day.

October 1877 saw a flood that destroyed a quarter of the line's work, "the most costly quarter" as Purcell described it. By November, bridge spans had arrived and were being placed for the line's third bridge. Later in the month a hoisting engine had arrived and was satisfactorily tested. By January 1878 work had progressed up to the pilings for Bridge No. 4, and later, spans arrived for Bridge No. 2. In the midst of this, Purcell lards his diary with references from his co-workers complaining that the furnace was situated in a bad location and that the dimensions for the mill drawings were wrong, and with his own complaint of significant delays in delivery of railway materials. By March 1878 work was progressing on Bridges Nos. 1 and 5 but as late as April 1878 the final location of the right of way was still being "settled." By July, Purcell was complaining to one of his Japanese supervisors that at

the present rate of progress, it would take an additional 2½ years to complete the railway and 50 more masons from Tōkyō (to aid in building bridge abutments) were promised. It had been decided in Tōkyō, apparently without consultation with Purcell, to order steam locomotives for the line. When Purcell got his first look at the drawings and specifications for the locomotives on August 29, 1878, he didn't like them and was of the opinion that they were not of a type suitable for the road he was constructing: evidence of bureaucracy at the Department of Mines ordering equipment for a project without determining the actual needs *in situ*. By November 1878 the initial tests of some of the machinery for the furnaces had been conducted and Bridge No. 7 was started the next month.

Finally, on January 28, 1879 a schooner arrived from Yokohama with the steam locomotives that had been transshipped from a steamer arriving there around the 18th (coastal shipping of the time was predominantly by sailing ship) and planning began for off-loading. It is hard to appreciate today what the arrival of a schooner-shipment of steam locomotives entailed at Kamaishi in 1879. A watercolor done by Purcell shows only a rudimentary quay at Kamaishi alongside which the schooner could moor, with no permanent hoisting cranes. The locomotives would have been hoisted from the schooner by means of improvised beams or improvised cranes and the "hoisting engine" of which Purcell spoke; landed ashore by might and muscle alone. By February 8th, adequate preparations and equipment—tackle, beams, pulleys and lines, skids, jacks—had been made and assembled for off-loading. Almost immediately disaster struck when the first locomotive was dropped over the side and lost into the har-

bor, taking one of the coolies with it and drowning him. By the 11th, the second locomotive was carefully and successfully landed. Thereafter, the first was successfully salvaged from the harbor with a method Purcell was forced to improvise, by lashing two boats together a beam's length apart with a winch in each boat, using divers to hook chains to the submerged locomotive, and hoisting it bit by bit, with nothing more than the two winches and sheer muscle. The body of the unfortunate coolie was found pinned under the locomotive frame. The first locomotive was finally brought ashore on the 13th. In all, the task of unloading two very small, toy-sized tank locomotives[3] consumed more than a two weeks of preparation, planning and effort. March saw the appearance of a fine new pump car or handcar for Purcell's use and he gleefully reports on the 21st that he obtained a speed of 12 mph on its first test. At the very end of April the first engine driver reported for duty and "loco coal" arrived.[4] By June one of the turntables was in place, and had passed tests. The next month saw the arrival of an inspection delegation from Tōkyō who pronounced themselves satisfied with the railway.

Apparently, there were continued disagreements between Purcell and his supervisor, Mōri Shigesuke ("Jusuke").[5] Mōri was the Chief Engineer of the Kamaishi project and later was to become the Deputy Chief Engineer of the IJR, but, judging by some of Purcell's entries, he was also the bane of Purcell's existence. Things had deteriorated so much between Purcell and his superiors on the little Kamaishi line that at one point Holtham was sent out to review matters and report what was amiss. He went north (on one of the government ships that Brunton was chronically

This view presumably shows Chūō-dori, the "Main Street" of the Ginza district, in Tōkyō in the 1880s, after the Tōkyō Basha Tetsudō (Tōkyō Horsecar Railway) had come into existence in 1882, but before electrification of the line and introduction of trolleys in the 1903. Note that the double roof construction has been adopted for the domestically-produced tramcar. The first route ran from Shimbashi Station, through Ginza, to the famous Nihonbashi bridge (the "zero milepost" of Tōkyō) and was later extended thence to the Nippon Tetsudō's terminus at Ueno, linking the two major railway stations of the Capital. The world-renowned Tōkyō metropolitan transport system grew from these relatively modest beginnings.

complaining were being taken from him) in the autumn of 1879, at the doing of Purcell, to inspect the line and to judge whether to condemn one of the new locomotives.[6] The ministry gave him a mandate to inspect the entire line, the works, mines, etc. Instead of condemning anything and coming to Purcell's rescue, Holtham wrote that he "blessed them all … and left them to quarrel among themselves as to whom… they should blame for all mishaps." One imagines Holtham concluded that there was adequate blame on all sides of the acrimony and from what one can discern, not much was resolved.

Misfortunes continued. The shops burnt down in October 1879, followed by flooding. There were numerous earthquakes encountered, with the expected resultant damage. The "gantry" (crane?) they were in the course of building was blown over in a gale. One of the ships carrying rolling stock for the line foundered in December 1879 on the voyage out from Yokohama. The workers could be problematic. On the day Bridge No. 16 was opened, one particular worker thought it amusing that he could out-run one of the slow-moving construction trains, jump in front of it, and then jump aside laughing before being overtaken. Evidently he was un-

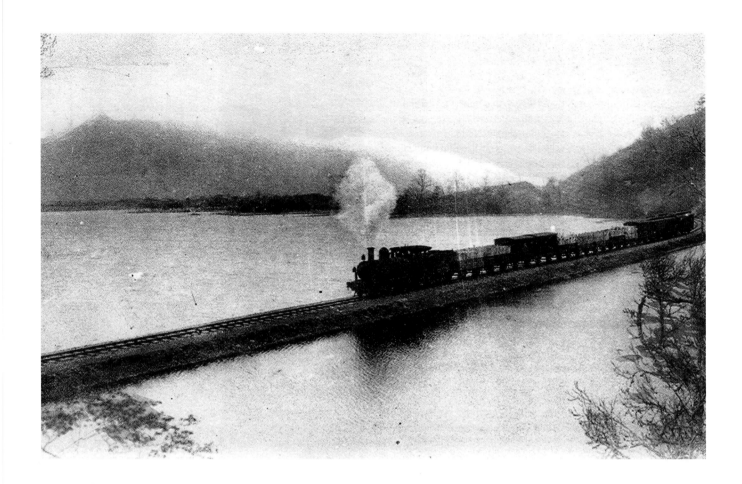

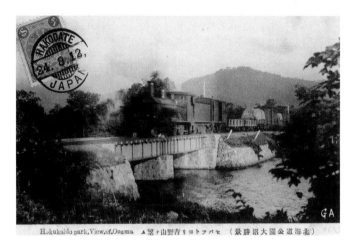

Hokukaido park, View of Onuma　　▲望ヶ山野古リヨトツバセ　（景勝沼大園公道海北）

The first section of the Hokkaidō Tetsudō, which was projected to run from Hakodate to a junction with the Hokkaidō Tanko Tetsudō at Otaru/Temiya, was opened in 1903 and included among the works a causeway across Lake Ōnuma, destined to become a part of Ōnuma National Park. With completion of the line to Otaru, the shortest feasible rail ferry service was inaugurated between Hakodate and Aomori on Honshū. In this view of the Lake Ōnuma causeway, a British Mogul E4 or 7700 Class steams by with a mixed train, while Mt. Komagatake looms in the background. The Hokkaidō Tetsudō's mogul class was one of very few classes of Beyer-Peacock British-built locomotives to be used on Hokkaidō, which remained almost exclusively rostered with American locomotives until Japanese-built examples replaced them. Note the by-then quaint practice of locating the marker lamp at the side of the boiler rather than atop the buffer beam. This view became a favorite of photographers, and would be replicated on other occasions in other times with more modern locomotives.

A closer view of another E4 mogul at the head of a freight train as it comes off the causeway, posted on August 24, 1912 after nationalization. The route of the former Hokkaidō Tetsudō was almost from the moment of opening a busy one, as it was the most direct route for all goods and passengers bound for Honshū.

that, with this tunneling, it would take ten years to complete the line via the Usui pass, at a cost of ¥100,000 per mile as compared to ¥70,000 per mile via the Tokaidō alternative.

One scholar neatly summarized the situation that Japanese civil engineers faced:

"Owing to the character of the land (mountainous regions, possibility of earthquakes), railway substructures, as well as the superstructures, are very costly. The difference between different regions is very striking. Whilst in level regions the cost of railway construction amounts, on an average, to 70,000 yen per mile, the cost on some mountainous sections (for instance on the Chuo line) is as high as 250,000 yen per mile. Some of the railway bridges have cost as much as three million yen. The large number of tunnels and cuttings, as well as the necessity of constructing supporting walls in order to prevent the occurrence of landslides, combine to render the cost of construction of railway lines in Japan very high."

The steep grades planned for the line would have rendered average speeds on the line intolerably slow, and in actuality there was little hope for any traffic to be generated along some parts of the route, with the exception of logs brought down from the

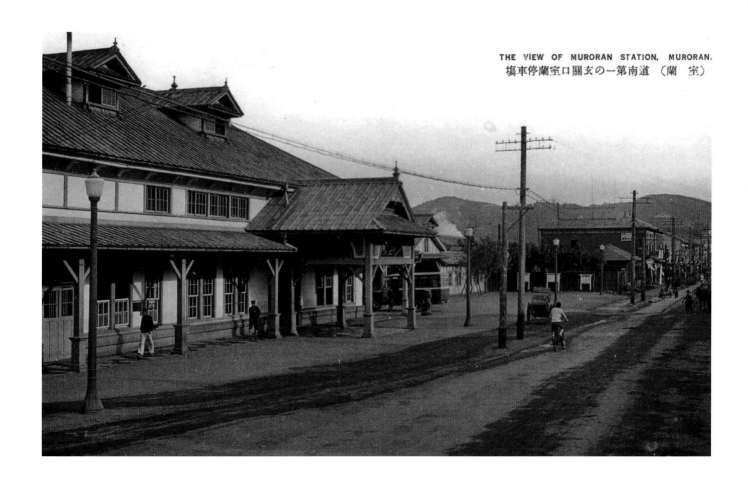

mountains, whereas the Tokaidō route would run through the population centers of Nagoya, Shizuoka, and Hamamatsu, bringing with it the promise of much more significant traffic returns. Moreover the cost of operating locomotives along a mountainous line was significantly more than the operational costs of a coastal line. IJGR engineer Minami Kiyoshi (1856–1904), who conducted the first survey of the Usui line the prior year, had plotted a line with gradients of 1 in 10, which is far too steep for conventional railway operation. Minami recommended that on these gradients, a rope hauled "funicular style" railway, similar to those employed today for ski lift railways, be employed, which would of course have meant for slowness of operation as arriving trains on one side would have to be uncoupled from the locomotive, broken up, hauled over the incline in segments, let down the other side, and then re-formed into trains to be hauled on by a waiting locomotive from a stable that would have to be kept in waiting at the other side. Another alternative was to build a single line in series of "switchbacks", formations of railway lines up the sides of the mountain in zigzag fashion that resembled a series of the letter "Y" laid on its side in ladder-like succession with the base of each "Y" forming a rung of the ladder pointing outwards, alternatively in opposite directions, requiring that trains reverse themselves back and forth and "switch back" above the line they had just ascended upon. As this was to be the principal railway line of the nation, the projections of the amount of traffic that would pass over these zigzags was substantial. Even before the railway, the pass was a major route for transporting rice and other staples from the hinterlands to Tōkyō, and some 300 people per day were making their way across it by foot, rickshaw, *kago* sedan chairs, or

Muroran was another of Hokkaidō's ferry ports, much closer to the mainland than Otaru, from which one could depart to Honshū, and its station (opened in 1892) was larger than average perhaps to accommodate increased traffic levels because of this. The view here shows the station in the 1920s, when a local bus can be seen parked just beyond the main entrance in the station forecourt.

horseback. This fact made it clear that the result of building such a line would have lead to chaos.

The safety, scheduling, and logistical disadvantages of either option were staggering from an operational point of view. Faced with these realities, the wishes of the military were overruled, and the decision was made in July 1886 to re-route the railway along the Tokaidō. Except for a detour over the Hakone Pass, the line roughly followed the original Tokaidō route as far as Nagoya, and thereafter took the ancient Minō-dō from Atsuta near Nagoya to Ōgaki. Despite the fact that the Tokaidō route to Ōgaki was 368 miles compared to 220 miles from Takasaki, there was a 13% savings in the total cost of construction, due to the fact that less of the line had to be built through mountainous terrain. Part of the savings was immediately earmarked for building a segment of the Kotō Line (*East Lake Line*) around the eastern shore of Lake Biwa to do away with the necessity of transferring loads and passengers from trains to lake steamers and back between Nagahama and Ōtsu. Even with the cost of the Kotō line added, the selection of the Tokaidō over the Nakasendō route amounted to a 10% savings, which made the decision to build a branch line from Ōfuna, a new station on the Tokaidō, to Yokosuka, then the most important naval base in the realm, much easier to make, and the additional branch that would greatly facilitate military supply was authorized in 1889.

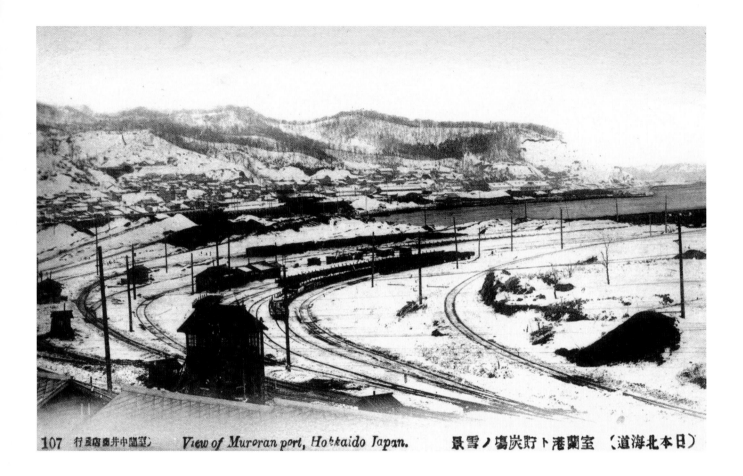

107 〔望遠中井庄府県行〕　*View of Muroran port, Hokkaido Japan.*　室蘭港ト貯炭場ノ雪景　〔日本北海道〕

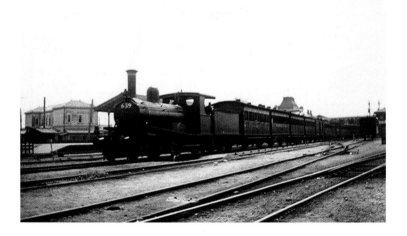

The rail yards of the harbor proper are shown in this winter view of Muroran, which evidences its importance as a port in Meiji times. Between 1892 and completion of the Hokkaidō Tetsudō (linking Otaru with Hakodate) in 1905, Muroran was the closest port to Honshū served by Hokkaidō's railway network. That period would be Muroran's golden age for coal transfer and passenger ferry service.

When the first section of the IJGR-built Tokaidō line opened in 1889, it was operated with a fleet of British built 4-4-0 tender locomotives able to handle longer and heavier trains than the 2-4-0T and 2-4-2T tank locomotives that had hitherto been the typical IJGR locomotives used in the Tōkyō area. These new locomotives were part of a long line of British 4-4-0 tender locomotives that would dominate long-distance operations in Honshū for a decade, starting in 1883 when the first examples were imported for the Takasaki line. Shown here in a photo taken before 1904 is No. 639, one of the later such 4-4-0s, the D9 or 6200 Class, a Neilson product dating from 1897, handling a long train of 4-wheel stock. The location is unknown, but the station roofline visible above the third carriage leads one to suspect it may be Ōsaka Station.

The new route of the long-desired grand trunk line branched from the Shimbashi–Yokohama line just before Yokohama. A new station was built on the mainline near the junction, which became the present day Yokohama station. The original Yokohama station was renamed Sakuragicho. In 1887, only a year after the decision to stop work on the Nakasendō route, the westbound portion of the Tokaidō had worked itself westward to 'Kodzu' (as the Victorians often spelled the name of the town *Kōzu*), while the eastbound line from Ōgaki had reached Hammamatsu, leaving a gap of only 120 miles. (In this same year, the first mechanical interlocking signal device was installed at Shinagawa, a notable step towards introduction of safety measures to the system.) The remaining gap was closed on April 16, 1889, and with the completion of the Kotō rail section around the eastern shore of Lake Biwa, shortly thereafter, the disparate rail systems had been linked and Japan at last had a *contiguous railway network*. Just prior to the final completion of the line on July first 1889, Inoue met a number of his colleagues in Nagoya to celebrate the attainment of the 1,000 mile mark for Japan's railway system.

Construction of the Tokaidō line went at a quicker pace than

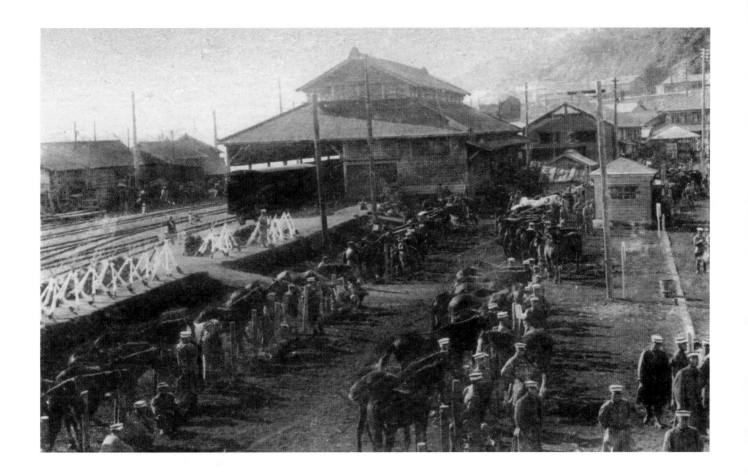

Bird's eye view of Muroran port. （其一）北海道室蘭港全景

Between October 21 and November 3, 1904 during the Russo-Japanese War some 35,000 soldiers and 5,000 horses of the Japanese Army's 7th Division passed through Muroran on the way to the front where they would be decimated in the final assaults on the soon-to-be legendary 203 Meter Hill, the capture of which proved to be the key to the fall of the "Russian Gibraltar" at Port Arthur. Although undated, it is believed this photo shows part of those troops before that fateful encounter, with white rifles neatly stacked along the loading platform of the Muroran freight station, and gives a good view of a rather substantial freight station (by Meiji standards) built to withstand the harsh Hokkaidō winters and to accommodate the traffic associated with Muroran's status as a port for transshipment of goods to and from Honshū. The horses have perhaps just been off-loaded from the train seen under the station roof.

The raison d'être for a railhead at Muroran is obvious in this photo, showing mound upon mound of coal in the sidings at right leading to the railway's coal-loading pier that is just visible beneath the stamp. The coal has piled up apparently even before the station has been completely finished, evidenced by the fact that the station turntable in the foreground is still under construction. This would seem to date the photograph to around the time the station was nearing completion.

had been estimated. Perhaps this put the IJGR in the unenviable position of not having adequate coaching stock for the new line at a time when its shops were working to capacity, and undoubtedly the IJGR took the opportunity to evaluate foreign examples. The result was an order for 60 new passenger carriages from the United Kindgom placed so as to have adequate rolling stock on hand in time for the opening, based on an earlier 1875 non-corridor bogie stock design. The first bogie carriages imported from Britain in 1875 had no corridor connection between, or indeed even within them. Once a passenger was seated in a carriage com-

partment, he or she was obliged to stay there until the next station stop, as there was no means of walking to the next compartment or carriage. This design was copied by Shimbashi and Kōbe carshops from 1876 to 1887. With the 1889 design, the carriages were at last updated to provide corridor communication within the carriage itself, but not between carriages. As these carriages were designed for long-distance services, they were also fitted with lavatories, the first such use beside the American-built passenger cars of Hokkaidō. The carriages ordered were equipped with the obligatory tropical double roof, ran on two four-wheel trucks, and were

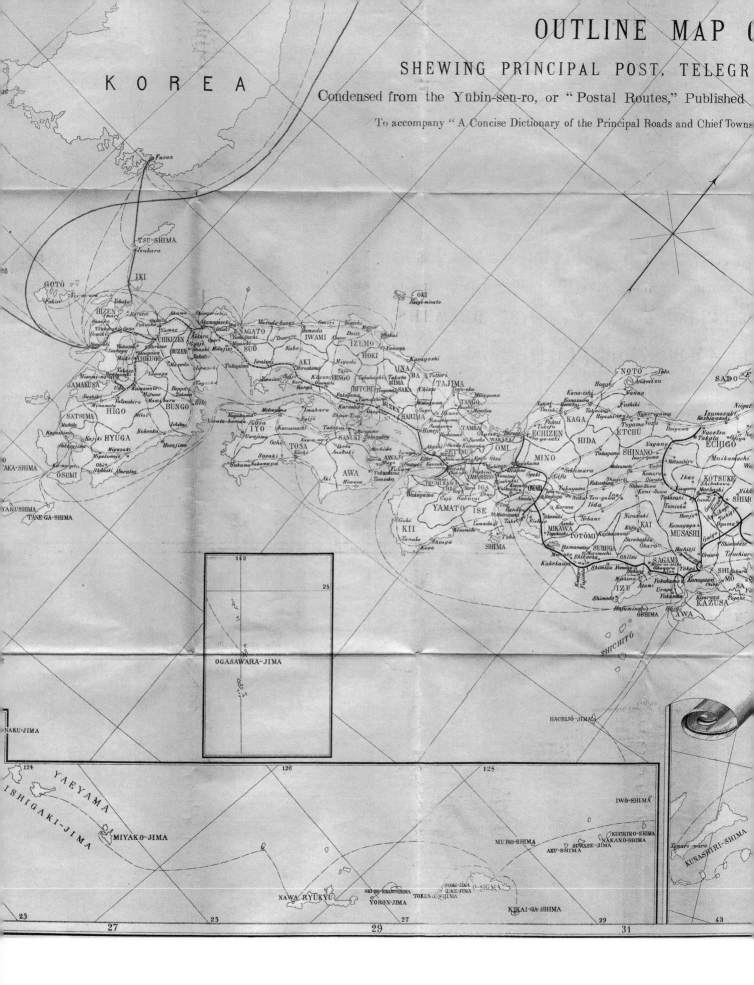

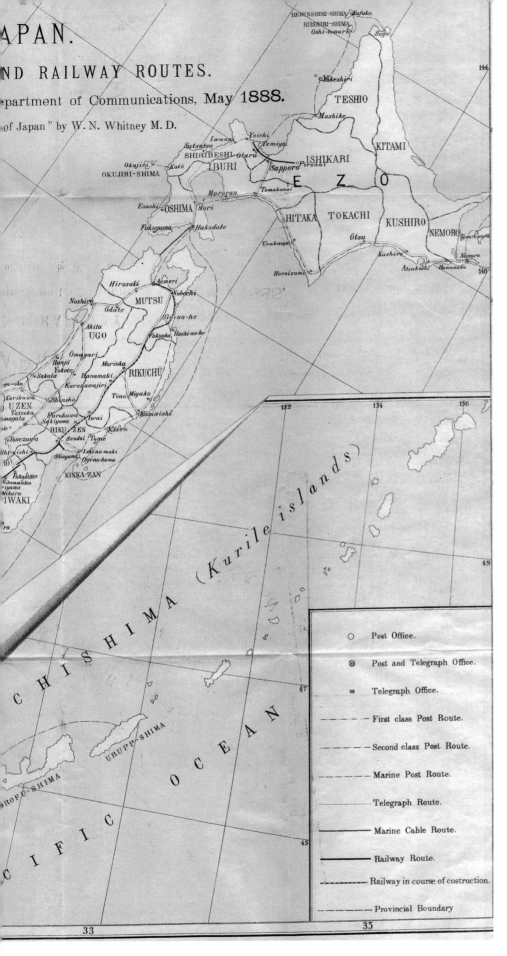

Map legend:

○ Post Office.

⊚ Post and Telegraph Office.

▣ Telegraph Office.

‒ ‒ ‒ First class Post Route.

········ Second class Post Route.

————— Marine Post Route.

————— Telegraph Route.

————— Marine Cable Route.

————— Railway Route.

————— Railway in course of costruction.

————— Provincial Boundary.

46½ feet long—certainly longer than anything operating on Honshū at the time, and exceeding the American coaches of Hokkaidō, which up to that time had been the largest carriages operating in Japan. Originally, two lavatories were placed in the center of the body, one opening only to one side of the carriage, and the other opening only to the other side, effectively dividing the carriage into two large common compartments between which there was no means of communication. Later, these came to be placed at each end. Their introduction gave cause for further adjustment of the social customs of the day. Initially, the traveling public simply declined to use them while the train was underway, with the result being a mad rush during station stops, and the right-of-way at stations became unbearable for the stench. (The lavatories emptied directly onto the tracks below, as was often the case worldwide even into the 1970s.) A speedy public education campaign was put in place instructing the public that it was forbidden to use the lavatories while trains were stopped in stations or along stretches of line abutting populated areas.

From that point forward, two passenger carriage standards came to be used by the government car shops at Shimbashi, Kōbe, and Nagano: the first being a 23 foot long rigid wheelbase four-wheel compartment carriage, in the English style for short haul services (curiously, the 6-wheel carriage with axles at either end and one in the center that was in vogue in the UK and Europe at this time never gained any real currency in Japan, probably due to cost factors) and the second being the 46½ foot long pattern carriage (or subsequent variations) riding on two four-wheel trucks of 5 foot wheelbase to serve in long distance trains. The four-wheel design however entered into a period of very gradual eclipse. Although construction of 4-wheel carriages ceased in 1913 on government lines, as late as 1929, 30% of the coaching stock in Japan was of the 4-wheel variety. Were it not for their cheaper building costs, their day might

Dating from May 1888, this map shows the extent of the railway system as projected upon completion of the Tōkaidō main line between Tōkyō and Kyōto/Ōsaka, before the final segment around the eastern shore of Lake Biwa had been completed. The Nippon Tetsudō had reached Sendai to the north, while the San'yo Tetsudō had only reached as far as Himeji to the southwest. The only railways showing on Shikoku and Kyūshū are projected lines. The Poronai Tetsudō is the only railway on Hokkaidō.

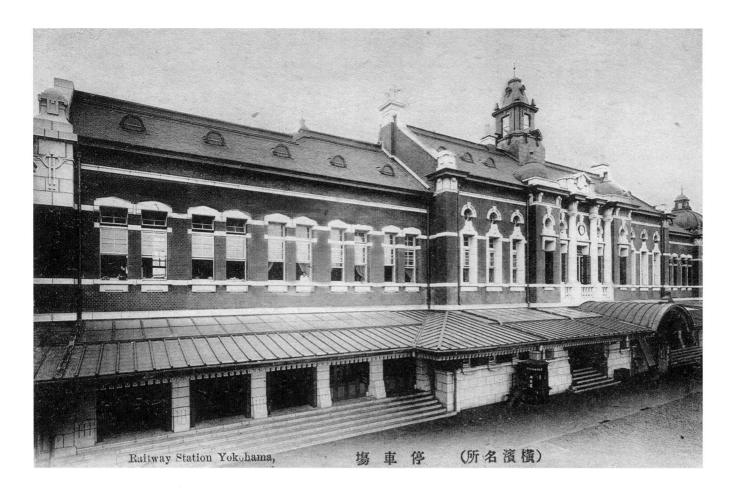

Railway Station Yokohama, 場 車 停 （所名濱橫）

(above)

The alignment of the Tokaidō line was such that it diverged from the original Shimbashi line just after Kanagawa, rendering the remaining portion of that line into Yokohama a branch. A new station for Yokohama was built on the line at what was then the north-eastern edge of town. Upon completion, the new station, shown here, took the name Yokohama, while the original Yokohama station was renamed Sakuragicho station, giving Yokohama the luxury of service from two stations, which was a rarity in Meiji Japan. Both stations were destroyed in the Great Kantō Earthquake of 1923.

(opposite below)

With the opening of the Tokaidō line in 1889, the IJGR put into service a fleet of new passenger cars, 46½ feet in length, running on two four-wheel trucks or bogies for the long distance service, which became a standardized design. Shown here is the third class version of one of them, stopped at an unknown station on a brisk, sunny day, circa 1900. With the introduction of these carriages, the short-wheelbase 4-wheel British compartment car started into a gradual eclipse. Note lamp pots on the roof. Japanese coaching stock adopted the British practice of keeping lamps at stations, and at dusk, a man would walk along the roofs of a train stopped in a station, while another station hand with a cart of lighted lamps would throw them up to the lamp man, who would open the lamp-pot cover and lower them into the car below. The gentleman at far left in the bowler hat looking toward the camera is more likely than not William Barclay Parsons, father of the New York City subway system, as the photo is from his book *An American Engineer in China*.

have ended sooner. Japanese passenger cars during most of the Meiji era were thoroughly utilitarian vehicles, as would befit a developing economy. Most were painted and furnished very plainly; other than first class, even spartanly. It wasn't until the final days of Meiji that this began to change.

Due to the narrowness of the car bodies necessitated by the narrower Japanese gauge, the seating arrangements of third class bogie carriages running on the IJGR and Kansai Tetsudō seem unusual by today's standard. Either two long longitudinal banquette style bench seats ran the length of the car or normal transverse seating for two persons the entire length of the car along one side, an off-center aisle, (and because the car body was not wide enough) on the other side of which was one banquette style bench seat the whole length of the carriage. Passengers in Meiji Japan often rode facing sideways to the direction of travel. Foreign travelers of the day noted a curious design feature. The seats of these carriages were deeper than expected, in order to permit of sitting cross-legged fashion upon them, in the Japanese manner. To insure that passage down the walkway was not impeded, some carriages had a white line drawn on the floor, beyond which the pas-

sengers were forbidden to allow their feet to protrude, on pain of stern reprimand from the train crew. Both designs were crowned with the idiosyncratic Japanese double-roof to aid in cooling during the hot summer months. Due to the IJGR car shops initial hegemony in rolling stock building at the time, these two designs became the *de facto* standard for many private railways.

The Tokaidō line was completed on July first and ready for official inauguration in August, 1889. In officiating over the inauguration of the Tokaidō line, the Emperor was called upon to open what was probably the most important line of railway from that point forward until the opening of the Shinkansen (*lit.* "New Trunk Line") high-speed service in 1964. At opening, there were a number of passenger trains daily along parts of the line, but only one through train each day in each direction that ran the entire length from Tōkyō Shimbashi to Kōbe. The trip along the entire 376 miles was scheduled at 20 hours and 5 minutes by that train.

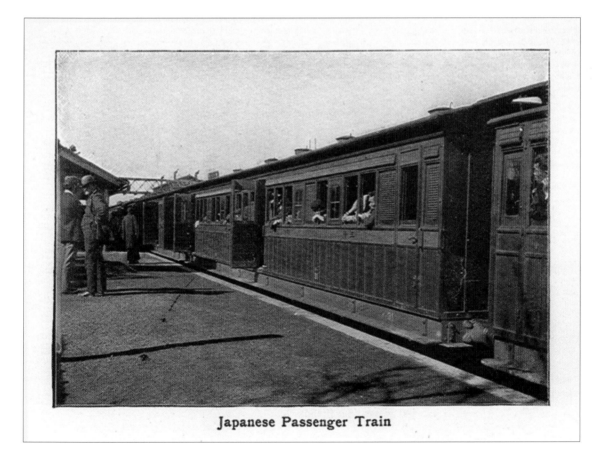

Japanese Passenger Train

(above)
This view, taken in the 1920s, shows the interior of a late-Meiji Japanese passenger carriage, probably second-class, with transverse seating due to the narrow loading gauge. Many of the cars were said to have had a white line along the floor, beyond which passengers were forbidden to allow their feet to protrude in order to keep the center aisle clear for passage.

景の寺見清

(top left)
The Tōkaidō main line skirted the temple precincts of the Seiken-ji temple near Okitsu, in Shizuoka Prefecture. The town became a celebrated winter resort with prominent Japanese. In this view a short passenger train piloted by an unidentified 4-4-0. Warning signs mark the crossing that provided access to a stone stairway leading up to the temple that is not visible in this view.

(middle left)
This IJGR express train is headed by what is probably a Schenectady-built D-12 class 4-4-0 as it steams past Fuji seen at Iwabuchi in this view from the turn of the 19th-20th Centuries.

(bottom left)
Growing crops are indicative of midsummer in this view of a passenger train of 4-wheel stock steaming past Mt. Fuji on the Tōkaidō line.

(bottom right)
Another classic view of a train with a British 4-4-0 and some of the earliest IJGR corridor stock introduced around the turn of the century. The view is taken from the mouth of the Numagawa river.

(opposite top)
The IJGR's Tokaidō mainline is shown here later, after the segment shown has been double tracked with Mt. Fuji looming in the background. An unidentifiable mixed train steams past some of the local farmland. This hand-colored scene, from an old glass transparency, probably dates from the closing years of the Meiji reign.

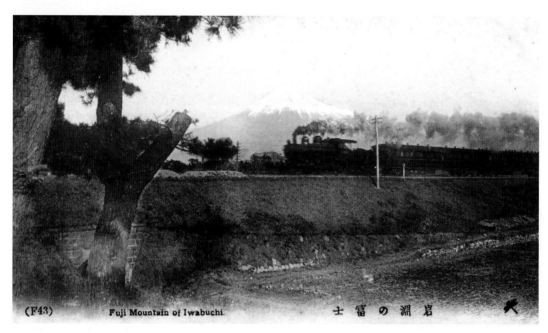

(F43) Fuji Mountain of Iwabuchi. 士富の淵岩

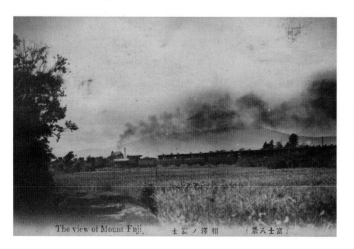

The view of Mount Fuji. 士富ノ澤相 (景八士富)

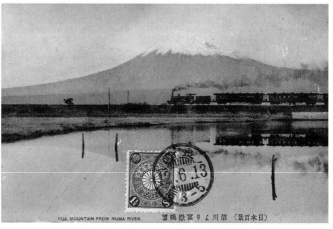

FUJI MOUNTAIN FROM NUMA RIVER. 望眺嶽富りよ川沼 (景百本日)

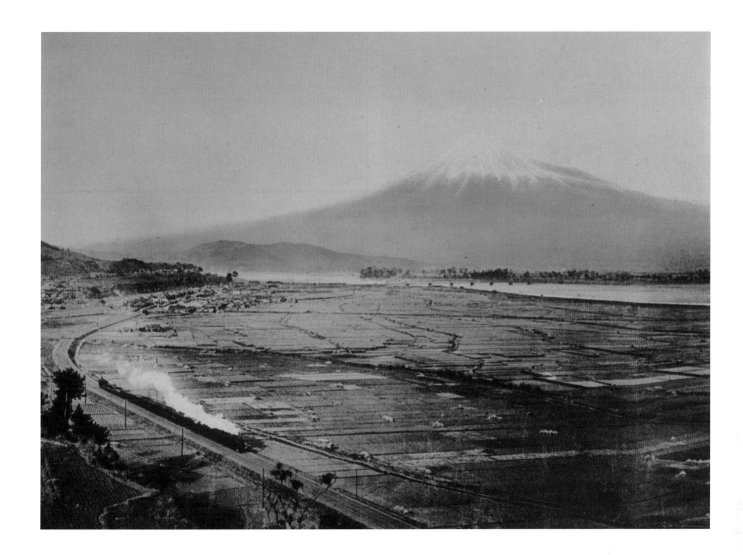

if other foreign powers followed the US lead. Sir Harry Parkes was soon ridiculing it and the British refused to entertain revision discussions, effectively killing the US treaty. It took the British another sixteen years to be convinced. The treaties that finally started the transition, with weight of both American and British backing, were concluded in 1894 and were to take effect in 1899, ameliorating an issue that had long been a sticking point domestically among the Japanese.

Of course, the opening of some 300 miles of new railway line necessitated not just rolling stock, but also additional locomotives to operate on it. British locomotive builders were at this time fast approaching the limits of their capacity. Order books were full or close to full, backlogs were beginning to be increasingly frequent, and delivery times were suffering. For British locomotive manufacturers, their reputation of building a product that was unrivalled worldwide had hitherto not seriously been challenged, and British builders had enjoyed a *de facto* monopoly on the Japanese locomotive market in Honshū, while the American builders enjoyed a similar situation in Hokkaidō. Indeed, Japanese locomotive orders were keeping some British builders quite busy: Nasmyth, Wilson for one, which provided many of the ubiquitous A8 class locomotives. Japanese purchases from that firm, although they only spanned a 22-year period from 1886 to 1908 when the last order was placed, accounted for no less than fifteen percent of

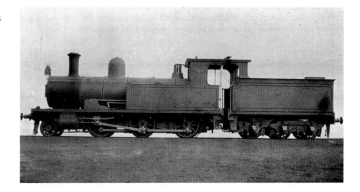

The region between Nagoya and Ōsaka was the center of the Kansai Tetsudō's activities, and when it completed its route between the two in 1898 as a result of building and merger, it provided the IJGR with its first real competition, as the Kansai's route was also shorter. It became a kind of "people's choice" vehicle through which dissatisfaction with government policies could be channeled. Political symbolism aside, the dozen class members of this Dubs-Kansai loco is built not exactly the standard government fare either. The protective cab extension over the tender is unusual among any locomotives running in Japan in that day and must have come as a welcomed feature to the fireman in inclement weather. Unusual too is the wheel arrangement under the tender. This "1+truck" configuration of one fixed forward axle and a truck under the rear is the wheel arrangement that the vast majority of American tender locomotives in Japan sported. Most British tender locos had six wheel rigid plate-frame tenders. On nationalization the class would be designated 7850.

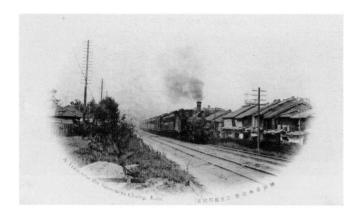

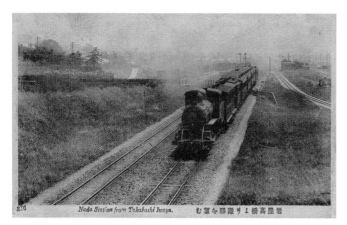

Nada Station from Takabashi Iwaya. 岩屋高架橋より灘を望む

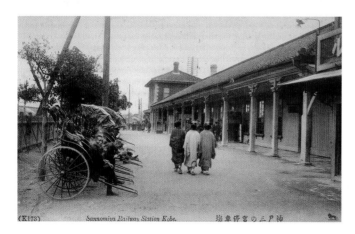

(K173) Sannomiya Railway Station Kōbe. 神戸三ノ宮の停車塲

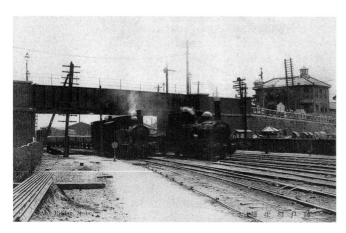

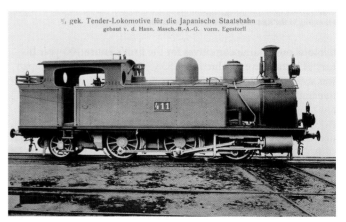

½ gek. Tender-Lokomotive für die Japanische Staatsbahn
gebaut v. d. Hann. Masch.-B.-A.-G. vorm. Egestorff

(top left to bottom)
A view of an IJGR express train making its final approach to Sannomiya Station in the vicinity of Kōbe with a mixed lot of coaching stock in the earlier times when the right-of-way crossties or sleepers were kept covered in ballast. Compare with the ballasting in the later Sannomiya departure scene shown on the opposite page.

The signals are off as an IJGR Kōbe-bound passenger train is seen leaving Nada. As the train appears to be on a slight upgrade, but only smoke, not steam is seen exhausting from the locomotive (possibly an IJGR 6400 class 4-4-0), one assumes it is a hot, humid, hazy day. Nada is on the IJGR line between Ōsaka and Kōbe, just prior to Sannomiya, and the surrounding area has long been noted for producing exceptionally fine sake. In 1905, with the opening of the Hanshin Denki Tetsudō, an all-electric railway between Ōsaka and Kōbe, Iwaya would become the name of the competing station next to Nada, where the lines ran parallel. Soon the clean, silent electric trains of the newcomer would be proving stiff competition for the sooty steam-hauled government trains.

Sannomiya Station was one of the original stations on the Kōbe–Ōsaka line, and was probably around 20 years old when this photograph was taken. The local rickshaw runners waiting for the next arrivals pass the time with a smoke as three maids pass by in a scene evocative of Gilbert and Sullivan. The foreign settlement was centered around Sannomiya, and many an unseasoned Western tourist bought through tickets for Kōbe, only to learn on arrival that the hotel where reservations had been made was situated one station back the line.

By late in the Meiji reign, the locomotives that had served for primary duties but had been rendered unfit for such trains due to increasing train weights and distances were relegated to local, branch line, so-called "pick-up freight", or yard duties. Two such examples are shown here leaving the station yard in Kōbe, which lies just beyond the bridge. To the left, what appears to be one of the first 2-4-0T tank engines (possibly bearing running number 4 on its smoke box door under the pre-1909 numbering scheme), which appears to be stopped with a short train of one boxcar and a brake van. The other (possibly number 103), running through with a short train of 4 plank open wagons, is one of the popular A8 class. The location is at the Aioibashi (the bridge spanning the lines) in the heart of Kōbe. Were it not for the line of rickshaws parked behind the wall at the far right and the slightly awkward cupola on the local corner shop, the scene might be mistaken for one in any large city in the north of England.

(below)
This photograph shows one of the long-lived B6 Class locomotives (Classes 2100, 2120, 2400, and 2500 under the 1909 scheme) as built. The B6 was by far the most numerous class of its time (no less than 528 were built) and came to replace the lighter A8 class as the workhorse of mid-Meiji railways in Japan. They served on passenger and freight trains alike, on both branch line and main line duties. They were built by Dubs, Sharp Stewart, North British, Henschel, Hannover, Schwarzkopff, Baldwin, and Kōbe Shops. This particular example is one of the Hannover class members. Dubs built the bulk of the class at 268 members. Except for the boiler-mounted (forward) sand dome and the air compressor behind the chimney, the locomotive has a typical British appearance.

(opposite)
A IJGR down train departing Sannomiya Station for Kōbe (the next station) probably in the early 1900s. The flat topped steam dome and sand dome with the running board flush with the top of the slide valve chest identifies this locomotive as a D11 or 5160 Class American-built Brooks 4-4-0. These classes were introduced in 1897. The red stripe along the train side indicates it consists of third class carriages. Box cars are unloading at the freight station to the left of the main line. Barely visible in the foreground are crossing guard's or switchmen's huts, another British convention.

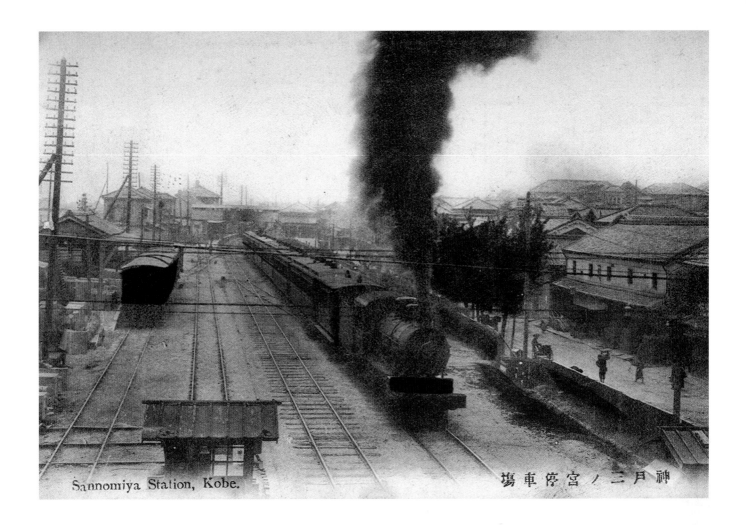

Sannomiya Station, Kobe.　　神戸三ノ宮停車場

no longer had the Japanese mainland as their exclusive market.

Once it became apparent that the government was adopting the policy of authorizing private joint-stock companies to build and operate railways, schemes started to be proposed that were not only for grand-scale trunk lines such as the Nippon, but also for small branch or feeder lines. The New York Times noted as early as August 7, 1881 that even Buddhist monks from one locality were actively helping to promote an extension of the railway from the Tsuruga terminal northeasterly to Kanazawa, which would have benefited pilgrimage traffic to their temples. Another proposal was for a line to be named the Hankai Tetsudō from Ōsaka southwards to Sakai, a distance of only 7 miles. It was authorized in 1884, and would have been of little historical significance were it not for bargain equipment and materials in the form of the abandoned stock of the Kamaishi railway which the promoters had snapped up at used prices, and brought to Ōsaka. With the failure of the Kamaishi railway, its equipment had been on the used equipment market. The locomotives, rolling stock, rails, and railway related plant such as turntables were dismantled, and the lot was shipped to Ōsaka. (The Hankai bought only two of the three Sharp-Stewart tank locomotives: the other was bought by the Mitsui Company's Miike coal mine railway.) The Hankai line was a passenger carrying line, and was an unqualified success, soon grossing more revenue per route mile than any other railway in the realm, although it was less than seven miles long. Its success was largely due to the fact that its route passed close-by Sumiyoshi

Temple, one of the great tourist and pilgrimage destinations of the area and by the end of 1896 was carrying 1,100 passengers per route-mile per day. Two new locomotives were hurriedly ordered from Germany. Unfortunately, the Hankai gave rise to an entire system of narrow-gauge railways in the Ōsaka vicinity, raising the spectre of all the evils and inconveniences associated with a break of gauge and a dual gauge railway system. Thus on completion of the tiny Hankai, the seeds were sown for a dual-gauge system of railways around Ōsaka, which exists to this day.

Around the time that the Hankai Tetsudō was in its first years of operations, the government's construction of the Nippon Tetsudō line had edged its way northward from Utsunomiya, past Shirakawa, to Koriyama, then Fukushima, and had reached Sendai, a major northern city, a distance of 217 miles. The line was opened to Sendai in 1887 and thereafter work was pushed northwards to Aomori.

On other fronts, in 1888 a charter was granted for a railway to run a trunk line southwesterly from Kōbe, where it had been granted running powers over the approach to the IJGR station, to the port of Shimonoseki at the very southern tip of Honshū. The railway was named the San'yo Tetsudō. *San'yo* is a term borrowing from the Chinese philosophical concept of *Yin and Yang* meaning roughly "the Yang [i.e. sunny] side of the mountains" and is the name of the geographical region of the Honshū seaboard southwest of Ōsaka/Kōbe which borders the Inland Sea. In terms of route miles, the new undertaking was on roughly the

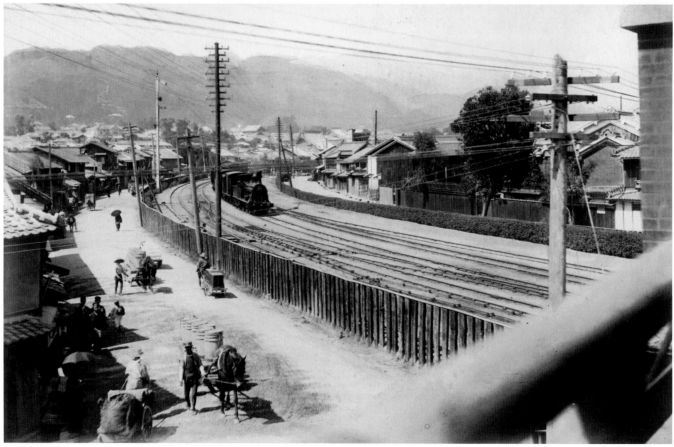

(opposite above)
This and the following two views trace the gradual development of the IJGR and the city itself in the Aioibashi area in Kōbe, as seen from the Aioi bridge. This early view probably dates from the late 1870s, when the neighborhood was essentially residential, the city had yet to be electrified, and the only overhead lines to be seen were the railway telegraph, with a pole sporting a traditional lotus bud finial (a quaint but unnecessary luxury). Notice the trailing crossover configured for left-hand running in the British fashion, the unpainted board and batten roof on the switchman's hut in the bottom left, and again the ballasting and ballast profile that approach utter perfection. The steeply pitched roof of the Zenpuku temple can be seen to the right of the telegraph pole.

(opposite below)
In this intermediate photograph, a mixed train headed by a neat British locomotive steams its way along the same stretch of track in a busier time of later Meiji, probably the late 1890s. Note the appearance of electric lines in comparison to the foregoing photograph and the wooden semaphore signals perched on a very high signal post to enable them to be seen over rooftops from well back along the curvature of the line. The station approach has become quadruple-tracked by this point. The locomotive carries running number 44 on the smokebox, and in profile is easily identifiable as one of a small class of six Kitson-built 4-4-0 tender locomotives of 1876 vintage (designated Class 5130 in 1909); copies of the 4-4-0 re-builds of the first Kitson 0-6-0 tank locomotives.

(top right to bottom)
Finally, this view shows Aioicho-dori (dori means street), most likely in the years just prior to Nationalization in 1906, as a cut of San'yo Tetsudō boxcars (with that line's distinctive twin mountain *mon* on the door sides) are shunted past by a small American-built tank locomotive. By this time the electric lines have proliferated, the neighborhood has taken on a distinctly commercial flavor, and the fencing of houses seen in the first photo has disappeared as all the housing has been re-oriented to face the street and has largely been converted to commercial use. Development can be seen creeping up the side of the distant mountain range. Kōbe station itself was located just behind the bridge on which the photographer stood to take this photograph.

Kōbe marked the end of the IJGR Tokaidō line and was the start of the San'yo Tetsudō. During building of the Kōbe–Kyōto line, Kōbe served as the national headquarters of the Railway Bureau. At the time of this view, sometime around the turn of the 19th-20th centuries, the station building had been enlarged. Rickshaws were a common sight outside every station in Meiji Japan. Note the rickshaw runner performing a wheel repair in the lower left corner.

A fuller view of Kōbe Station, with a puff of steam from a passing train seen in the background. The prominent pediment over the main entrance, centered between its two wings of office blocks, is a distinct feature of the neighborhood in these views, echoing the massive Georgian revival pediment of Waters' Takebashi Barracks in Tōkyō, completed around the time Kōbe station was first opened.

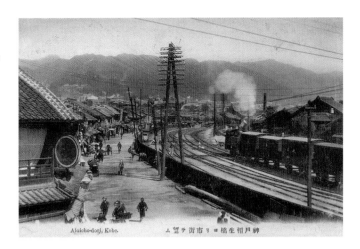

Aioicho-dori, Kobe. 神戸相生市街ヲ望ム

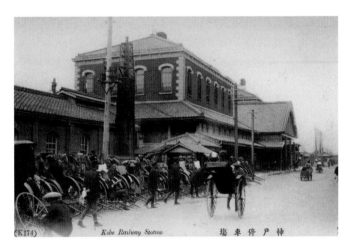

(K174) Kobe Railway Station 神戸停車場

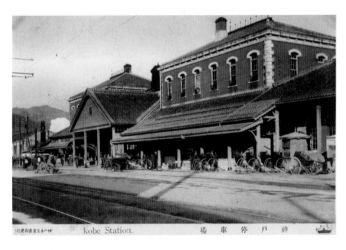

Kobe Station. 神戸停車場

same order of magnitude as the Nippon Tetsudō. Both the Nippon and the San'yo were destined to be among the largest railways in the realm. Both served to link the growing IJGR network that stretched from the Kansai to the Kantō region railway network with the planned railway networks of Hokkaidō and Kyūshū respectively. The San'yo however ran through one of the most populous areas of the realm (while the Nippon's territory was less populated) and served as a link to Kyūshū, also a heavily populated region, at a time when Hokkaidō was sparsely populated frontier.

The San'yo could rightly claim to be the "great connecting link" of the Empire, and did so in its promotional material. It had the good fortune of having for its first president the dapper Nakamigawa Hikojiro, nephew of Fukuzawa Yukichi, the founder of Keiogijuku (present day Keio) University. Nakamigawa was a foresighted president, who very early on realized that the San'yo was destined to form the southern third of the national trunk line (along with the Nippon Tetsudō and the IJGR Tokaidō line) that was slated to run the length of Honshū. Being cognizant of that destiny, Nakamigawa never shrank from building bridges and acquiring right-of-way for the day when double tracking would be needed, and insisted his line be built with no tight curves and easy grades with an eye toward the day when speed would be paramount in running and heavy traffic volumes would prevail.

Additional expense was encountered due to the surveyed route that hugged the coast wherever possible such that, "for miles upon miles it [the railway line] has to be protected from the dashing waves by solid walls of stone" as a San'yo brochure put it. Nakamigawa didn't shrink from those, or other costs: he bought the best British and American locomotives in adequate amounts against the day the San'yo would assume it's *great connecting link* role. Unfortunately, his fellow officers and board members were not as far-sighted, and objections were raised to the grand style in

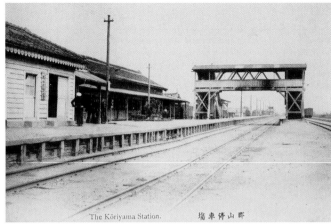

The Kōriyama Station.　塲車停山郡

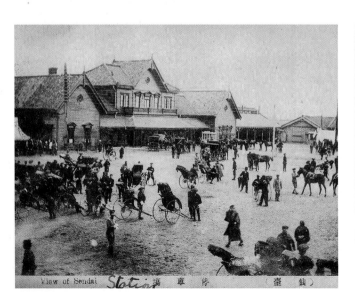

View of Sendai Station　塲車停　（塞仙）

(above left)
The extreme narrow gauge of the track in this photograph is obvious confirmation that the subject right-of-way belongs to the 838 mm gauged Hankai Tetsudō. This early view shows the entrance to the line's Namba terminal, located just beyond the footbridge, behind the large tree. The photograph was taken sometime between opening of the line in 1885 and 1890. Hankai is a portmanteaux word derived from splicing the last character of Ōsaka (using the Chinese pronunciation Han) together with the character for Sakai, its southern terminus, which could also be pronounced kai. The seven-mile-long line ran between the two towns using equipment purchased second-hand from the ill-fated Kamaishi steel mill railway. In 1898 it became part of the Nankai Tetsudō, which escaped nationalization in 1906 and still uses the Namba terminus site to this day.

(above right)
The town of Koriyama is roughly mid-point of the Nippon Tetsudō mainline between Utsunomiya and Fukushima, and its station, shown here, is a fairly representative example of a typical Nippon Tetsudō station. The station makes a good specimen of a small town station against which to compare the earlier view of Kanzaki station. The IJGR builders have learned well how to economize. Compared to the British-influenced Kanzaki, there is not a brick to be found: the station and its subsidiary buildings, the pedestrian overbridge, and even the platform walls appear to be constructed from wood. Although opened in 1887, only thirteen years after Kanzaki, the station clearly manifests the intervening radical re-alignment of spending priorities.

(below)
The Nippon Tetsudō reached the important regional city of Sendai in 1887 where outlay for a more expensive structure was justified, and the eventual result was this handsome station. The company's mon has been used to form the three oculus roundels under the gables. Judging from the presence of numerous horses, closed carriages in the busy station forecourt, this view was taken in late Meiji.

which Nakamigawa was building the railway and buying locomotives. There was a parting of ways, with Nakamigawa stepping down from the presidency (although remaining on the board) in 1891, and the shortsighted board thereupon embarked upon selling its excess stock of locomotives to other new private railways that were getting underway. Nakamigawa went on to save the then-ailing Mitsui business conglomerate from financial difficulty, putting in place a turn-around scheme that would pave the way to its becoming one of Japan's largest corporate conglomerates. His vision while president of the San'yo was vindicated within 5 years when the economic boom that followed on the heels of the Sino-Japanese War found the San'yo in short supply of locomotives and rolling stock and forced to repurchase some of the very items its board had sold earlier at nearly double the price. But that jumps ahead of the story: for the time being, the San'yo concentrated on its first segment, Kōbe Hiogo to Himeji, a distance of 34 miles, which was opened to traffic in 1888. By the end of 1889, it was possible to travel by uninterrupted rail line from Shiogama, a port on the Matsushima Bay slightly north-east of Sendai on the Nippon Tetsudō, to Tatsuno station, on the other side of the Ibo River about ten miles west of the old castle town of Himeji on the San'yo Tetsudō.

The dashing and far-sighted Nakamigawa Hikojiro served as the first President of the San'yo Tetsudō. To him is due much credit for building the San'yo to a higher standard than many other railways of its day and in creating the culture of innovation for which the San'yo became known. As a youth, Nakamigawa had studied for an extended period in England, and came away with a much deeper understanding of railway design and of the relative importance of his line than some of his contemporaries. His insistence that grades in excess of 1 in 100 be avoided if at all possible earned him the nickname of "One Percent" among soon-to-be exasperated directors and shareholders who would have preferred cheaper construction shortcuts.

On the island of Shikoku, a small railway was started on October 28, 1888 from Iyo to Dogo, the first on the island of Shikoku, using a locomotive built by Krauss of Germany. For this line, and many other short rural or light railway lines in Shikoku and Kyūshū, German 762 mm or 1067 mm gauge 0-4-0T locomotives were used. A German engineer, Hermann Rumschöttel, was employed by the President of the fledgling Kyūshū Tetsudō, reputedly due to the notable success the Prussian railway systems were said to have achieved in supporting

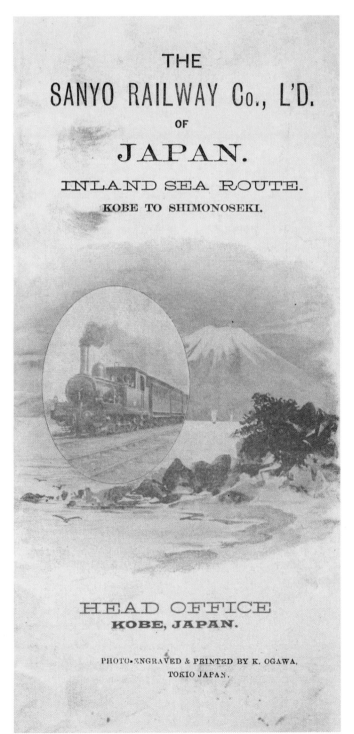

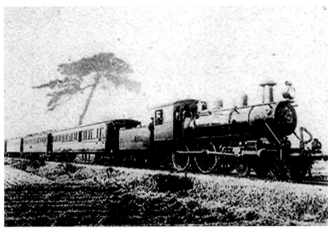

(left)

Proud as the San'yo was of its highly scenic route that skirted the Inland Sea along much of its way, management couldn't afford to risk disappointing tourist expectations by not including Mt. Fuji—which was not even remotely near the railway—on the front cover of its brochure. When London's Moore's Monthly Magazine (as The Locomotive Magazine was then known) received its complimentary copy of this pamphlet, its editors' national pride was wounded by the decidedly glowing terms in which the line described its latest service improvements—all of which were American-inspired. The magazine had the last word and ran a feature in a subsequent issue that was a trifle indignant in tone, implying that it was a mystery why the railway had even bothered to put a British-built A8 type tank locomotive on its cover if it was seemingly so pro-American. The petty, chiding recriminations that were traded back and forth between the British and the American railway press of the late 19th century seems amusing by modern standards, but it was symptomatic of a very robust and earnest competition between the two economies for railway export business in that era. For its part, the San'yo never really considered itself to be unfavorably disposed to British practice or equipment, but simply was choosing the best from both worlds as it saw fit.

(top)

Pictured here is the first San'yo Tetsudō Terminal building at Hyogo, opened on November 1, 1888 when the San'yo began its inaugural services to nearby Akashi. It would not be until September 1, 1889, almost a year later, that the San'yo would close the short gap between its terminal and the IJGR railhead at Kōbe, linking the two railways.

(above)

Pride of the San'yo Tetsudō, its Shimonoseki Express, is seen here in an officially posed photograph from before nationalization in 1906. The locomotive is one of the San'yo Railway's Baldwin-built 4-4-0 locomotives (later IJGR 5900 class), among the fastest in its roster. Express trains such as this were to launch the first era of Japanese railway innovation and improvement, which would gradually effect government and other lines throughout the realm. Note the distinctive San'yo pattern open air platform coaches visible in this and the next photograph.

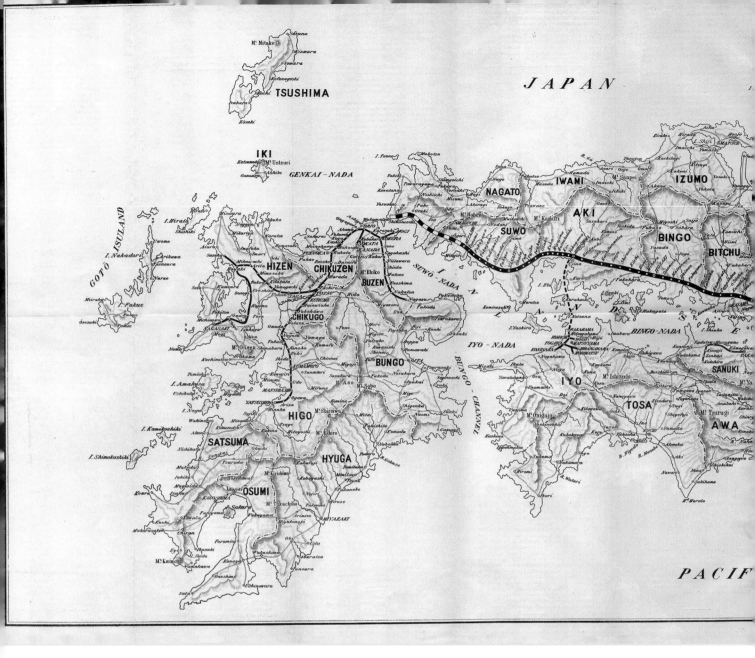

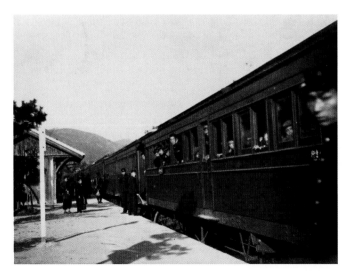

(above)
This map is taken from the San'yo English language travel pamphlet. The San'yo route is depicted as the boldest of all railway lines seen. At the time of publication, the railway had reached Mitajiri, which dates the map to around 1898. The remainder of its projected route is shown in a dotted line. A connecting ferry from Hiroshima to Iyo on Shikoku is shown as having been in service by that time. Curiously, the map completely neglects to depict the Nippon Tetsudō mainline north through Utsunomiya.

(left)
According to a notation on its back, this photograph shows Kōbe Station on November 27, 1905, although perhaps is it one of the smaller stations farther along the line. A San'yo train for Shimonoseki is about to depart as a station staffer and all but two of the passengers and train crew focus on the foreign tourist who took this snapshot, perhaps wishing he or she would stop dawdling and board, so as not to delay departure. Western tourists to places outside major population centers that had become accustomed to foreigners were often the subject of intense scrutiny and unrelenting curiosity in Meiji Japan; their every movement watched. This phenomenon is often mentioned in passing in published travel accounts. Some Western visitors came to feel as though they were oddities on display and found the experience to be quite disturbing.

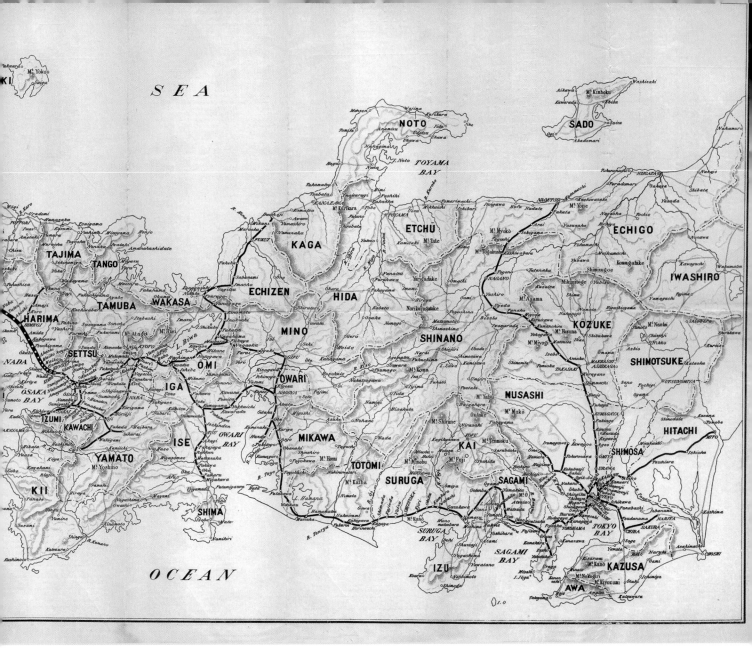

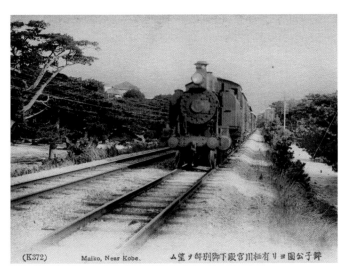

(K372) Maiko, Near Kobe. 舞子公園ヨリ有栖川宮御別邸ヲ望ム

A San'yo train pulled by an American-built 2-6-2T tank locomotive, more likely than not a Baldwin product and probably a member of what would become IJGR 3300 class upon nationalization, seen on the San'yo Tetsudō mainline at Maiko in the late 1890s or early 1900s. By the time of this photograph, the San'yo had double tracked only a short amount of line, starting from Kōbe. Many of this type of locomotive were ordered straight from the builder's locomotive catalogue, without significant modification, in order to keep purchase price to a minimum. Baldwin exported more locomotives to Japan than any other single foreign manufacturer by far.

the Prussian Army during the Franco-Prussian War. Even to the Japanese used to smaller narrow gauge trains of the day, the railways in Shikoku, and the Iyo Railway in particular, seemed like toy trains with their tiny German 0-4-0T tank engines and passenger cars no longer than a typical four wheel European box car of the time. The famed novelist Natsume Soseki described a thinly veiled fictional counterpart of an Iyo Tetsudō train in his seminal 1906 novel "Botchan," perhaps of equivalent stature in Japanese literature to "The Adventures of Huckleberry Finn" in American,

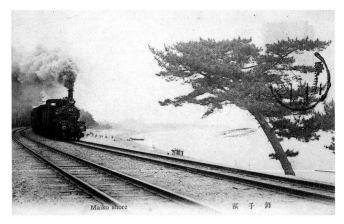

Maiko shore 舞子濱

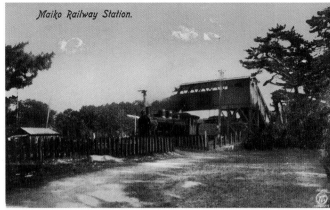

Maiko Railway Station.

The Ashidakawa Tekyo （中行進車列行急）橋鐵の川田芦

停車場 【岡山名所】

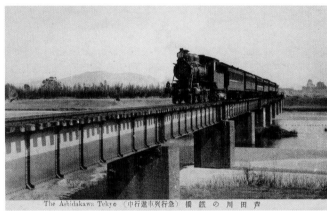

THE SANYO HOTEL, SHIMONOSEKI. テホ陽山園下

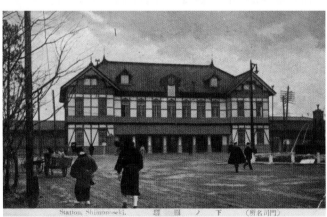

Station, Shimonoseki. 驛關ノ下 （所名司門）

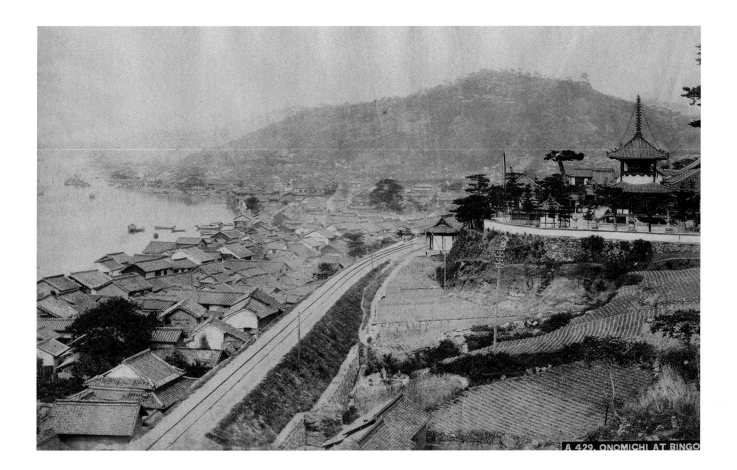

A 429. ONOMICHI AT BINGO

(clockwise from opposite top left)

The San'yo Tetsudō's Maiko section as a train skirts the shore. Numerous people are on the beach in this view as this express, piloted by No. 20, a British-built 4-4-0, storms by. That the locomotive still bears its San'yo Tetsudō running number would seem to indicate that the photograph pre-dates the 1906 nationalization.

One of the first stations west-bound trains came to on the San'yo line after leaving Kōbe was the sea-side station of Maiko, shown here with an American-built Mogul pulling in with a train of clerestory coaching stock. The sandy nature of the soil and the wind-gnarled pine trees are indicative of the shoreline, which is no great distance from the station.

The San'yo's station in the thriving regional town of Okayama was opened on March 18, 1891, and was larger than the average station in view of Okayama's regional importance and population. This view shows the station and surrounding forecourt area probably just after the turn of the 20th century.

Photographs of Meiji-era railway operations at night are extremely rare for obvious reasons. According to the head lamp positions on the locomotive front, the train in this image (from around 1904) would seem to be an up express train along the Maiko section of the San'yo Tetsudō on a moonlit night.

With a similar nocturnal motif is the commercial postcard seen in this view, showing an approaching San'yo express. Maiko beach was a favorite location for would-be photographers of San'yo trains.

Shimonoseki was the terminal of the San'yo Tetsudō at the southern tip of Honshū, where this picturesque station structure was built virtually at pierside. The final section to Shimonoseki was inaugurated in 1901, when the station was opened. Ferry service across the Kanmon Straits to Moji, where the Kyūshū Tetsudō had already arrived, served as the link to Kyūshū.

For travelers breaking their journey before proceeding to Kyūshū or Korea, the San'yo Railway built and operated the eponymous San'yo Hotel, shown in this photograph, literally across the street from the station. The hotel was located at a right angle to the station just beyond the fountain appearing at the right in the station view. It was successful enough that the original hotel shown here had been replaced by a larger structure built on the same site by the 1920s.

A typical San'yo express train passes over the Ashida River bridge in this view. The river passed through the town of Fukuyama, between Okayama and Onomichi on the San'yo mainline to Shimonoseki. Note the two-tone paint scheme of the bridge girders.

(above)

The San'yo Tetsudō's segment to Onomichi, in the former Bingo province, was opened on November 3, 1891. The town's famed Jodoji Temple, founded during the reign of Prince Shotoku (574–622 AD), and its two-storey pagoda, a listed National Treasure, are visible here. This photograph must have been taken shortly after opening of the extension, as the embankment sod doesn't quite look completely "grown in." The scenic beauty of the San'yo's Inland Sea coastal route is readily evident in this view.

as consisting of a carriage "about the size of a matchbox."

The introduction of German engineering, locomotives and rolling stock in Shikoku and Kyūshū marks the introduction of the third nation that was to have significant impact upon railway development in Japan, mainly in the area of locomotive design and development. With this addition, all the major non-indigenous ingredients that would combine with those purely Japanese to form the design standards for domestic steam locomotives for the era stretching to the end of steam locomotion in Japan were in place.

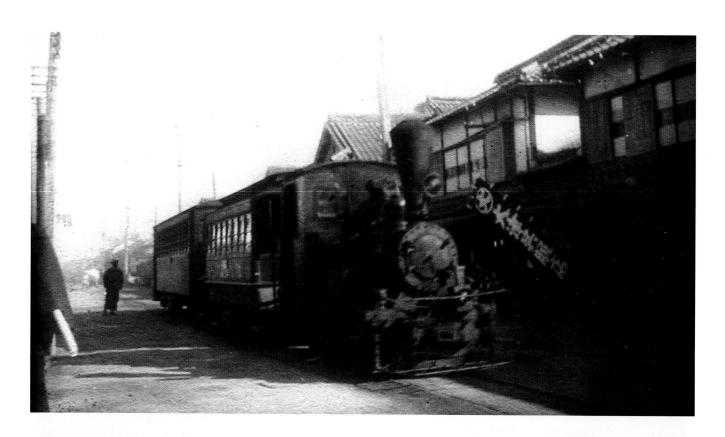

(top)
Another local keiben tetsudō (light railway) in an unknown location, perhaps Shikoku where small German tank locomotives were abundant. Such an example slowly edges its train of two unmatched passenger carriages along the streets of a local town.

(above)
Komatsushima station in Shikoku on today's Mugi Line south of Tokushima opened in 1913. It is believed this photo shows a company of soldiers who were being mustered for action assembling in the forecourt of that station in 1914. At the start of WW1, Britain called upon Japan to assist the Allies under the Anglo-Japanese Treaty, and Japanese troops were soon to capture German-occupied territories in the Shantung province of China.

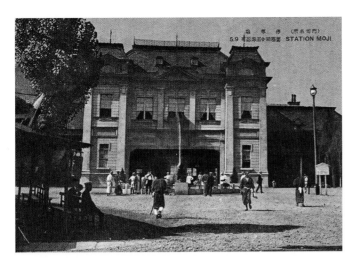

Another notable railway venture was commenced in the outskirts of Tōkyō in 1889: the Kōbu Tetsudō. The Kōbu initially ran from Shinjuku on the Akabane line westward a very modest distance to Hachioji, then an important center of the silk industry, but it was destined to become the first link of a IJGR extension line, called the Chūō (*Central*) line, that would eventually reach Nagoya and would at last give the military the defensible interior railway line that it had long argued was desirable from the point of view of national defense, providing an alternative route to the coastal portion of the Tokaidō that was so vulnerable to the threat of foreign attack or occupation.

By this time also, it was becoming clear that Japan had a confirmed financial phenomenon on its hands that had been witness in both Great Britain and the US, as its first, rather short-lived phase of what has come to be known as a *Railway Mania* ensued and investors rushed to speculate on the building of proposed new lines.

Similarly, the government's bureaucratic structure would undergo a bit of a mania itself. In 1885, the *Kōbushō* was abolished and the Railway Commission was put under the direct supervision of the Cabinet. By 1890 with the introduction of the new *Imperial Diet*, the Railway Commission had been replaced by the Railway Agency (sometimes translated Railway Board), and put under control of the Home Office. Naturally its First Chief Commissioner was Inoue Masaru, who by 1887 had become *Viscount* Inoue, and who, in the same year as he assumed his position as head of the new *Railway Agency*, would be elected to the House of Peers. Then, in July of 1892, the Railway Agency was put under the control of the newly created Department of Communications. By August of 1897 the Railway Agency had grown to such an extent that it split itself into two *Bureaux*; one supervisory over both government and private lines (the *Tetsudōkyoku*) and the other the operative arm of the government railways (the *Tetsudō Sagyokyoku*). Next, as mentioned, in 1896 on Hokkaidō, railway oversight was transferred from the Department of Communications to the Department of State for Colonial Affairs (Hokkaidō was still treated as a colonial endeavor at that time) only to see that Department abolished in 1897 and railway jurisdiction transferred back to the Department of Communication.

The initial Railway Mania continued only briefly until the bubble burst in 1891. In that year, the failure of one of the most

(above left)
Moji was a town largely created by the Kyūshū Tetsudō as its northern terminus, port, and ferry link to Shimonoseki. For most rail travelers arriving from Honshū, Moji served as the gateway to Kyūshū. Accordingly, when it came time to rebuild the station, it was given a suitably imposing terminal, replete with forecourt fountain, as befits such a symbolically and operationally important location. This second station building was opened in 1914. The town is now a neighborhood of Kitakyūshū and the station building shown here has been preserved.

(above right)
An overall view of the Kyūshū Tetsudō's terminal facilities at Moji on a clear spring day before remodeling of the original station. The company's yards and coal staithe are clearly visible, while its loco sheds and several locomotives are visible at the end of the line adjacent to the red brick building at the right.

(below)
Part of the charm of Meiji railway operations was the sometimes quaint or unusual practices to be encountered. By the 1840s in Europe and North America, the use of 0-4-0 locomotives for mainline heavy freight haulage was basically a thing of the past, however, in the 1890s, one could find a diminutive German 0-4-0T built by Hohenzollern hauling coal trains along the Kyūshū Tetsudō's mainline at Moji Harbor. These were the first locomotives bought by the Kyūshū Tetsudō in 1889 and on nationalization became IJGR Class 10. The fact that the world's smallest type of conventional railway locomotive would be called upon to handle one of the heaviest duties in railroading (mainline coal hauling) evidences the tight finances facing many of even the larger railways of the era. This "make do with what's available" attitude pervaded Japanese railways in the Meiji era and gave them a truly unique flavor quite their own.

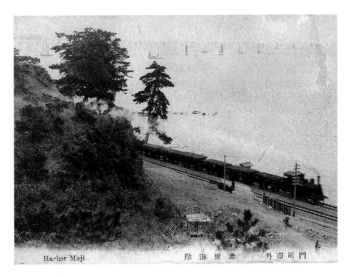

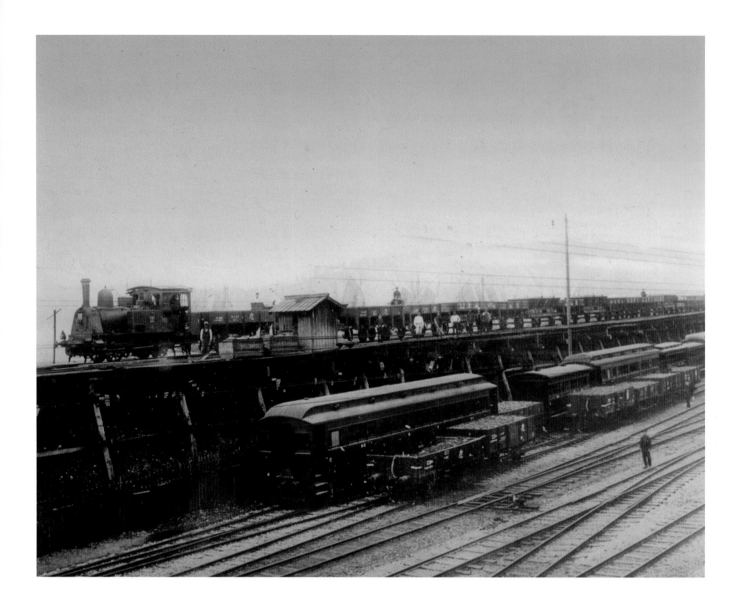

(above)
Passengers arriving at Moji in the late Meiji-era were able to view the yards and the company's coal staithe for loading coal from Kyūshū's extensive coalfields onto waiting ships for transshipment to Honshū. A neatly designed German 0-4-0T Hohenzollern tank engine appears to be bringing a trainload of empties back. These locomotives, first imported in 1889, were designated "10 Class" after nationalization. Note the character 九 ("Kyū", the first character of Kyūshū), on each of the wagon sides and the idle mix of coaching stock in the yard below.

(opposite above)
Coal was one of the major commodities that were transshipped through Wakamatsu Station, the Chikuho Tetsudō's port in competition with Moji. The harbor itself was developed beginning in 1889 with coal traffic expressly in mind. Its passenger station is at the end of the curve at the far left. In 1897 the Chikuho was absorbed into the growing Kyūshū Tetsudō system. When this photo was taken around 1903, a single American-built locomotive, probably one of the moguls favored by the Kyūshū, is seen steaming out of the passenger terminal. Hopper cars full of coal are otherwise the predominant vehicles seen in the rail yard, while the masts of coastal lighters are predominate in the harbor.

promising and highly-touted proposed private railway schemes, the Koshin Tetsudō (which was projected to run between Matsumoto and Gotemba), retarded the building of private railways, putting an end to Japan's first Railway Mania. Investors' confidence was shaken, and stock offerings were not subscribed as quickly as had previously occurred, putting a damper on the brief flourish of railway speculation. Francis Trevithick bemoaned the naïve assumptions of certain would-be railway builders of the time, noting that some "seem to think that they have made ample estimate of the cost of construction when they reckon with an expenditure of thirty to forty thousand Yen per mile, without taking into account the nature of the locality through which their railway is to run; that they sufficiently provide for the cost of carrying on their road if they set apart half of their income for the purpose, no matter how much or how little that income may be; and that industrial and other advantages must at once follow upon the opening of a line."

Despite the bursting of the bubble, the year 1891 nevertheless saw the passing of two significant milestones. The Kyūshū Tetsudō mainline from Moji to Kumamoto was completed on July 1st and the Nippon Tetsudō reached Aomori on September

1st. (The Railway Bureau formally turned over operations of the Nippon Tetsudō to the company's management on April 1, 1892.) Inasmuch as the San'yo had opened its mainline as far as Onomichi on November 3rd 1891, it was now possible to travel from the interior of Hokkaidō by rail to Temiya/Otaru, ferry to

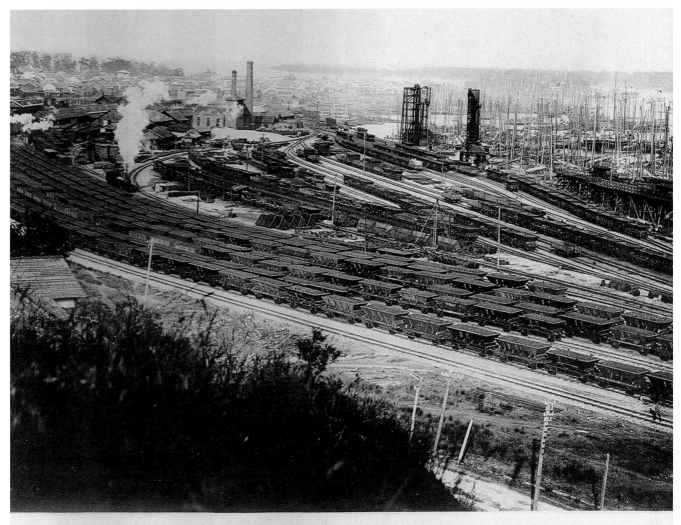

General View of Wakamatsu Station Yard, Kyushu R. R.

門司三井倉庫

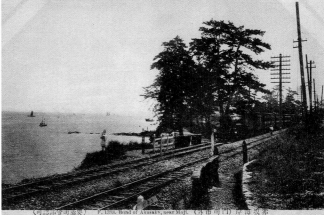

（司港市舊司門）　F. 1358. Bond of Akasaka, near Moji.　（外市司門）岸海坂赤

A mundane scene of the Mitsui Company's warehouses in Moji harbor, with the corporate *mon* worked into the pediment brickwork: a good view showing Kyūshū Tetsudō boxcars and hopper cars circa 1890. American-inspired self-emptying hopper cars to facilitate transshipment of coal were used from earliest days by the Kyūshū Tetsudō. Note the two boxcars with brakeman's duckets.

Leaving Moji, the Kyūshū Tetsudō's mainline ran along Akasaka Beach, much in the manner of the San'yo's mainline in the vicinity of Maiko. A Kyūshū passenger train cuts through the summer haze in this shot. Note the white gradient marker in the foreground in the British style.

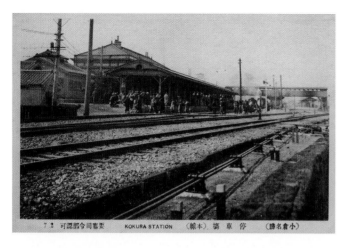

7.2 可認部司令憲要 KOKURA STATION （線本）場車停 （勝名小倉）

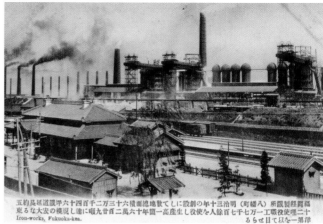

福岡縣鐵設置の明治三十年に創設しに此地鐵面積六萬三千二百四十六坪延長道鐵約五
東るな大宏の模凝し達に喘九廿六萬二千高一高産生し役使人餘百七千七萬二工職使理二十
Iron-works, Fukuoka-ken. るら目て以一第澤

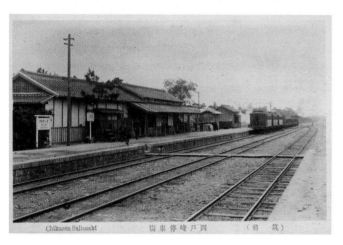

Chikuzen Saitozaki　　　場車停崎戸四　　　（前　筑）

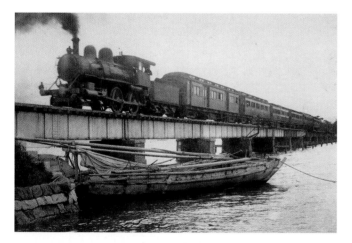

Chikuzen Saitozaki　　　内港崎戸四　　　（前　筑）

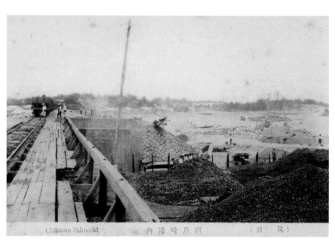

(top left)
Kokura, part of present day Kitakyūshū, was the largest city in the north of Kyūshū, situated between Moji to the east and Wakamatsu to the west. Despite its importance, the town was given a relatively modest station building, as this view shows, although the length of the pedestrian footbridge is evidence of several departure and arrival platforms.

(top right)
Yawata Station and the Yawata Steel Mill that was to be the cradle of the Japanese steel industry are shown in this view taken shortly after the plant started operations; the Kyūshū Tetsudō's mainline separating the two. The start of steel production at the mill would be the first step in enabling Japan to become self-sufficient in the production of steel for its domestic locomotive building (and other) needs. Yawata is a part of the present day city of Kitakyushu, and is situated almost directly south of Wakamatsu.

(above left & right)
Saitozaki is located on a long peninsula creating the Hakata Wan (Wan is the word for Bay) and sheltering Hakata and Fukuoka harbor in the coal-rich northern region of Kyūshū. The town was the terminal of the Hakatawan Tetsudō when it opened in 1904. In the first of these two scenes from that town, a mixed Hakatawan train consisting of coal hopper cars with three four-wheel passenger cars at the end departs from the station, while the station staff return to other duties, in a scene redolent of local or branch line operations in Meiji times. In the second view, a train of coal hopper cars, apparently empties judging from the brakeman riding inside the last one, is being pulled away from the coal staithes at Saitozaki after being discharged there. Coal was the major commodity carried by railways in this region of Kyūshū.

(bottom left)
A fine view of a Kyūshū express train piloted by a 4-4-0 locomotive on the Tatara River bridge in the Chikuzen area on the approach to Hakata and Fukuoka, with a traditional Japanese boat moored in the foreground. The Schenectady-built class would become IJGR 5700 class on nationalization.

Aomori, travel the length of Honshū south to Onomichi, take a steamer to Moji and thence travel by rail to Kumamoto. The major segment of the trans-Japan system still glaringly incomplete was the San'yo Railway's Onomichi to Shimonoseki segment. Much of the San'yo's difficulty would lay in the lack of a comprehensive set of eminent domain laws, which emboldened landowners to hold out for excessive sums. Progress had been delayed partly as a result of the high number of rivers that had to be

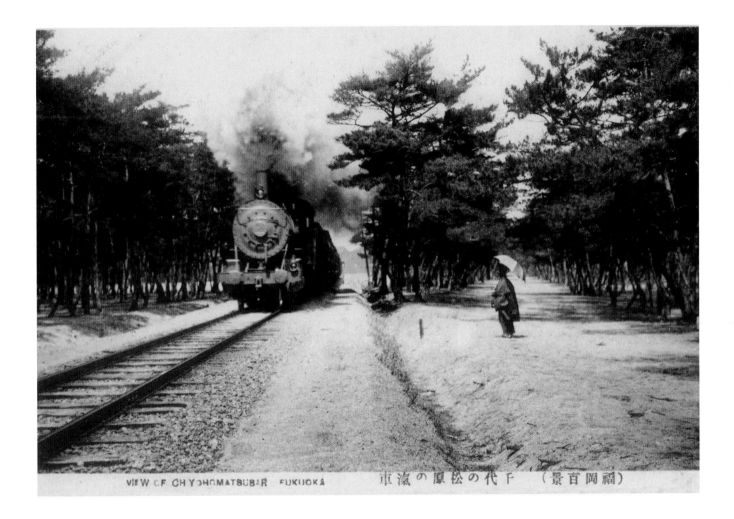

VIEW OF CHYDHOMATSUBAR FUKUOKA　　下代の松原汽車　（福岡百景）

bridged as the San'yo followed its route along the coast, but the intransigence of landowners formed a notable impediment. Writing at the time, Japan authority Basil Chamberlain commented, "The construction of the Inland Sea Railway [San'yō Tetsudō] is at a standstill for this reason, as no capitalists can afford to buy land at the preposterous sums demanded by the owners." The travel writer W. E. Curtis agreed generally, "[In Japan]…there is no law authorizing condemnation proceedings to secure a right of way, which is often troublesome." This was something of a misunderstanding. Land condemnation in the Western sense had been recognized as early as 1872 by Finance Ministry Ordinance No. 159. In 1875, Grand Council of State Ordinance No. 132 "Regulations on Land Purchase for Private Use" (*Kōyō Tochi Kaiage Kisoku*) were issued, which specifically provided a private company the right to condemn privately owned land for the construction of railways. However, in 1889, the 1875 regulations were replaced with the Land Condemnation Act (*Tochi Shūyō Hō*), which added the requirement of satisfactory consultation with landowners as an additional step in the process. This gave enterprising landowners a procedural windfall. As the realization of the new law's import set in, "consultation" frequently came to be used as a delaying tactic by which lucky landowners often extracted a higher price, and it is during the time in which the 1889 Regulations were effective that the San'yo met with its right-of-way acquisition difficulties. The consultation requirements were only in effect for a year or two before the abuses to the system had

Fukuoka's Chiyō-no-matsubara, ("Thousand Year Old Pine Grove"), was on the route of the Kyūshū Tetsudō, and this view shows one of its trains passing through the celebrated location, probably piloted by a Schenectady mogul. The locomotive appears to have its headlamps positioned at smokebox top and right bufferbeam positions: the reverse of what was used by the IJGR and San'yo (smokebox top and bufferbeam left) to indicate an express train.

become evident enough that the law was amended, in 1890, to accelerate the consultative process, undoubtedly much to the relief of the railway industry in general. By 1900, the whole statutory scheme for condemnation was settled with the adoption of a new set of statutes that would remain the basic condemnation law up to the end of the Second World War.

As all this new building had been getting underway, it became clear to the government that the theretofore piecemeal way in which it had been treating railway charter approval was inefficient and that regulation would be necessary for policy, public safety, and national security purposes. As mentioned, a start in setting forth a comprehensive body of law governing railways had been made in 1872 and again in 1879 and 1883 saw the extension of the general and punitive rules that had applied to Government lines to all private railways. December 1885 saw the adoption of laws governing railway finance and created a distinct difference in the manner of railway finance in Japan vis-à-vis Western nations: in Japan debenture bonds were less likely to be used as a first line source of funding. 1887 saw the adoption of an Imperial Ordinance styled the "Private Railway Regulations," but the 1887

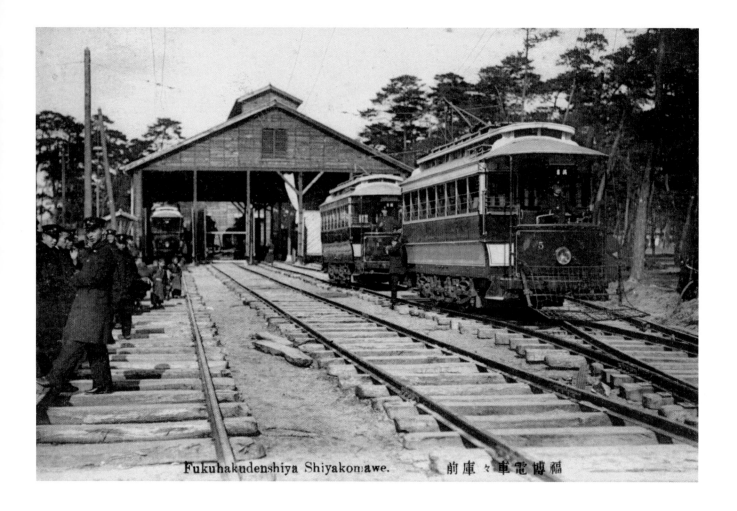

Fukuhakudenshiya Shiyakomawe. 前庫々車電博福

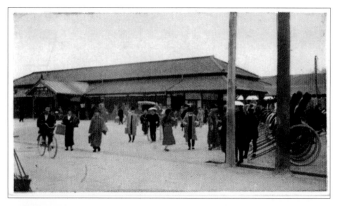

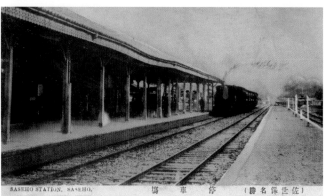

SASEHO STATION, SASEHO. 塩車停 (勝名保世佐)

(top)
The Fukuhaku Densha Kidō took its name from the initial kanji of Fukuoka and Hakata, between which it ran. The all-electric railway was built to 1435mm gauge and opened in 1910. This view shows one of the railway's carbarns being visited by a group of local schoolboys. Within a year, the line had changed it's name, so the photo caption and track so newly laid (apparently on little or no sub-base) that it had yet to be ballasted seem to date the scene to the first year of operation. Note the roughly hewn irregular crossties.

(left & bottom)
These two views shown the station in Sasebo, town-side and track-side, dating from late Meiji. As one of Japan's principal naval bases was located there, the Kyūshū Tetsudō naturally ran a short branch line to the city and port from its Nagasaki main line. The station was opened in 1898.

Regulations eventually would prove to be unduly cumbersome. In 1892 the government again restructured, creating the Department of Communications and putting the Railway Agency under its aegis, severing it from Home Office jurisdiction, but not before reverting its name to the old formula of *Railway Bureau* mentioned earlier. By this time, the earlier regulatory scheme was seen to be undesirable. Accordingly the government promulgated its first comprehensive legislation on the subject, the *Law of Construction of Railways* that later came to be known in short-hand manner as the "1892 Railway Law" and formed by Imperial Ordinance what became know in English as the "Railway Council" as an advisory regulatory body charged with supervising the nation's railways. The Council was to consist of 21 members, a President, ten members from the Diet, three members (one each) from the Department of Home Affairs, the Treasury, and the Department

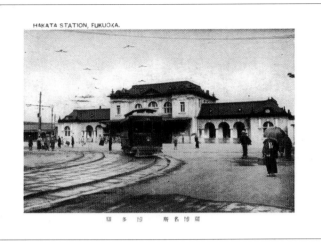

HAKATA STATION, FUKUOKA.

博関 名所 博多駅

of Agriculture and Commerce, four from the Department of Communications, and four from the Military. This law and the Council would constitute the legal and regulatory framework for railway building for the balance of the Meiji era, with the addition to another act added later in 1910. (Hokkaidō was addressed specially in a law governing railway building on that island in 1896 and there was a further law of 1900 superseding the existing private railway regulation.) As one can see, concerns over maintaining national integrity in the face of foreign colonial adventures was reflected in the large influence the military was given on the Council: its members equaled in number those that the Railway

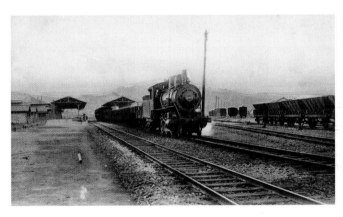

(above)
In early Meiji times, Fukuoka was an old castle town across the Nakagawa river from the commoner's town of Hakata. By the time this photograph was taken, Fukuoka had started to envelope Hakata, which is now a ward in Fukuoka. As these twin cities formed one of the larger population centers of Kyūshū and as this point was also near the junction (actually at nearby Tosu) between the Kyūshū Tetsudō's mainline south to Kumamoto and its branch west to Karatsu, plans for a station on a grander scale were put in hand by late Meiji as seen here. It seems to have lent its style to the second Moji terminal that would be completed in the following Taishō reign.

(top right to bottom)
This and the following three views trace the development of Nagasaki station, trackside and street side. The Kyūshū Tetsudō reached Nagasaki in 1897. The station it built, shown here, was a thoroughly utilitarian structure, similar to IJGR standard designs. The railway was extended an additional mile in 1905 to a more desirable location for a terminal, on land reclaimed from the harbor in the very heart of the city. When the new terminal was opened, this station was renamed Urakami.

The first Nagasaki station, at far left, from the yards as a mixed train departs. Note the ornate reverse-curve bracketing on the side braces of the wooden hopper cars to the right. As Nagasaki was a strategic refueling station for both international and domestic shipping, it was inevitable that a brisk trade in coal would develop to supply the port's busy stream of steamships. The fact that the station is not called Urakami in this view dates the scene to before 1905.

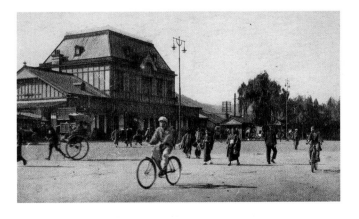

The second Nagasaki station, a structure in Japanese vernacular cottage orné style, shown after its opening in 1905. Within the space of a few short years, passenger traffic had increased to a point that the Kyūshū Tetsudō judged that a much more imposing edifice was justified for its new station when the line was extended, including a second story with an enlarged suite of offices. Bicycles and electric lighting have come into vogue by the time of this photo.

This trackside view of the second Nagasaki station obviously suggests conscious planning for increased train lengths. Initially, many early Japanese stations were built with relatively simple track plans that didn't necessitate large signal boxes from which to operate the station turnouts. The small kiosk at the end of the platform canopy appears to serve that purpose in this view.

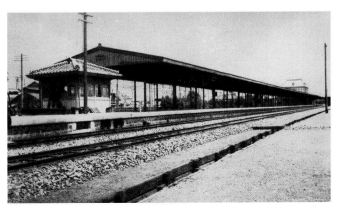

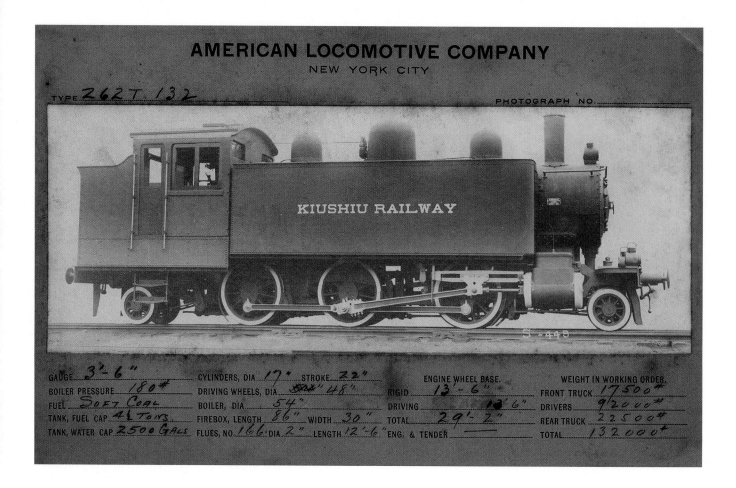

AMERICAN LOCOMOTIVE COMPANY
NEW YORK CITY

TYPE *262T 132*

PHOTOGRAPH NO.

KIUSHIU RAILWAY

GAUGE *3'-6"*	CYLINDERS, DIA *17"* STROKE *22"*	ENGINE WHEEL BASE.	WEIGHT IN WORKING ORDER.
BOILER PRESSURE *180#*	DRIVING WHEELS, DIA *48"*	RIGID *13'-6"*	FRONT TRUCK *17500#*
FUEL *SOFT COAL*	BOILER, DIA *54"*	DRIVING *13'6"*	DRIVERS *92000#*
TANK, FUEL CAP *4½ TONS*	FIREBOX, LENGTH *86"* WIDTH *30"*	TOTAL *29'-2"*	REAR TRUCK *22500#*
TANK, WATER CAP *2500 GALS*	FLUES, NO. *166* DIA *2"* LENGTH *12'-6"*	ENG. & TENDER	TOTAL *132000#*

(above)
A prime example of an ALCO (Pittsburgh) Prairie tank locomotive built for the
Kyūshū Tetsudō, destined to become Class 3400 upon nationalization. These were
among the heaviest American 2-6-2 tank locomotives imported to Japan and were
placed in service between 1896 and 1899. American locomotive builders often provided
photographs with specifications such as this to potential customers as a sales device.

(right)
A Kyūshū Tetsudō Express train on the approach to Nagasaki, running along the
Honmyo River near Isahaya, a town at the very south-eastern tip of the Ōmura Bay.
The train is piloted by a Schenectady Mogul mixed traffic locomotive introduced in
1899 and favored by this line due to its heavy coal traffic. On nationalization, these
locomotives would be designated the 8550 class.

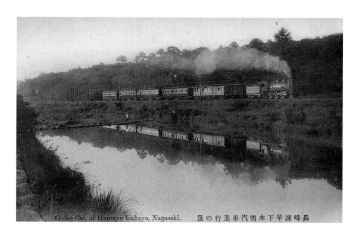

Going Car, at Honmyo Isahaya, Nagasaki. 長崎諫早下本明汽車進行の景

Bureau itself could name, and it formalized what had come to be
military involvement in railway matters, out of national security
concerns, dating back from the aftermath of the Satsuma
Rebellion. Along those lines, the 1892 law codified the require-
ment of private railways to offer their lines for the use of the Army
or Navy either in time of peace or war.

The Railway Law of 1892 also set forth a rational plan for fu-
ture railway development in the realm. The touchstone of the law
was the premise that every prefecture of the realm was to be
served by rail transport. A two-phased construction programme
was envisioned: the so-called "First Period Construction
Programme" of high priority lines to be completed within 12
years and a "Second Period Construction Programme" of low pri-
ority lines. Some 40 proposed routes totaling about 1,900 miles
were selected for inclusion in the First Period group, based upon
the familiar factors of the proposed line's role in encouraging eco-
nomic development of particular areas or industries, strategic mil-
itary importance, and the like. The new law allowed a private rail-
way to opt to build any of the lines identified in the government
programme if construction had not been started and the Diet con-
sented. A pattern soon was to develop that the government would
leave the proposed lines which showed greater potential for prof-
itable returns to private companies to build and operate, while it
would build some of the lines which showed less potential for
profit, but which were deemed necessary for national policy pur-
poses: the purely military lines, or lines which would integrate re-
mote, sparsely inhabited regions into the nation. The Second

早スぐもしの声に開けば
追ひ届けこうつけて
菜の花の海えて事を
薩摩寺
隣に机き何檐
三北三池岸難苗枯田

(above)
One of Mitsui's American industrial saddle tank locomotives built by H. K. Porter goes about its chores at Manda, where the locomotive sheds were located, in this pre-1910 view of the conglomerate's Miike Mine that appears on this early (used) postcard. High-sided iron plate gondolas such as the one shown were atypical for the period.

Ōmuta Station. 大 郵便 宙堀

(left)
Ōmuta lies on the Kyūshū Tetsudō mainline, roughly two-thirds of the way from Fukuoka to Kumamoto. The brass-radiatored landaulette parked at the front door awaiting the arrival of the next train would have been quite a rare thing to see at a small-town Meiji-era station such as Ōmuta. But Ōmuta was located near the abundant Miike coalmines, which added to civic wealth. The auto is an obvious manifestation of that prosperity; perhaps a taxi, but more likely the limousine of a particularly prominent local citizen. The town was also near one of the largest prisons in Meiji Japan, the Sūchi-kan, where a sentence of hard labor usually meant work in the mines.

Period group totaled around 2,525 miles. The stage had been set for extensive railway expansion.

* * * * * * * *

The Tokaidō line had been completed only a bit over two years when disaster struck and service was cut. At 6:40 in the morning of October 28, 1891, minutes after a Tokaidō line train had crossed the Nagara-gawa bridge near Nagoya, a violent earthquake struck and the bridge was toppled into the river below. This event marked the beginning of the Great Nōbi Earthquake of 1891, the epicenter of which was centered in the Nōbi plain, where Nagoya is located. The first indication to those areas unaffected was the interruption of telegraph communications with the area. A Tōkyō correspondent for *The Times* of London caught the first available Nagoya-bound train and left us his observations of the devastation wrought along the Tokaidō line:

> "From the outskirts of a district covering the Nagoya-Gefu [sic, Gifu] plain, which, roughly speaking, lies half-way between Tōkyō and Ōsaka, news came fast, but as it came it grew more terrible. From the district itself, although it was covered with towns and cities, and through it the trunk line of Japan passes, for some time nothing could be learnt. All was silent. Trains did not appear, and as telegraphic commu-

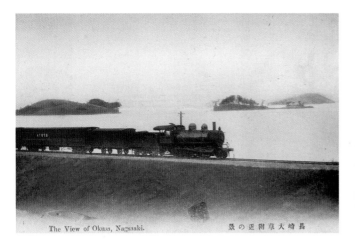

The View of Okusa, Nagasaki. 長崎大草附近の景

The Rail Road, "Okusa," Nagasaki.

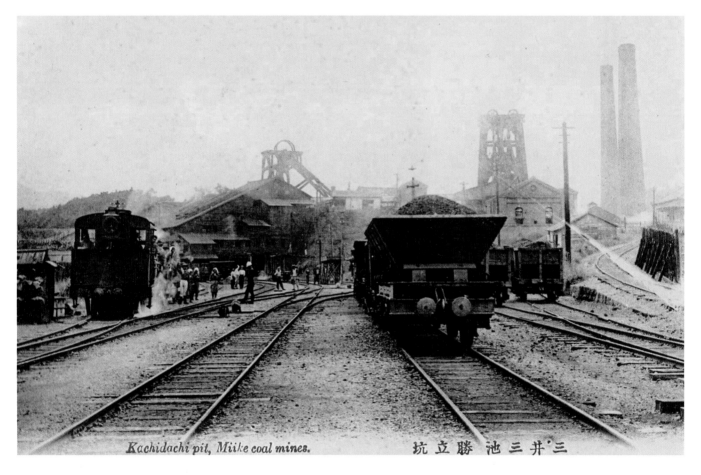

Kachidachi pit, Miike coal mines. 三井・三池勝立坑

(top left)
Shortly after Ishaya on the Kyūshū Tetsudō's route to Nagasaki came the town of Ōkusa on the southern shore of the Ōmura Bay, which partially delineates the Nishisonogi Peninsula. This view shows a northbound passenger train along what was a particularly scenic segment on the Nagasaki line.

(top right)
Still in the Ōkusa vicinity, an express passenger train through the approaches of town. Humble box cars such as the one seen directly behind the tender were often found in Kyūshū passenger train consists of the day, used for baggage or express parcel service.

(above)
A good view of the Miike industrial railway's own hopper cars, with buffers well to the center line to enable them to negotiate the tight radii of the curves present in the Kachidachi pit's railway system, seemingly rendering them incompatible with conventionally buffered mainline stock. This fact may indicate that these hoppers generally were not expected to leave the limits of the mine's industrial railway network. The very steep curved incline at the far right of the image seems to suggest the existence of a return ramp from a gravity loading-trestle where the mine hoppers could have been discharged into empty mainline cars waiting underneath, and then rolled back down via that ramp by gravity into the yards of the mine system.

《大日本肥前三池御崎山》 DIX, IN MIIKE HAIBOUR LORDING COAL. 炭載スタイデ船用御國米

SHINDO OF HOMMYOJI KUMAMOTO. （其三）景の道新寺妙本 （景百本熊）

FRONT OF STATION KAMI-KUMAMOTO 景の前驛本熊上 （景百本熊）

THE FUJISAKI SHRINE KUMAMOTO 前の居鳥大社神崎藤 （景百本熊）

(top left)
The other end of the Miike coal trade's traffic pattern in Kyūshū is shown in this view of very modern (by Meiji standards) bulk transfer loaders that were adopted for coaling ships or lading colliers. Even until the end of the Meiji era, one of the most common ways of coaling a ship in Japanese ports was by masses of coaling crews in a flotilla of small craft laden with baskets of coal who would come alongside ship with scaling ladders and perform the entire coaling operation by dint of sheer human muscle.

(top right, above left & right)
Kyūshū Tetsudō travelers arriving at Kumamoto could have transferred to the tiny trains of the Kumamoto Keiben Tetsudō, which opened on December 20, 1907 and was a harbinger of the way future light railways that resulted from the 1910 Light Railways Law would appear. These three scenes show the station at Kami-Kumamoto (about 2 miles north of Kumamoto), a train near the Fujisaki Shrine entrance, and a train crossing a bridge alongside the unfinished iron bridge of a newly built road near the celebrated Honmyō-ji temple. Note the fascinated toddler intently watching the passing train in the Fujisaki scene at far right. The low-boilered locomotive in the top photo appears to be a domestic product of the Amemiya Works, founded in 1907.

nication had ceased, their whereabouts was unknown. Next we learned that several bridges had been destroyed; then that cities had been shaken down, that many were burning, and that thousands of people had been killed.

Leaving Tōkyō by a night train, early next morning we were at Hamamatsu, 137 miles from Tōkyō, on the outside edge of the destructive area. Here, although the motion had been sufficiently severe to displace the posts supporting the heavy roof of a temple, and to ruffle a few tiles along the eaves of houses, nothing serious had occurred. At one point there was a sinkage in the line, and we [the train] had to proceed with caution; but farther along the line signs of violent movement became more numerous. The general appearance was as if some giant hand had taken rails and sleepers and rubbed them back and forth in their bed of ballast, piling the sand and gravel into bolster-like ridges. At places where the sleepers held too tightly to their bed, the rails themselves yielded and had been bent into snake-like curves.

The ground is cracked and thrown into huge waves, whilst near the bridges the embankment has been shot from beneath the sleepers so that the rails remain suspended in the air. The huge masonry piers have almost invariably been cut through near the base, and have then been danced and twisted from their true position. Cast-iron columns and huge cylinders have been snapped into several pieces, much as one might snap a carrot. For twenty-eight miles no stations remain; only platforms and floors, hummocked and thrown into waves, mark their places. For five years the railway works withstood traffic, typhoons, and floods. When they succumbed it was not only to the unexpected, but to the application of forces practically irresistible."

No fewer than 63 bridges of the Tokaidō line alone were destroyed or wrecked and railway embankments sank at 45 places, sometimes subsiding over 13 feet. The stretch of line between

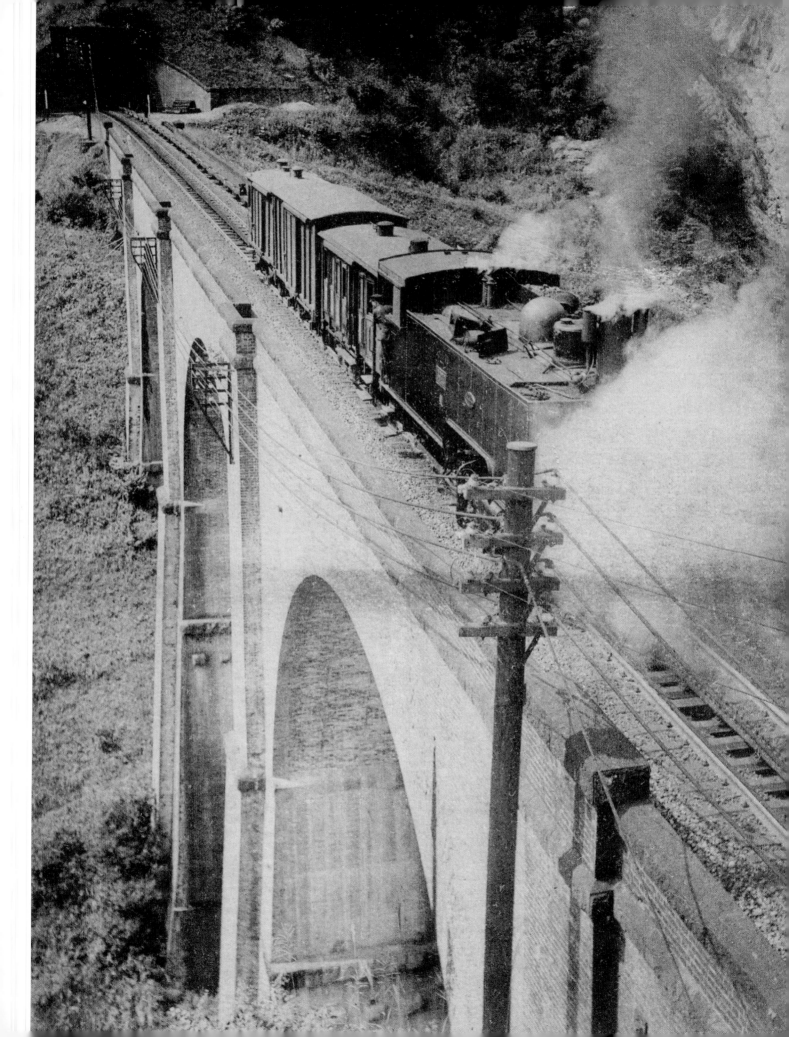

CHAPTER 7: 1895–1905
The Second Railway Mania and the Russo-Japanese War

The defeat of China in the Sino-Japanese War not only boosted Japan's self-image, but also went a considerable way towards creating the perception worldwide that Japan was henceforth a confirmed regional power with considerable potential of becoming a world power. In the aftermath of the war, a wave of energy swept the nation, and with that exuberance, Japan experienced a second railway mania. In the year after the war, according to one source, roughly 20,000 miles of competing projected railway lines were put forth by various proposed companies. Only a fraction received the approval of the Railway Council. Schemes were posited in all quarters of the realm for railway extension. The two years of 1896 and 1897 were remarkably active. 555 applications for provisional charters were received in 1896 alone. Private railways had by now become beyond question the primary builders of new railway line, the amount of private railway line increasing, on average, about 400 miles per year in both 1897 and 1898, a remarkable achievement when compared to prior years. The enthusiasm was not confined just to the home islands: railways using Japanese financial and technical backing were projected in Korea, where as a result of the war Japan's influence was now firmly recognized, as well as Taiwan, the one significant territorial gain ceded by China to Japan. (Japan had demanded and had been ceded the strategic Liaodong peninsula and other areas, but France, Russia, and Germany had interceded, nominally on behalf of China, but coincidentally in their own self-interest, in what became known as the Triple Intervention, to force Japan to retrocede all Chinese territories gained except Taiwan and the Pescadores, which quite naturally was bitterly resented by the Japanese populace.)

In the aftermath of the war, proposals were made to nationalize the private lines, to build a direct line through central Tōkyō to connect the Shimbashi terminal with the Nippon Tetsudō's Ueno terminal, a distance of 2½ miles, and to build a central station. Prior to this time, the German architectural firm of Ende-Boeckmann had been engaged to do city planning for Tōkyō, and the decision was made in 1895 to build such a line from Hamamatsucho station, just below Shimbashi, to the proposed site for a central station to be built in an area between the Imperial Palace and Ginza. It was suggested that the new line be constructed as an elevated line on an arched masonry viaduct, the underside of which could be rented for warehouse (*godown* was the term of the day) or shop space, thereby generating income to offset the high land acquisition and construction costs, similar to a plan that had been undertaken in Berlin. An appropriation of

¥3,500,000 was passed by the newly prorogued Diet to cover costs. It was proposed that the Nippon Tetsudō should thereupon build a line south from its Ueno terminus to join at a new central station. Even at this early date, it was realized that due to the land values, the cost of construction would be sizeable. The Nippon demurred; understandably perhaps in view of the high land acquisition costs the scheme would have entailed, and for a time the scheme was to complete the line as far as the new proposed central station site, which was planned to serve as a terminus until further construction funds could be made available. In 1896, planning for the new elevated railway was entrusted to Franz Balzer, of the Royal Prussian Railways' Stettin office, who had had a hand in the similar Berlin project.

The IJGR was called upon for the first time to participate in its first Imperial Funeral in January 1896. The Empress Dowager had died that month at Aoyama, and a special train was scheduled to conduct the Imperial coffin to Kyōto for burial alongside the Komei Emperor on February 2nd. There was accordingly something less than a month for the IJGR shops at Kōbe to turn out a suitable Imperial train for the occasion. There were at this point several Imperial carriages, based in both Tōkyō and Kyōto, but no bier carriage. With such little time at hand, work was focused on building the carriage for the Imperial coffin, while a first class and a first/second composite carriage were hastily converted to serve as new carriages for the Imperial Party. Japan's first State Funeral train consisted of four first class carriages, one first/second composite carriage, three second class carriages, the bier carriage, two goods trucks (converted for use for baggage), and three brake vans (for railway officials). Departure was at 2:00 p.m. from Aoyama and arrival at Kyōto was the following day at 8:35 a.m. According to the Imperial Railway Department, "locomotive tenders" (freshly stocked with water and coal, leaving one to wonder if the main locomotive was changed or not) were changed at Shinjuku, Yokohama, Yamakita, Numadzu, Shizuoka, Hamamatsu, Nagoya, Ōgaki, Maibara, and Baba. Lest there be any delays or mishaps, the train was double-headed over mountainous sections of the route. The top engineers and firemen were selected for the train, and two back-up engine drivers accompanied the train in case of mishap. Special carriages were held on reserve at all the planned stops, to cover any exigencies. Clearly, the care evidenced was befitting the Imperial responsibility assumed. The day had changed from the times when an Imperial Train could be routed through an improperly set turnout at main line speed.

Curiously, on the return trip, one of the few instances was recorded when the Emperor Meiji actually asserted his Imperial will by whim. The Imperial train was set to depart Kyōto at 8:55 am, but on the morning of departure, the Emperor requested to have the train depart twenty minutes later. When informed that this would wreak havoc in the IJGR's Tokaidō main-line schedule, he

The extremely short length of this train—two "brake vans" (cabooses) and a single box car—leads one to believe it was a special train either with an important cargo or for maintenance, repair, or "break-down" purposes. The location is the viaduct near the Usui (Shin'etsu) Line summit. The prodigious amount of steam seen escaping from the front of the locomotive seems to indicate it is in need of new cylinder packing to stop leakage: perhaps an ailing unit working its way back to shops for repair.

GOVERNMENT RAILWAYS.

LINES OPEN.

NO.	LINES	SECTIONS.	DISTANCES. M.	Ch.
1	TŌKAIDŌ.	Shimbashi (Tōkyō)-Kōbe.	376	31
		Ōfuna-Yokosuka.	10	3
		Ōbu-Taketoyo.	12	1
		Maibara-Kanagasaki.	31	1
		Baba-Ōtsu.*	1	23
		Fukadani-Nagahama.*	9	60
2	SHINYETSU.	Takasaki-Naoyetsu.	117	3
3	ŌU.	Aomori-Ikarigaseki.	35	60
4	HOKURIKU.	Tsuruga-Fukui.	38	40
		Total...............	631	62

LINES PROJECTED.

NO.	LINES.	SECTIONS.	DISTANCES.
3	ŌU.	Fukushima-Ikarigaseki.	263 46
4	HOKURIKU.	Fukui-Toyama.	85 18
5	Tokyo Elevated Railway.	Shinsenza-Yeirakuchō.	2 0
6	CHŪŌ.	Hachiōji-Nagoya.	222 73
7	SHINONOI.	Shinonoi-Shiojiri.	41 55
8	INYŌ-RENRAKU.	Himeji-Sakai.	135 27
9	KAGOSHIMA.	Yatsushiro-Kagoshima.	91 61
		Total...............	841 40

LINES OPEN.

NO.	COMPANIES.	SECTIONS.	DISTANCES. M.	Ch.
10	NIHON.	Uyeno (Tōkyō)-Aomori.	456	71
		Shinagawa-Akabane.	12	76
		Ōmiya-Mayebashi.	51	14
		Utsunomiya-Nikkō	25	0
		Iwakiri-Shiogama.	6	23
		Uyeno-Akihanohara.*	1	15
		Oyama-Mito.	41	45
		Mito-Nakagawa.*	0	62
		Oyama-Mayebashi.	52	17
		Shiriuchi-Minato.	5	4
		Tabata-Tomobe.	61	60
		Mito-Taira.	58	43
		Total........	771	30
11	KŌBU.	Iidamachi-Hachiōji.	26	77
12	KAWAGOYE.	Kokubunji-Kawagoye.	18	40
13	ŌME.	Tachikawa-Ōme.	11	40
		Ōme-Hinatawada.*	1	40
		Total.......	13	0
14	SŌBU.	Honjo-Sakura.	31	40
15	NARITA.	Sakura-Narita.	8	0
16	BŌSŌ.	Chiba-Ōami.	14	44
17	SANO.	Kuzuu-Koyena.	9	54
18	KANSAI.	Nagoya-Kusatsu.	72	33
		Kameyama-Tsu.	9	60
		Tsuge-Uyeno.	8	14
		Katamachi-Shijōnawate.	9	35
		Total........	99	35
19	SANGŪ.	Miyagawa-Tsu.	23	58
20	KYŌTO.	Nijō-Saga.	3	65
21	NARA.	Kyōto-Nara.	26	0

NO.	COMPANIES.	SECTIONS.	DISTANCES. M.	Ch.
22	ŌSAKA.	Minatomachi-Nara.	25	37
		Ōji-Sakurai.	13	31
		Tennōji-Umeda.	6	57
		Total..........	45	25
23	NANWA.	Takata-Gojō.	14	69
		Gojō-Futami.*	1	71
		Total.......	16	60
24	HANKAI.	Namba-Sakai.	6	22
25	HANKAKU.	Kanzaki-Ikeda.	6	57
26	SANYŌ.	Kōbe-Hiroshima.	189	62
		Hyōgo-Wadamisaki.*	1	64
		Total.........	191	46
27	BANTAN.	Shikama-Ikuno.	30	62
28	SANUKI.	Takamatsu-Kotohira.	26	70
29	IYO.	Takahama-Hiraigawara.	10	19
		Tachibana-Morimatsu.	2	60
		Total.........	12	79
30	DŌGO.	Dōgo-Komachi & Mimuro-machi.	3	6
31	NANYO.	Matsuyama-Gunchū.	6	66
32	KYŪSHŪ.	Moji-Yatsushiro.	143	35
		Tosu-Takeo.	33	0
		Kokura-Gyōbashi.	14	64
		Total.........	191	19
33	HŌSHŪ.	Gyōbashi-Gotōji.	18	30
34	CHIKUHŌ.	Wakamatsu-Usui.	28	65
		Nōkata-Kanada.	6	20
		Kotake-Kōbukuro.	3	42
		Total.........	38	47
		Grand Total.......	1641	72

PRIVATE RAILWAYS.

LINES, FOR WHICH CHARTERS HAVE BEEN GRANTED.

NO.	COMPANIES.	SECTIONS.	DISTANCES. M.	Ch.
10	NIHON.	Taira-Iwanuma.	81	64
14	SŌBU.	Sakura-Chōshi.	40	40
15	NARITA.	Narita-Sawara.	17	0
16	BŌSŌ.	Ōami-Ichinomiya & Naruto.	20	76
18	KANSAI.	Uyeno-Nara.	22	50
		Kidzu-Shijōnawate.	23	60
		Ōzumi-Yamata.		
		Total.......	46	30
19	SANGŪ.	Miyagawa-Yamada.	2	40
20	KYŌTO.	Kyōto-Nijō.	100	21
		Saga-Miyadzu.		
		Maidzuru-Amaribe.		
		Ajikata-Wadayama.		
25	HANKAKU.	Ikeda-Fukuchiyama.	60	23
26	SANYŌ.	Hiroshima-Akamagaseki.	130	1
27	BANTAN.	Ikuno-Wadayama.	14	18
32	KYŪSHŪ.	Takeo-Nagasaki.	64	69
		Haiki-Sasebo.	5	36
		Udo-Misuni.	16	20
		Total.........	86	45
33	HŌSHŪ.	Gyōbashi-Yanagigaura.	27	53
34	CHIKUHŌ.	Usui-Shinoyamada.	3	30
35	ŌTA.	Ōta-Mito.	12	18
36	ISOMINATO.	Mito-Iwaimachi.	8	26
37	KŌTSUKE.	Takasaki-Shimonita.	20	53
38	DZUSŌ.	Nagaidzumi-Tanaka.	10	41
39	TSUGARU.	Kidzukuri-Kuroishi.	19	70

NO.	COMPANIES.	SECT...
40	HOKUYETSU.	Naoyetsu-S... Niidzu-Nu...
41	CHŪYETSU.	Takaoka-Jo...
42	NANAO.	Tsubata-Na...
43	TOYOKAWA.	Toyohashi-I...
44	BISEI.	Ichinomiya-...
45	ŌMI.	Hikone-Fuk...
46	SEIWA.	Sakurai-Ma... Kawasi-Akos...
47	IGA.	Haibara-Mi...
48	HASE.	Nara-Sakur...
49	KAYŌ.	Kashiwara-...
50	KŌYA.	Sakai-Hashi...
51	KIWA.	Gojō-Waka...
52	NANKAI.	Minatomac...
53	NISHINARI.	Kawakita-S...
54	CHŪGOKU.	Okayama-Y...
55	KIRI.	Okayama-A...
56	KOJIMA.	Kurashiki-A...
57	KIBE.	Takahama-S...
58	KARATSU-KŌGYŌ.	Karatsu-Us...
59	IMARI.	Imari-Arita...
60	YAMAGA.	Yamaga-Mi...
		Grand...

LINES, FOR WHICH PROVIS... HAVE BEEN GR...

NO.	COMPANIES.	SECT...
14	SŌBU.	Funabashi-I...

Note: Footnotes appear under several columns: * Goods lines.

GENERAL RAILWAY MAP
OF
JAPAN.

MARCH, 1897.

SCALE : 1 / 3,200,000
JAPANESE RI

ENGLISH MILES

Inset map:

SCALE : 1 / 1,500,000
JAPANESE RI
ENGLISH MILES

Legend:

GOVERNMENT RAILWAYS.
LINES, OPEN.
LINES, PROJECTED.

PRIVATE RAIL...
LINE...
LINE...
LINE...

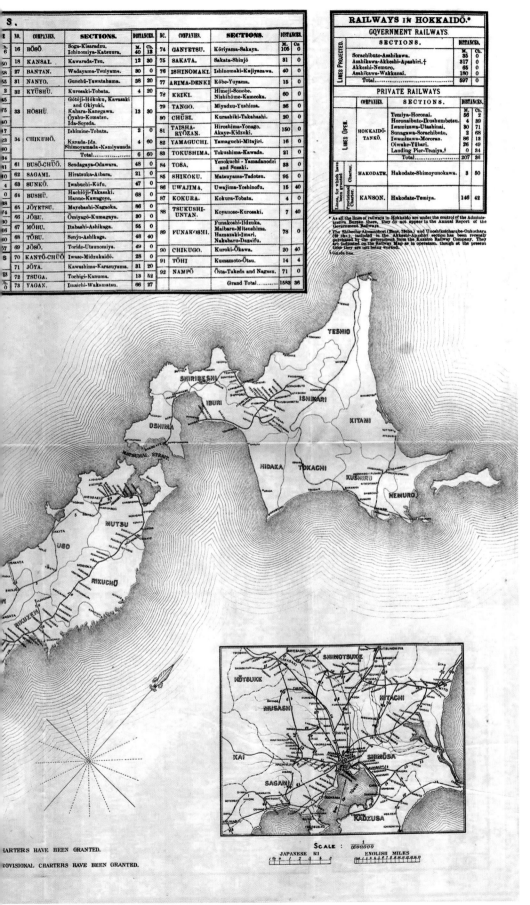

No.	Companies	Sections	M.	Ch.
16	BŌSŌ	Soga-Kisaradzu, Ichinomiya-Katsuura.	40	13
18	KANSAI.	Kawarada-Tsu.	12	30
27	BANTAN.	Wadayama-Tsuiyama.	30	0
31	NANYO.	Gunchū-Yawatahama.	38	20
32	KYŪSHŪ.	Kurosaki-Tobata.	4	20
33	HŌSHŪ.	Gōtōji-Hōkoku, Kawasaki and Okiyuki, Kahara-Kanegawa, Ōyabu-Komatsu, Ida-Soyeda.	13	30
34	CHIKUHŌ.	Ishimine-Tobata.	2	0
		Kanada-Ida.	4	60
		Shimoyamada-Kamiyamda.		
		Total......	6	60
61	BUSŌ-CHŪŌ.	Sendagaya-Odawara.	48	0
62	SAGAMI.	Hiratsuka-Aibara.	21	0
63	SUNKŌ.	Iwabuchi-Kōfu.	47	0
64	BUSHŪ.	Hachiōji-Takasaki, Hanno-Kawagoye.	68	0
65	JŌYETSU.	Mayebashi-Nagaoka.	86	0
66	JŌBU.	Ōmiyagō-Kumagaya.	30	0
67	MŌBU.	Itabashi-Ashikaga.	55	0
68	TŌBU.	Senju-Ashikaga.	48	40
69	JŌSŌ.	Toride-Utsunomiya.	49	0
70	KANTŌ-CHŪŌ.	Iwase-Midzukaidō.	28	0
71	JŌYA.	Kawashima-Karasuyama.	31	20
72	TSUGA.	Tochigi-Kanuma.	13	52
73	YAGAN.	Imaichi-Wakamatsu.	66	27

No.	Companies	Sections	M.	Ch.
74	GANYETSU.	Kōriyama-Sakaya.	105	0
75	SAKATA.	Sakata-Shinjō.	31	0
76	ISHINOMAKI.	Ishinomaki-Kajiyazawa.	40	0
77	ARIMA-DENKI.	Kōbe-Yuyama.	15	0
78	KEIKI.	Himeji-Sonobe, Nishihōme-Kameoka.	60	0
79	TANGO.	Miyadzu-Yushima.	36	0
80	CHŪBI.	Kurashiki-Takahashi.	20	0
81	TAISHA-RYŌZAN.	Hiroshima-Yonago, Akaye-Kidzuki.	150	0
82	YAMAGUCHI.	Yamaguchi-Mitajiri.	16	0
83	TOKUSHIMA.	Tokushima-Kawada.	21	0
84	TOSA.	Yenokuchi-Yamadanodzi and Susaki.	33	0
85	SHIKOKU.	Matsuyama-Tadotsu.	95	0
86	UWAJIMA.	Uwajima-Yoshinofu.	15	40
87	KOKURA.	Kokura-Tobata.	4	0
88	TSUKUSHI-UNTAN.	Koyanose-Kurosaki.	7	40
89	FUNAKOSHI.	Funakoshi-Iidzuka, Maibaru-Mitsushima, Hamazaki-Imari, Nakabaru-Dazaifu.	78	0
90	CHIKUGO.	Kuroki-Ōkawa.	20	40
91	TŌHI.	Kumamoto-Ōtsu.	14	4
92	NAMPŌ.	Ōita-Takeda and Nagasu.	71	0
		Grand Total............	1583	36

RAILWAYS IN HOKKAIDŌ.*

GOVERNMENT RAILWAYS.

	Sections	M.	Ch.
Lines Projected	Sorachibuto-Asahikawa.	35	0
	Asahikawa-Akkeshi-Apashiri.†	317	0
	Akkeshi-Nemuro.	65	0
	Asahikawa-Wakkanai.	180	0
	Total............	597	0

PRIVATE RAILWAYS.

	Companies	Sections	M.	Ch.
Lines Open.	HOKKAIDŌ-TANKŌ.	Temiya-Horonai.	56	2
		Horonaibuto-Ikushumbetsu.	4	39
		Iwamizawa-Utashinai.	30	71
		Sunagawa-Sorachibuto.	2	68
		Iwamizawa-Mororan.	86	13
		Oiwake-Yūbari.	26	49
		Landing Pier-Temiya.‡	0	34
		Total............	207	36
Provisional Charter.	HAKODATE.	Hakodate-Shimoyunokawa.	3	50
	KANSON.	Hakodate-Temiya.	146	42

* As all the lines of railways in Hokkaido are under the control of the Administrative Bureau there, they do not appear in the Annual Report of the Government Railways.
† The Shibecha-Atosanobori (Busi, 78chs.) and Uncoshikotcharube-Onkocharu (59 chs.), included in the Akkeshi-Apashiri section has been recently purchased by the government from the Kushiro Railway Company. They are indicated on the Railway Map as in operation, though at the present time they are not being worked.
‡ Goods line.

HARTERS HAVE BEEN GRANTED.

ROVISIONAL CHARTERS HAVE BEEN GRANTED.

SCALE : 1/1600000

JAPANESE RI

ENGLISH MILES

This map shows the extent of the railway network as projected on March 1897. By this point, many of the trunk lines on the Pacific coast of Honshū have been completed. Major building efforts were being concentrated on Hokkaidō, Kyūshū, Shikoku, and along the Sea of Japan coast. Many of what would become the commuter lines of Tōkyō are starting to appear.

was indignant and is reported to have crossly retorted by saying, "Why should it be impossible to re-arrange the schedule, considering that this is a special train for my use?" Obviously, his majesty had little inkling of what ramifications such a change would have caused on the timetable and railway operations of that particular day.

On the heels of war's end, a trend of marked service improvements was becoming evident among certain railways, starting with the San'yo Tetsudō's introduction of the first station porters, the *akabo* (lit. "red caps"). The war had given a boost to San'yo traffic and thanks to Nakamigawa's foresight, one of it's English language publications could boast,

> "...the entire track, with the exception of a section of six miles, is free from any sharp curves or heavy grades [both impediments to high speed running], while the road-bed throughout, because of its unusually solid construction, affords the smoothest and easiest possible running of trains."

As the century drew to a close, the San'yo overcame its lingering land acquisition woes and began to assume the form of a major trunk line. With typical San'yo vigor it showed signs (even before it had completed its mainline) of being the innovator among railways in Japan; a reputation it would cement in the course of following years. That innovations sprang from the San'yo is understandable when one considers that it faced the stiffest competition from well-established Inland Sea steamship lines that ran services to many of the towns along the line. In the earlier mentioned brochure-guide, the railway touted its innovations:

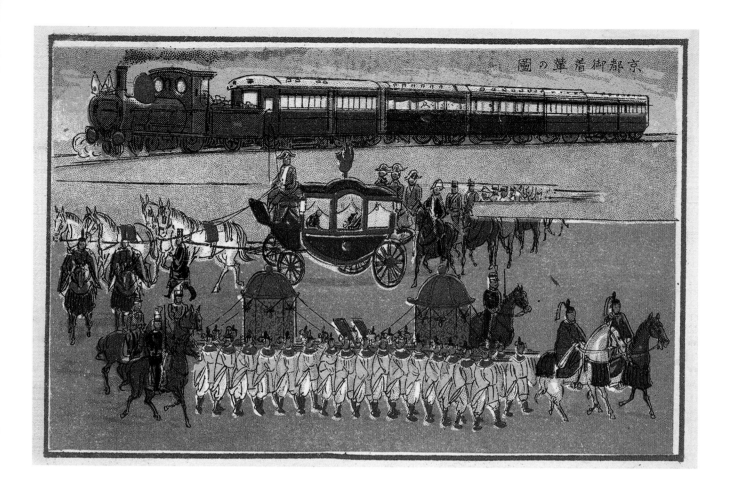

This postcard is believed to depict the funerary procession and train for the Dowager Empress Eisho. Shown in the foreground is part of the cortège in traditional court attire, followed by the Imperial Carriage, and at top the funeral train itself. The locomotive appears to resemble one of the Sharp Stewart D1 (later the 5000 Class) 0-4-2 tender locomotives that were among the first lot bought for the Kōbe–Ōsaka–Kyōtō route, although undoubtedly one of the newest and finest British or American 4-4-0s would have been used for the occasion.

> "...It is now conceded that in America the art of railway management has reached a higher state of development than elsewhere.
>
> The management of the Sanyo in the adoption of the latest modern inventions and appliances has taken America for its model, with the result that more attention to the comfort and convenience of travelers may be found on its line than on any other part of the railway system of Japan.
> ...
> In the winter season the first and second class carriages are well-provided with heaters, while at all seasons electric lamps on the night trains have superseded the clumsy and noisy English system of car-lighting."

The San'yo was a veritable fount of innovation. It kept its ticket offices open into the evening, bucking the archaic practice of limited sales hours then generally in place on other lines. It introduced group rate tickets, and tickets that were good for ten days rather than strictly for the day of issue. It made arrangements with the IJGR to operate a through-car service to Ōsaka and Kyōtō. (For it's part the IJGR was permitted to operate excursion trains over San'yo metals.) The San'yo instituted a half-rate return fare for round-trip tickets on longer distance bookings. It was the first to adopt the American system of through-checked baggage. At a time when no dinning cars were operating in Japan, a San'yo first class passenger could order catered meals at stations along the line that would telegraph the order, free of charge, to certain stations farther along the line with catering facilities so that a hot bento box meal (*choice of Western or Japanese cuisine*) would be waiting at the next catering station on the train's arrival. Its improvements were not always focused on passenger traffic: among the innovations introduced by Nakamigawa's proud line were the first widespread use of American-style freight cars on trucks outside Hokkaidō, and some of the first steel-bodied wagons, for coal haulage. As noted, the San'yo was one of the more enthusiastic early adopters of American-built locomotives, while the more conservative Nippon Tetsudō continued to remain loyal to British-built locomotives for some time.

1896 saw the introduction of class color coding that was to become a future nationwide standard when the seven year-old Kansai Tetsudō started coloring first class tickets white, with a corresponding white stripe along the sides of first class passenger cars, blue tickets and car stripes for second, and red for third class. By 1898, the first electric lighting had been introduced on San'yo passenger cars as noted and in the same year, the innovative San'yo had introduced "car boys," young men who served on-board trains; what we would today call stewards or attendants.

"Car Boys" came to be an institution, and as demeaning as it sounds today to have the word *Boy* embroidered on the collar of

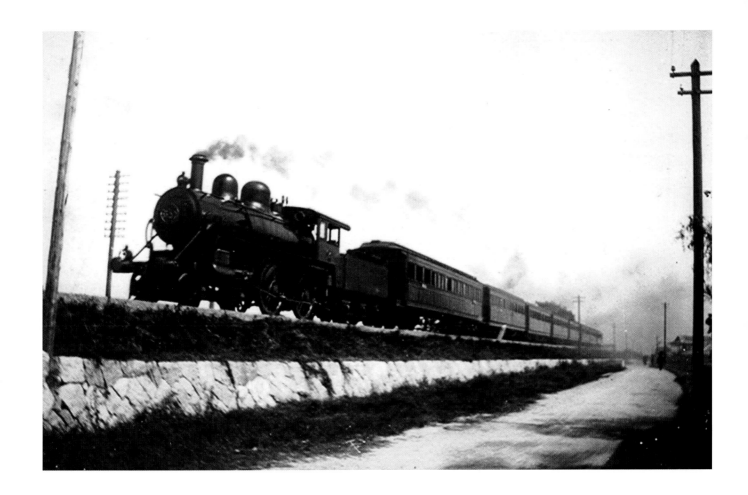

one's uniform (as the car boys of the Japanese railway service did), at that time, when the word hadn't acquired such a pejorative connotation, it was undoubtedly taken with more of a matter-of-fact reaction. Apparently, they outshone many of their American counterparts—Pullman Porters who were grown men. One American effused, "There are [in Japan] all the modern conveniences to be found on an American train, including politeness on the part of trainmen, which goes much further than our popular notion of civility. … The nattily uniformed 'boy,' who is called that even by the Japanese themselves, is a sort of ideal Pullman porter, who attends to his duties as no [American] Pullman porter would think of doing, and smiles his sincere gratitude for the few coppers that a thankful passenger gives at the end of the journey."

In point of fact, another traveler found the number of youths who held jobs of not inconsiderable responsibility on Japanese railways remarkable. These were perhaps the young people of whom Surgeon Purcell was speaking in the 1870s: "…youngsters, old-fashioned before their time by reason of their need to work for their daily food from tender years…" Teenage boys occupied every post from the car stewards to the ticket collectors at the wickets (the British ticketing system was employed), to the station booking and ticketing agents, to the train guards who rode in the trains' baggage cars and were responsible for applying train brakes and acting as safety lookouts, often chosen for having some ability in English language in order to be able to assist foreign travelers in case of need. Young girls as well were often used as what the British called *crossing guards,* the worker who closed the gates at roadway crossings to stop traffic on the approach of a train.

A Schenectady D12 Class (6400 in the 1909 renumbering) locomotive is seen handling an IJGR excursion train to Maiko beach via the San'yo Tetsudō mainline before the outbreak of the Russo-Japanese War. The photo dates to sometime between 1902 and 1904. Among American builders, Schenectady, Brooks, and Rogers all were very active in solicitation of orders from Japan, along with their principal competitor, Baldwin. These locomotives were results of the first competitive bid process undertaken by the IJGR. The 6400 class is easily recognized by its distinctive asymmetrical cab-side window configuration.

The San'yo was not alone in the introduction of innovations. On November 21, 1898 the Kansai railway, which had been inching eastward from Ōsaka, by a combination of mergers and construction of new lines, reached Nagoya, thereby creating the first alternative rail route between the two cities in competition with the IJGR's Tokaidō line, and the first instance of significant genuine competition in Japan's brief history of railway operations. Not oblivious to the need to project its image over that of the IJGR with which it would have to compete, the Kansai built an imposing Neo-renaissance station in Nagoya that compared very favorably to the one-story wood-frame and tile roof standardized IJGR design station,[1] such that for a while, the Kansai Railway's Aichi Station became known locally as the *Gateway to Nagoya.* That competition was in large part responsible for ensuing service improvements by the IJGR and started a process whereby the IJGR was prodded into improvements in order to meet the new competition arising from private companies. But not all private railways launched headlong into service improvements. While the San'yo was developing the reputation of being an innovator, the Nippon Tetsudō was developing a reputation for being hidebound and for

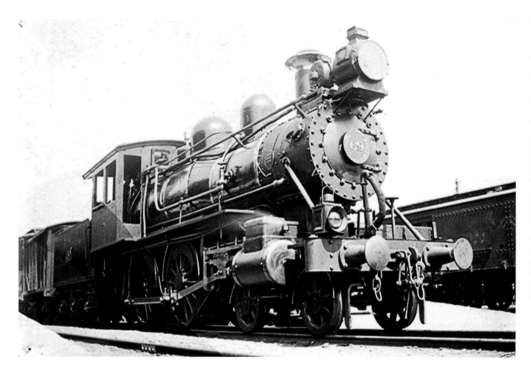

This view of a San'yo Tetsudō 4-4-0 shows the classic lines of a high-drivered (for Japan's narrow gauge) 5' 0 ¾" Baldwin express passenger engine introduced in 1897. On absorption into the IJGR roster, its class was designated the 5900 Class after nationalization. The San'yo Tetsudō had perhaps the best reputation as being one of the more innovative and best-equipped railways in Japan at that time. Note the state-of-the-art steam turbine electric generator situated between the headlamp and chimney to power the large American style headlamp, the likes of which would enable the San'yo to equip its passenger fleet with electric lighting. (Nevertheless, the marker lamp on the buffer beam is a thoroughly British oil lamp.) Just to the right of the buffer beam is a San'yo iron-plate open wagon for heavy coal traffic. Such a wagon, at a time when most Japanese railways were using wooden-bodied varieties, is another example of the San'yo's forward-thinking philosophy.

treating its customers with something approaching condescension.

There was a need for service improvements in many aspects of the typical Japanese passenger train of the day. With the advent of the first trains, anything was a luxury when compared to making an overland journey by foot, on horseback, in a *kago*, or by one of the few stagecoach lines then operating, but by the 1890s, matters had progressed to the point in Japan that issues of passenger comfort were being considered. As late as 1894, it was ill-advised to attempt to read at night in a typical Japanese passenger car, as Francis Trevithick noted when lamenting the low grade rape oil, inferior type of burners, and poor wick trimming in the standard oil lamps for lighting; this at a time by which most of the American and European passenger car fleets had long been equipped with the superior Pintsch compressed oil gas system, and many had been fitted with electric lighting. The first electric lighting only began a very gradual conversion of the existing fleet.

On another point of traveling comfort, Kadono Chōkyūrō observed:

"As regards passenger accommodation there still is plenty of room for improvement. When distances were short and traffic local, what accommodation there is was sufficient; but as at present the continuous lines or rails between Shimonoseki (Mitajiri) in the south and Aomori in the north reaches about 1,000 miles, a through passenger, unless of the most robust constitution, cannot undertake the journey without one or two stoppages for recuperation. Under the best circumstances, a railway journey over ten or twelve hours is tiresome enough (unless passed in sleeping), but when it comes to 1,000 miles without proper accommodation, one shrinks from the attempt. Refreshments are obtainable at almost every station, but travelers from foreign countries generally provide themselves with wicker baskets from the hotels, instead of relying upon station refreshments for subsistence.

In warming the carriage in winter, the old-fashioned, awkward hot-water foot-warmer is used. The heat from these usually proves to be rather pretense than an actuality, especially in the north."

A foot-warmer was a large zinc or tin container, often wedge-shaped like a footrest, with a screw cap on one end, into which boiling water was poured. Kadono is speaking of the situation on Honshū, where British practice was in place. Trevithick agreed that the imported British institution of the foot-pan, which was provided only to first and second class passengers, was unacceptable, particularly in its total absence from third class carriages: "[T]he Japanese kimono is not a garment which offers great protection against cold when the wearer has to place himself upon a wooden railway seat, and unless provided with warm wrappers, which the majority of third class passengers do not possess, a long journey at night during the winter must prove a very trying undertaking."

Of course, foot warmers were only good for as long was the water in them remained hot. Trevithick was mindful of "the inconvenience and annoyance to passengers of continually changing foot warmers on a long night journey" when he noted that a patent foot warmer using a newer chemical technology of acetate of soda in place of water could be adopted, which held its heat for 8 hours: nearly 3 times longer than ordinary water, which lasted only about 2½ hours. (Japanese railways by and large used plain water.) One can only imagine the scene in winter some two and a half hours after a train had gotten underway as a mad scramble ensued at the next station to exchange spent foot warmers for fresh ones. The use of foot warmers, of course, is a result of following English practice on Honshū. On Hokkaidō passengers fared better, as its American-style passenger cars had been equipped with a cast iron coal-burning stove for heat in each car from the beginning of railway services there. Steam heating wasn't introduced until very late in the Meiji era, commencing in 1903, and then only slowly. The

exception was the San'yo which had installed steam heat on all its express trains by 1904. Noted one weary American in that same year: "There is only one experience so cold and cheerless as a winter trip on some of the English railways—and that is a journey in the snow season on a train in Japan."

Other areas where Japanese railways lagged behind their Western counterparts were in clear definition of their responsibilities and liabilities as common carrier vis-à-vis the traveling public, shortage of motive power, freight facilities inadequate to handle demand, and shipping delays. This latter had risen to such a level around this time that complaints were raised that lags caused a delivery time of from ten to fifty days for a journey that should have taken only one or two by rail. Such was the excess demand for railway shipment of goods that when one particular shipper asked for a discount from the Nippon Tetsudō, the general manager would not allow for any discount at all if the shipper shipped 10,000 tons of freight or 100,000 tons. Freight hauling concerns took second priority to passenger traffic for almost the entire Meiji era.

The Sino-Japanese War only exacerbated the situation. The writer W. E. Curtis recorded the flavor of passenger service at the War's end,

> "While the railway management in Japan is in many respects admirable, they have an aggravating way of changing the schedules of trains without the slightest notice. People never know when or why a train is taken off, or the hour of its departure postponed. Sometimes a regiment of troops coming home from the war [with China] will disarrange the whole service. A member of the ministry, or some high public functionary, may want to take a trip by a special, and the railway managers will take off one of the regular trains to accommodate him. Such incidents are occurring every few days, and of course someone always suffers annoyance in consequence."

* * * * * * * * *

By the war's conclusion, railways were ever increasingly becoming an integral part of the lifeblood and social fabric of the nation and as the network expanded, the effects began to be felt throughout the realm. In remote villages, the pace of life, as in countless small towns in America and Europe, began to be marked by the arrival and departure of trains. Newspapers and periodicals arrived on those same trains, helping to form public opinions in a novel manner with a speed hitherto unknown. With the advent of small parcels service by the railways, many items previously out of reach began to become more easily available to the well-off. Foods hitherto unavailable gradually became within reach. All manner of consumer goods once difficult to come by in the provinces were in reach if a person was wealthy enough to order them. The foreign tourist and domestic traveler alike were given a reasonable hope of finding bottles of Bass India Pale Ale or cans of corned beef from the packing plants of Chicago on sale in even modest sized towns where only twenty years hence finding a live chicken to buy and cook for dinner was not always possible. In any given town, the railway station became both a hub of activity, a civic forum, and the backdrop before which many of the notable incidents of the day would play out. The writer Lafcadio Hearn recorded one. On June seventh 1896, a passenger train, probably piloted by one of the American-built 4-4-0s or Moguls then favored by the Kyūshū

The introduction of rail technology to Japan brought with it improvements not always appreciated today. A case in point is the trolley shown in this postcard. Modern day readers are likely to assume that it is a street washer and in a sense, it is. But a clue to its real purpose is found in the broken English caption of "Powder Water Electric Wheel." At a time when many of Japan's roads and streets were still of unpaved dirt, they could be muddy quagmires in wet season. But in the dry season of summer, particularly on heavily-trafficked roads, the amount of dust created by that traffic could be prodigious. This trolley was Ōsaka city's answer. Its purpose was to spray dusty roads with water during the dry months to make the dust lay and thus alleviate the problem until another pass was needed; surely a welcome improvement for many a nearby housewife or shopkeeper weary from dusting. In addition to keeping the air cleaner, the trolley also presumably cooled down many a young boy on a hot summer's day who was bold enough to play trolley dodger.

Tetsudō for passenger service, pulled in to Kumamoto station, which was mobbed with a crowd of people. Hearn was among them and recorded the event in his short story *At a Railway Station*. On the train was Nomura Teichi, a thief who was wanted for the infamous murder of a well-known and much respected Kumamoto policeman named Sugihara some years hence, and the news of his apprehension had spread rapidly enough throughout the city, which still had not forgotten the crime, that there formed a curious crowd to await the train's arrival. Behind the ticketing gate in the throng that day was the policeman's widow and his small son, unborn at the time of the murder. As the thief and his police escort moved through the wicket, the escort called forth for the wife of the fallen man, who approached with the little boy. At that point according to Hearn's narrative, the escorting officer broke the silent tension in low and certain words; "Little one, this is the man who killed your father four years ago. You had not been born; you were in your mother's womb. That you have no father to love you now is the doing of this man. Look at him—look well at him, little boy! Do not be afraid. It is painful; but it is your duty. Look at him!" The crowd stood silent as the boy did indeed look the man in the eye, gazing "with his eyes widely open, as in fear; then he began to sob; then tears came; but steadily and obediently he still looked—looked—looked—straight into the cringing face," as the thief broke down, kneeling on the platform in contrition. As the man was brought to his feet he begged for pardon of the small boy and the crowd parted to make way, silent and touched. Hearn then saw "what few men ever see, … the tears of a Japanese policeman." By the time it was written, Hearn's short story could have happened in any one of an increasing number of small provincial towns and bears eloquent witness to the fact that by the 1890s, a railway station in Japan had unmistakably taken a

By the opening years of the 20th Century, railways were starting to integrate themselves into the national psyche of Japan in all the ways they had in the West. This included new generations of children who grew up taking for granted forms of transport that their parents and grandparents thought of as revolutionary. In this obviously posed view, two young boys are seen participating in that process as they play with toy trains most likely imported from Europe. Typically, only the sons of a family of above-average means would have had such expensive toys in the Meiji era. On the blackboard is written the picture's title: "Well...This time, let's play with our toys!"

central place of importance in civic life of the nation; no less than the *depot* did in small-town America.

One of the most lasting examples of the integration of railways into the daily fabric of Japanese life from this time is "The Railway Song" (*Tetsudō Shōka*), written by Owada Takeki to celebrate the opening of the Tokaidō Line. The lyrics describe a trip from Shimbashi southward along the new line, with each station being the subject of a verse.

The first verse reads:

Kiteki issei Shimbashi wo
Haya waga kisha wa hanaretari
Atago no yama ni irinokoru
Tsuki wo tabiji no tomo to shite

A rough approximation:

With a single whistle-blow,
My train departs Shimbashi.
The moon, set low, o'er Atago,[2]
Goes with me on my journey.

The song became immensely popular and to this day continues to be a time-honored children's song. The first few verses are by now as hoary an old chestnut of Japanese children's pop-culture as "*I think I can, I think I can, I think I can*" is of American. Such was its popularity that when the San'yo line was completed to Shimonoseki in 1901, additional verses for each station along that line were added, and must have rendered the song utterly monotonous to sing in its entirety.

Naturally too, railways came to be the subject of the humorous side of daily life in Japan and did not escape public satire. In the comments to one of the lectures on Japanese railways which was given by Kadono Chōkyūrō at the local Asia Society, one worldly Hungarian wag, a certain Mr. Diósy, was recorded as having gone on record in the discussion that ensued after presentation with the tongue-in-cheek observation that:

"So well had the Japanese learned their lesson from our [Western] railway management that he was informed that at various stations in Japan, trains came in as much as forty-five minutes after the time advertised in the time-table. He also believed that many of the railway carriages were exceedingly draughty; and he had the authority of Professor Milne[3] for saying that the names of the stations, as called out by porters, were perfectly indistinguishable, which showed that the best traditions of [Western] railway management were being carried out in Japan."

Heating inadequacies and porter's intonations notwithstanding, improvements continued apace. On May 25, 1899, the San'yo introduced Japan's first dining cars on its premier trains, and a

Pictured here is one portion of an early surviving San'yo Railway menu (announcing "We are ready for your Lunch") from the San'yo's very first years of dining car operation, before nationalization in 1906 rendered "San'yo Railway" an obsolete term, replacing it with the San'yo Line of the IJGR. Unfortunately, the other portion of the menu has been lost. The Kyōto-based Mikado Hotel assumed operation of the San'yo's dining car services as a concessionaire in 1901, a position it held until 1938 when its operations were merged with those of another concessionaire. Aki oysters, a celebrated variety, have long been cultivated in the area around Hiroshima as a particular delicacy. The first laws regulating oyster cultivation in that area date back to the Tenmon period (1532–1542). The Aki oysters on the menu are an example of the San'yo's efforts to make its service more appealing than those of the well-established Inland Sea steam boat lines against which it competed. Before delivery to the San'yo dining cars at the start of the run in Kōbe or Shimonoseki, the oysters would have been shipped in special closed box cars or vans, with louvered ends and sides and purpose-built racks of tray tanks containing saltwater to ensure live delivery.

year later, the San'yo again took the lead with the introduction of the first sleeping cars in the realm. By 1900, Basil Chamberlain, Professor Emeritus at Tōkyō University, would write, "The arrangements of this line [the San'yo Railway] for the comfort of travelers are superior to those of the government and other private lines. It alone has had enterprise enough to provide dining and sleeping-cars."

Finally, on May 27, 1901 the San'yo completed its mainline to Shimonoseki, Japan's port of embarkation for the Asian mainland and for Kyūshū. As might have been expected, the San'yo immediately put a steamer service in operation with its own small steamers to cross the two-mile straits to the Kyūshū railhead at Moji. (The San'yo had previously put steamer services in place between Shikoku and Hiroshima.) By 1904, the San'yo could also boast that it was operating the fastest express trains in the realm, although at an average speed of just under 29 miles per hour, it was more telling of the poor speed of the other lines than any true boast of speed compared to average express speeds worldwide. Also from the San'yo Railway's efforts came the first joint luxury express train in Japan, which commenced running between Tōkyō and Shimonoseki in 1905 consisting of all first and second class carriages, sleeping cars, a dining car (worked on a concession basis by the Union of Lunch Box Salesmen), and later possessing Japan's first observation/lounge car at the end. The new super-express was called eponymously the Shimbashi–Shimonoseki Special Express. After the period covered by this book, when a sister express which included third class accommodation was added and named the *Sakura* ("Cherry Blossom"), the

Shimonoseki Express, as it was then commonly known, would be rechristened the *Fuji* and the two would become the most celebrated of Japan's pre-World War II expresses. Due in part to the speed restrictions implicit in a narrower gauge, the speed of the new express, while novel by Japanese standards, fell well short of the mark of American and European speed standards: the average speed was 47 miles per hour, while in the US and Europe, average speeds on the best express trains at the beginning of the 20th century were in the neighborhood of the 60 mph mark.

A writer who traveled on the San'yo Express at this time was surprised to learn that budget conscious travelers in first class could book a berth on San'yo sleeping cars on a half-night basis. First class berths were surcharged at 2 *yen* 50 *sen* for the entire night, but only 1 *yen* 50 *sen* for a half-night. Second class sleeping berths were evidently seen as enough of a bargain at 20 *sen* for the top berth or 40 *sen* for the lower, such that no half-night discount was offered.

1897 saw the importation of the first locomotives with the "Atlantic" 4-4-2 wheel arrangement from the Baldwin Locomotive Works in Philadelphia for use by the Nippon Tetsudō. In that same year, the Nippon Tetsudō took delivery of a type of locomotive that had never before been built in the world in any great quantity, but would prove to be such a versatile design that thou-

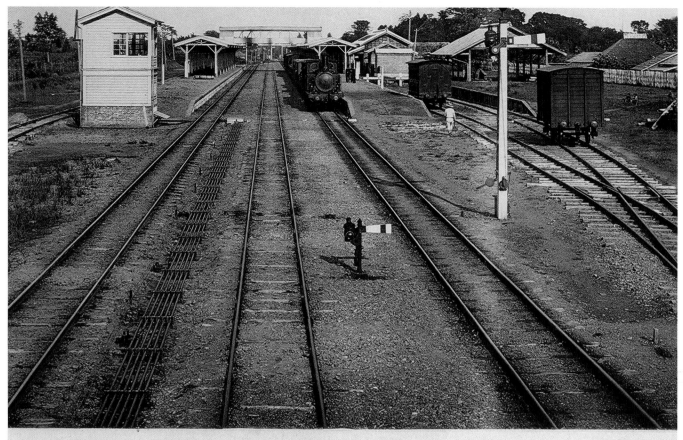

Abiko Station yard, Nippon R. R.

A short freight train trundles through the station at Abiko on the Nippon Tetsudō. Abiko is located on the Nippon Tetsudō Jōban line, approximately 40 kilometers from Ueno. The locomotive appears to be one of the Beyer-Peacock 0-6-0T tank engines imported starting in 1896 that would be designated the 1900 Class when absorbed into the IJGR's roster upon nationalization. Note the short wheelbase compartment carriage in the station bay and the freight station consisting of nothing more than a canopied roof between it and the boxcar on the adjoining siding. A track ganger appears to be walking towards the station staff standing on the platform. Abiko, the junction from which the Narita Tetsudō departed for Narita, was deemed busy and significant enough to merit a full British style signal box. Over all, the British influence is clearly evident in the station configuration and signaling. In a scene unchanging worldwide, irrespective of era, the train has captured the attention of three small boys (to the right of the boxcar) who have stopped to watch as it passes by.

sands of the type later would come to be placed on American railroads. There were significant coal reserves to be found in the Jōban coalfields that were situated along the new Jōban line of the Nippon, but the coal was hard anthracite, not top quality bituminous "loco coal." When the line opened in 1897, the Nippon naturally wished to use the local Jōban anthracite coal rather than the costlier coal transported from outside the Nippon's service area.

The wider Wooten firebox of the Atlantic type locomotive (a wheel arrangement suitable for fast passenger trains, which were comparatively light in weight) was well-adapted to burn such coal; hence the Nippon's ordering a number of this locomotive type from Baldwin. However, the Nippon management also wished to have a heavy freight locomotive that would operate effectively on Jōban anthracite. Baldwin was consulted on this point as well, and it confidently promised it could satisfactorily design a locomotive

that would perform suitably burning the Jōban anthracite, although no such designs existed at the time. The Nippon awarded it a contract for several, and Baldwin's designer-draughtsmen took to the drawing boards. What evolved was a conventional "Consolidation" type 2-8-0 locomotive of the day—at that time, the freight locomotive of choice of many American railroads—but with a much larger and wider Wooten firebox. This firebox enabled it to burn Jōban anthracite, while at the same time produce a heating capacity equivalent to a conventional firebox that could only perform well on higher-grade "loco coal." The result was a locomotive with roughly a comparable amount of pulling power, using coal of a lower caloric value. As the firebox needed to be much wider than the typical firebox, it could not be fitted between the rear driving wheels of the locomotive as was conventional; hence its place in the new design was behind the driving wheels, and a small set of wheels was placed beneath to support its weight. There had been a few scattered 2-8-2 type locomotives built earlier, but the result of the Nippon Tetsudō's order was the world's first class of 2-8-2 locomotives in any number. The type was dubbed the "Mikado" type to honor Japan and its Emperor and proved to be such a serviceable design that Baldwin capitalized on the design's potential for other customers. Other builders followed suit, and eventually many thousands of these very versatile Mikado types would be appearing on railroads in America and throughout the world, where they quickly became the workhorses of freight haulage. The Mikado design, which had for its proving grounds the Nippon Tetsudō lines running through the Jōban an-

tracite coal beds, would be destined to remain one of the world's most common types of locomotives well into the 1930s.

Moves were afoot to establish locomotive manufactories and additional rolling stock manufacturers, not only for domestic purposes but also in anticipation for increasing demand that was expected to occur as China, Korea, Thailand and other countries on the mainland started railway building more extensively. First to be established were private rolling stock manufacturers, such as Hiraoka Kojo, founded by Hiraoka Hiroshi, the first Japanese Superintendant of Shimbashi Works. Then the first locomotive manufacturer, the Ōsaka Kisha Seizo Goshi-Kaisha, commenced business in 1896. It was founded by no less a personage than Inoue Masaru, who had retired three years before its founding from his post with the IJGR, and obviously saw his talents and reputation in developing Japanese railways as best applied in newer endeavors. The firm he founded would go on to merge with Hiraoka Kojo in 1901 to form the legendary Kisha Seizo Kaisha. Competitors also entered the field, and by the end of the Meiji reign loco builders such as Atsuta Tetsudō Sharyo (1896), the celebrated Nippon Sharyo (1896), and the world-renowned Kawasaki (an existing shipbuilder whose railway rolling stock manufacturing commenced in 1906) were on their way to making a name for themselves.

The days of the railway *yatoi* were almost at a close. From a high of some 200 *yatoi* who were first engaged in the first years of building, by 1882 that number had dropped to 21, and by 1895 had dropped to only 6, by which point, the day-to-day management of the lines was entirely in Japanese hands. The remaining half-dozen *yatoi* were in positions like that of the Trevithick brothers, who were among the last to go.

Partly as a result of the war with China, labor costs had risen, as had the prices of foodstuff and the cost of living in general. It was reported that the wages of coolies had risen by a factor of almost 100% between 1886 and 1896. By 1897 track or plate-layer gangs, normally consisting of seven men assigned to a two mile single line section, consisted of the following positions and wages: two at twenty cents a day, two at 24 cents a day, one at 27 cents a day, one at 30 cents a day, and one at 35 cents a day. Foremen for these gangs normally were assigned sections ranging from ten to twenty miles and were paid the equivalent of 40 to 75 Mexican cents per day accordingly. While prices and wages were rising generally across Japan, railway wages were stagnant on many lines, and labor unrest ensued, first in the paint shops of Shimbashi, but later notably on the recalcitrant Nippon Tetsudō, where one of Japan's first and most effective major labor strikes occurred in 1898. The strike was noteworthy enough to merit mention in the foreign press. The Nippon Tetsudō had been the subject of complaints of poor treatment of its employees for some time and had in fact *lowered* the pay of engine drivers and firemen. Quite naturally in a time of rising cost of living, the affected staff had repeatedly petitioned for higher wages, all to no avail, to

(top right to bottom)
A Dubs product ordered for and used by the Nippon Tetsudō, despite the caption. This 4-6-2T tank locomotive class consisted of four members that were introduced in 1898. The Nippon Tetsudō remained partial to British locomotives long after the other major railways had become customers of American locomotive builders in ever increasing degrees. This locomotive came equipped with a steam actuated reversing gear, something of an innovation for the day. The confusion in the foreign press of Victorian and Edwardian times as to which railway had purchased locomotives was due to the Japanese Government, through the Railway Bureau, acting as a purchasing agent on behalf of private railways, which the technical press of the day mistakenly assumed meant automatic use by the IJGR. The locomotives were designated as the 3800 Class upon nationalization.

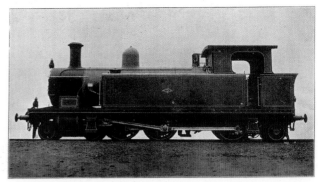

FIG. 225.—PASSENGER TANK ENGINE FOR THE 3 FT. 6 INS. GAUGE, IMPERIAL JAPANESE RAILWAYS.
Built at the Glasgow Works of the North British Locomotive Company, Ltd.

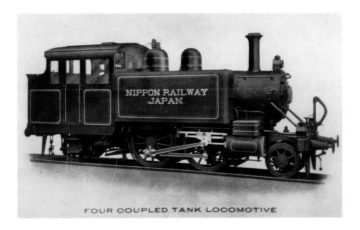

FOUR COUPLED TANK LOCOMOTIVE

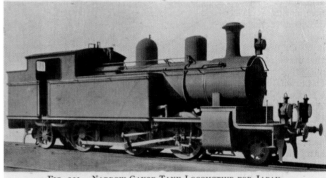

FIG. 221.—NARROW GAUGE TANK LOCOMOTIVE FOR JAPAN.

Twenty-six of these neat little Columbia type 2-4-2T tank locomotives were imported in 1898, the last year of importation of American examples of this particular type of small locomotive to Japan, although importation of British-built A8s would continue up to 1904. Schenectady was the builder, and the locomotives would become IJGR Class 900 under the 1909 numbering scheme. This builder's photo however shows a class member "as-built" for the Nippon Tetsudō, complete with English language tank-side road name. Liveries such as this typically lasted no longer than the first re-paint, however photos do exist of a Nishinari Tetsudō British-built A8 locomotive with the road name spelled out in the Romaji alphabet. As the style of the lettering on the Nishinari tank loco was American, not British, the lettering was almost certainly applied in Japan, probably as a public relations device at a time when anything foreign was faddishly seen as progressive.

A builder's photograph of one of the Hannover 2-6-2T "Prairie Tank" type locomotives built in 1904 for the Nippon Tetsudō, a neat hybrid of British and German design practice. Six of these locomotives were imported from Germany for mixed service and were assigned Class 3170 during the 1909 renumbering.

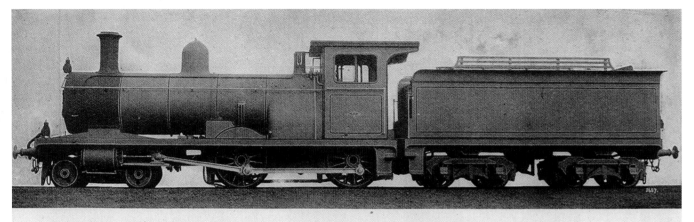

FIG. 180.—NARROW GAUGE PASSENGER LOCOMOTIVE FOR THE IMPERIAL RAILWAYS OF JAPAN, BUILT BY THE NORTH BRITISH LOCOMOTIVE COMPANY, LTD., GLASGOW.

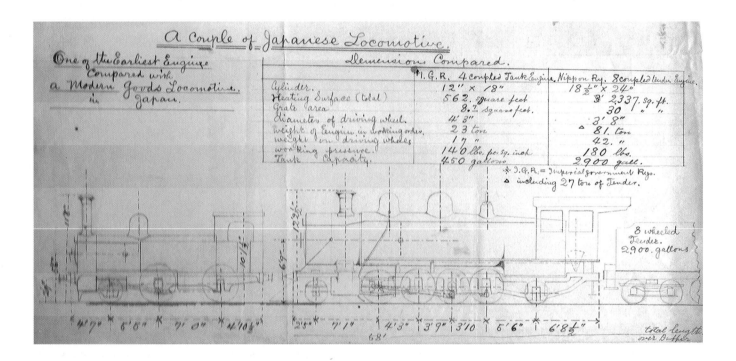

(top)

The Nippon Tetsudō (again, not the IJGR as captioned) ordered two of these small-drivered 4-4-0 locomotives from Dubs in 1898. They would be designated as Class 5830 upon nationalization. The two-truck tender used in this class is unusual and seems almost disproportionately large compared to the locomotive. Most of the tenders for the British-built locomotives were rigid wheelbase six-wheel tenders. As the Nippon Tetsudō was never known for particularly fast running even by the slow Japanese standards of the day, the small diameter of the drivers would not have been unusual. Note the wide firebox. In the decade before Nationalization, the Nippon Tetsudō began to order some forward-looking designs, and became increasingly sensitive to locomotives that could burn the anthracite coal that was available in the Jōban region through which it ran once its Jōban line was opened in 1897.

(above)

A relative comparison is made in this general arrangement outline between one of the earliest tank locomotives and the world's first mass-produced 2-8-2, built in 1897 by Baldwin for the Nippon Tetsudō to burn an anthracite coal from the Jōban coalfields situated close-by the railway's main line. These locos were designated Class 9700 on nationalization. The 2-8-2 locomotive type was dubbed the "Mikado" wheel arrangement in honor of the Meiji Emperor; a name that came to be used throughout the English speaking world as the shorthand term for this versatile wheel arrangement. From a 1903 pen and ink drawing by Kashima Shosuke.

the point where they formed an association to militate on their behalf. Management responded by terminating the employment of the employees it perceived to be the primary instigators. The ploy backfired and only served to stiffen the resolve of the rank and file who began circulating strike notices to all stations up and down the line at the end of February 1898. Traffic movement came to a standstill. Part of the strike resulted from the feudal mindset of management, many of whom came from the former Samurai class and still comported themselves with the attitudes by which they had been raised. At the time, the IJGR had a four-grade ranking system, which many other railways, the Nippon included, followed. In descending order the grades were titled *Chokunin-kan, Sōnin-kan,* and *Hannin-kan* roughly translated "Imperially Appointed Official," "Official Appointed with Imperial Approval," and "Junior Official" respectively. At the bottom was a fourth class that didn't even merit an official class title, consisting

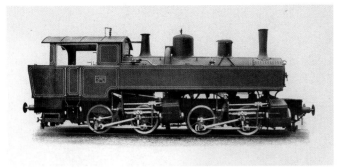

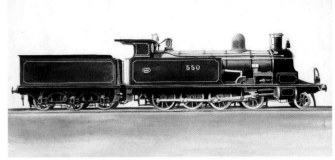

The Nippon Tetsudō took delivery of this Mallet compound 0-4-4-0T locomotive from the German builder Maffei in 1903. A slightly different sister locomotive was ordered for comparison. Together, these two examples were the first Mallet type locomotives imported to Japan. The design was a natural for Japanese operating conditions with its four cylinder drive in place of the usual two, and articulated front power unit to negotiate tight curves necessitated on mountain lines. They were a type well-suited for mountainous freight haulage or banking duties. The locomotives were 1067mm versions of similar locomotives that had been built for the Royal Bavarian State Railways, but were heavier, had larger fireboxes, and larger water tanks, all of which resulted in slightly greater tractive effort. Nationalization cut short further purchases, and when the IJGR began purchasing Mallet locomotives, it was for much larger Alco 0-4-4-0 tender locomotives from the US for heavy freight hauling.

An interesting comparison can be also be made between the Kōbe-built F1 (later 9150) class Consolidation locomotive for the IJGR shown here and the Baldwin-built F2 Class locomotive shown following this image. The lines of this locomotive bear a vague resemblance to the contemporary "E Class" locomotives of the London North Western Railway. Side tanks on a tender locomotive are a somewhat unusual feature worldwide, but were an obvious advantage both in adding to a locomotive's range between water stops and additional weight on the locomotive's driving wheels, increasing its tractive effort. The class was built between the years of 1900 and 1908. The device behind the chimney was used to compress air in the cylinders when going downgrade with the steam cut off. It assisted in maintaining the British system vacuum brakes, which were used on Honshū, and would have been very useful, given the general inferiority of the vacuum brake system over American Westinghouse airbrakes, particularly in a mountainous land such as Japan. They were much in vogue on various Japanese locomotive classes used on mountain services of the day. The painting is a watercolor by the Keio University student Kashima Shosuke, circa 1904, and seems to indicate that the lining and numbering of these locomotives was blue.

of rank and file workers. (To make matters worse, *hannin* was pronounced exactly like another word using different characters that meant *a suspect* or *criminal,* with all its negative implications.) Out of this arose friction, as stationmasters and conductors were classed as *hannin,* while engine drivers and firemen were classed in the nameless bottom ranking. This was not a distinction without a difference: there were more liberal travel allowances, perquisites, and the like that were allowed to *hannin.* During the Sino-Japanese War, the contrast in classes was made even sharper, as many of the *hannin* rank received special commendations and awards, as particularly exemplary performance records merited, but few rewards were distributed for the many extraordinary efforts put forth by the drivers and firemen.

Another grievance called for the removal of certain individuals in higher management, due to the fact that some ¥60,000 had disappeared from the company books, and rather than pursue the individuals in management who were responsible, the company made good the embezzlement loss on its books by drawing down the fund put aside for employee bonuses. The company's wage structure was also the cause of dissatisfaction: for workers who earned less than ¥25 per month (such as drivers and stokers) the rate of the first pay increase on promotion was ¥2½, while for those making over ¥25 per month, such as a typical *hannin,* the first pay increase rate was double at ¥5. Similarly, if one was paid on a daily basis, if a person was making a daily wage of less than 90 *sen,* the rate of first pay increase was 5 *sen,* while those paid over 90 *sen* were increase by double that amount. In short, the wage scale discriminated against the lower-paid workers, when, in 1897 (at a time when wage levels elsewhere were rising at rates of 30–50%, and the cost of living had risen by almost as much), mere office clerks who were trained in a matter of months received proportionately a larger pay increase than engine drivers who took years to train and who had much heavier responsibilities for public safety. The discontent was palpable: so much so that the drivers and stokers petitioned management with their grievances, only to have management respond by firing the individuals perceived to have been instrumental in presentation of the grievance. Rather

than cowing the workers, this only resulted in a countermeasure, as the rank and file's response was the forming of an association known as the *Treatment Improvement Association,* Taigū Kaizen Kumiai (待遇改善組合).

When confronted anew with the demands of the new organization, management employed the same tactic of firing the key figures in the Treatment Improvement Association, and this act would proved to be the watershed event. Within a short time after the dismissals, work stoppages spread up and down the line, and public opinion turned in favor of the workers after the press had reported enough of the facts to have generated public interest. After about two weeks of traffic suspension, management capitulated in large part to the demands. Drivers and stokers were raised to *hannin* class, on par with stationmasters, they were given less condescending job titles, there was wage structure reform, and all the strike participants, except the two chief agitators, were re-instated. Of course the two agitators who sacrificed themselves to benefit the greater good went on to become some of the founding members of the Japanese labor movement, and indeed this strike went down in the annals as having pride of place in the history of the organized labor movement in Japan.

Frances Trevithick likewise admitted that there still remained much to be improved. Speaking in 1894, he noted that the case of staff being on duty long hours without adequate periods of rest was an area in dire need of amelioration. Amusingly, another area where Trevithick saw room for improvement was the need of train crews to do a proper stop before descending a grade to pin down the brakes of the freight cars in their train (operating on the British system, there were no freight car brake wheels to set the car brakes, by walking along the rooftops of moving cars as American brakemen did… a train would need to come to a full stop before the downgrade, and the brakemen would walk along the train, fixing the brakes using the brake lever found on the under-frame of every so many wagons as were appropriate) instead

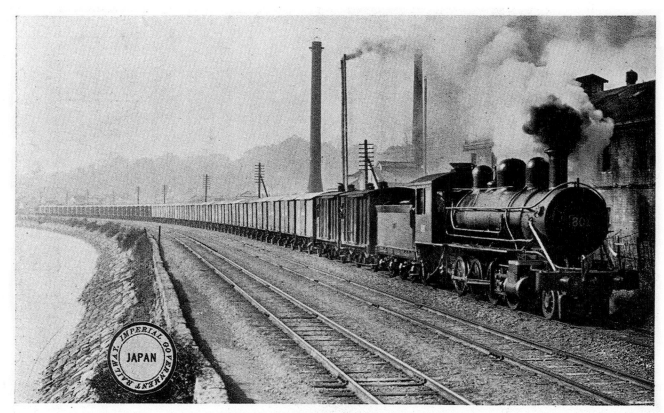

GOODS TRAIN RUNNING ON THE TOKAIDO LINE.

The length of the freight train in this busy scene suggests that is has been specially posed for the IJGR photographer. The mere fact that the locomotive bears running number 801 would date the view to before the 1909 renumbering, but in fact it is known to have been taken in 1905–1906. Number 801 was a Baldwin Consolidation-type of the F2 or 9200 class. The view is most likely taken in the vicinity of Kawasaki. Note the heads of two brakemen peering out of the windows in the brake compartments of the first two boxcars behind the tender. Freight cars with brake cabins were characteristic of Japanese freight rolling stock.

of relying simply on the brakes of the locomotive, tender (if any) and brake van (caboose) where the brakemen rode.

By roughly mid-point in the decade, America has started to become competitive in the manufacture of steel rails, and the first large orders from Japan for steel rails from US rolling mills dates from around this time. The *New York Times* first mentioned the trend in the spring of 1896, remarking on an order for 500 tons of rail from the Illinois Steel Company that was set to be shipped on the steamer *P. Sawyer*. By summer, it was interviewing Iwahara Kenzo, the Mitsui Co. purchasing agent who had come to negotiate rail contracts with Carnegie Steel, this time for almost ten times the initial amount at 9,000 tons. By the time Joseph Ury Crawford was mentioned in its pages in late November, the amount he had been authorized to purchase on behalf of the Japanese Government was 15,000 tons. All this within the course of a single year—a year coincidentally that saw Matsumoto Sohichiro, Inoue's successor at the Railway Bureau come to the US on a fact-finding study of the American railway system. Matsumoto's report was favorable and receptive to further orders of American-made equipment. Not surprisingly, American locomotives continued to supplant British-built competitors in point of price and delivery times,

in part because the British manufacturers were contentedly happy with their full order books at the time and were not inclined radically to expand capacity. British manufacturers were somewhat more accustomed to building locomotives to drawings supplied from the Chief Mechanical Engineer's offices of the particular railway than American locomotive manufacturers, who were more accustomed to receiving only performance specifications and preparing design drawings from those parameters in-house for the customer's approval. The latter method was attractive to Japanese railways, allowing them to shift the design tasks (for which there were few domestic candidates) and research and development costs to the builder. In 1898, when market demand on British locomotive production capacity was reaching a peak, British builders couldn't keep up with domestic demand, let alone demand from abroad, and locomotive delivery dates were being quoted some two years from the order date for large orders. Against this, American builders such as Baldwin were able to turn out two locomotives per day and could ship an order as large as 40 locomotives *in eight to ten weeks*. A *New York Times* headline under date of February 19, 1905, reported that Baldwin had just received the largest order for locomotives by any foreign government in the firm's history: 152 locomotives having been ordered by Japan. According to the reckonings of the day, an American locomotive could be bought for about 20% less than a comparable British locomotive, once shipping costs were factored in. Despite the superior quality and claimed economy of the British product (American locomotives tended to burn more coal to pull the same load) it was understandable, and perhaps unavoidable, that the period from 1895 to 1910 was the period of American locomotive ascendancy in Japan.

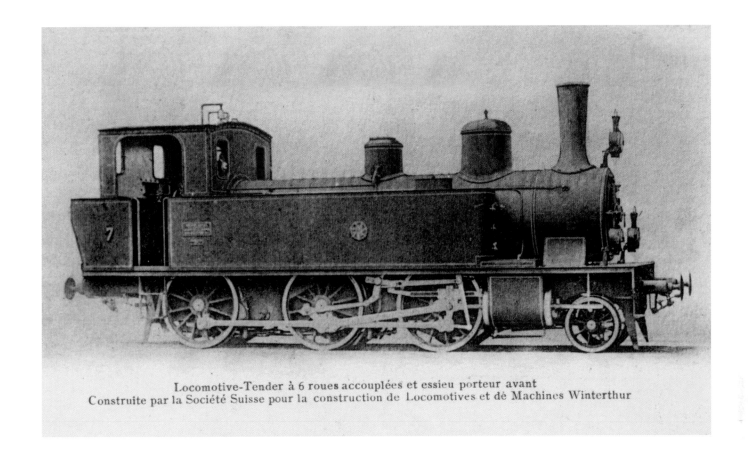

Locomotive-Tender à 6 roues accouplées et essieu porteur avant
Construite par la Société Suisse pour la construction de Locomotives et de Machines Winterthur

With the opening of the Tokaidō line and the revision of the Extraterritoriality Treaties, the scrapping of the internal passport system of travel for non-Japanese would eventually occur—but not until the new century had opened. Nevertheless, by the mid-1890s the internal passport system was becoming a matter of routine. An English traveler in 1898 described his experiences in the following words:

> *"Arrived at the railway station, we are received by an officer in full uniform, who will direct sundry menials clad in butcher blue kimonos, but bare as to their hairy brown legs, to carry our luggage into the station while he conducts us to the booking office. The gentleman (usually in spectacles), who smiles benignly at us through the diminutive pigeon-hole, then disburdens his mind of a polite but totally unintelligible sentence in Japanese. A dim recollection of the hints of the guide-book leads us to correctly surmise that he is making affectionate inquiry for our passport. This indispensable document is not the banknote-looking paper, signed 'Salisbury' in one corner... It is a State document obtainable only at the Japanese Foreign Office. ... [I]n most of the large seaports of Japan there exists a portion of the town known as the "Foreign Concession," within which all foreigners... may reside... Within twenty-five miles of this concession, but no further, may the foreigner direct his wandering steps. To advance one yard outside this special district, known as the 'Treaty Limits,' is a criminal offence, unless the individual be armed with a "passport." ... It is easy of acquirement, and of great service. At the Japanese Foreign Office are drawn up lists of places arranged in the form of tours, separate*

The Nara Tetsudō opened in 1895, directly linking the ancient towns of Nara (Japan's capital from 710 to 794) and Kyōto, with a roster of twelve locomotives, of which this example was one. The locomotive is one of the very few Japanese locomotives that did not originate from Great Britain, Germany or the United States, having been built by Switzerland's well-known Winterthur works. No. 7, shown as delivered, ran for ten years as a Nara locomotive before the Nara Tetsudō was absorbed by the Kansai Tetsudō in 1905, giving the Kansai (which had already reached Nara) access to the city of Kyōto. Nationalization the following year cut short the potential for the renewal of competition with IJGR Tokaidō trains respecting the Kansai's new Kyōto/Ōsaka and Kyōto/Nagoya routes.

> *passports being issued for each series. The traveler selects the itinerary for which he desires a passport from one of these lists. The routes cover all the places of beauty or interest in Japan, but no passport can be extended, nor can a traveler deviate in any particular from the tour laid down for him therein. A passport is valid for three months, and each traveler before obtaining one has to sign a declaration stating that he is traveling 'for the benefit of his health.' This declaration is of a sufficiently elastic nature to prevent anyone from doing violence to his sense of veracity in subscribing to it. Three large seals depend from the passport in an imposing manner. One of the conditions of issue is that this document shall be returned to the Foreign Office immediately upon expiration or upon the holder leaving the country. Failure to comply with this rule entails very heavy penalties, and also the certainty of a refusal should an application ever again be made for a passport at a subsequent date."*

Despite the strictures and inconvenience of the Internal Passports for foreign tourists and resident aliens, with the extension of the railways to many parts of Japan by the mid-1890s, a

景風之川宮田山勢伊

It would be difficult to conjure a photograph that expressed the aesthetic of Meiji-era railways better than this view, showing a small A8 style 2-4-2T tank locomotive of the Sangu Tetsudō pulling its train of three box cars, a string of four-wheel passenger compartment carriages, and one sole first/second class bogie carriage, positioned in the center of the train as was typically the case in Meiji-era train consists, over the Miyagawa Bridge on the approach to Ise, home of the most sacred Shintō Shrine in all Japan. The Sangu opened Miyagawa Station, across the eponymous river from Ise in 1893, but it wouldn't be until 1897 that this bridge had been completed and the line could run the remaining few miles into Ise proper.

modern tourism industry began to germinate for native Japanese and foreigners alike. Japan had had tourism for centuries. Visits to Mt. Fuji, the Itsukushima Shrine, Kyōto and its many sights, the Tokugawa mausoleum and the scenic beauties of Nikko were as popular before the advent of the railways as they were after. As early as 1881, according to the *Tōkyō Eiri Shimbun*, trains on the Shimbashi line had to run until as late as 2:30 in the morning from the stop nearest Ikegami Temple to accommodate crowds who had been there for festivities. Pilgrims had been streaming to Japan's holiest site, the Grand Shrine at Ise, since the earliest feudal times; centuries before the Sangu Tetsudō (*lit.* "Shrine-bound Railway"), the epitome of the Japanese extension line, was established in 1893 to transport pilgrims from the closest station on the Kansai Tetsudō to the shrine precincts.

With the opening of the Tokaidō line and the rapid extension of the major trunk lines of the Nippon, San'yo, Kyūshū and Kansai railways in the 1890s, many of Japan's points of interest were placed within convenient and feasible reach of both native and foreign travelers. Before 1880, a typical Westerner visiting Japan would probably have debarked at either Nagasaki or Yokohama, visited Tōkyō and environs, proceeded to Mt. Fuji and the Great Buddha at Kamakura (both of which were in reasonable proximity to Yokohama) and if adventurous, would have culminated the sightseeing with a trip to the impressive tombs of the Tokugawa Shōguns amidst the scenic grandeur of Nikko, as one of the best maintained roads led there from Tōkyō and it could be reached via one of the earliest stagecoach lines in the realm. The more seasoned travellers would have gone to the length of obtaining an internal passport enabling them to take a steamer to Kōbe/Ōsaka, and then proceed to visit the ancient cities of Kyōto and Nara. Rarely did a typical foreign tourist travel farther afield.

By the middle of the 1890s, the situation was changing. Nikko was at the end of a short branch line leaving the Nippon mainline from Utsunomiya that was completed in 1890. Nara, the ancient capital of Japan with its giant Buddha and 8th century Horyu-ji

Temple complex (where the oldest wooden buildings in the world are to be found to this day), via the Kansai Tetsudō and the new Nara Tetsudō, and Kyōto both were accessible by rail. Fuji stood along the Tokaidō line, and resort towns in its vicinity such as Miyanoshita were already publishing brochures and guidebooks in English aimed at the foreign market. The Great Buddha of Kamakura was rendered a mere day-trip by train from Tōkyō or Yokohama, as was the Grand Shrine of Ise from Nagoya. Later, as the San'yo mainline was completed, the celebrated sites along the Inland Sea were more easily accessible: the scenic town of Onomichi, the historic sites of the great naval battles of Dan-no-Ura and Ichi-no-Tani, the Itsukushima Shrine at Miyajima, built partially over water with its celebrated "floating" Torii gate. At Shimonoseki, the San'yo built the San'yo hotel, which it operated as an adjunct operation. Similarly, the Kansai Tetsudō's president invested in construction of the celebrated Nara Hotel in Nara, one of Japan's top tourist destinations, situated on the Kansai's main line, as a joint venture with the owners of the Miyako Hotel in Kyōto. Both were adopting the innovation of the *railway hotel* that had proven profitable in Europe and North America and had helped to stimulate tourism.[4]

Even the little Kyōto Tetsudō made a bid for both the domestic and foreign tourist markets: it touted its proximity to the famed *Kinkakuji* (Golden Pavilion) of Kyōto and white water boat rides over the Hozu river rapids departing from its Kameoka station with postcards and tourist brochures in both Japanese and English; this at a time when the road was only 38 miles long (the railhead had only reached Sonobe, less than halfway to the railway's intended terminus on the Japan Sea at Maizuru) and the railway only possessed twelve locomotives on its roster. The grottos at Gembudō soon became accessible with completion of the Bantan Tetsudō and with that line's completion and the building of the IJGR Inyō-Renraku line, Japan's second-most sacred Shintō shrine at Izumo became accessible. Hot springs and hill towns (to escape the stifling humidity of Tōkyō summers) were then fashionable among well-to-do Japanese and foreign residents. Karuizawa,[5] earlier mentioned, became a popular summer resort for the well-to-do nestled high in the mountains northwest of Tōkyō on the Shin'etsu mainline. Various hot springs ("Onsen") in Shikoku came to have a little narrow gauge train leading to them. One of the most visited stations on the little Dōgo Tetsudō in Shikoku was the local hot springs. Prior to the advent of railways, a good day of hearty tourism in Japan would result in an average of between 18 and 25 miles covered, depending on terrain and the passability of un-bridged rivers. This was often by foot or on horseback, rain or shine. The prospect of traveling eight hours in pouring rain on foot or atop a packhorse to accomplish only 20 miles of travel was alone enough to discourage travel among all but the most stalwart. Given the alternative, a train trip from Tōkyō to Kōbe that included some 70 stations stops, some of which were quite lengthy, wasn't as bad a prospect as it might seem by today's standard. The fastest express in the mid-1890s cut out twenty of the 70 odd stations on the Tōkyō–Kōbe route, but still only averaged 12 miles per hour. Nevertheless, the results of the first steps of tourism development were remarkable, stirred notably by the domestic market. By the close of the nineteenth century, the first steps taken to develop what we would see as the germ of a modern tourism industry were showing promising signs of success. Indeed by 1902, more than a hundred million passenger tickets were sold annually in Japan, an increase of more than double the amount sold in 1896.

THE SANYO RAILWAY CO.,

The Sanyo Railway runs from Kobe to shimonoseki (Bakan) along the whole length of the " Inland Sea " on its northern shore.

The beauties of this " Inland Sea " are so well known to foreign visitors, that it is quite unnecessary to dwell upon them here.

SLEEPING CAR.

Excellent views of the magnificent scenery and picturesque landscapes which make the Inland Sea so famous can be seen from the train.

The Company affords every opportunity to travellers to visit places of interest on the line such as Maiko, Himeji Castle, Okayama Koraku-en (park), Miyajima, the Kintai Bridge, &c.

For full description of the railway, travellers are referred to our Guide which is given free of charge.

EXPRESS TRAINS.

Four Express Trains (morning, noon, evening and night) leave Kobe and Shimonoseki daily, connecting with the Tokaido Railway express trains at Kobe and with the Kiushiu Railway at Moji. Passengers being conveyed between Shimonoseki and Moji by the Co's ferry boats which cross the straits in 15 minutes. The morning express train is the fastest on the line—in fact the fastest in the whole Empire—and covers the distance of 330 miles in 11½ hours. Sleeping and Dining Cars are attached to all express trains, which are made up of large corridor bogie coaches fitted with electric light and heated by steat.

CONNECTIONS WITH SHIKOKU.

The Company maintains three lines of steamers on the Inland-Sea plying between Okayama-Takamatsu, Onomichi-Tadotsu, and Ujna-Takahama. These steamers are built after the latest models in Europe and America, and are up-To-date in every particular. They make several trips daily, steaming among numerous islands, through indiscribably beautiful scenes, connecting the Sanyo with the Sanuki and the Iyo Railways in Shikoku.

Places of interest most worth seeing in and about Shikoku are the farmous Kotohira (commonly called Kompira) Temple ; the Kuribayashi Park, one of the best examples of apanese horticulture ; the Kankakei in the Island of Shodoshima, a romantic valley full of crags and rocks of the quaintest and most fantastic shapes imaginable ; the Dogo Hot Springs which have a wonderful efficacy in cases of debility and skin disease ; and the City of Matsuyama where the wounded Russians are nursed by the members of the Japanese Red Cross Society at present.

INTERCHANGEABLE TICKETS.

First and Second Class passengers by the Nippon Yusen Kaisha steamers may travel from Kobe to Shimonoseki or *vice versa* by the Sanyo Railway if they desire, and railway tickets may be obtained on board the steamers or from the Nippon Yusen Kaisha and its branch offices.

CUSTOMS ARRANGEMENTS.

There is a Branch Gffice of the Imperial Customs in Shimonoseki Station for the convenience of foreign travellers.

Fine steam-launches convey passengers to and from the ocean-going steamers.

HOTEL.

The Railway Company maintains an excellent hotel at Shimonoseki Station called **the Sanyo Hotel** specially fitted for the accomodation of **foreign travellers** either for a short stay. Charges are very reasonable.

HIMEJI CASTLE.

Ever the innovator, the San'yo Tetsudō was not afraid to bid for the foreign tourist market, as shown by this advertisement in English. When this ad first appeared in 1904, during the Russo-Japanese War, the progressive line had put in place three steamer routes connecting with Shikoku and a ferry route to Kyūshū. It could also state that all its express trains (four in number) were electric-lit, steam heated, and furnished with sleeping and dining cars, a boast that other railways in the realm would have been hard pressed to make. Other interesting traveling arrangements are evident in the advertisement. One can't help but wonder how many foreign visitors chose to visit Matsuyama for the purpose of seeing a P.O.W. infirmary "where the wounded Russians are nursed."

The United Kingdom's renowned Royal Navy China Squadron visited Japan in October 1905 on a congratulatory and goodwill visit at the end of the Russo-Japanese War and its arrival was fêted as way to further the Anglo-Japanese Alliance. Two railway passes are shown from that visit. The Kansai Tetsudō treated the Royal Navy to an excursion to the ancient city and former Imperial capital of Nara with its giant Buddha and famed domesticated deer that roam the city freely. Minatomachi was the Kansai's own Ōsaka terminal, from which the special departed, but the pass-holders could take a regular Kansai train from Ōsaka Umeda, into which the Kansai apparently also had running rights, and change upon arrival at Minatomachi. The Kōya Tetsudō offered trips from it's Shiomibashi terminal in Ōsaka to Nagano (present day Kawachi Nagano), south of the city, from which the Kanshin-ji and Kongō-ji Temples could be visited.

to enter the train and go on to Nikko, while he will await the arrival of the jinricksha with our baggage and follow on the 12.30 train. But I tell him I will not desert him at the last minute; we will both wait. He urges me repeatedly, and finding me persistent in my refusal asks the guard if he cannot hold the train a few minutes till the men [rickshaw runners

with the baggage] appear. The obliging guard consents to wait ten minutes, saying that beyond that he dare not delay the train. The greatest interest is manifested by all the railway officials in the arrival of our [baggage] jinricksha. Some of the passengers, wondering what is wrong, get out and ask questions. A crowd quickly gathers at the station and around me. Minutes pass and no sign of the jinricksha. Finally, when it is within two minutes of starting time the men and wagon are seen in the distance. A shout of joy goes up, and a half-dozen men from the station run at the top of their speed to meet the tardy jinricksha, and all together fairly make it fly to the station. It is exactly twenty minutes past ten when the baggage is placed on board the train. Another glad shout fills the air. I bow and smile and try to thank the people for their good-will, and they bow and bow, and we are now steaming along in comfortable cars to Nikko. I think often of this incident, as well as of many other kindnesses shown

to us by these good-natured people, and wonder would an American train wait a traveler's convenience in any State in our Union?"

[After further rain delay at Nikkō Taylor resumed his trip...] "After a rest of a couple of days we take up our regular plan of travel, proposing to leave here to-morrow for Tōkyō. It has been raining in Nikkō for the past five days, and is still raining. We learn that the railroad between Nikkō and Tōkyō is badly washed [out], and in some places covered with water to a depth of ten or twelve feet, and that passengers to the latter city are conveyed by boat over the breaks in the road and across the rice fields to places of safety; also that you can go to Tōkyō in ten hours, three of which are by boat. A boat capsized this morning and its occupants were thrown out, but none of them were drowned. We are hoping for more favorable reports, but will, in any case, attempt to reach Tōkyō to-morrow by the early train. We arise early and find the sun shining brightly, as if to give us a good send-off. We leave Nikkō by the 7.30 train... We arrive at Utso-No-Miya Station, where we change cars, and in about twenty minutes take another train, which carries us to the village of Nakada. We can go no further by train, for although the water is subsiding in other places the tracks here are under three or four feet [of water]. Large sampans await us, and taking our places in one of these, with other passengers, we are sculled to a temporary station provided by the railroad company. ... The temporary station is made of a canvas stretched over long poles to protect us from the sun. Benches are here, made of rough boards. There are fully four hundred people here awaiting the arrival of the train... We have waited here since 11.45 this morning, and it is two o'clock before the shrill whistle announces the approaching train, and an engine draws a long line of empty passenger coaches up beside the station. Then follows a comical sight. There is a great scramble for the cars. Some of the people, in their eagerness actually jump through the windows.... And now they are all in and we are off, really off, for Tōkyō. We cross the Tone-gawa on a fine iron bridge, which was, several days ago, under thirteen feet of water."

Like Taylor, many a foreign visitor praised the level of personal service encountered on Japanese railways. W. E. Curtis, writing in 1896, was similarly impressed with the level of service and dedication of Japanese railway employees:

"As a rule, however, railway officials are very obliging and take a great deal of trouble to accommodate travelers. Nor is it possible to induce them to accept a fee. In Europe a traveler is compelled to pay everybody connected with a train or a railway station if he wants to protect himself from annoyance. He has to fee the baggagemen, the porters, the conductors, the guards and all hands, and the treatment he receives is governed by his generosity. In Japan you are expected to give a penny to the porter who carries your luggage from the jinrikisha to the baggage room, for that is his 'pidgin,' [7] and he receives no pay from the railway, but if you offered a fee of any amount to any one else he would be grossly insulted. The same is true of policemen. As an illustration, I carelessly left a notebook on the seat of a car in which I had traveled from Tōkyō to Yokohama, and did not discover my

In 1907 US President Theodore Roosevelt wished to send the so-called "Great White Fleet" of the US Navy on an around-the-world good will tour, but faced not inconsiderable Congressional opposition on grounds of government waste. Undaunted, the President realized he had sufficient funds unspent within his current appropriations to finance roughly half of the undertaking. In true "bully" fashion, the President ordered it half way around the world, leaving it for Congress to decide whether to appropriate enough money to enable the fleet's return. The visit helped ease Japanese resentment felt towards the US at a tense time, as the US had brokered what the Japanese public felt was an unfair peace treaty ending the Russo-Japanese War and California had recently enacted discriminatory laws segregating Japanese children in public schools. When they reached Japan in October 1908, officers were given complimentary first class passes for unlimited travel on the IJGR during their leave (above). The enlisted sailors didn't fare quite as well. Out of concern over an international incident and in view of an earlier barroom brawl in Brazil involving the crew, sailors with a history of heavy drinking were confined aboard ship, but those sober enough to be granted shore leave privileges were greeted in Tōkyō with streetcar passes and these specially decorated Tōkyō Municipal trolleys, which by then had replaced the original horse-drawn trams.

loss until the train had left for the next station. I went to the stationmaster, who immediately sent a telegram to the man in charge of the train, and I found my notebook awaiting me when I returned to the hotel at Tōkyō that evening. I offered to pay the stationmaster and the telegraph operator for their trouble. They made very polite bows and assured me that they felt greatly honored by having an opportunity to do me a service, but declined to accept money."

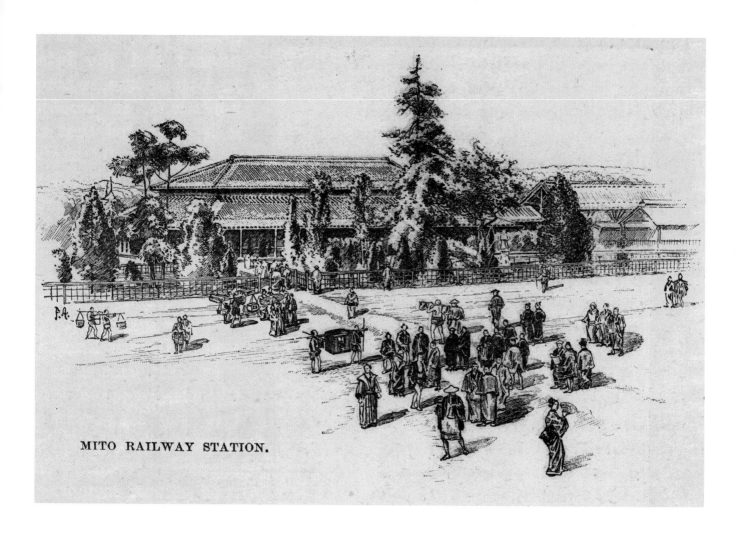

MITO RAILWAY STATION.

The Mito Tetsudō was among the first of a number of railways that came to be formed to connect a sizeable town with a mainline railway and thus afford railway service to the locale. Mito was the provincial seat of one of the three great branches of the Tokugawa family from which Shōguns could be chosen. As such it had become an important center of learning and culture over the centuries. The 41-mile-long line departed from the Nippon Tetsudō mainline at Oyama. The Mito terminus, shown here, was inaugurated on January 16, 1889, and is a typical station of that period. By the turn of the century, when many smaller lines were undergoing a process of being absorbed by the "Big Five," the Mito Tetsudō had become the Nippon Tetsudō's Mito branch.

* * * * * * * * *

In 1900 a new milestone was passed when the IJGR hired its first women employees, clerks hired in Tōkyō, although Charles Taylor's foregoing observation makes clear that young girls had been employed as crossing guards at an earlier date. That year also saw a recession and a constriction in new railway building. Bankruptcies occurred, while some of the financially weaker or smaller lines were amalgamated with sounder or larger lines of the industry. The Nippon Tetsudō had its Nikko branch and acquired Ryomo Railway and Mito Railway, which had itself swallowed the smaller Ōta Tetsudō. The Kansai had absorbed the Naniwa and Ōsaka roads. Through a labyrinthine series of mergers, managing committees, and interlocking identities of controlling shareholders (primarily wealthy merchants and bankers in Ōsaka) the little Hankai and Nankai Tetsudō were operated as one system. The 762mm-gauged Settsu Tetsudō had been sold to the 1067mm-gauged Hankaku Tetsudō and re-gauged accordingly. On Shikoku, the Dogo and the Nanyo railways joined the Iyo Tetsudō. Back on Honshū, the Nara Tetsudō had by then acquired the Hatsuse Tetsudō, and on Kyūshū the ever-growing Kyūshū Tetsudō system had completed its acquisition of the Chikuho and Imari railways. The Private Railway Law No. 64 of March 19th, 1900 limited the abilities of the *Shitetsu* (non-government railways) to mortgage their railway lines and buildings, which resulted in very few small railway companies being chartered thereafter until 1910 when the situation was remedied by the promulgation of another major railway law.

As venture capital was still scarce in Japan, even in the boom that followed immediately on the heels of the Sino-Japanese War, small destinations took to developing their own local branches to the closest railway with typical Japanese ingenuity. The resultant railways endeared themselves to Western tourists as a source of bemusement and curiosity: the *gyusha kidō* and the *jinsha kidō*. *Gyusha kidō* translates literally "Ox car tramway," and they were just that; small, light railways where oxen were used for motive power, for the most part industrial ventures on private land that were not authorized under the existing statutory framework for railway regulation.[8] The most notable example among them was the Ashio Tetsudō. Ashio lies just west of Nikko, and as the Nikko Tetsudō from Utsunomiya was completed, it became feasible to run a rail line to Ashio, only a short distance away. The prize for the effort lay in the fact that at Ashio was one of the largest copper

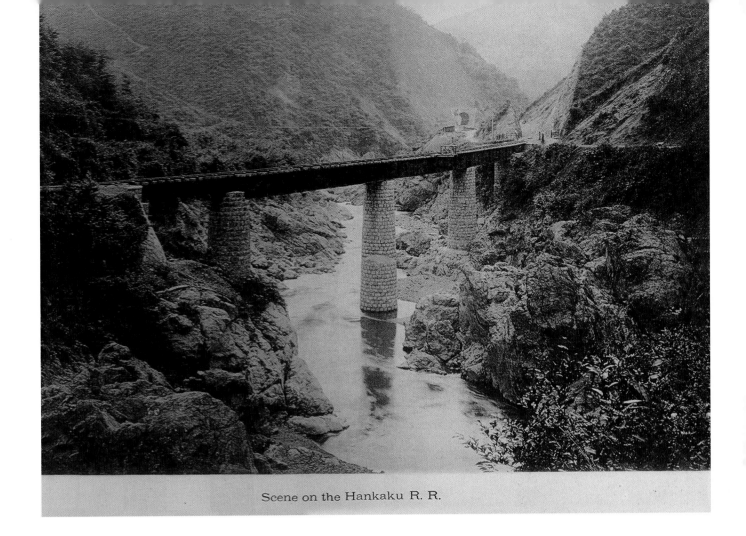

Scene on the Hankaku R. R.

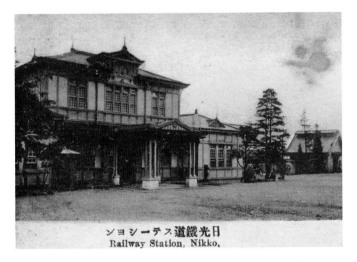

ヨシーデス道鐵光日
Railway Station, Nikko,

(above)
The Hankaku Tetsudō ran from Amagasaki on the coast near Ōsaka northwesterly to Fukuchiyama and in so doing, crossed some very scenic mountainous terrain. One of the bridges on this 70-mile-long line shows the amount of civil engineering lines with relatively modest route mileage would have faced. Note the tunnel in the background, and the footpath zigzagging over the mountain at the left of this pre-1904 photo: what would have passed as a fairly typical back-country road in Japan before the advent of railways.

(left)
The Nikko Tetsudō, an undertaking of the Nippon Tetsudō, was quite understandably created to link the venerable town of Nikko with the Nippon Tetsudō's mainline some 25 miles away at Utsunomiya. Service to the Nikko station terminus was commenced on August 1, 1890. For decades Nikko had been (and still is) one of Japan's major tourist destinations, with its spectacular mountain scenery, Lake Chuzenji, the Kegon Falls (one of Japan's three largest), and the famed tombs of the first and third Toku-gawa Shoguns. For this reason, the second station shown here that was inaugurated in 1915 (a work of the noted American architect Frank Lloyd Wright) included a VIP waiting room and a ballroom/reception hall on the second floor. The structure still serves as a station today. One of the other lines in the area, the Nikko Denki Kidō opened in 1910, would eventually be absorbed by the Tobu Tetsudō in 1947 and give Nikko the rarity of competing train services to Tōkyō.

deposits in Japan, and the line was seized upon as a way to transport the output from the mines to the railhead at Nikko. While the line was primarily a commodity carrier, the locals used it for transportation as well. Due to its terminus at Nikko, tourists came into contact with it, considered it quite a curiosity, and because of that, quite a number of photos of it were made, recording its operation. There was even one example of a logging railway powered by dogs on the island of Shikoku, which was commonly called a kensha (*dog car*) tetsudō.

The most celebrated of the *jinsha kidō* was the Zusō Jinsha Tetsudō, later re-named the Atami Keiben Tetsudō,[9] established in 1895 at Odawara—the first jinsha railway in Japan. It ran to the hot springs (*onsen*) at Atami, a celebrated seaside resort. What distinguished Jinsha Tetsudō or Kidō (tramway) from their breth-

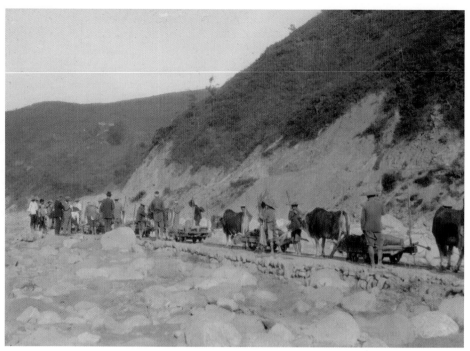

Plans to exploit the copper deposits at Ashio led to the construction of a Gyusha Tetsudō (Ox-drawn railway) from the mines to the railhead at Nikkō. The small flatcars were locally built to the most rudimentary standards. Wooden "dummy" balks serve as buffers, while the braking was effected by skid shoes that are visible between the wheels in the third of these photographs, which shows some of the local girls, with younger siblings slung on their backs, hitching a ride into town with a load of copper. The first view shows one of the drivers and oxen at rest. Note the brake stand for operating the hand brake that is situated at the front of each car. The gauge of the Ashio Tetsudō was 610mm (2 foot). The remaining three pictures show trains—perhaps convoys is a more accurate term—operating over the line, the latter showing its entry into Nikkō over one of the municipal bridges. Note the canopies of branches fitted over the oxen in the last view.

ren was the motive power: strong-legged stout youths from among the local populace. "Trains" consisted of small push-cars on rails, each just big enough to seat 4 to 6 adults, and each of which were propelled typically by a crew of three runners who would push the car along level stretches and upgrade, and then hop on the end platforms at downgrades to serve as brakemen to operate the handbrakes. The cars would not be coupled together, but would generally operate in convoy fashion, as the three or four runners would position themselves directly behind or at the rear corner of each car. From the time of the inception of the Atami Jinsha, as it came to be called by many, and its ilk until the final years of the Meiji era, a number of Jinsha (lit. "Man[powered] car") Tetsudō sprang forth at various locations throughout Japan where finances would not permit the acquisition of a steam locomotive.

Some Western travelers viewed the Jinsha Kidō in bemusement, evidence of the topsy-turvy or backward nature in which they perceived Japan compared to the West, rather than as an ingenious response to light railway development using minimal capital outlay in a country where the cost of labor was then a fraction of the prevailing cost in Western nations and the cost of horses was still rather high. An American tourist, Charles Lorrimer, who traveled on the Atami Jinsha (before increasing profitability permitted it to convert to steam motive power) saw

matters with a less jaundiced eye than some, was clearly charmed by the little line, and left one of the more enlivened descriptions of a trip along its length, dating from his visit around 1903:

> "[Shimbashi] station resounded with the click-clack, click-clack of clogs [geta; wooden sandals] as the crowds waddled down the long platform and disappeared into the second and third class carriages. Japanese of all kinds and conditions are the most inveterate travelers you can imagine. … Presently several passengers, after repeated bowings and scrapings climbed into our car; one, an old lady… might have dated from the Age of Chivalry: that is, if one might judge by the delightful farewells she gave to a friend… as the train began slowly to move, one poetic, musical phrase, over and over, 'Rokkon shojo oyama wa kaisei'—'May your six senses be pure and the honorable mountain weather for you, fine.' …
>
> The railway runs first through fields of pink and white lotus, which as we passed were in full flower for miles—and of a beauty and sweetness indescribable. Another lovely member of the lily family was blooming, also, along the little green dykes separating the rice fields—a vivid scarlet lily growing in a full, feathery cluster on a single, strong, wine-colored stem. When the wind tossed the hundreds of blood-red tassels they fluttered like tiny flags… After an hour the train set us down at Kodzu [Kozu], close to the seashore. While diminutive porters piled our bags and baggage into the tram car which runs a few miles farther on [the Odawara Denki], we took tea in a pretty inn room—all windows as Japanese rooms invariably are in summer.
>
> Presently the rattling tram, after four jolty miles, deposited us at Odmara [sic; Odawara], a sad stronghold of departed grandeur. … From Odamara [sic] it is five minutes' walk to the point where the Atami road branches off, the fork being marked by a little station with a swinging sign 'Jinsha Tetsudō'—Jinricksha Tramway.

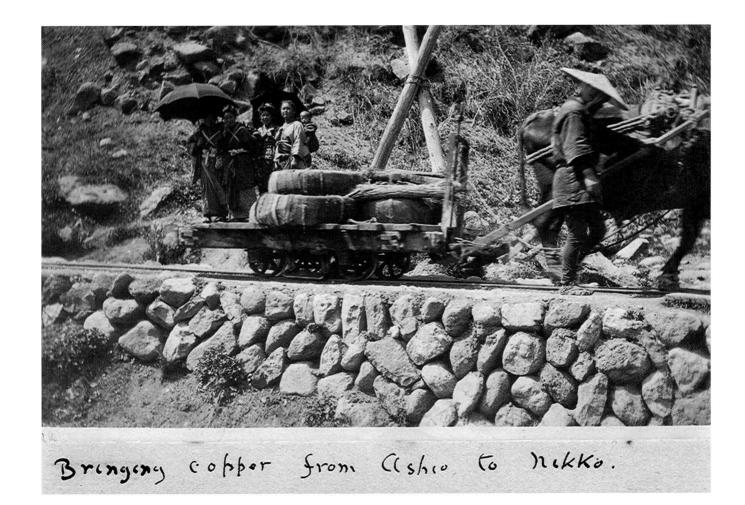

Bringing copper from Ashio to Nikko.

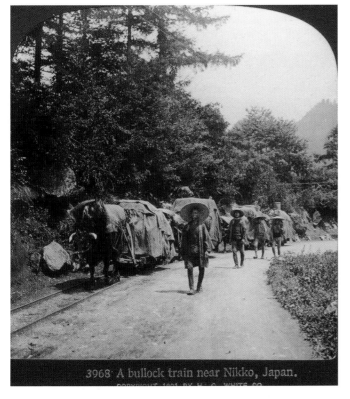

3968 A bullock train near Nikko, Japan.

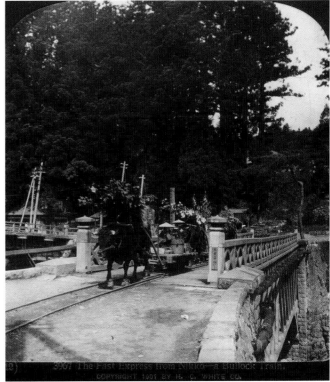

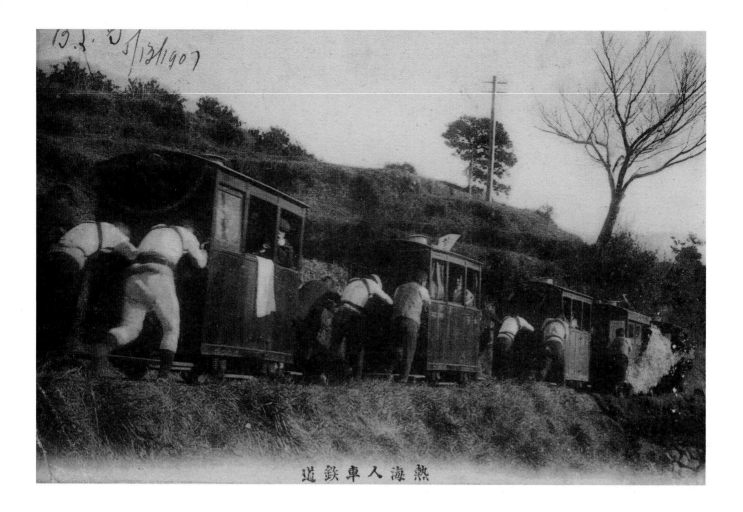

熱海人車鉄道

(above)
A typical train on the Atami Jinsha Tetsudō is shown being pushed upgrade. On level and downgrade stretches while underway, much more space was kept between the individual carriages.

(opposite top left & right)
These two photographs give a good detailed view of second and first class Atami Jinsha Tetsudō coaches during the last days of manpower operation in 1907. In the first photo, a second class carriage rolls by as the trackworkers take a rest and let the excavation tools from the current tasks lay, on what is probably an unpredictable spring day judging from the amount of runners' outerwear hanging from the carriage. Note the proper carriage rooftop lamp pot for interior lighting during night runs. The second view shows a first class open-air carriage and gives a good view of the brake mechanism that was operated on downgrades by the chief runner from the front running board; left hand on the brake lever, right hand on the grab-iron.

The inside of the station is like a doll's house—three people and a bag fill it to overflowing. As our party consisted of four, each of us had to stand outside in turn, while the rest negotiated at a tiny stall in one corner for the Asahi beer and lemonade, destined presently to chaperone our luncheon of sandwiches.

Meanwhile, the Jinricksha 'train' was being made up. Three little cars, marked ostentatiously 1st, 2nd, and 3rd, with the dumpy figures of shoe boxes, were pushed towards us on a track without exaggeration only two feet broad.[10] No visible motive power appeared. Where there should have been dynamos or engines [as in a trolley], there were only primitive brakes. Nor were the cars coupled together.

A tin horn manipulated by a fearful and wonderful official was the signal for 'all aboard.' Our car, open at the sides, and on top covered only with a fluttering awning [i. e., the first class car] had two little seats facing each other. The space between left scant room to put our knees, for the scale of everything connected with the car was like a child's make-believe toy, rather than a serious grown-up passenger train.

First, our conductor pompously closed and locked our half-doors himself. Next he verified his original calculations over our fares (we each paid 97 sen—44 cents gold—for 16

miles) with a gilded official behind the ticket office window, who almost consumed with curiosity over the unusual sight of four Americans, had great difficulty in delivering his parting instructions impressively. A little tin box like a specimen case, containing our fares and accurate descriptions of each passenger, his destination, occupation, the color of his eyes and hair, with other details, was slung about the conductor's neck, giving him the look of an ardent naturalist. Then we were quite ready.

At this last moment, the motive power appeared—five stalwart coolies for each car. More splendid specimens of manhood I have never seen. Their muscles were like gnarled trees; their chests like Sandow's.[11]

Off we started with a whoop and a shout, the men trotting and pushing as though they enjoyed it. Our car, by reason of its [first class] dignity, went ahead, the second-class following about six paces behind, the third next, the baggage car last, which proved an unsuitable arrangement, for it was

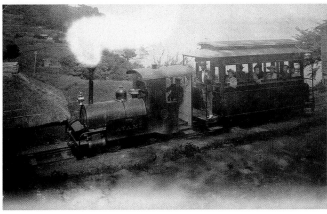

(above)

This photograph gives an interesting insight into the nature of the civil engineering works found on one of the tramway lines that emanated around Nikko and Lake Chuzenji. Pictured is a portion of the Nikko Denki Tetsudō along the Daiya river, roughly midpoint between Nikko and Umagaeshi, beyond the limit of electric traction operation. A detailed examination of the trestle skirting the hill on the left and the small bridge crossing the stream in mid-ground reveals the fact that both have been built from rough-hewn small logs that were completely unmilled. Cost was obviously a consideration in initial construction of the line.

(above)

Pictured here is the new "Atami," locomotive Number 1, with its small train on the Atami Tetsudō shortly after conversion to steam operation and re-gauging in 1907, as the 610mm/2' gauge rail can still be seen in place between the outer rails on this stretch of line. The entire train seems aware of the fact that it is being photographed while passing by a local thatched-roof minka, or peasant's house. The locomotive is probably an open-air tram-style locomotive bought from Baldwin that originally had a canopy roof its entire length, but was later re-configured along more standard lines with a conventional cab. Note the new tram-style carriage and the brass automobile headlight serving as a headlamp.

by far the heaviest, and came down the hill upon us periodically, in spite of brakes, causing terrifying shouts from the coolies, and thumping the poor third-class passengers. …

After about three miles, our most important conductor, in his wonderful uniform blew a little tin horn, and suddenly we ran into a village that appeared instantly as if at the call of the cracked trumpet. We slowed up between two lines of cottages, with sliding screens pushed back, leaving them, according to summer custom, open to the day. … Leaving our little car we looked [about the village]. …

Another blast of the tin horn… summoned us to rejoin the train. We ran absurd risks of choking with laughter at the sight of the conductor, who appeared, evidently for our benefit, in a semi-military suit of fearful and wonderful make. The material was ticking, blue and white [pillow] ticking, which, combined with the natural plumpness of his figure, made him look like an over-stuffed pillow. For ornaments, he had white cotton covered buttons in dazzling rows which began where his celluloid collar and coat met uncertainly—like the brook and the river—and then continued straight down to his native waraji (straw sandals) that contrasted strangely with the enormous pith helmet finishing off the other end of him. …

From this first station the road wound up the hills. Our coolies pushed hard the whole day puffing regularly like engines and uttering grunts of encouragement to one another periodically. At the top of each incline we stopped, rather to let them wipe the streams of perspiration off their faces than to rest, for they were such splendid men that the effort hardly appeared to tire them at all. Really they seemed to be playing rather than working; laughing and joking continually, as if they enjoyed the idea of pushing us immensely.

One of the fellows on our car appeared to be a 'head man'—a practical leader rather than a gilded functionary like the conductor. He was a splendid, powerful youth, a very Hercules for muscle, and for endurance hardly to be matched by that ancient demi-god. At the end of each mile he seemed fresher and stronger than at the start. He told us that his 'run' was twelve miles, six with the up-train to a certain unpronounceable little station, then six back to Odawara with the down train, and this he did every day of his life, winter and summer, for the sum of thirty yen (about $15.) It sounds little enough, but in reality this is a big wage for a man of the coolie class. Farm laborers and even mechanics receive a good deal less. But then, they work steadily for the greater part of their lives, whereas these tram coolies can only endure the physical strain for a few years. In addition to their hard work the convivial life of the roads leads the men into temptations, induces them to squander their pay gambling, or worse, drink the deadly hot sake wine. Instead of regarding their splendid muscles as invested capital, they draw continual overdrafts on their strength, and after a time lungs or heart weaken, so that it is rare to see a 'pusher' over 30 years of age.

Skirting a fence of hills, we reached our second little station on the summit of a green ridge. … We made a very short stop, then were off again—gently down hill this time, and actually overhanging the sea without more than a twelve-inch margin between our track and the jagged spray-washed rocks—which made it the more exciting. Our coolies at once divided in two groups; half climbed on to the little step in front of each car, the rest on behind. The men ahead manipulated a very primitive brake between them; except for that we were entirely at the mercy of our own impetus.

This 1903 map shows the railway system three years before nationalization, when the number of private railways was close to its peak.

PRIVATE RAILWAYS.

No.	COMPANIES.	LINES.	M.	Ch.
	CHŪETSU.	Takaoka-Jōbana.	15	41
		Takaoka-Fushiki.	4	45
		Total	23	6
	NANAO.	Tsubata-Nanao.	33	45
		Nanao-Yatashin.*	0	63
		Total	34	27
	TOYOKAWA.	Yoshida-Nagashino.	17	30
	BISEI.	Yatomi-Shin-ichinomiya.	15	46
	ŌMI.	Hikone-Kibugawa.	26	1
	KANAN.	Kashiwara – Nagano.	10	22
	KŌYA.	Shiomibashi-Nagano.	17	31
	KIWA.	Futami-Wakayamashi.	31	49
	NANKAI.	Nanba-Wakayamashi.	40	06
		Tenguchaya-Tennōji.	1	37
		Total	41	43
	NISHINARI.	Ōsaka-Ajikawaguchi.	3	52
	CHUGOKU.	Okayamashi-Tsuyama.	34	76
	JŌBU.	Kumagaya Hakure.	14	15
	TŌBU.	Adzumabashi-Kawamata.	41	39
	RYUGASAKI.	Ryūgasaki-Sanuki.	2	64
	MITO.	Mito-Ōta.	12	11
	GANYETSU.	Kōriyama-Wakamatsu.	39	11
	TOKUSHIMA.	Tokushima-Funato.	21	30
	HOKKAIDŌ-TANKŌ.	Temiya-Horonai.	55	44
		Horonaibuto-Ikushumbetsu.	4	39
		Iwamizawa-Utashinai.	30	69
		Sunagawa-Sorachibuto.	3	11
		Iwamizawa-Mororan.	86	11
		Oiwake-Yūbari.	26	49
		Temiya-Sanhashi.*	0	34
		Total	207	17
	HOKKAIDŌ.	Hakodate-Neppu.	86	45
		Sandō-Otaruchūō.	25	69
		Total	112	34
		Grand Total	3,121	33

LINES, FOR WHICH DEFINITE CHARTERS HAVE BEEN GRANTED.

COMPANIES.	LINES.	M.	Ch.
NIPPON.	Nippori-Mikawajima.	0	58

No.	COMPANIES.	LINES.	M.	Ch.
11	KŌBU.	Iidamachi-Kajichō.	1	19
14	SŌBU.	Honjō-Akihanohara.	2	52
		Chōshi-Togawa.	4	5
		Total	6	57
16	BŌSŌ.	Soga-Kisaradzu.	18	75
18	KANSAI.	Kawarada-Tsu.	13	40
25	HANKAKU.	Kawanishi-Ōsaka.	10	52
		Fukuchi-Fukuchiyama.	0	35
		Total	11	07
26	SANYŌ.	Nii-Wadayama.	8	60
32	KYŪSHŪ.	Ongagawa-Muroki.	7	40
		Nakama-Koyanose.	3	34
		Hakata-Sasaguri.	7	2
		Hakata-Imari.	44	0
		Maebaru-Funakoshi.	0	0
		Hamazaki-Mitsushima.	2	72
		Kawasaki-Soyeda.	3	13
		Azamibaru-Kubota.	9	27
		Ōshima Line.*	0	18
		Shimoumi-Hirayama.	0	65
		Total	82	21
40	HOKUYETSU.	Niidzu-Shibata.	14	34
		Nuttari-Bandaibashi.	1	28
		Total	15	62
48	KISHŪ.	Wakayama-Kuroye.	7	66
54	CHŪGOKU.	Okayama-Okayamashi. Tsuyama-Yonago.	63	17
		Okayama-Tatai.	13	25
		Total	76	42
57	KIBE.	Takahama-Shimoyamada.	26	74

No.	COMPANIES.	LINES.	M.	Ch.
66	JŌBU.	Ōmiya-Hakure.	15	65
68	TŌBU.	Kawamata-Ashikaga.	11	54
		Kameido-Honjo.	1	15
		Adzumabashi-Etchūjima.	5	76
		Total	18	65
71	JŌYA.	Kawashima-Karasuyama.	31	26
74	GANYETSU.	Wakamatsu-Sakaya.	73	49
80	BINGO.	Fukuyama-Fuchū.	13	58
86	UWAJIMA.	Uwajima-Yoshinofu.	15	40
87	HAKATAWAN.	Saitozaki-Umi. Doi-Sasaguri. Sakadono-Haramachi.	22	34
102	HOKKAIDŌ.	Otaru-Otaruchūō. Sando-Neppu.	43	31
60	HYAKKAN.	Hyakkan-Tazaki.	4	35
99	MINO.	Gifu-Nagase.	29	50
		Seki-Kōdzuchi.	4	19
		Total	33	69
		Grand Total	543	13

No.	COMPANIES.	LINES.	M.	Ch.
61	BUSŌCHŪŌ.	Sendagaya-Odawara.	48	0
69	JŌNAN.	Azubuminohashi-Setagaya.	4	0
85	ASAN.	Muya-Takamatsu.	45	0
72	RYUGASAKI.	Ryūgasaki-Isadzu.	8	73
93	YŌRŌ.	Kuwana-Haginaga.	35	40
94	BINŌ.	Ichinomiya-Ōdome.	13	0
95	SHINSAN.	Shinkawa-Asuke.	30	40
98	TSUKUSHI.	Ogi-Ōmuta.	27	0
107	SŌKAI.	Yokohama-Dzushi.	32	40
108	YOKOHAMA.	Kanagawa-Hachiōji.	25	60
		Grand Total	354	79

LINES, FOR WHICH PROVITIONAL CHARTERS HAVE BEEN GRANTED.

No.	COMPANIES.	LINES.	M.	Ch.
14	SŌBU.	Funabashi-Sakura.	14	0
83	TOKUSHIMA.	Tokushima-Iwawaki.	13	0
40	HOKUYETSU.	Kashiwazaki-Nuttari.	47	0
43	TOYOKAWA.	Ōmi-Kawai.	10	66

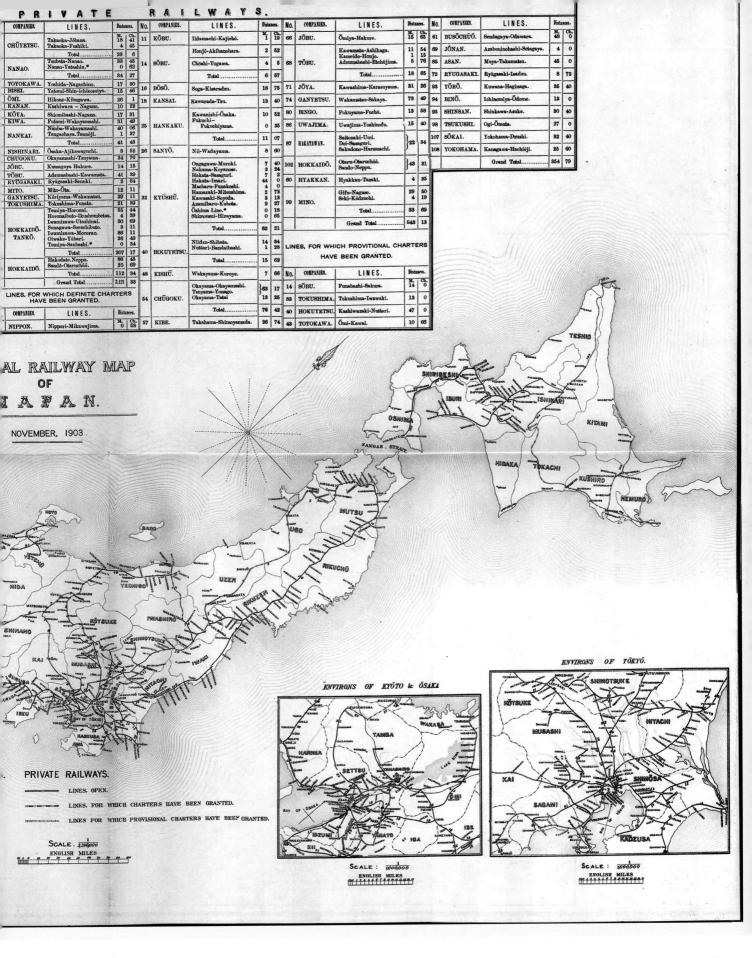

RAILWAY MAP OF JAPAN.

NOVEMBER, 1903

ENVIRONS OF KYŌTO & ŌSAKA

ENVIRONS OF TŌKYŌ.

PRIVATE RAILWAYS.

—————— LINES, OPEN.

—————— LINES, FOR WHICH CHARTERS HAVE BEEN GRANTED.

—————— LINES, FOR WHICH PROVISIONAL CHARTERS HAVE BEEN GRANTED.

SCALE: 1/3200000
ENGLISH MILES

SCALE: 1/1600000
ENGLISH MILES

SCALE: 1/1600000
ENGLISH MILES

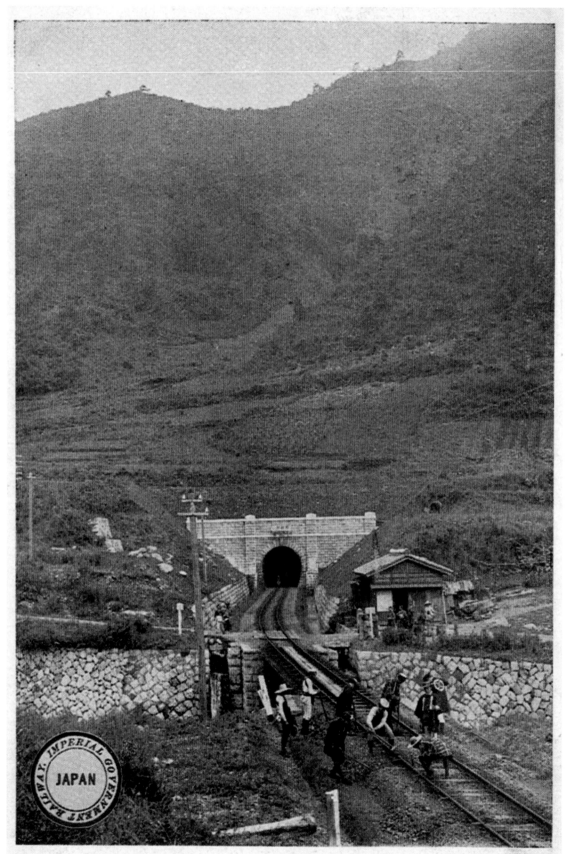

SASAGO TUNNEL IN KAI PROVINCE (THE LONGEST IN JAPAN MEASURING 15246 FT.) ON THE CENTRAL LINE EASTERN DIVISION.

The Sasago Tunnel was on the IJGR's Chūō (中央 "Central") Line, which finally gave the military the defensible national mainline away from coastal areas that it had long desired. At the time of its completion in 1903, the Sasago Tunnel (4.656 kilometers in length and 2,250 feet above sea level) was the longest in Japan, and the pride of the IJGR. It would remain so for almost 30 years until completion of the 9.7 kilometer Shimizu Tunnel in 1931. The Chūō line terminated in Nagoya, serving as an alternate route to that portion of the Tokaidō line running from Tōkyō to Nagoya along the coastline via Chigasaki, Kōzu, Numazu, Shizuoka, and Hamamatsu. A track crew of nine is making adjustments to the line shortly after opening while some of the local inhabitants look on from the grade crossing next to a trackworkers' or crossing guard's hut.

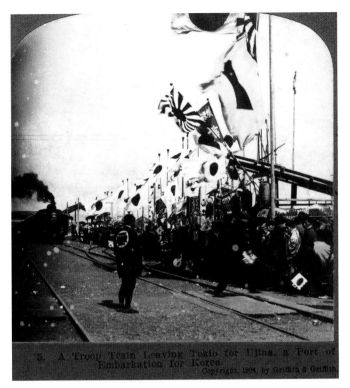

5. A Troop Train Leaving Tokio for Ujina, a Port of Embarkation for Korea.
Copyright, 1904, by Griffith & Griffith.

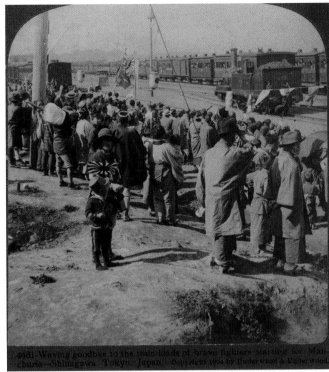

4461—Waving goodbye to the train-loads of brave fighters starting for Manchuria—Shinagawa Tokyo, Japan. Copyright 1904 by Underwood & Underwood.

Feeling the gentle slope of the downgrade, each little car leaped playfully forward, then along at a growing speed. We whirled past most lovely views of wooded promontories jutting out into the sea as blue as periwinkle. We darted through groves of bamboo, hung with prayer-papers tied by pious pilgrims in the hope that the fluttering wind might waft the desires there written down to Buddha. We flew past battered little wayside shrines, from which a thin odor of incense, the never-to-be-forgotten smell of the Far East, was wafted to us. We crossed the most ridiculous little bridges, over rushing streams that made quiet pools of light…

It was a most delightful and exhilarating sensation, this quick run through the air… with the delightful element of wonder as to whether at the next corner we should get around it safely or not. With regret we came to the last bend, the other side of which our exotic conductor promised we should find Idzusan [Izu-san], the last stop before Atami. It was a splendid corner, to be sure, this final one. All the coolies leaned as far as ever they could towards the bank, so close that the ferns and lilies brushed them—and with a whoop and a yell we negotiated it safely, and entered Idzusan, a little hamlet, whose houses nestle against the rocks like swallow's nests. …

We left the car and walked a little way towards the beach… We were inclined to idle there, … [b]ut our conductor came after us, to beg that we… retrace our steps… The coolies made a final spurt up the last hill. The reflection of the sunset was dazzling [on the sea]—as if a hundred signal corps heliographed to one another: Atami. 'The honorable hot water,' our coolies explained, by which they meant the geyser, pride of Atami, the only one in Japan.[12] …

Our little train reached the top of the hill, and then ran dizzily down into the little station. There we reluctantly alighted, charmed by our novel and unique experiences…"

The outbreak of hostilities in the Russo-Japanese War brought with it a wave of patriotic fervor among the populace. Seen here are two views of troop trains leaving Tōkyō for the ports from which troops were dispatched. The first view shows a train piloted by an American-built 4-4-0 leaving Tōkyō for Ujina (Hiroshima's port) while the second view shows a train of older style four-wheel compartment stock leaving Shinagawa station on the original Shimbashi–Yokohama line, with a good view of an idle A8 class locomotive standing in the yard. That four-wheel compartment non-corridor carriages that were gradually coming to be used only on suburban services or secondary lines were pressed into service for long distance troop trains shows how hard-pressed the railways must have been to muster rolling stock to meet the magnitude of the necessary troop movements. It must have been a long and arduous journey (averaging 20 mph) for the troops to have been in carriages with no corridor connections, many providing no access to lavatories except during stops in local stations. Note the small boy in his soldier's suit and flag in the foreground of the second view.

* * * * * * * * *

By the time Lorrimer was decrying the drinking of "the deadly hot *sake* wine," Japan was second in Asia only to India in railway development. The average passenger car contained 38.5 seats, a relatively low figure due to the high percentage of 4-wheel stock (the standard 4-wheel compartment type carriage carried only 50 people in third class configuration or 32 people in 2nd class configuration). There was more than adequate growth potential: in 1903, passenger traffic volume per person still amounted to only 2.4 trips per year aggregating a yearly average per person of only 42 miles. In 1903, 1,313 passengers and 547 tons of goods passed over each mile of railway every day on average.

In the ten-year period since adoption of the 1892 Railway Law, "First Period" lines were starting to open. The Ōu line was well underway and would be completed in 1905. The Inyo–Renraku line was inching southwesterly along the Sea of Japan coast and would eventually be the first segment of what is now known as the San-in line. The Shinonoi Line, built in part to assist in the construction of the Chūō line, from Shinonoi on the Shin'etsu line was opened in late 1902, vaguely approximating the original proposed 1885

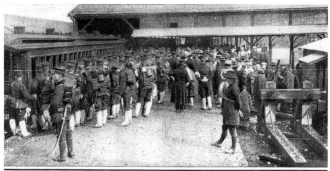

TROOPS BOARDING A TRAIN AT THE SHIMBASHI RAILWAY STATION, TOKIO

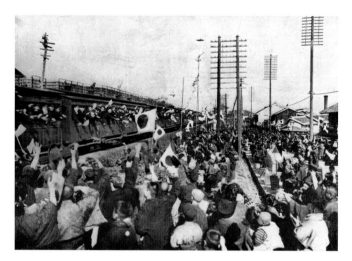

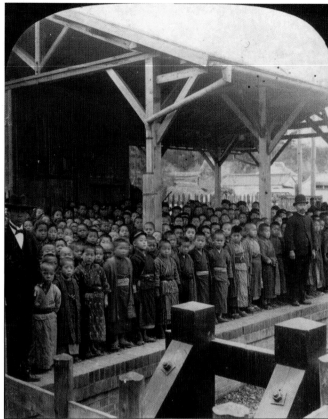

6010 Japanese Schoolboys Waiting to see Soldiers bound for the War. When the train arrives they all sing a war song and shout '' Bonzai '' (good luck).

(top left)
The unit pictured here boarding at the Shimbashi station freight platforms early in the war has the luxury of some of the newest passenger stock then in service, as evidenced by the profile of the clerestory roof of a design introduced around the turn of the century. Of particular interest is the as-yet unused specimen of the standard IJGR pattern buffer stops seen to the right in this view. As this example has yet to be embedded in an excavated site and laid-over with rails and ballast, the photograph neatly shows the manner in which they were pre-fabricated.

(above)
Accompanied by the shouts of *Teikoku Banzai* "Long live the Empire" according to the original caption, a troop train leaves Kōbe early in the war bound for the front. The depth of popular support for the cause of checking Russian territorial expansion and the morale-lifting effect it had on the troops could not be more obvious in this ebullient photograph.

(above)
A rather more poignant farewell is evidenced this view showing a class of schoolchildren brought to an unidentified station to see departing troops off in song. Almost instinctively, and without parallels in the coming conflicts of the 1930s and 40s, the Japanese populace realized the gravity of the undertaking facing them, and were perhaps at the zenith of national unity of opinion in support of their national cause.

route from the Usui region to a junction with the new Chūō line at Shiojiri. By March 31, 1903 some 1,101 miles of so-called "First Period" lines had been opened to traffic, and well over half the entire "First Period" programme was complete. By that same date, 674 miles of "Second Period" designated route mileage had been assumed by private lines with Diet approval, of which 365 miles had been opened. 1903 also saw the completion of the Sasago Tunnel on the ever-lengthening Chūō line. That tunnel, at some 4,656 meters in length, would stand as the longest tunnel in Japan until completion of the Shimizu Tunnel (9,704 meters) in 1931. Similarly, the Torii Tunnel (at an elevation of 3,189 feet) on the same line was the highest elevation then reached by any railway in the realm. The interior *Central line*, long desired by the military, became a reality when the final link on the route to Nagoya was completed in 1911. By 1905, the railway system of Hokkaidō had

been extended to Hakodate, creating a ready rail link to Honshū by the shortest available ferry route to Aomori. The steadily-growing accretions couldn't have come at a better time, for Japan once again found itself confronted with foreign problems.

Russia, then in the course of one of the more expansionist phases in its history, was moving still more aggressively in Manchuria and close to Korea. As had been noted earlier, it had commenced building of the Trans-Siberian Railway in 1891 to strengthen its foothold in East Asia, which would make the supply and arming of Vladivostok and Russian towns along the line in Yakutsk all the more easy. Indeed, the railway never served an economic function during the first decades of its operation, as its use was overwhelmingly military. The situation in China had deteriorated even more. The abortive Boxer Rebellion in north China, centering in Beijing, had proven to be the first international crisis of the 1900s. By the time of its conclusion, brought about by an international military coalition consisting of Britain, Germany, France, the US, Russia, Italy, and (notably) *Japan*, only the most blind could not have foreseen that the Manchu Ch'ing dynasty was about to topple under the weight of it's own corruption and ineffectiveness. The period of Chinese history known as "The Scramble for Concessions"[13] had been underway for some

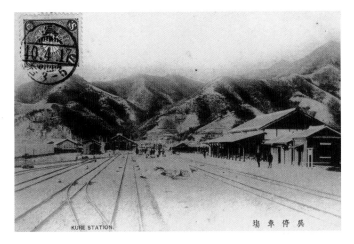

time, and in the wake of the Boxer Rebellion, it was not unrealistic to assume that the world powers would soon be partitioning China into respective "Zones of Influence" that arose out of those concessions, from which eventual colonization was the expected result. Insofar as East Asia was concerned, Japan was indisputably one of those powers and was determined to make sure its position was not diminished vis-à-vis the gains that seemed to be within grasp of the other powers.

The situation with Russia had gone from bad to worse. The Japanese viewed Russian expansionism with great alarm, and saw the homeland itself as one of Russia's ultimate goals. Russia had, after all, acquired large tracts of land north of the Amur river in Manchuria (about twice the size of France) by some very sharp dealing and sharp diplomatic maneuverings with China with the Treaty of Aigun and the Treaty of Peking in 1858 and 1860 respectively, and had dispatched a force to the Japanese island of Tsushima (which is strategically situated in the 100-mile-wide straits that separate Korea from Japan) in 1861 to take the island from Japan, only to be evicted by British force of arms. Similarly, it had forcibly evicted Japan from Sakhalin Island by 1875. Despite having initially indicated publicly its intention to build the Trans-Siberian Railway approach to Vladivostok in Russian territory, the 1890s weren't over before it used its leverage to coax from China's weakened government a railway concession to allow the building of the Trans-Siberian directly across Manchuria in a more direct route, leading to the formation of the Chinese Eastern Railway. The Chinese Eastern Railway was nominally under joint Chinese and Russian direction and control, but this fooled no one. Only the most naïve of diplomats would have expected Russia not to seize the Chinese Eastern Railway (and to annex a generous swath of territory on both sides of the right of way) if the threat was ever *perceived* to be grave enough to Russian security. The pact creating the Chinese Eastern even went so far as to permit Russian troops to be garrisoned along the line, ostensibly to protect it from local acts of sabotage. (This was not altogether unrealistic. Railways were a lightning rod for anti-foreign fervor which was then gathering in northern China. During the Boxer Rebellion, the fledgling Imperial Chinese Railway was to be particularly hard-hit as a symbol of the Western colonial influence that the Boxers sought to eradicate, and was the subject of considerable destruction during that rebellion.) True to form, Russian troops started pouring into Manchuria to protect the Chinese Eastern Railway during the Boxer Rebellion. In its aftermath, the

The two postmarks date these scenes of the railway and station at Kure to sometime between 1904 and 1907. Kure was located by an excellent natural harbor and a railway line to that harbor and adjoining military base were government priorities in the very first years of the 20th century. With the advent of the Russo-Japanese War in 1904, Kure was to become one of the main ports of debarkation for troopships to the front. In fact, the government's 12-mile "Kure Tetsudō" that departed from the San'yo mainline at Kaita on the outskirts of Hiroshima was hastily finished as a war priority and was inaugurated on December first, 1903. It was immediately leased to the San'yo on its completion, and that railway continued to operate it until nationalization. One imagines that the station was quite a bit busier during the war than it appears to be in the view shown. The view of the "Kwannombana Tunnel" and the one farther beyond, the mouth of which is visible over the postmark gives a good indication of the terrain through which the San'yo Tetsudō ran.

international community fretted ineffectually, trying to negotiate their withdrawal, which Russia promised, but never undertook. After a number of hollow promises passed without consummation, it became clear that Russia had colonial designs on Manchuria that were gradually to coming to fruition.

It was a time when Russia was perceived by the British as a great threat to the carefully crafted European balance of power. Britain had, for the first time since the defeat of Napoleon, entered into its first alliance formalized by written treaty, which was designed to counter the increasing threat it was feeling from Russia and a rising Germany. That treaty was the Anglo-Japanese Treaty negotiated during 1901 and signed in January 1902, in large part designed to give Japan additional security from Russian incursions, while freeing the Asiatic Squadron of the British Royal Navy from police and patrol duties in the Far East to permit it to be returned to Europe to be put to more effective use countering any Russian or German threat to European security.

To make matters worse, in the wake of the coerced concessions that followed the abortive Boxer Rebellion, Russia had the arrogance in 1901 to extract from China, by lease, the Liaodong Peninsula—the very Peninsula which Japan had conquered and won in the Sino-Japanese War, but only some 6 years before had been forced by Russia (with France and Germany) to return to China. That act alone was one of the most maladroit blunders of Russian Far East policy of the period, coming as short on the heels of Japan's capture of the same lands as it did. Evidently, it mattered little to Russia's government ministers and military, who gravely underestimated Japan's new-found abilities and sense of mission, and it probably mattered less to Tsar Nicholas, for while still a crown prince in 1891, on his way to inaugurate construction of the Trans-Siberian at a ceremony set for Vladivostok by decree

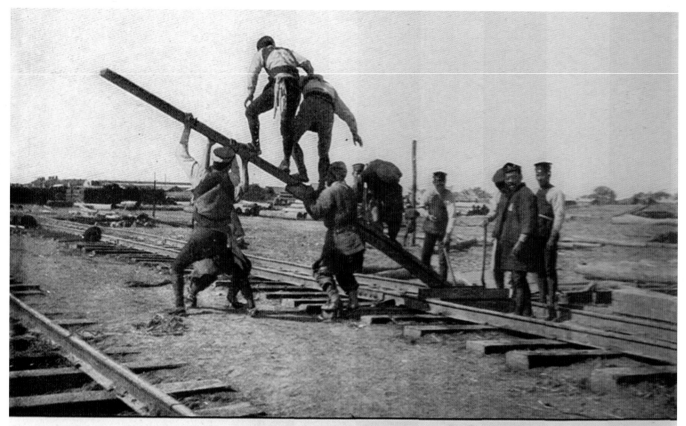

ALTERING THE GAUGE OF THE TRACKS TO FIT THE JAPANESE ROLLING STOCK

The Japanese Army's Tetsudō Rentai generally re-gauged the captured Russian railway lines with commendable efficiency, given the resources with which they had to work. This view of re-gauging in the vicinity of Liao-Yang, however, is not without its comic aspect. It's difficult to tell whether the crew is attempting to straighten a bent rail, curve a straight rail, or is simply attempting to raise the height of the line for leveling, using a spare rail as a lever. In at some instances, re-gauging was mistakenly depicted by both war correspondents and graphic artists to have been Japanese destruction of the lines, showing an ill-considered analysis of the situation by the observer: advancing armies generally seek to keep captured lines intact for future supply purposes, only retreating armies seek to destroy them, and it was the Russian forces, not the Japanese, that were consistently on the retreat.

been completed to Shimonoseki (only some 100 miles from Pusan, Korea across the Tsushima Straits) and troops could be dispatched much more effectively to the mainland. In the interim since the Sino-Chinese War, the Japanese had developed the logistical capacities of the railways and of the harbor facilities in various southern coastal towns to permit its army quickly to concentrate and dispatch troops to the Asian mainland. All up and down the trunk line formed by the Nippon–Tokaidō–San'yo trio, troops were seen off by throngs of patriotic subjects at stations as their trains headed for the southern ports of embarkation: Sasebo, Kure, Ujina (Hiroshima's main port facility), Moji (now Kitakyūshū), and Nagasaki. As had occurred during the Sino-Japanese War, traffic was again disrupted on home lines, and the burgeoning passenger traffic was seen as a source of financing for the war efforts. War taxes in the form of ticket surcharges were levied on passenger journeys, having the salutary effect of depressing unnecessary civilian travel, while raising funds. To keep troop movements as secret as could be from any Russian spies or sym-

pathizers, many troop trains ran at night and lighting was put out on all passenger trains in the vicinity of any troop train, and vice-versa. According to one source, of the total Japanese troops put in the field, roughly 1 in 20 were engineers or transport corps; a figure unmatched in any other non-colonial Asian army, and more on par with some European armies of the day.

The Japanese Army had studied and adopted the tactics of the German army in the wake of its rapid victories in the Franco-Prussian War, and had adopted the use of 600mm German Feldbahn ("field [of battle] railway") equipment for logistical support. The army had created its first Railway Battalion, the Tetsudō Rentai (鉄道連隊 Railway Regiment) in 1896, based across the Tōkyō bay from Tōkyō on the Chiba peninsula. The unit was expected to operate the German Feldbahn equipment the government had ordered before the outbreak, some shipments of which were still in transit and much of which arrived too late to be effectively used. Nevertheless, the battalion was much employed in Korea and Manchuria, as it hurriedly built, oversaw, or sped completion of several railway lines to support the Japanese advance. Likewise, the government had come to the assistance of the Japanese contractors who were engaged in building a railway between Pusan (the Korean port at the very south-eastern corner of Korea) and Seoul, on the condition that the railway be opened for traffic by the end of 1904. Work was done around the clock, day and night, all along the entire 276 route miles of the line, rather than in segments. True to schedule, on New Year's Day 1905 the railway was opened for service, and with it, for the first time, Tōkyō was linked by rail (*and a 100-mile ferry service*) with the

capital of another country. From Tōkyō, Seoul could be reached in the unheard of time of 34 hours by train to Shimonoseki, nine hours across the Tsushima Straits, and another 15 hours from Pusan to Seoul.

Japan's first attack was made at a time of year most advantageous to Japan, during winter, when the fleet at Vladivostok was frozen in, and troop movements along the Trans-Siberian would be most difficult, due the bitter Siberian winter and the fact that the railway had not yet been built around frozen Lake Baikal, when ferry service was suspended each winter.[15] The entire Trans-Siberian had been built very lightly. The rails were only 54 pounds to the yard, which would bear only light locomotives, resulting in shorter trains and commensurate load restrictions precisely at a time when heavy trains bearing maximum loads would have been desired. The gap at Lake Baikal caused concern. The Russians had for some years been in the habit of laying a light temporary rail line across the ice of Lake Baikal, which froze to an average depth of some 9½ feet, but in the winter of 1904, the ice was proving to be particularly unstable, and the laying of that temporary line was disrupted, hindering troop and materiel movement to the East. With the Russian ships in Russia's only warm water facility at Port Arthur effectively neutralized as a result of the success of Japan's first-strike assault, and the Vladivostok ships largely frozen in, there were effectively no other Russian naval squadrons of any size in the region,[16] the unhindered transport of Japanese troops across the Straits of Tsushima to Korea was greatly facilitated, and the IJA quickly accomplished it's build-up on the Korean peninsula, while the Russian Viceroy for the East, Alexieff, and the field commander Kuropatkin were obliged at the outset to make a tactical retreat, moving their headquarters to safer points inland from Port Arthur. This of course made Japanese occupation of the Korea much easier. With the garrisons at Port Arthur and Dairen pinned down, Russian forces in Korea had to be supplied from more remote locations. Russian reinforcements trickled in to Harbin (hundreds of miles inland from the threat of any Japanese naval attack), the strategic junction on the Chinese Eastern Railway where the branch to Port Arthur diverged from the mainline to Vladivostok and to Mukden and Liaoyang to the south.

The Japanese Army's northward advance to the Yalu River boundary between Manchuria and Korea was so quick that the small Feldbahn-type railway equipment (which was suited to serve as short lines from a major railhead for a moderate distance to the front) proved to be less useful than had been expected. However, a short Feldbahn-style line was built after the victory over the Russians at the Battle of the Yalu that ran from Antung (present day Dandong) to Fenghuangshang, roughly 30 miles, which was operated in Jinsha fashion with local "war coolies" pushing convoys of the tiny cars until the locomotives could be brought forward. Orders had been hurriedly placed just before the war's outset for additional locomotives from Baldwin and the American Locomotive Company ("Alco" a recently formed amalgamation of the Brooks, Schenectady, Cooke, Pittsburgh, Rhode Island, Dickson, Manchester, and Richmond locomotive manufacturers) and any other manufacturer who could promptly supply locomotives.[17] As the Japanese advanced from the Yalu and other landing points along the Manchurian coast, by-passing Port Arthur and moving northward up the Liaodong Peninsula along the Port Arthur Branch of the Chinese Eastern Railway toward the critical junction of Harbin, they learned that the Russians had managed to evacuate virtually all of the locomotives and rolling stock, leaving the railway useless, as it was built to the Russian 1520mm (5' 0")

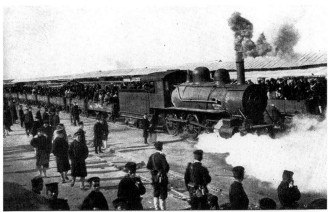

FRESH SOLDIERS ARRIVING TO TAKE THE PLACES OF THOSE LOST AT LIAO-YANG

Once re-gauging efforts were completed, Japanese reinforcements and supplies began to pour ever northward by rail. This view shows one of those troop trains supposedly arriving at Liao-Yang, headed up by a Kyūshū Tetsudō mogul (8550 Class upon subsequent nationalization) that was among the rolling stock hurriedly gathered up and imported to Manchuria. Troops traveled in the ubiquitous three plank wagons found throughout the Japanese railway system. As evidenced by the locomotive, any private railway that could afford to contribute stock was approached and urged to donate to a pool of expeditionary stock. One often finds photos of "Big Five" rolling stock in Manchuria during the war.

gauge and both Japanese and Korean rolling stock were of different gauges. However, when Dalny (Dairen) was cut off and captured, the Japanese discovered that a considerable number of freight wagons that had been abandoned there and again *war coolies* operated the line using the captured freight cars by manpower.

Tetsudō Rentai engineers were soon pressed into service re-gauging the Port Arthur Dalny Branch to the north to 1067 mm gauge to allow Japanese-gauge locomotives hastily brought over from Japan to be used: about 200 locomotives, mainly B6 0-6-2T tank locomotives (at least 30 of the latest batch from Dubs B6), 2-6-0 Moguls, and F2 class 2-8-0 Consolidations—locomotives that were otherwise badly needed at home to handle the increased traffic to embarkation ports were hastily shipped to Manchuria. It was easy work to unfasten the rails, move them 1' 6" inwards, and then re-spike them to the Japanese gauge. To ensure the Russians couldn't re-gauge with as much ease if the tides of war shifted back against the Japanese, the Japanese crews who re-gauged the Russian lines were mindful to cut the cross-ties off after the re-gauging to the narrower gauge.

As Japanese troops pushed ever northward toward Mukden, Russian forces had not gained one significant victory, but had become very adept at skillful retreats and had avoided decisive routs along the way. The effects of the meagre logistical support due to the limited capacity of the single-tracked Trans-Siberian Railway was beginning to show, and the balance of fortune was tipping in favor of the Japanese, whose forces were blessed with the higher morale resulting from the string of successes. Tahshihchiao, the town that formed the junction on the railway to the north with a branch running to the nearby port of Newchuang (*Yingkou*), fell on July 25th. With control of that branch and with Newchuang port having already fallen to Japanese control, the Japanese obtained yet another railway line of supply that was of great utility. Next along the rail line to Mukden, Liaoyang fell on August 25, 1904. By October 3, 1904 the Tetsudō Rentai had completed re-gauging of the Port Arthur branch from the port of Dalny into

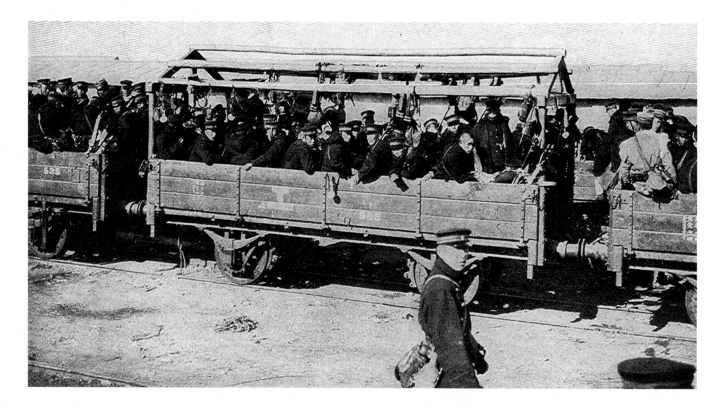

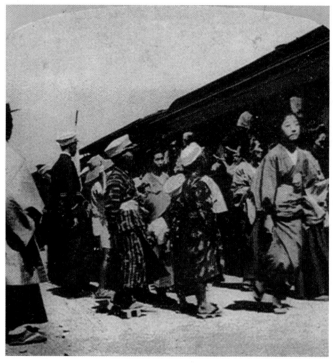

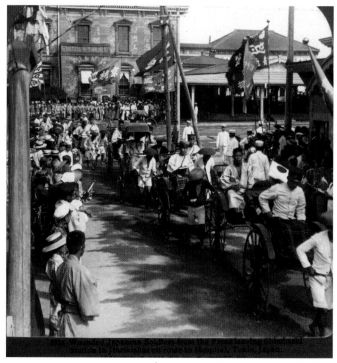

(top)
An interesting view of a purpose-built field alteration to one of the IJGR three-plank wagons used to transport troops and materiel in the aftermath of Liao-Yang, permitting tent canvas to be stretched over the car for protection from the elements of the occupants or cargo, as the case may be.

(above left & right)
The first of these two views records the arrival of a train of wounded soldiers in Tōkyō during the progress of the war. Note the four schoolboys in their white caps, probably which identify them as volunteers, each ready to do his part, as assistants in some capacity, the smallest of who is probably no more than 6 or 7 years old. One can't help but admire the sense of responsibility and service shown by a youngster of such tender age. After arrival at stations, the wounded were taken to local hospitals. The second view shows newly-arrived wounded being taken from the side entrance of Shimbashi station as an assembled crowd welcomes them home.

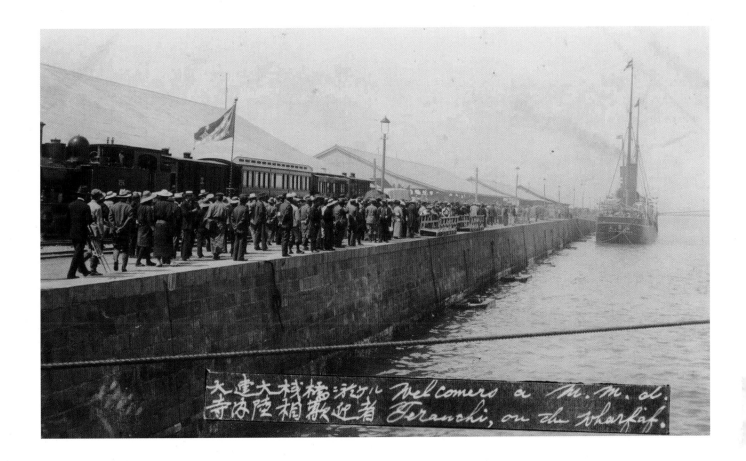

大連大棧橋ニ於ル Welcomers a M. M. d.
寺內陸相歡迎者 Terauchi, on the wharf af.

Liaoyang, and the sound of steam whistles were heard at the station as supply trains powered by the 1067mm locomotives hurriedly brought over from Japan started to arrive. The stronghold of Port Arthur itself finally capitulated on January 2, 1905, providing yet another supply port linked to the ever-expanding former Russian rail system in Japanese hands and leaving the way clear for the forces involved in the siege to join the main bulk of the Army in its push to Mukden and the prize of Harbin.

On learning of the fall of Port Arthur, in an effort to regain some initiative, to disrupt Japanese supply lines, and to relieve Mukden of some of the pressure slowly coming to bear upon it, the Russians launched a cavalry raid from their positions north of Liaoyang consisting of 6,000 Cossacks and several batteries of field guns under Major General Mischenko. The raiders were to flank the Japanese army and once the lines had been penetrated to proceed southward. The objective was the port of Newchwang, where the ever growing Japanese supply depot was guarded by a small garrison of roughly 500 men that would have been easily overrun. Along the way Mischenko planned to stop at points to destroy the rail line between Newchwang and the rear of the Japanese army. The Russians were able to succeed in penetrating the line and maintained something of an element of surprise, but as soon as the first intelligence reports reached the Japanese, it was not difficult to guess at the raiders' objective. Alerts were sent to the garrison and a relief train of 16 wagons was hurriedly dispatched in the direction of Newchwang with a crew of civil engineers, extra rails, spikes, bridging timbers, tools and supplies, and several hundred reinforcements for the small garrison. The race to Newchwang was on. Although the Russians had a head start, fortune smiled on the Japanese. Because it was the dead of winter and

While there are a fair number of photographs of the Imperial Train from the Meiji era, fewer photographs of V.I.P. trains that were specially run as circumstances merited have survived. This photo is one of those few although not in the homeland. It shows the arrival of then Minister of War (later Prime Minister) Terauchi Masatake at Dalian (Dairen) Manchuria, during or just after the Russo-Japanese War. An all Japanese special train of stock brought from Japan consisting of B6 locomotive number 756, an IJGR brake van, a special salon carriage (perhaps one of the carriages from the Imperial Train?), a first or second class carriage for his entourage, and an additional brake van for baggage and impedimenta at the rear stands ready quayside as the party arrives on a ship who's stern bears the name "Ōyo Maru Naruo." Naruo is in the vicinity of Kōbe.

the surrounding countryside had been rendered a wasteland by the prior fighting, Mischenko's raiders were encumbered with a larger than average number of supply wagons, which slowed their pace significantly, turning what would typically have been a two day ride during forage season into four. Worse yet, the Cossacks had not been properly instructed how effectively to render a railway useless, and their damage consisted in the main of removing rails and other minor works of sabotage, all of which was quickly repaired by the nimble Japanese under the careful supervision of the accompanying Tetsudō Rentai engineers. The race came down to the wire. As Mischenko's raiders were making their final approach to Newchwang along the railway line they believed they had disabled, they heard the furious exhaust beat of a locomotive at speed to their rear. Surprise was now on the side of the Japanese, who raked the cavalry column with fire as they steamed past full speed on their way into the city. The approaching scream of the steam whistle was enough to put the small garrison, already on alert behind hastily strengthened defenses, on notice of the arrival of reinforcements, and considerably buoyed morale. This heart stopping, nick-of-time arrival roughly doubled the number

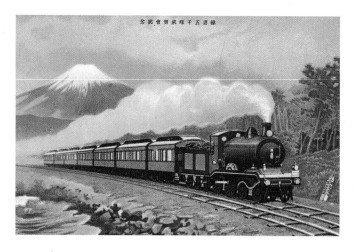

On the eve of nationalization, Japan celebrated the 5,000 mile mark in the development of its railway system, in conjunction with which the commemorative postcard at left was issued, supposedly depicting an up express train on the Tokaidō line roaring past the 5,000 milepost. A charming scene, but the card does not depict a Japanese train. The postcard publisher has merely copied a Tuck postcard (shown at right) of the celebrated London Brighton and South Coast Railway Brighton Belle express train, superimposed a seashore in the foreground, and drawn Mt. Fuji in the background. Even the distinctive "Stroudley's Improved Engine Green" livery on a Billington 4-4-0 that never ran in Japan has been kept. No Japanese railway is known to have employed such a livery and no such locomotives were imported. Even the marker lamps and indicators on the locomotive front, unique to the LBSCR, have been set over in wholesale fashion from the Tuck card. Not all Meiji railway illustrations can be taken at face value.

of defenders to about 1,000. The reinforcements were quickly assigned posts at the defenses as quickly as they could be de-trained and after three successive cavalry charges had failed, Mischenko was obliged to withdraw his Cossacks and rejoin the main body of the Russian army. The supply depot at Newchwang had been relieved, while the Russians had been denied the initiative and handed yet another defeat. The repulse of the Newchwang Raid was the only notable role (other than supply and troop transport) that railways were to play during the course of the war.

Mukden fell in March. With the fall of Mukden, the fate of Harbin, and with it Vladivostok, was now in balance. To have lost Harbin would have effectively denied Russia of any practical means of re-supplying Vladivostok. The fall of Harbin would have sealed the fate of Vladivostok and with that would have withered any realistic hope for Russian victory absent an absurdly costly and protracted war of attrition. With the Japanese in a position to move on Harbin, having defeated General Stoessel's defenses at Port Arthur, Russia's last and only realistic hope lay in a hastily assembled relief fleet, cobbled together from its Baltic fleet and any older ships that could be pressed into service. That fleet had left the Baltic ports near St. Petersburg in October 1904 under command of Admiral Rozhestvensky for a long voyage around the Cape of Good Hope on its way to Port Arthur.[18] On its arrival in Asian waters, after a long-suffering voyage replete in mishaps and adversity, it was quickly dispatched by the Imperial Japanese Navy under the formidable Admiral Togo in the decisive Battle of Tsushima, named after the small island roughly midway between Japan and Korea in the 100 mile stretch of water that separated them where the battle occurred. The victory at Tsushima and the fall of Port Arthur left the Japanese navy at liberty to deal with the remaining ships based at Vladivostok. Predictably, Sakhalin Island was next

to fall to the Japanese. This didn't bode well for Vladivostok as the war machine in Manchuria crept ever closer to the critical rail junction at Harbin, and new forces on Sakhalin raised the specter of Vladivostok soon finding itself in the jaws of a vice.

In the meantime, domestic revolution and unrest in Russia had intervened, obliging the Czar to agree to share some of his power with Russia's first national legislature, the Duma, and to be favorably disposed to a peaceful resolution. The cost of the war was staggering to Japan's economy, such that Japan was approaching the point of financial exhaustion. Japan had accomplished a great deal of its objectives. To it, the difficult logistical task of supplying an army far inland beyond Harbin quite naturally must have appeared altogether less than attractive. Both parties agreed to a mediated peace conference proposed at the opportune moment by American president Theodore Roosevelt, which resulted in the Treaty of Portsmouth and the cessation of hostilities.

* * * * * * * *

On the heels of the war's conclusion, further cause for celebration occurred in 1905 when the railway mileage in Japan reached 5,000 miles. People looked back nostalgically to the days of 1889 and drew suitable parallels, as just on the eve of completion of the Tokaidō line, the nation had celebrated its 1,000 mile landmark. As business returned to normal, the amalgamation trend that was well underway before the outbreak of hostilities continued apace: The Kansai had acquired the Kiwa, Nanwa, and Nara railways. The Kyūshū Tetsudō had merged into its route-mileage the rights-of-way of the Hōshu and Karatsu Tetsudō. The San'yo had taken the Bantan under its wing and across the Inland Sea on Shikoku had absorbed the Sanuki Tetsudō, to become the only railway other than the IJGR operating on more than one island. By this point in time, the largest private railways, which consisted of the Nippon Tetsudō, the San'yo, the Kyūshū, the Kansai, and the Hokkaidō Tanko Tetsudō (successor of the Poronai), had in the public consciousness collectively attained the nickname of "The Big Five."

Well prior to the war, the government had made another effort at establishing a steel industry, this time with a better chance of success. The Diet had passed enabling legislation in 1896. February 1897 saw Yawata, near Kokura in north Kyūshū being chosen as the site and plans were soon put in hand to build a large-capacity steel-making complex there. The proposed complex

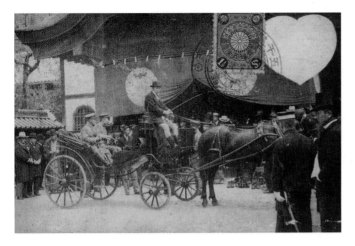

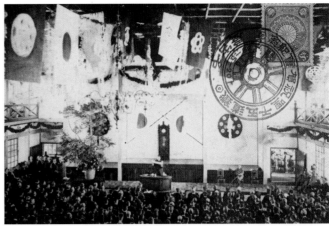

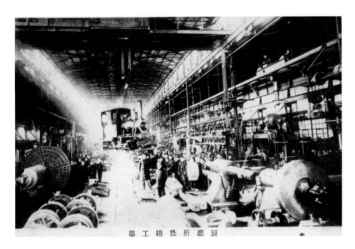

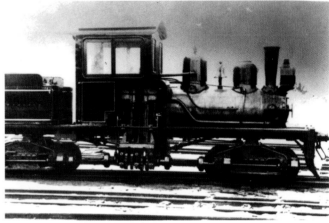

(top)
The IJGR made quite a celebration of the ceremonies marking the completion of 5,000 miles of railways in Japan. This view is believed to show the arrival at ceremonies of one of the dignitaries; perhaps General Nogi (judging from appearances) who would have been one of the biggest celebrities of the day as it was the era just following his victories in the Russo-Japanese War. Note the footwear of those who have already entered the hall that are visible through the horse's legs.

(above)
This photograph of a repair shop for railway and other heavy works, probably part of the Yawata complex, is emblematic of the extent to which Japan was becoming increasingly self-sufficient by the end of the Meiji era. A class of engineering apprentices stands beneath a small German-built Orenstein und Koppel tank locomotive (Yawata bought several in 1911 for its own rail network at the factory complex) during a class visit in an obviously posed scene.

(top)
This is a more accurate commemorative postcard view depicting the ceremonies marking the completion of 5,000 miles of railways that took place in Nagoya on May 20, 1906. Note the hanging banners emblazoned with the *mon* of the various railway companies, many of which were on the verge of being nationalized when this photograph was taken. The postcard bears the special cancellation of the 5,000 mile festivities.

(above)
Yawata ordered 5 of Shay's patent locomotive from Ohio's Lima Locomotive Works: four 10-ton, two-truck Shay (order nos. 1867, 1868, 1882 &1883) and one 13-ton, two-truck unit (order no. 2001). The first four were shipped on April 27th, 1907 and were assigned running numbers 47 through 50. The larger unit shipped on November 6th that same year. These locomotives were used in the construction of the Kawachi Dam, which formed the reservoir for the mill's water supply. This photograph shows Lima order number 1883, in 'as-built' or close to 'as-built' condition, around 1907. Despite the adaptability of the gear-driven Shay locomotive to mountainous terrain, particularly to logging operations, the slow but sure-footed type never gained as much acceptance in Japan as one might have expected. Some examples made their way to Taiwan for use there by Japanese colonial interests.

was carefully studied and planned, with as much study as one would have expected of the best contemporary European or American steel mills. In order to cope with the increased materials being off-loaded, development of the port of Wakamatsu was subsidized. A dam was built to form a reservoir that would provide the necessary amounts of water the plant would consume, and to aid in construction of that dam, Shay locomotives from the Lima Locomotive Works in Lima, Ohio were ordered. When it opened in 1901, the results were every bit as successful as the results at Kamaishi had been a failure, and it couldn't keep up with demand, being expanded as rapidly as efforts would allow. Yawata was the cradle of the Japanese steel industry and became one of its

centers. With it came the ability to mass-produce high quality steel in larger volumes than had ever previously been accomplished in Japan and with *that* came the possibility of domestically manufacturing locomotives and rails on a large scale. Indeed, a factory expressly designed to forge and turn the steel tires that are put on locomotive driving wheels and other railway shops were envisioned for the Yawata complex and had become operational by 1905. As had passed the epoch of the *yatoi* in Japan, so was the epoch of foreign-built locomotives about to follow.

CHAPTER 8: 1906–1912
Nationalization and Self-sufficiency

Shortly after the end of the Russo-Japanese War, the inveterate traveler Charles Lorrimer traveled to Miyajima, a scenic tourist destination, via the IJGR Tokaidō line and the San'yo Railway, laying over for a night in Kyōto, and left an impression on what first-class travel was like aboard the best express trains of the time. He departed Shimbashi on the 6:00 am express to Kōbe, at a time when riots were feared to be brewing in Tōkyō due to the introduction of new tram fares of 4 sen. Cavalry was patrolling the streets, which he negotiated without incident or mishap: Lorrimer didn't record whether he paused to breakfast at the Shimbashi branch of Tsubo-ya restaurant of Hiyoshi-cho, which was operating dining rooms on the second floor of the station by the turn of the century that served "European meals at all hours" and "French confectionery," but he did observe that:

"Once at the station, the modern triumphs over the antique with a perceptible jar. 'Red caps,' as the porters are always called, clustered about us, seized our bags, turned each carefully upside down and then started serenely for the platform. At the ticket office window we saw several new notices posted up. These concerned the war taxes. ... We ourselves paid a transit tax as well as an express train tax.

Unluckily, all this expenditure did not secure us much comfort. Other more enterprising passengers—early birds— had arrived before us. Their bags, carpet, leather, rattan, and their bundles, cloth, paper, silk, occupied at least half the seats. Some of the travelers had their blankets and rugs neatly spread out already, their air cushions blown full, their elastic-sided boots kicked off and placed on the floor in front of them, and themselves stretched full length on the seats enjoying a newspaper. We entered the car, coughed, and stumbled over the inevitable spittoon to attract attention. Not the slightest result. Nobody moved. Those exquisite Japanese manners, famous in two hemispheres, simply 'were not.' They never are—we have since been told—in trains, which, being modern Western inventions, were not provided for in the old rules of politeness. The best-bred Japanese in the land can therefore indulge in the absolute selfishness of squatter rights to his heart's content.

We succeeded after some difficulty in squeezing ourselves between two yielding carpet bags just as the train started.

This postcard is probably the best known of the official postcards commemorating the 5,000 Mile Ceremony in 1906, replete with a distinct Art Nouveau influence and picturing Nagoya Castle in the town where the ceremonies were held. Nagoya was chosen in part out of tradition as the 1,000 Mile ceremony had been held there in 1889. Once again, the locomotive depiction is fanciful and bears a more faithful resemblance to the Johnson-Deely compound 4-4-0s of the United Kingdom's Midland Railway (relatively new locomotive marvels at the time) than to any Japanese locomotive: probably another instance of a locomotive image being appropriated from a press article of the day.

Soon pretty scenery helped us to forget the discomforts of rocking and rolling incidental to the absurdly narrow gauge railways of Japan. Three feet six inches is not wide enough to give steadiness to any line, but at present the Japanese cannot afford to relay miles of track for a little matter of comfort. Indeed, since the [Russo-Japanese] war, economy is the motto for every department of public works, and so even the old-fashioned carriages whose seats run sideways and have their backs and arms at exactly the wrong angles cannot be replaced for some years.

['Shidzuoka'] ... is a very important place, and the railway company acknowledges this fact by stopping the express there for one full round minute—just long enough to allow passengers to walk unjolted into the dining car.

We took advantage of this opportunity, installed ourselves at a table with the cleanest cloth in sight, and waited. At first we waited patiently. No attendant appeared. Then we waited impatiently, with the same result. As the car was small, but one 'boy' (a nom de guerre applied irrespective of the incumbent's age) attended to all guests, and he happened at this particular time to be engaged in painfully working up the account of a Japanese gentleman and his daughter. In vain we beckoned, gesticulated, called; in vain we fumed and fretted, for we had all unknowingly run up against a simple law of Japanese society. Where servants in public places are concerned, the foreign guests wait for the Japanese...

All annoyances, however came to an end, and we finally saw our hated rival leave the car and ourselves treated to the menu. It was short and quaint, leaving us a most limited choice. There was a table d'hote lunch (called tiffin, of course, according to Far East custom) for 40 cents; a set meal composed of three dishes chosen by the clemency of the cook, and then, besides, there were separate things—a beefsteak at 10 cents, for instance, cold chicken at 7 cents, sandwiches positively given away at 6 cents. Apples at one cent formed the dessert. We found the beefsteak plain and eatable when washed down with the Japanese beer, which is so excellent and cheap, and the cold chicken neither more nor less tasteless than its colleagues all over Japan.

Our scanty meal over, we returned to our car and the pleasant surprise of seeing our full-length neighbors astir. There was much folding of rugs and flattening of air cushions going on in preparation for Nagoya, a big and important city, with a beautiful old feudal castle whose golden dolphins decorated the roof we saw quite plainly from our window. From Nagoya, the train hurried on past Gifu...

At 7:30 p. m. the lights of Kioto began to float past the windows like dainty fireflies singly or else in merry compa-

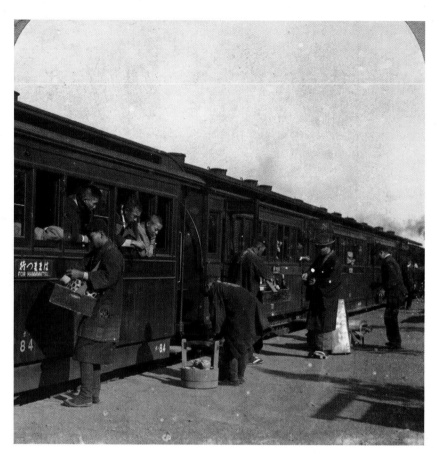

How the rest of us traveled: a Tokaidō line train with Hamamatsu destination boards below the window at far left. This 1902 stereoview is titled "Ten Minutes for Refreshments;" a typical scene in Meiji Japan each time such a train would stop at a station of any size. From left, the first hawker is selling small food items, the second is bending to pick up a pot from his inventory of tea pots, the third is selling bottled beverages to a standing passenger, who stands in front of a hand truck carrying what appears to be foot warmers for rent or exchange, tended by the staffer at far right. This scene represents what was by far and away the most prevalent form of obtaining meals while traveling by rail in Meiji times. Dining cars were not introduced until 1900 and, even by the end of the Meiji reign, were only available on select express trains of the day.

A pencil drawing by Kashima Shosuke of a Sleeping Car for the IJGR built in the UK by Oldbury Railway Carriage and Wagon Co., as running circa 1903. Although the IJGR had long been self-sufficient when it came to wagons and carriages, it ordered sleeping cars to identical specifications from the UK and USA for the Night Tokaidō Express it inaugurated between Tōkyō and Kōbe around the turn of the century. Kashima describes the livery as being chocolate brown, lined in gold, "kept polished like a piano" with varnished cabinet oak interior. The American cars varied in that there were two, not three windows per compartment. Kashima lists the consist of that express in 1903 as being one baggage van, two 2nd class day coaches, one 1st and 2nd composite carriage, one 1st class sleeping car, one dining car and one 2nd class and mail combine, each being 50 feet long and 8' 10" wide. There was no third class accommodation on this initial IJGR train de luxe.

nies, and five minutes later we were in a big station bustling with directions and notices, 'Station Master,' 'Keep to the left,' 'Passengers must cross the line by the bridge only.' It would have been so easy just to slip across the track—but that would be an unconventional proceeding calculated to strike terror into the heart of Japanese officialdom, so we toiled laboriously up steps, across the overhead gangway and down steps again with a law-abiding crowd who would never have thought of rebelling against even the authority of a porter.[1]

The next morning we were in the train again and journeying for two hours past Ōsaka… to Kōbe…

The Sanjo [sic] Railway, is a line vastly different from the Tokaidō. It has an excellent roadbed and wide cars, which help to mitigate the discomforts and annoyances of the absurd narrow-gauge system unfortunately fastened on Japan.

At noon, we had our second experience in a Japanese dining car. The menu was identical with that on the Tokaidō train, but things looked far cleaner and more inviting. Unfortunately, there was no Kirin beer to be had, and we were offered Yebisu, a brand of a more bitter flavor, instead. … At the very hottest hour of the afternoon, our train drew up at Miyajima station. The station at Miyajima was as primitive as treaders of unbeaten tracks could wish… a hotel boy dressed in a cap, and undershirt, short trousers and bicycle stockings took our bags. He had just sufficient English at his command to say 'cross sea in sampan' as he led the way down a tiny village street lined with inns to the shore. A little steam ferry puffed away from a doll's pier just as the train arrived without waiting for passengers. In true Japanese

fashion, her agents had fixed the time-table irrespective of the express, and most of our fellow travelers sat themselves on the beach in a broiling sun to await the steamer's return."

Aside from the quaint and remarkable difference between Japanese express trains of 1905 compared to today's polished Shinkansen expresses, Lorrimer's comments show how deeply attached the Japanese populace had become to its rail transport. For a country that feared, in 1872, that the populace would be antithetical to railways, it is quite telling that a mere 30 years later, the public had become so dependent upon their city trolley cars that they would threaten to riot over a three sen (about a cent and a half) increase in the Tōkyō trolley fare. By this time, railway fares were two sen per mile for first class on IJGR lines. First class passengers were allowed one hundred kin (60 kilos, or just over 130 pounds) of baggage free. Excess baggage was charged at a rate of one sen per kin for journeys of less than 25 miles, 1½ sen for trips between 25 and 50 miles, and two sen for trips between 50 and 100 miles.[2] Baggage could be checked through to almost any station, and the railway company would conveniently deliver it to any city address or carry it by cart for a considerable distance into the surrounding countryside. On the well-travelled Shimbashi–Yokohama trip, the cost of a first class ticket had dropped by 20% from its 1872 level to a fare of 90 sen, while second class had dropped by 30% of the 1872 rate to a fare of 53 sen, and third class had dropped by more than half to a fare of a mere 18 sen. For the record, the fare for a pet dog on a journey of less than 25 miles was two sen, about the value of one US cent in 1904.

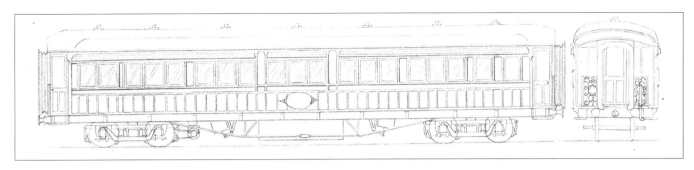

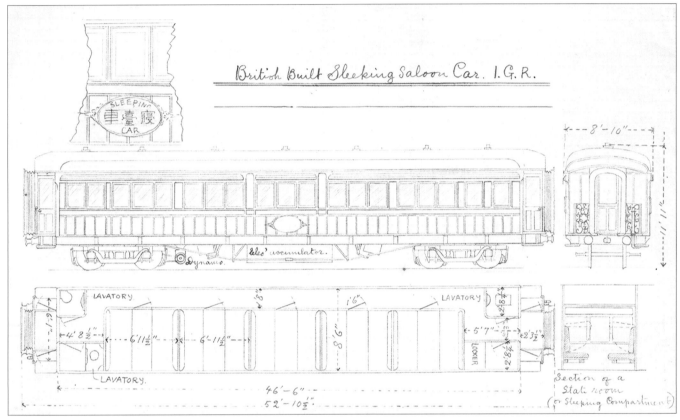

British Built Sleeping Saloon Car. I.G.R.

In the aftermath of the Russo-Japanese War, the military emerged as a driving force in Japan, and given its influence on the Railway Council, its views on railway development were increasingly heeded. Preeminent among the railway matters which interested the Ministry of War was nationalization, which was thought would make management and coordination of the railway system much easier in times of war. This added weight to a movement that had been afoot for some time. The Nippon Tetsudō had not been completed to Aomori for two months before Inoue Masaru presented his 'Proposal for Railway Administration' to the Government. Among other things, it was a proposal to nationalize the country's private railways. In November, 1891, the Matsukata cabinet put a motion before the second Diet to nationalize the railway system. The stated purpose was to speed development of the railway system by putting into government hands the construction of those lines where the organizing companies were having trouble raising funds. The motion failed in part over fears that it was merely a sop to the investors and because the legislative session ended. The issue was brought up a second time the next year

as part of the 1892 Railway Law agenda, but the Matsukata cabinet again did not succeed in passing it. The next proposal was made by the opposition Liberal Party in 1899, which carried by a vote of 145 to 127 and the issue was thereupon referred to a committee, chaired by Viscount Yoshikawa, which failed to render its (favorable) report before the end of that particular session, and the measure again died. The fourth attempt was made in 1900 under the Yamagata cabinet, which failed in face of opposition by a coalition of the Liberal, Imperialist, and Progressive parties. By this point, the public started to take an active interest in the matter.

With the end of the war, the military, and its political supporters, were not satisfied with the potential for operational integration that a railway system consisting of various private railways seemed to be capable of sustaining. The military successes of the recent war, coupled with the public dissatisfaction with what was perceived to be a less than warranted treaty result and the political situation in China (it was apparent to all in 1906 that the Ch'ing dynasty was on the verge of collapse, as indeed it did as a result of the revolution that came only 5 years later in 1911) all combined

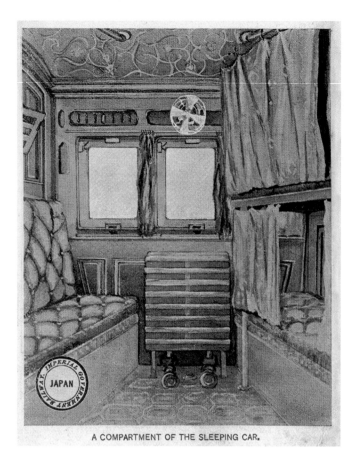

A COMPARTMENT OF THE SLEEPING CAR.

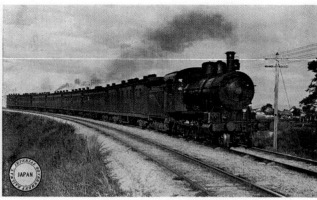

EXPRESS TRAIN RUNNING ON THE TOKAIDO LINE.

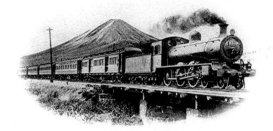

SHIMBASHI-SHIMONOSEKI SPECIAL
DAILY TRAIN de LUXE

(above)
A first class sleeping compartment on one of the IJGR's compartment sleeping cars is shown here made up for night on the right side, and day travel on the left. A folding table is between the seats, and a ventilator above the left-most window. The ceiling is finished in embossed Lincrusta, a forerunner of linoleum. First class compartments featured state-of-the-art cooling by means of an electric oscillating fan. This type of carriage would have been part of the first IJGR trains offering sleeping car services. It is probably a compartment of one of the British-built examples shown on page 225.

(top)
This view of an express train on the Tōkaidō Line was taken in the 1905–1906 period and shows how one of the better express trains of the day would have appeared. It is piloted by one of the Brooks 5160 Class 4-4-0s, and when one considers the small driver diameter of these machines, it is no wonder that a good turn of speed on trains such as these was considered to be 35 miles per hour. This rake of 7 coaches is fairly typical of heavy express train lengths at that time.

(above)
By 1911, new cars and locomotives had been introduced on the Shimbashi-Shimonoseki Special Express. This view shows the up section steaming by Fuji on the Tōkaidō Line, en route to Tōkyō. This train would later be renamed The Fuji. The locomotive is one of the North British 4-6-0 8700 class with Walschaert's valve-gear, bearing running number 8711, one of the last British-built locomotives imported for the IJGR in 1911, the year before the IJGR adopted the policy of using only Japanese-built locomotives. It was purchased to serve as a model for study by the IJGR in formulating their standardized line of locomotive designs. Similar locomotives from the same builder were used on the meter-gauge Royal Thai Railways.

(opposite above)
Taken in 1905 this photo shows the interior of one of the first IJGR dining cars introduced on the joint express operated by the IJGR and the San'yo briefly before nationalization; the Shimbashi–Shimonoseki Special Express.

(opposite below)
Compare the interior of this dining car of the late Meiji stock with the earlier version shown above and observe the results of the efforts that had been made to increase the loading gauge in Japan and to widen and heighten the interior space of rolling stock that was undertaken when Baron Gōtō Shimpei assumed leadership of the IJGR in 1908. In the space of a few short years, a much more spacious effect was attained through these efforts and the introduction of a higher clerestory roof to the dining car shown.

to tempt Japan to ready itself for even greater acts on the Asian continent. Militarism was becoming ingrained in Japanese foreign policy. If that were to be the course of Japanese foreign policy, a nationalized railway system was seen to be preferable to the one in place. New arguments for nationalization were again brought before the Diet, and the debate renewed. It was asserted that nationalization would permit freight and passenger rates alike to be cut, but of course, rate cutting regulation short of nationalization could have accomplished the same thing. Proponents seized upon the operational and organizational economies that would result in a single integrated system, which in hindsight seemed to have overlooked the countervailing inefficiencies of government bureaucracies vis-à-vis private enterprise. Nationalization was seen as a means of preventing railway ownership from falling into foreign hands via stock purchases or mortgaging of assets, but this as well could have been prohibited with laws restricting stock sales or encumbrances to foreign individuals or entities, short of as drastic a measure as nationalization and, like the rate reduction argument, was not thoroughly convincing. However, this time the military added considerable weight to the debate and in the aftermath of the Russo-Japanese War, its political capital was second to none in the realm. The military vociferously asserted its dissat-

isfaction with the coordinating abilities of the various private railways in the past war, but conveniently ignored the fact that many of the delays and inconveniences were not attributable to interne-

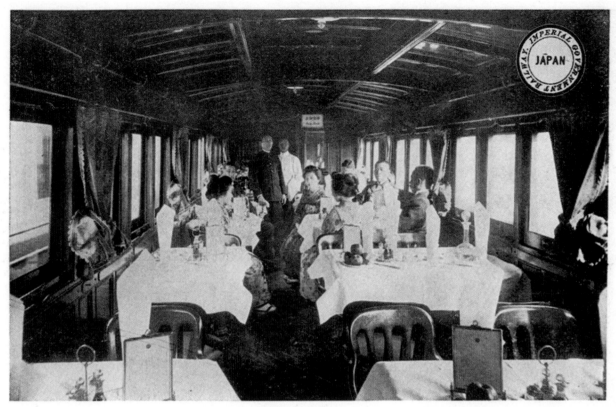

DINING CAR.

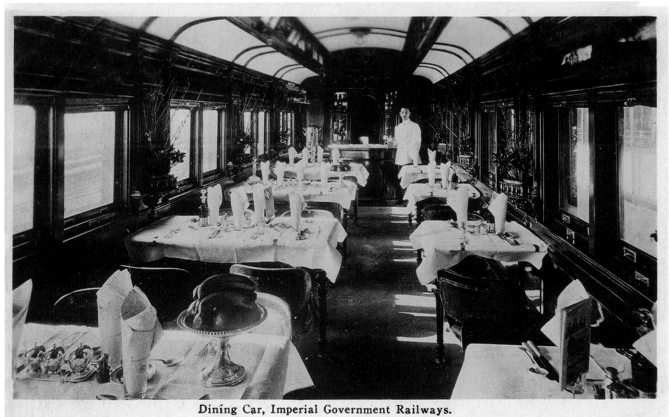

Dining Car, Imperial Government Railways.

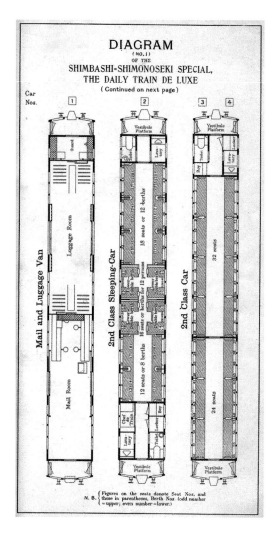

DIAGRAM
(NO. 1)
OF THE
SHIMBASHI–SHIMONOSEKI SPECIAL,
THE DAILY TRAIN DE LUXE
(Continued on next page)

Car Nos. [1] [2] [3] [4]

Mail and Luggage Van — Luggage Room — Mail Room

2nd Class Sleeping-Car — 18 seats or 12 berths — 12 seats or 8 berths

2nd Class Car — 32 seats — 24 seats

N. B. { Figures on the seats denote Seat Nos. and those in parentheses, Berth Nos. (odd number = upper; even number = lower.)

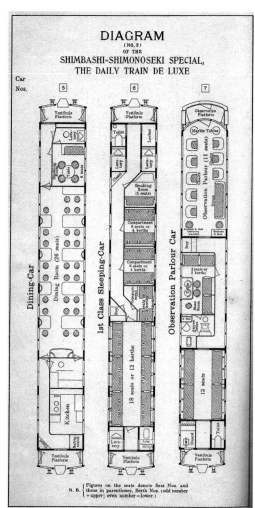

DIAGRAM
(NO. 2)
OF THE
SHIMBASHI–SHIMONOSEKI SPECIAL,
THE DAILY TRAIN DE LUXE

Car Nos. [5] [6] [7]

Dining-Car — Dining Room (28 seats) — Kitchen

1st Class Sleeping-Car — Smoking Room (5 seats) — Compartment 6 seats or 3 berths — Compartment 8 seats or 4 berths — 18 seats or 12 berths

Observation Parlour Car — Marble Tables — Observation Parlour (11 seats) — 12 seats

N. B. { Figures on the seats denote Seat Nos. and those in parentheses, Berth Nos. (odd number = upper; even number = lower.)

The version of the Shimbashi–Shimonoseki Special Express as running in the very last years of the Meiji reign is seen in these two diagrams, showing the floor plan of the consist and, from left to right, order of carriages in the seven-car train. From the diagrams' staff seat count, one assumes that the IJGR crew was 10 in number, an Engine Driver, Fireman, Chef de Train, two Guards, and a "Boy" for each carriage except the Mail/Luggage Van and Dining Car. Add to this the postal workers and the waiters and cooks who would have been employed by the concessionaire of the dining service, and the number approaches a total of around 20 staff members. The diagram proudly notes that complimentary stationery is available at the desks found in the observation parlor. Letters written en route would have been given to one of the "Train-Boys" for purchase of stamps, delivery to the mail van, and posting at the next stop. The view of the train steaming along beside Mt. Fuji piloted by the North British 8700 Class 4-6-0 locomotive (shown on page 226) is taken from the letterhead of that stationery.

cine squabbles between various private railways, but were more likely the natural consequence of a railway system that was still overwhelmingly single-tracked and strained to its limits. (Of course, the problems created for the railway industry by shipping sorely needed domestic locomotives to the theatre of operations exacerbated the shortage of domestic motive power at a time when the system was being worked *à outrance,* only making matters worse and contributed to the false sense of systemic failure.) An ambitious program of double-tracking all primary routes might have been just as effective a solution. The various arguments pro and con were posited, but in the end, after more than a decade of debate, the vote for nationalization carried in the Diet on March 31, 1906. Watarai Toshiharu, the former assistant councilor to the Imperial Board of Railways, speaking in 1915, before the period when such criticism became difficult to make, bluntly stated in his doctoral thesis on the subject of the recent Japanese nationalization, "There is no doubt that nationalization was carried through mainly on the strength of the military argument" and labeled the arguments that had been marshaled in support of it "not very convincing." The first seeds of the growing militarism were germinating, and as a result, the railway system was being affected, but it was certainly fair to argue that due to the government's policy of building lines that private ventures did not want to undertake (as extensions of private railways, as isolated inde-

pendent lines, or as connecting lines between private railways) the IJGR was a fragmented system, and nationalization resulted in a considerable benefit to the IJGR in the systemization and economization resulting from integration of the fragments into a unified network.

While the government carried the day, it did not do so without notable opposition. The measure only carried at the end of the legislative session, after opposition members had walked out. Cabinet member Katō Takaaki, the foreign minister, was so strongly opposed to nationalization as an invasion of private property rights that he resigned in protest. Typically, such resignations had in the past been couched in terms of ill-health, to spare the Emperor the embarrassing appearance of having disunity within his cabinet. Katō however felt so strongly about the matter that he was the first minister in the modern political history of Japan to state the true reason for his resignation, which is said to have raised the Imperial eyebrow.

With passage of the bill, a formula was determined for paying the shareholders for the value of their shares. In the end a scheme was adopted that guaranteed a price equal to the average rate of net profit to the companies absorbed during the first six working half-years from the second half of 1902 to the first half of 1905 multiplied by the aggregate construction costs up to the date of purchase, and multiplying that amount by 20 times to arrive at the

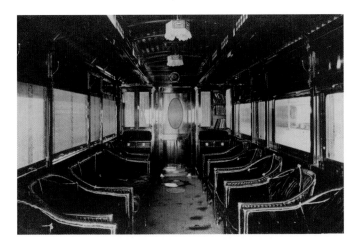

The comfortable interior of the Shimbashi–Shimonoseki Express observation car (looking toward the locomotive end of the train) consisted of this lounge with cushioned rattan armchairs, writing desks to the fore of the compartment, and was stocked with album-sized books, which one imagines encouraged rail travel and tourism. Presumably this photo was taken shortly after cleaning, as the floor has yet to dry from a vigorous swabbing.

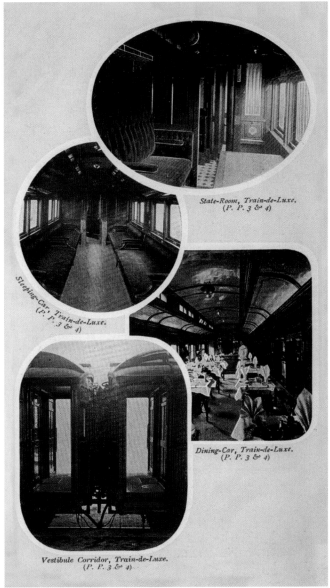

State-Room, Train-de-Luxe.
(P. P. 3 & 4)

Sleeping-Car, Train-de-Luxe.
(P. P. 3 & 4)

Dining-Car, Train-de-Luxe.
(P. P. 3 & 4)

Vestibule Corridor, Train-de-Luxe.
(P. P. 3 & 4)

The Shimbashi–Shimonoseki Special Express interior views shown here consist of the observation car special state room, replete with palownia crest lacquered panels and plush upholstery spangled with gold embroidered *mon* on the seats, followed by the standard sleeping car, the dining car, and the vestibule corridor, then something of a novelty of which to be proud in a country that had long followed the British example of non-corridor compartment carriages. In its day, the stateroom represented the *ne plus ultra* of overland traveling comfort, affordable by only the wealthiest of passengers.

final price. Materials and stock in hand were to be reimbursed at prevailing market prices. Further provision was made for non-leased rolling stock being covered by a series of state bonds. Shareholders were also paid for their outstanding shares by state bonds issued in exchange. The total price for nationalization was reported at about ¥500,000,000. The total purchase price was relatively high, and burdened the national system for some time, while making a very favorable settlement that notably benefited the former *daimyo*, samurai, and court nobles who, as a class, had been heavy investors in private railways.

Initially, the nationalization law (*Tetsudō Kokuyuka-ho*) called for the nationalization of some 35 private railways. The bill was introduced in the lower house of the Diet, while the upper house amended the bill reducing the number to 17, and the lower house agreed to the amendment, bringing the number down to 17 lines, among which were what was known as the "Big Five" (the Nippon, San'yo, Kansai, Kyūshū, and Hokkaidō Tanko) and twelve of the remaining largest, most important lines. For the record, on the date of transfer, October 1, 1907, the other twelve railways absorbed were: the Bōsō, Gan'etsu, Hankaku, Hokkaidō, Hokuetsu, Kōbu, Kyōto, Nanao, Nishinari, Sangu, Sōbu, and Tokushima Railways. What was left after nationalization of these lines were basically commuter lines or short lines of local character, and that was to be the flavor of future private railway development for many years to come.

As the old century came to a close and the new century opened, tables were being turned, and increasingly Japanese personnel were serving abroad, in *yatoi*-like capacity, on the Asian mainland. This occurred first when Taiwan was transferred to Japanese possession in the aftermath of the Sino-Japanese War. As mentioned earlier, the next logical extension occurred in Korea. As a result of the Russo-Japanese War, that influence spread to Manchuria. In 1907, for example, the British trade monthly *Railway Gazette* was reporting that "the first railway in China built with Chinese capital," the line between "Chaochowfu and Swatow" (Chaozhou and Shantou), was constructed using crossties supplied from Japan. Additionally, all the line's passenger coaches were built in Japan by Japanese rolling stock builders. And, reminiscent of the first decades of railway development in Japan, the enginemen, conductors and the train dispatcher were Japanese. Japan was quickly taking its first steps at becoming an *exporter* of railway technology.

By 1909, the nationalized lines were settling into a working system to enough of an extent that a comprehensive numbering scheme to organize all the duplicated running numbers of the locomotives absorbed was adopted. In the same year, the Government Railways Account Law was passed, which separated railway accounts from the government budget, insuring that the

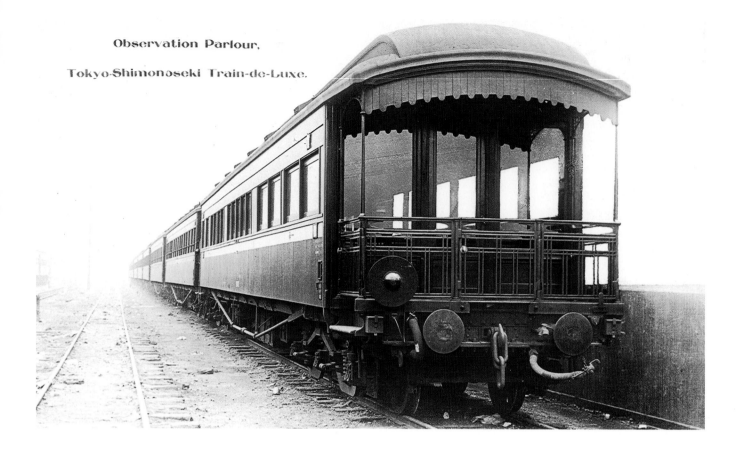

Observation Parlour,

Tokyo-Shimonoseki Train-de-Luxe.

railways would not be used as a cash-cow to make good budgetary shortfalls or to fund government spending sprees. This proved to be a sound decision and the policy of financing future railway expansion out of profits was immediately adopted. Eventually it became clear that, windfalls to the upper class notwithstanding, the government had still struck a good deal in buying up the railways, and the trend continued for some years. One economics commentator in 1934 noted,

"One of the main principles of their [the Government Railway's] business policy is to prevent the railways from getting into debt. Up to now [1934] these endeavours have been entirely successful. All new constructions as well as purchases of new equipment are exclusively made out of profits, whilst at the same time a substantial amount is carried forward each year to the next year's account. The Japanese railways are sparing no effort to ensure up-to-date equipment and construction work capable of lasting many years. This is proved, among other ways, by the fact that bridges and tunnels are made from granite which is a very expensive material and specially used on American railways. It is for this reason, too, that the coaches are fitted with pneumatic brakes and that all-steel passenger cars are constructed.

The Japanese railways employ the greatest care in the maintenance of their rolling stock, as appears from the fact that the number of new cars and locomotives put in commission each year represents a very considerable percentage of the existing equipment. This is, of course, only possible with a railway administration so highly profitable as that of Japan."

(above)
With the addition of this Observation/Lounge Car to the rear of the train, the Shimbashi–Shimonoseki Express showed influence from American luxury express trains. This view shows the end veranda of the car, which was introduced in the final years of Meiji's reign, to good effect. Note that even on the finest example of rolling stock in the realm (barring Imperial carriages), the IJGR frugally opted for a plain three-link loose chain coupling rather than a screw coupler.

(opposite above)
The view towards the rear of the observation car of the Shimbashi–Shimonoseki Express around the first years of the Taishō era.

(opposite below)
Borrowing from Western precedents, in 1906 the *Ōsaka Jiji Shimpo* newspaper sponsored the traveling exhibition train shown stopped at an unknown location in this commemorative postcard. Traveling expositions such as this helped acclimate the populace in more remote locales (who still traveled very little) with the advances and modernization being made in the leading centers of the realm. Note the special multicolored livery of the carriages.

In addition to nationalization, another scheme which had been debated, shelved, re-debated, and re-shelved with seeming clockwork regularity in Japan was again brought down from the shelf and dusted off. The military would have preferred to have regauged the entire Japanese railway system to 1435mm gauge, and the word of the day was that the entire rail system was "inadequate to meet the requirements of the present time." It is difficult to imagine today how important railways were in a time when they were the sole efficient means of mass land transport, doubly so in Japan with its inadequate roads. With nationalization came yet another bureaucratic restructuring, and a new Railway Agency, also called the Board of Imperial Railways, was created in 1908. Since Inoue had departed in 1893, there had been a constant change in the officials who held the nation's top railway post, none

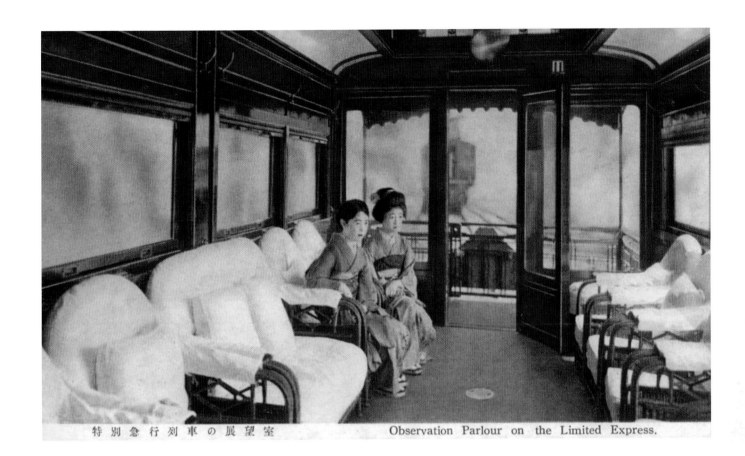

特別急行列車の展望室　　　　　　　　　Observation Parlour on the Limited Express.

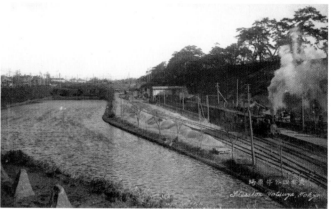

Cherry Blossom at Ichigaya-mitsuke, Tokyo. 東京市ケ谷見附櫻

Hanshin Electric Car. 阪神電気門道

(above)

In frock coat and top hat after having reported to the Emperor on his return from an official visit to Russia, Gōtō Shimpei, who was always impeccably dressed, poses for the photographer. Baron Gōtō originally studied medicine in Germany and return to Japan to practice. He was destined for greater things however, and eventually he served as the colonial head of the Railway Administration of Taiwan. By 1906 he was named the first President of the South Manchuria Railway (one of the gains of the Russo-Japanese War), and was brought home and appointed Director-General of the Railway Agency in 1908. It was under his tenure that Tōkyō Station was completed and dedicated.

of whom left as much of a personal legacy as Inoue had managed to do. Inoue's immediate successor Matsumoto served until May 13th 1897, when Suzuki Daisuke assumed the post, serving only a mere seven months, until December 18th. Thereupon, Matsumoto resumed the helm, serving until he was succeeded by Hirai Seijiro on March 20, 1903. Hirai served only eleven days before the post went to Furuichi Kohi. Furuichi himself only served 8½ months from March 31st to December 28th 1903, at which point Hirai Seijiro returned to the top post, to serve until December 5, 1908. On that date, the new head, Baron Gōtō Shimpei, assumed his post. Gōtō was the most energetic and dynamic figure to preside over the Railway Agency since Inoue's departure, and in many ways was the only one of comparable stature to him during the entire Meiji reign. None of the intervening heads managed to leave the mark that either Inoue or Gōtō managed to make.

Among one of his first acts, Gōtō obliged conversion proponents by directing the laying of a third rail experimentally along a stretch of track to test how easily such conversion to "Standard" 1435mm gauge could be accomplished and assigning IJGR engineers to conduct a gauge conversion feasibility study. The report

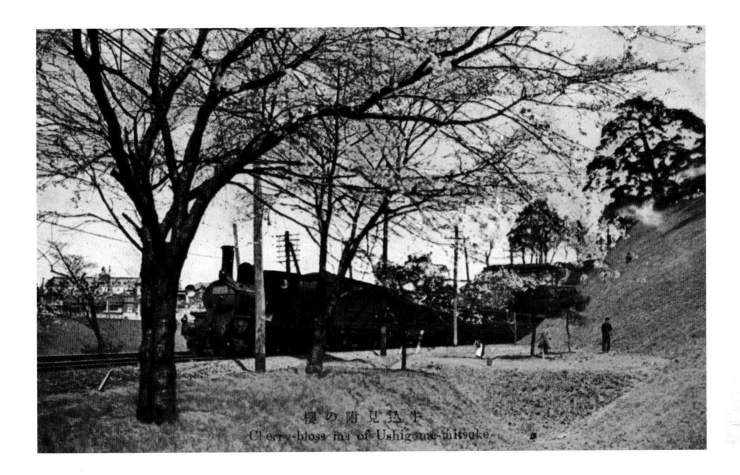

Cherry-blossoms of Ushigome-Mitsuke-

(opposite top right to bottom)
This view shows Manseibashi Station, the start of the Chūō Line. In front of the station is the statue memorializing Cmdr. Hirose Takeo, a hero of the Russo-Japanese War killed during the siege of Port Arthur. The station was situated at the end of a spur from a junction near Shinjuku on the Akabane line and served as a terminal for Kōbu Tetsudō and IJGR trains. It was designed by Tatsuno Kingo, the architect of Tōkyō Station, and shared much with that station in terms of aesthetics. The station was greatly damaged during the Great Kantō Earthquake of 1923 and was not rebuilt. The Museum of Transportation was, until quite recently, for many years situated on a portion of the tracks where Manseibashi (from the nearby-named Thousand Year Bridge in Tōkyō's Kanda district) once stood.

Yotsuya was another station along the Chūō line between Manseibashi and the Akabane Line. In this pre-electrification view (dating it to before 1904), a down Kōbu train consisting of 4-wheel compartment carriages and probably an A8 tank locomotive is making a start from the station on its way to Shinjuku. The photographer is probably situated near a roadway bridge that crossed over the line at about this point. The ballast piles along the station sidings would lead one to suspect that the view dates to shortly after opening, when ballasting was still being completed.

Farther along the Chūō Line, a IJGR Hode 6110 class EMU makes its way in the height of cherry blossom season along the former outer castle moat. Note the electric disk signal, colloquially known as a "Banjo Signal" in America and as an Enban-type in Japan, an innovation of the Kōbu Tetsudō and among the first electric signaling installed in Japan, borrowing from American signaling practice.

One of the Hanshin Electric Railway's cars is shown here at the simply-but-solidly-built Ikutagawa bridge on its way between Ōsaka and Kōbe. The name Hanshin is another portmanteaux word derived from taking the second character "saka" from Ōsaka and "be" from Kōbe, and pronouncing them using their Chinese pronunciation to achieve the word "Hanshin." Identical linguistic practices were sometimes used in naming US railroad lines; to wit the Pennsylvania Railroad's Delmarva division. As the Hanshin was privately built, and was engineered well after the disadvantages of the Japanese standard gauge of 1067mm were becoming appreciated, it was built to the more conventional gauge of 1435mm.

(above)
An IJGR train travels along the Chūō line at Ushigome-Mitsuke, along the outer moat of the former Edō castle, bearing a post-1909 number plate with a train of late-Meiji stock. The image dates from the transition time around the close of the Meiji and beginning of the Taishō eras.

was favorable enough to result in the Diet appropriating ¥269,644,190 for gauge conversion for the 800 route miles from Tōkyō to Shimonoseki during the tenure of Prime Minister Katsura Taro in November 1910, which was almost immediately reversed on grounds of cost when the *Seiyukai* party of Saionji Kinmochi returned to power in 1911. In the end, all that was accomplished was the modification of existing tunnels and trackside structures so as to permit a larger loading gauge, and enlarging the rolling stock to the new larger standard, as an expedient. The conversion issue itself again was shelved, only to be brought down again in the early days of the Showa reign, when congestion along the Tōkaidō line had reached such a point that preliminary studies for building an entirely new trunk line of standard-gauged railway between Tōkyō and Kyōto–Ōsaka were undertaken. The Second World War interceded to postpone the gauge conversion matter once more, but after the war, in the 1950s, it was again revisited and the 1930s study for the "new trunk line," (*Shinkansen* in Japanese) was again brought down, and used as the preliminary point of departure for the development of a supplemental Tōkyō–Kyōto–Ōsaka route. Out of this grew the famous Shinkansen "bullet train" system (built to 1435mm gauge) that today is the envy of the world.

Improvements continued in the wake of nationalization. This period saw the first proposals for steam railcars; two prototype

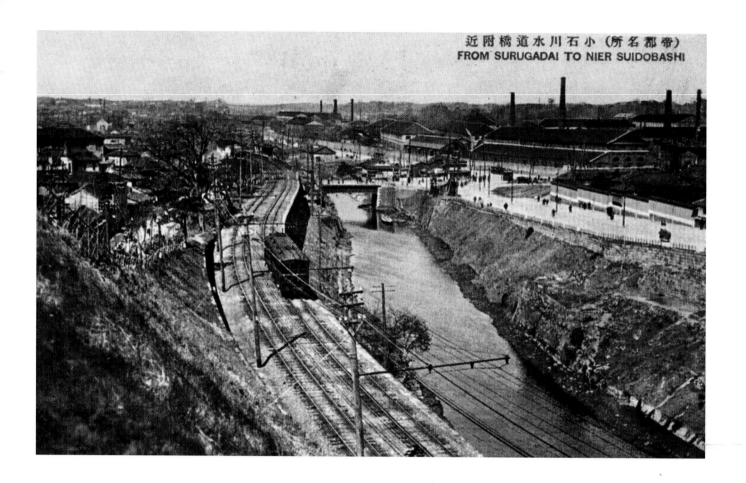

近附橋道水川石小 (所名都帝)
FROM SURUGADAI TO NIER SUIDOBASHI

The Chūō line right of way followed the Ocha-no-mizu Canal (Tea Water Canal, from the purity of its water) part of the way from its Manseibashi station starting point to the junction with the Akabane line near Shinjuku. The Kōbu Tetsudō and IJGR both operated trains to Manseibashi. From Shinjuku, the Kōbu line ran to Hachioji, over which the IJGR had running rights, beyond which the Chūō line proper headed west. This view of the Suidobashi taken from the Surugadai neighborhood shows an IJGR up train heading for Manseibashi. The EMU appears to be a Hode 6110 class, introduced in 1911, dating the view to the closing years of Meiji reign or early years of Taishō. The factory complex to the right is a government arsenal, now the location of the Kōrakuen garden.

designs—company drawings 12644 and 14866—were produced in 1906 and 1908 by the UK's Metro-Amalgamated (as the renowned firm of Metro-Cammell was then known, itself a successor of the Oldbury Railway Carriage and Wagon Company that had built the first carriages for the Shimbashi line in 1872). One was a rather British-style steam railcar of the period, the other was an open "toast-rack" configuration with weather-curtains. Neither were ever built or imported—domestic models were soon to be introduced. The year 1908 saw the introduction of the first refrigerator cars to Japan, built for transporting fish in quantity from the fishing banks off Korea. Initially only ten were built, but they quickly came to be used for all types of perishables, and within roughly twenty years' time there were 1,250 in service.

Of course one of the consequences of nationalization was that the investors in the private railways suddenly found themselves divested of their shares, in place of which they had the proceeds of the conversion. Many of these of course, were the next generation of the Samurai families who had used their stipend settlement monies to invest in railways in the 1880s. Much of this money was again reinvested by these families into a new technology that was

still a "start up" at that time: electric generation and with it, electric-powered interurban railways. An outgrowth of the municipal trolley system, the interurban railway was in great currency in the US as a clean and rapid alternative to steam-hauled railways. After the first electric trolleys were introduced to Kyōto in 1895, trolleys came to be adopted in many Japanese cities, including of course Tōkyō (1903), Ōsaka (1903), and Yokohama (1904). In 1904 also, the first suburban railway section was electrified on the Kōbu Tetsudō, which ran in the Tōkyō area. One year later, the Hanshin Denki Tetsudō inaugurated the first electric interurban service between Kōbe and Ōsaka.

The benefits of electrification of railways were immediately apparent to all, and electric lines, at a time when similar lines were in great currency in America, began to sprout in major metropolitan areas. Japan was not blessed with superabundant coal reserves, relative to the position of the United Kingdom or United States, for example. Most coal located in the Kyūshū and Hokkaidō beds was good for generating steam, but soft and very smoky, as has been seen. Being an extremely mountainous country, Japan had the good luck of being ideally situated for application of hydro-electric engineering to build facilities to harness the generational potentials of its many mountain rivers as they descended along their courses. By as early as 1913, it was being noted in the engineering journals that a not inconsiderable reduction in Japan's coal consumption among railways had been affected. Some of the coal that hydro-electric generation saved began to be put to use in foreign trade: by 1912, for instance, Japanese coal was being exported and sold cheaper than competing US and Australian varieties to the Chilean State Railways.

The IJGR was as quick to capitalize on the new form of motive power as finances permitted after the war. The most mountainous sections of line were the prime candidates for electrification. The Usui Pass segment of the Shin'etsu Line was one of the first segments to be electrified in 1911. Neat appearing Abt system electric locomotives, designated the "10000 Class," from AEG of Germany were imported for the duty, were initially assigned to passenger trains, and soon rendered obsolete the Esslingen, Beyer-Peacock, and domestic-built tank locomotives that had previously been used. Their introduction did not come any too soon for the long

suffering crews who worked the summit segment; the conditions on the line were close to unbearable, even by the lax safety standards of the day. Charles Pownall, the Englishman who served for many years as the Chief Engineer of the IJGR and who quite naturally would have been expected to have taken a "management" view of operations, described the conditions on the Usui segment prior to electrification:

"The present 34-ton engines of the Usui line are worked with a strong forced draught in order to obtain as much

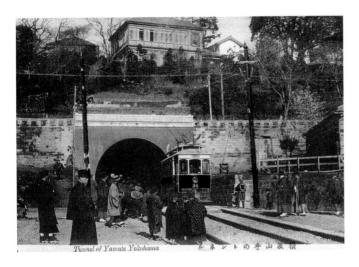

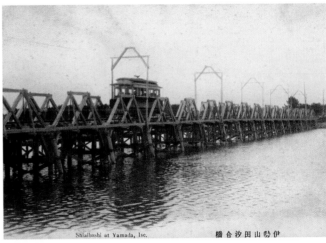

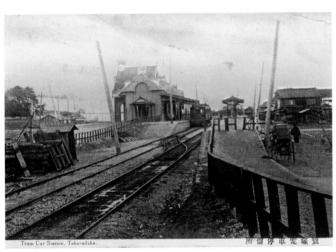

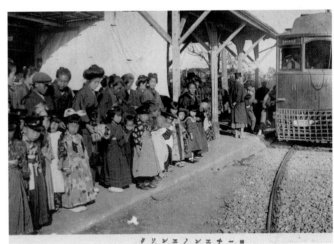

(top)
There were only two tunnels built for municipal trolley lines in Meiji Japan. One was in Wakayama, and the other is the one shown here in Yokohama. The scene shows the arrival of Yokohama Municipal trolley 32 on a brisk, sunny fall day as a small crowd waits to board. Above the tunnel is seen the fabled Yokohama Bluff, historically a part of town where the more fortunate residents built their homes.

(above)
The Minō-Arima Denki Tetsudō opened to Takarazuka (famed for its hot springs) on March 10, 1910, and this view shows what looks to be the first train of the morning ready to depart that station, as the points are set for it to crossover onto the up line. The railway was built to link the growing Kōbe-Ōsaka metropolitan area with the resort town of Minō and eventually became part of the Hankyū system, the president of which would be seeking ways to increase the revenues of this branch in the 1920s and hit upon the idea of creating an all-female theatrical troupe in the town in order to augment ridership. Thus was created the Takarazuka Review, still widely popular in Japan with female audiences.

(top)
Yamada is now one of the stations on the Kintetsu in Ise, near the venerated Ise Shrine. This view shows what was probably a Miyagawa Denki Tetsudō tram making its way over a very elaborately constructed wooden Shioai Bridge in the environs.

(above)
By the end of the Meiji period, railways had become matter of fact for many walks of life; and electric 'interurban' lines, many of which were destined to become Japan's network of commuter lines, had penetrated the fabric of daily life to the point that even those of more modest means sometimes traveled by rail as part of their routine activities, as evidenced by this classic "Pre-schoolers' class trip" view. Judging by the Gibson Girl hairstyle of one of the teachers, the scene would date from the mid to late Edwardian era. Note the teenage boy with his hand behind his back, who apparently serves as the station's ticketing clerk and is supervising boarding. The boy at the far left seem to be acutely suspicious of the photographer. The location and railway are unknown, although the gauge appears to be 1435mm, judging from the car width.

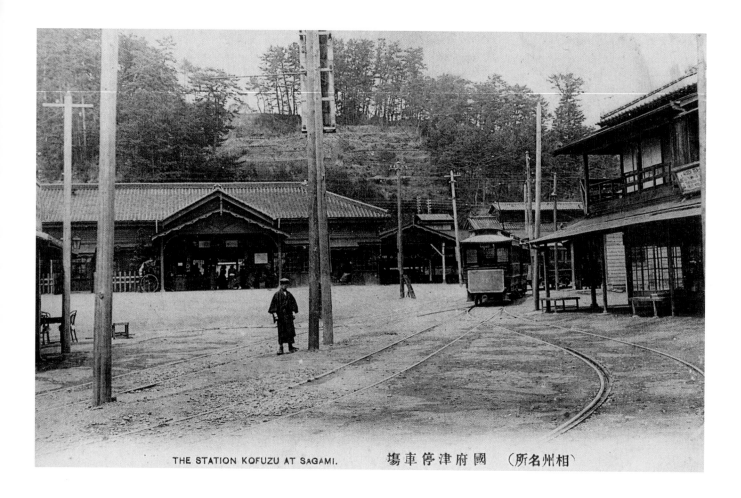

THE STATION KOFUZU AT SAGAMI.　　國府津停車場　（相州名所）

Kōzu station on the Tokaidō mainline is shown in this turn-of-the-century view. Kōzu is situated on the shores of Sagami Bay and was the point where the Tokaidō line turned inland (in the Meiji era) to skirt the various peaks in the vicinity of Mount Hakone. With completion of the Tanna tunnel in 1934, Kōzu became the junction at which the Tokaidō line's Tanna cut-off diverged from what was re-designated the "Gotemba Line," as the existing portion of the Tokaidō line became known. A trolley-powered train of the Odawara Denki Tetsudō is seen in the station forecourt ready to depart, perhaps as a connecting service timed to the arrival of the next Tokaidō line train.

steam as possible, and this causes an excessive amount of smoke—a great annoyance in the numerous tunnels, up which the smoke rises. The engine is always below the train [to prevent break-aways]. As the speed is so slow the train cannot run away from the smoke, which follows and overtakes it when the wind is blowing up the valley."

Commenting on the problem, Francis Trevithick noted that the Japanese coal, while giving excellent steaming quality, was very smoky. As a result:

"The ventilation of the tunnels was a very serious question, there being twenty-six tunnels, 2.76 miles, in a distance of a little over 4 miles. The atmospheric conditions in these tunnels were very trying to those on the engine, the immediate cause being the intense heat of the air, caused by the great volume of steam from the four cylinders working together, and almost without expansion, and added to other products of combustion discharged from the chimney. The feeling on the uncovered parts of the body was not far short

of acute pain, and to this was added the necessity of breathing the heated atmosphere. The conditions varied with wind and weather; the same tunnel would be passed through on the same day, one time without discomfort, the next with great discomfort. The train on entering the tunnel acted as a plunger or piston, driving the air before it: the exhaust steam was discharged against the tunnel roof, and enveloped the engine in smoke; the vacuum caused by the train entering the tunnel was filled with the air following the train into the tunnel, this volume of moving air being increased as the train proceeded and being also aided by the incline of 1 in 15, and by the condensation of the steam from the engine. Eventually, this volume of air drove the smoke beyond the engine and the carriages. A canvas curtain was now pulled across the mouth [of the tunnel] directly [after] the train had entered. The vacuum was then filled with air from the front of the train, thereby keeping the smoke behind the engine. This arrangement had acted in a more satisfactory manner than any other appliance which had been tried. The speed with six carriages (50 tons) was about 5 miles per hour."

Most conventional locomotives had only two cylinders, so an increased volume of steam was emitted by the special Abt system four cylinder locomotives (two of which powered the cog drive) used on the Usui Line. The new electric locomotives must have come as a *very* sweet relief to the crews who worked the trains over the Usui line, and management was probably also pleased that the 2 or 3 staffers who would have been required to station

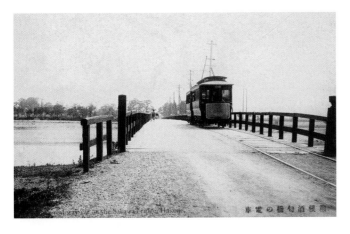

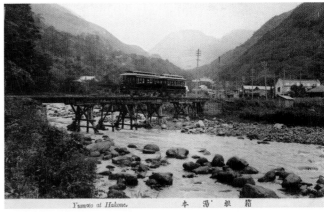

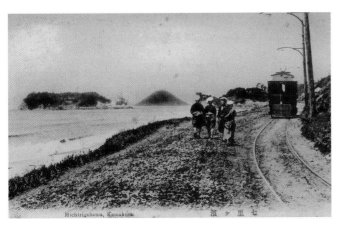

(top)

The Odawara Basha Tetsudō opened in 1888 from Kōzu first to Odawara, and eventually ran to the hot springs resort of Yumoto, roughly halfway up the ascent of Mount Hakone, along the route to the popular resort town of Miyanoshita. By 1896 it had converted from horse operation to electric traction and changed its name to Odawara Denki. A short tram-and-trailer train is shown here crossing the bridge over the Sakawa River after electrification. The scene is archetypal of Meiji-era tramways, the rights-of-way of which were permitted to be built to the sides of public roads and bridges under the 1910 Light Railway Law.

(above)

The Enoshima Denki Tetsudō completed its first segment in 1902 on the way from the town of Fujisawa on the Tōkaidō Line to the scenic islet of Enoshima. By 1910 it had reached beyond Enoshima to Kamakura, running along the celebrated Shichiriga-hama (Seven Ri Beach named for being approximately seven ri, about seventeen miles, long), to its Kamakura terminus. Four schoolboys walk along a local road as an Enoshima interurban runs by in this view of that famed beach with Enoshima Island and Mt. Fuji in the background. The Enoden maintained its independent existence and is still a popular line today.

(top)

Due to its proximity to Tōkyō, the Odawara Denki became very popular with Japanese and foreign visitors alike. This post-conversion view shows a tram-and-trailer train approaching the terminus in Yumoto, undoubtedly loaded with more than a few refugees from the ever-increasing urbanization of the Metropolis seeking fresh mountain air and a soak in the celebrated onsen. In 1901, the trip from Kōzu to Yumoto took about one hour by these tramcar trains. This part of the line would eventually become part of the Hakone Tozan Tetsudō.

(above)

This view of the civil engineering that went into building of the Hakone Tozan Tetsudō illustrates why the potential offered by the new technology of electric traction was of particular utility in Japan. Electric cars such as this were powered with an electric motor on each axle, while on a conventional steam-powered train only the driving wheels of the locomotive proper were powered. The grade indicator in this photograph of one of several switchbacks seems to indicate a grade of 12.5 in 1 (8%). No steam locomotive could have climbed such a steep grade, unless it was cogged, as was the case of the slow-moving Abt rack locomotives used on the Usui Pass line, which averaged roughly 5 miles per hour. The electric cars of the Hakone regularly took this grade in stride and at speeds well in excess of the speeds that could have been obtained on a rack railway. By the close of Meiji, electrification had begun to establish itself as one of the most promising agents of modernization for Japanese railways.

themselves around the clock on stand-by status at each of the tunnel mouths for "canvas curtain duty" could be re-assigned to other tasks. Unfortunately for freight train crews, the steam locomotives continued to be used for some time, as there weren't enough electric locomotives to handle all traffic.

It goes without saying that, in those days of less management concern about rank and file well-being, for such a matter to have drawn the attention of top management such as Pownall and Trevithick, it must have been grave indeed. Nevertheless, the IJGR was taking positive steps to ameliorate the lives of its workers. In 1911, the first mutual aid society was established, providing disability allowances, employee discounts for daily necessities of life, and loans to members at attractive rates.

As 1909 turned to 1910, the last segment of major inter-city mainline railway was completed; linking Kagoshima, the southern-most major city of Japan in Kyūshū with the railhead at Hitoyoshi. It was the last link in a 1,750-mile-long main-line system that linked Kagoshima, at the extreme south of Japan, with Nayoro, which was the northern-most point to which rails had been pushed in Hokkaidō. To have made a trip between those two points would have taken a mere five days and nights of travel.

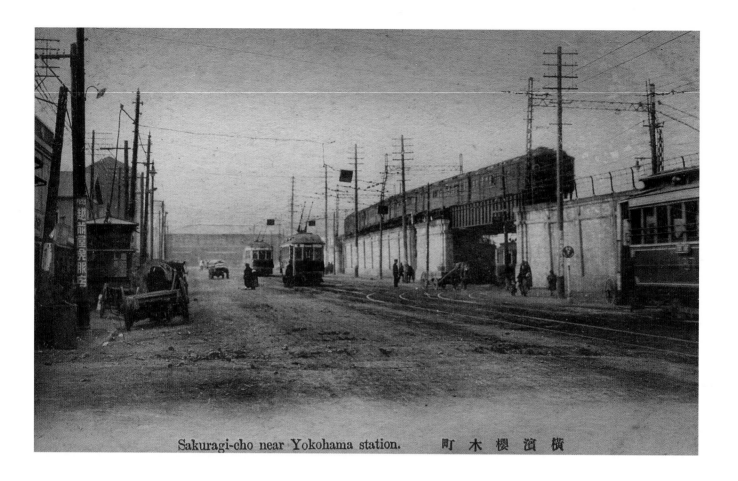

Sakuragi-cho near Yokohama station. 町木櫻濱横

Railways figured prominently in the diplomacy of the times. In 1907, as Japan was embarked on the assimilation campaign that preceded its annexation of Korea in 1910, it was decided that the Crown Prince, Yoshihito (later to reign as the Taishō Emperor, the father of WW II's Emperor Hirohito) would make a goodwill tour of Korea. He traveled in a special Imperial train turned out by the Japanese-built and controlled Seoul–Pusan railway on the occasion of his visit, arriving in Seoul on October 16th of that year.

No less than three of the articles of the Treaty of Portsmouth which ended Russo-Japanese War dealt with the subject of the railways in Manchuria. Russia and Japan were required by that treaty to "conclude a separate convention for the regulation of their connecting railway services in Manchuria." At that time, the quickest way from Europe to the Far East was via the Trans-Siberian Railway's express trains (slow though they were) and this line of railway, with those through Manchuria, were expected to develop into a major traffic route. It was said that travel times from Europe were reduced by as much as 75% from some of the more remote points with the route's inauguration. Even more centrally-located points experienced a notable reduction: prior to completion of the Trans-Siberian, traveling from Paris to Vladivostok required 45 days by ocean voyage (via Marseilles and Suez) on average. After its completion such a trip took only 17 days by rail. Thus by 1910, when the Trans-Siberian and the Seoul–Pusan railway both were fully-operational and the gap between closed by Korean lines joining with the South Manchurian

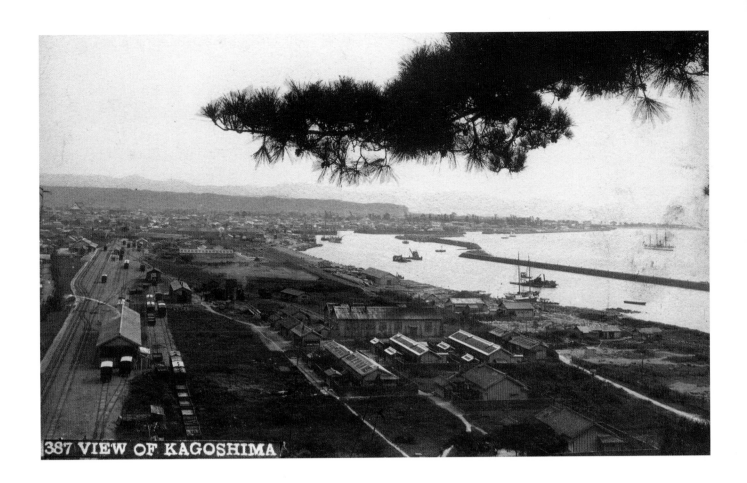

387 VIEW OF KAGOSHIMA

(top)
When railways reached the town of Kagoshima, they extended the entire length of the Japanese archipelago with the exception of the extreme north, very sparsely-inhabited areas of Hokkaidō. This view shows the Kagoshima freight station and locomotive shed area, just prior to the passenger facilities. Various freight facilities are seen built over sidings, with the large building in the center foreground appears to be a shop or shed facility, as a turntable and water tower can barely be seen to the left of it. The rows of building in the nearer foreground with white-tiled roof edging may be rows of railway workers' housing provided as an employment benefit.

(right)
One of the 3950 Class Beyer-Peacock 0-6-2T Abt geared locomotives (sporting running number 507) that were the largest and most powerful locomotives purchased expressly for service on the Usui line and imported from 1898–1908. As the first geared electric locomotives for this line were barely able to cope with the burgeoning demands of passenger services, these stout and sturdy locomotives soldiered on with mundane freight services for some time to come.

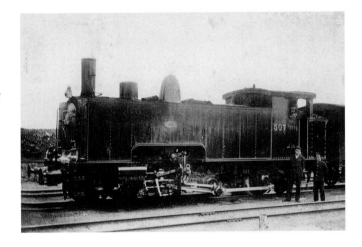

Railway (the former Chinese Eastern Railway Liaodong Branch renamed: a fruit of victory that was transferred into Japanese hands by the Portsmouth Treaty), the day was fast approaching when it would be possible to travel directly from Tōkyō to London on a single ticket by train with only two ferry transfers (the Tsushima Straits service the IJGR had inherited from the San'yo and the English Channel). In April of that year the first formal agreement for a coordinated through-service was made with the Chinese Eastern Railway and the Trans-Siberian beyond that. By March of the next year, through service was inaugurated to the Russian capital, and by May of 1912, there was a coordinated through-service virtually circling the globe, commencing in London, via boat train and steamer to the US and Canada with corresponding express trains, linked to steamship departures bound for Yokohama, where there were waiting trains to link

them to the new Korea–Trans-Siberia–Moscow route, from which one could return to London with relative ease. For a brief two-year period the dream of a world-encircling coordinated through-service was a reality—until the outbreak of World War I and the subsequent Russian Revolution interceded to ensure that this vision never developed to its full potential.

In 1910, Inoue Masaru, by then an ailing man of 68 years, was nonetheless eager to promote the potential of this route. Baron Gotō was actively interested, and gave him the task of studying European railways as a part of the international coordination endeavors then being undertaken, and although ill, Inoue jumped at

the chance and took the Korean–South Manchurian–Chinese–Eastern–Trans-Siberian rail route to London; a two-week journey and half the time it would have taken by ocean liner. In the end, the trip was too much for Inoue, and he died in London, although not before having the opportunity for a fitting reunion with such old friends who were still alive from his days as *Wild Drinker*. In accordance with his instructions, his ashes were returned to Japan, to be interred in Tokaiji Temple in Shinagawa alongside the pioneer Shimbashi line, where his spirit could make sure all was well along the line. On his death, when matters of his estate became public, it was seen that he left only his government pension and a modest home as the bulk of his estate and the falseness of the rumors that had been circulated at the time he had put forth his "Proposal for Railway Administration" and had been pilloried for the alleged act of secretly amassing great wealth just before his retiring from the Railway Agency was proven.

* * * * * * * * *

Also by 1910, when the desire to construct more railways was close to its peak, the cost of developing a railway to main line standards was likewise becoming more costly. As the framework of a national railway system was well underway, with most of the major trunk lines built and the few still needed under construction, most of the new lines projected were short local lines with modest traffic potential. In order to stimulate such lines, the government passed a Light Railway Law, which brought many *keiben tetsudō* "light railways" into being. Within three years, the effect was notable. By 1913 the number of *keiben tetsudō* had greatly increased, thanks to the simplified organizational procedures authorized by the new law and other governmental encouragements. As of that year, there were 38 *keiben tetsudō* with 574 route miles in operation, an additional 44 with a route mileage of 800 miles under construction, and some 126 companies with a combined mileage of 1,953 miles which had received a preliminary charter, but which had not commenced construction. The law would be augmented in 1924 with the addition of a Tramway Law. In all, by the close of the Meiji period, there were approximately 208 such *keiben tetsudō* contemplated to add some 3,328 route miles to the Japanese railway system. Many of the *keiben tetsudō* were short, local affairs that acted as branch line extensions from the "main-line" grade *shitetsu* or IJGR, meandering along old cart tracts or the banks of local streams to bring rail transportation to small towns, remote locations, and otherwise un-served villages and hamlets of the hinterlands. They were often times on the shakiest of financial grounds, operating as it were "on a shoe-string" with second-hand, obsolete equipment purchased used from their more established "main-line" brethren if they happened to be of a matching gauge. Thus they often retained a quaint, nostalgic flavor, often all the more charming due to the hodgepodge of dated and mismatched equipment with which they were furnished.

The immediate effects of nationalization were more evolutionary than revolutionary to the typical traveler. An Englishman,

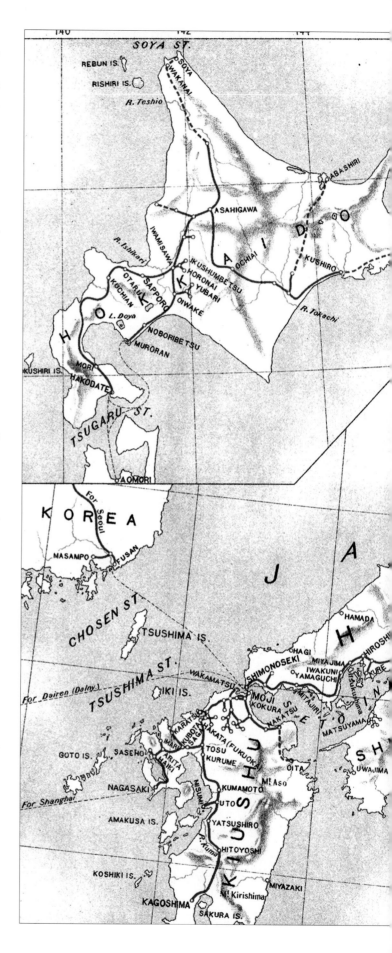

The Japanese railway network in 1910, at the close of the Meiji era. Government lines are shown in red and private lines in black. After nationalization, the only private railways consisted of feeder lines augmenting the government system. Railways had been built the length of the archipelago with the exception of the extreme north of Hokkaidō. Least serviced by any semblance of a railway network is the island of Shikoku.

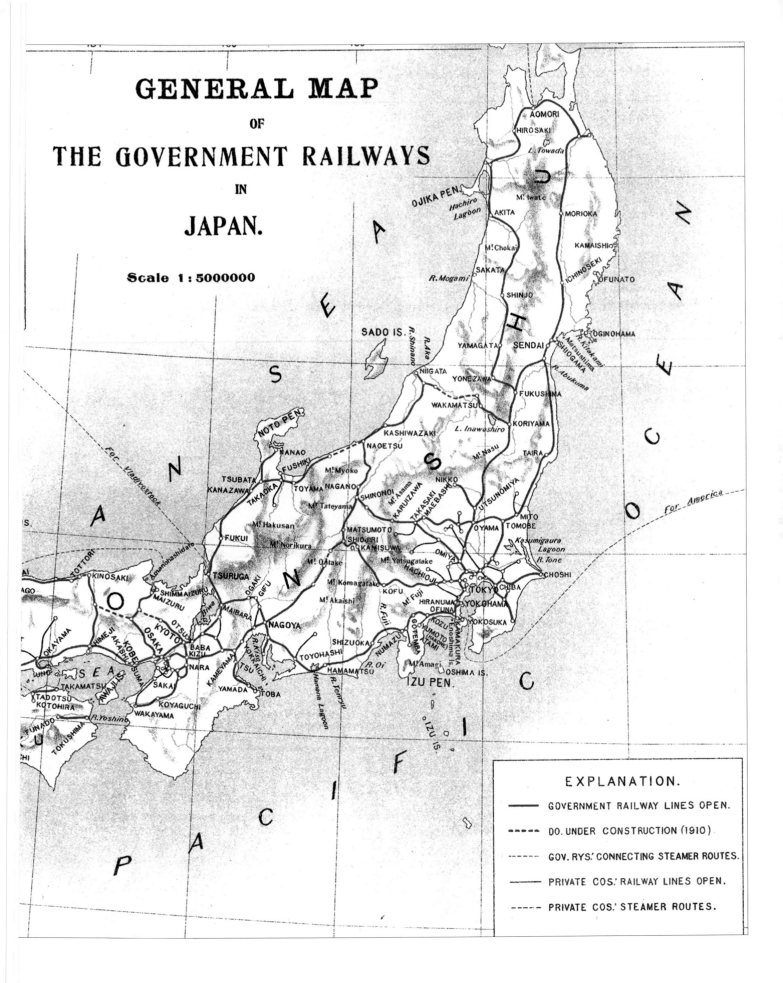

GENERAL MAP

OF

THE GOVERNMENT RAILWAYS

IN

JAPAN.

Scale 1 : 5000000

EXPLANATION.

—————— GOVERNMENT RAILWAY LINES OPEN.

- - - - - DO. UNDER CONSTRUCTION (1910)

--------- GOV. RYS.' CONNECTING STEAMER ROUTES.

————— PRIVATE COS.' RAILWAY LINES OPEN.

- - - - - PRIVATE COS.' STEAMER ROUTES.

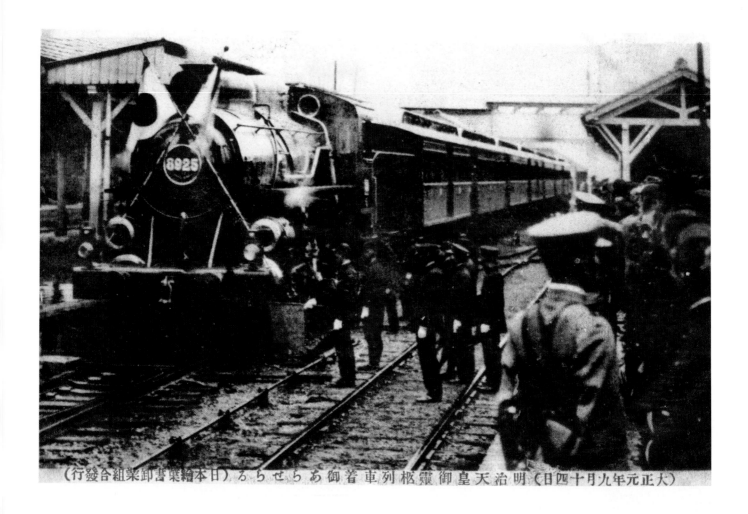

（日本繪本業書卸組合發行）　るらせらあ御着車列柩靈御皇天治明（日四十月九年元正大）

September 14, 1912. The Imperial Funeral train bearing the remains of the Meiji Emperor is seen stopped at an unidentified station on the Tōkaidō main line the day before final interment at Momoyama near Kyōto. The carriage containing the bier appears to be fourth in the consist, judging by the wide center door. The trainside platform has been cleared for dignitaries, while the opposing platform is thronged with mourners. Locomotive 8925 was one of the newest Alco "Pacific"-type locomotives that had only been in service for a few months at the time of this photograph, and, as one would expect for such an occasion, was the largest and finest express passenger type in the realm at the time.

rocking of the Imperial Train, and blamed the locomotive driver for excessive speed. When an Imperial Chamberlain told him that the train was traveling at a normal rate of speed, the Emperor snapped, "You're taking the side of the railways." Word was passed up to the cab of the locomotive, and the train was an hour late arriving in Nagoya. It was his penultimate train trip of any consequence. On returning to Tōkyō, his condition continued to decline, and the year 1912 found him considerably weaker. Just after midnight on July 30, 1912, the end came; the result of a combination of maladies, together with heart failure.

The Meiji Emperor had chosen Momoyama ("*Peach Mount*") near Kyōto as his final resting place. In Tōkyō, the city hurriedly repaired the streets along which the funeral cortège was to pass, newly lit with electric arc and gas street lamps, and covered them in white sand (white being the color of mourning in the Far East). The streets were lined with brocade and fresh greenery, in accord with *Shinto* precepts. The cortège consisted of two torch-bearers, followed by some three hundred functionaries, carrying white

and yellow flags, regalia, spears, banners, and drums, then fifty nobles, and finally the hearse drawn by oxen in accordance with millennium-old Imperial ritual, attended by close court officials. Some twenty-eight generals, admirals, and field commanders followed, as did other dignitaries. The entire length of the procession route was lined with crowds thronged thick in hushed silence. The final service was held in purpose-built pavilions in the precincts of the Aoyama military parade ground complex, to which the IJGR had hurriedly laid a special branch line. It concluded shortly after midnight on September 14 and his body was taken on its final rail journey to Kyōto. The Imperial Special departed Tōkyō early in the morning with a seven car consist. In the center of the train was the catafalque car, a special clerestory vehicle on four-wheel trucks hurriedly built by the IJGR when Meiji's final illness became evident, with central, wide sliding doors with gilt ironwork in traditional style, such that it appeared they might have been the sliding doors from some grand shrine, which opened onto the compartment for the bier. Hauling the train was one of the new Alco Pacific 4-6-2 locomotives, the largest and best in the realm, bearing running number 8925. It was one of the "8900 class" which consisted of six locomotives that reached Japan on March 27, 1912. They were the first Pacific locomotives, a type designed primarily for heavy passenger trains, in Japan and the very last batch of the various foreign steam locomotives the IJGR imported (the last English and German locomotives were 4-6-0 types that had been placed in service a month earlier in February). In the Imperial Carriages rode the Princes Kotohito

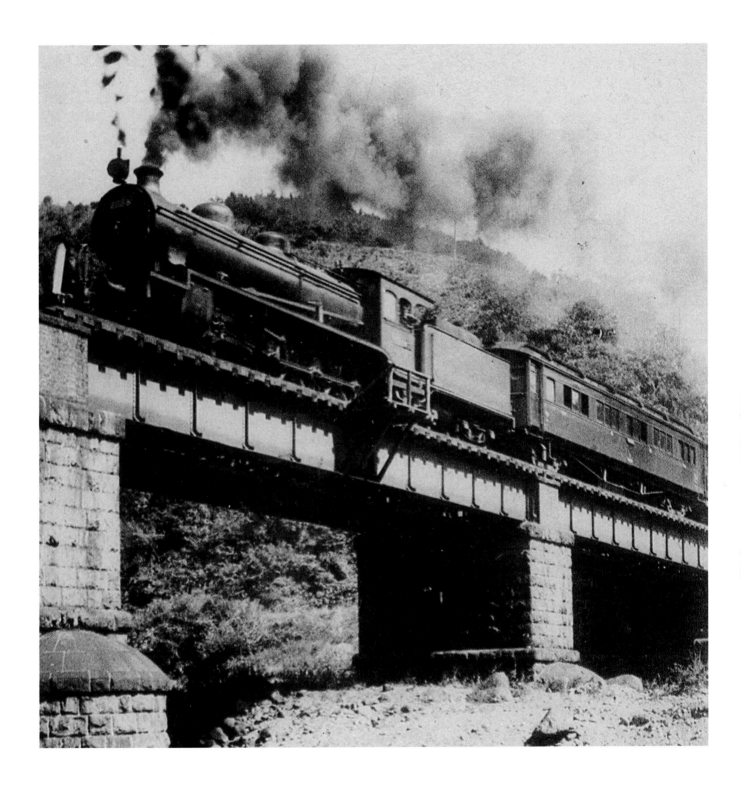

and Sadanaru, leaders of the official delegation. At each principal station along the way, the train stopped briefly, just long enough for the throngs to pay silent homage. In the English-speaking World, only two funeral trains had been equal in witnessing the depth of emotion and solemnity, the overwhelming sense of loss and of the *passing of an age* which attended their solemn progress: those of Abraham Lincoln and Queen Victoria. Crowds lined the entire route, bowing deeply in respect as it passed. As the train pulled into Momoyama at 5:10 that afternoon, the guns of the twenty-second field artillery fired salutes and bands played

Locomotive size started to show notable increase in the final years of Meiji. This view shows one of the 8850 Class locomotives built by Borsig piloting a passenger train over a bridge at an unknown location.

the dirge *Kanashimi no kiwami*, ("Extremity of Grief"), written by the German Franz Eckert (composer of the Japanese National Anthem) in 1897 for the funeral of the Dowager Empress. Early in the morning of September 15th the Imperial coffin was interred, and with that act, one of the most momentous epochs of Japanese history came to an end.

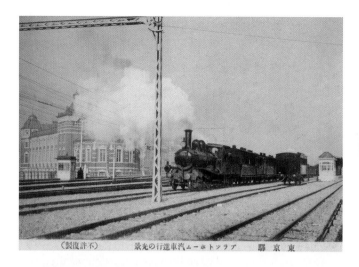

（不許復製） 東京驛 プラットホーム汽車進行の光景

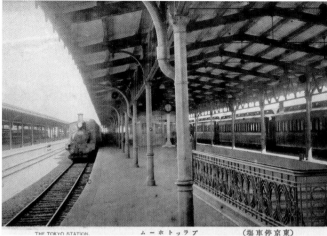

THE TOKYO STATION. プラットホーム （東京停車塩）

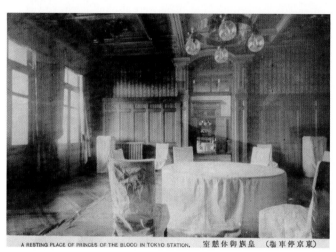

A RESTING PLACE OF PRINCES OF THE BLOOD IN TOKYO STATION. 皇族御休憩室 （東京停車塩）

opened in 1914. The new Kyōto station was the most modern in the realm in respect of appearances, a transitional structure squarely between Lutyensesque Edwardianism and the coming modernism of the 1920s.

The new central station, Tōkyō Station as it would eventually come to be known, the crown jewel of the Meiji railway system, was also its final capstone. Tatsuno Kingo had reworked the station's design, and his plans called for massive and stolidly late-Victorian structure that was thoroughly Western in appearance with its bulbous octagonal domes;[1] yet unabashedly Meiji in spirit. It was sited in Maronouchi, a location that had been proposed as part of the ambitious urban re-design scheme for Tōkyō undertaken by Ende-Boeckmann starting in the late 1880s. The edifice would not have looked out of place in Amsterdam, Antwerp, Hamburg, Copenhagen or in any large Northern European city on the Continent. When Balzer was replaced by Tatsuno in 1903, his design for the Japanese Revival style station withered. The IJGR management, encouraged by Gotō Shimpei, decided upon a more grandiose station. Tatsuno's design continued the style he had employed in his Manseibashi Station that stood in Tōkyō's Kanda district, but it was grandly expanded: the station was made large enough to include a hotel, three restaurants, a post office, and of course there were three special waiting rooms, one for dignitaries and nobles, one for the Crown Prince, and one for the

Emperor. Preliminary construction had commenced in 1908, final approval for Tatsuno's plan was obtained in 1910, and the station was not completed until 1914, with opening ceremonies held on December 18th. The event was of such import that, at a time by which even in Japan railway inaugurations had become routine, the Prime Minister, none other than Ōkuma Shigenobu who had negotiated the building of the first railway line 1869 with Itō, Sawa, Parkes, and Lay, agreed to officiate. It was both fortuitous and serendipitous that the inauguration was dedicated by one of the few surviving from the handful of men who had been instrumental in the initial decision to introduce railway technology to the realm. In short order too, a larger-than-life statue of Inoue Masaru would be erected in the station forecourt as a memorial to the man even then known as the Father of Japanese Railways. The line beyond to Ueno wouldn't be completed until 1925, after the Great Kantō Earthquake in 1923 had leveled some of the improved land, rendering right-of-way acquisition less costly.

Upon dedication of new Tōkyō Station, Shimbashi Station, where so much Meiji-era history had played out, where a young and hitherto sheltered teenage Emperor in silk robes of ancient pattern had publicly inaugurated the railway system, where a perspiring Ulysses S. Grant on one hot, sultry July night in 1878 had been chased down a corridor by a crowd of small girls who were daughters of high officials, was cornered, and "took each little

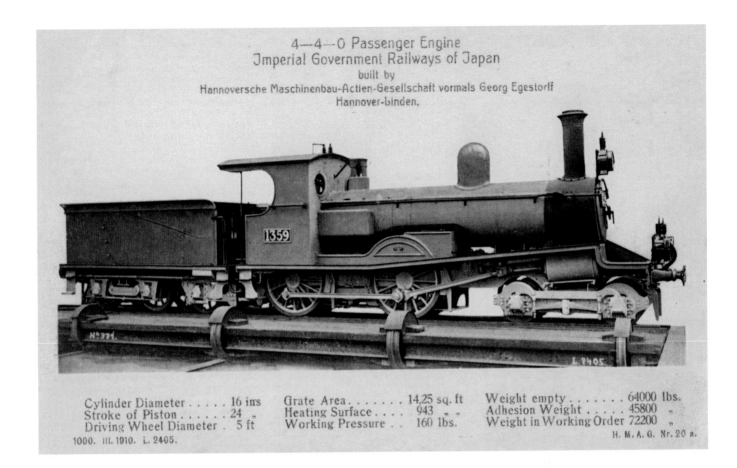

4—4—0 Passenger Engine
Jmperial Government Railways of Japan
built by
Hannoversche Maschinenbau-Actien-Gesellschaft vormals Georg Egestorff
Hannover-Linden.

Cylinder Diameter	16 ins	Grate Area	14,25 sq. ft	Weight empty	64000 lbs.
Stroke of Piston	24 „	Heating Surface	943 „ „	Adhesion Weight	45800 „
Driving Wheel Diameter	5 ft	Working Pressure	160 lbs.	Weight in Working Order	72200 „

1000. III. 1910. L. 2405.

H. M. A. G. Nr. 20 a.

(above)
One of the more unique 4-4-0 classes is shown here in a builder's card; the D9 or 6350 class that was introduced in 1909. Built by Hannover M. A. G., the class was a German build of the British 6270 class of 1900, from blueprints probably provided either by Dubs or by the IJGR at a time when Dubs order books were likely full. They were the only German 4-4-0s ever to run in Japan. The most obvious difference when compared to the 6270 class was the "1+truck" tender, however there were other slight variations. The small, low-pitched boiler of this class gave it a distinctly old-fashioned appearance. Even the progenitor 6270 class had been ordered at a time when the benefits of large boilers were becoming widely understood in the engineering world. By the time this class was ordered almost a decade later, there was little reason to retain a small boiler design. With what was fast becoming relatively small cylinder dimensions of 16" dia. x 24" stroke and five-foot drivers, the class had a distinctly retrogressive air for its day. In hindsight, it could be said to represent a missed opportunity for a bolder order to more modern design specifications. The class consisted of 36 members. As these Hannomag locomotives were ordered just before the 1909 renumbering, they received an 1891 numbering scheme class designation of D9. This example bears an 1891 scheme running number on what is somewhat similar to the standard style number plates introduced with the 1909 scheme.

(right)
The first section of the Chugoku Tetsudō (lit. "Midland Railway") was commenced from the San'yo mainline at Okayama in 1898; ambitiously bound northward for Yonago on the Sea of Japan Coast. The mainline never made it beyond Tsuyama. However, the company did complete another segment westward from Okayama in 1904 to the town of Tatai, giving it a system shaped like a backwards letter "L." The entire system (including its sole branch of one mile to Inariyama) barely exceeded 50 miles. The Chugoku started with 8 locomotives from Nasmyth Wilson: 5 versions of the popular A8 class 2-4-2T and 3 beautiful little 0-6-0 tank locomotives, identical to the IJGR 1220 class. By 1910 the line had prospered enough to afford to increase its roster of 8 locomotives by one, and the 2-6-2T prairie tank locomotive shown here was that single addition, bearing running number 10. Although built in Germany by Hannover, its general design is obviously inspired by the numerous Schenectady and Baldwin 2-6-2T locomotives that were very popular in Japan at the time. This diminutive Prairie tank would remain the largest locomotive on the Chugoku for the remainder of the Meiji reign. Paradoxically, while this locomotive was equipped with the venerable Stephenson's valve gear, the smallest locomotives on the line, the tiny 0-6-0Ts, were fitted with the more modern Walschaert's valve gear.

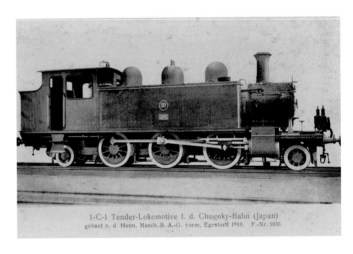

I-C-1 Tender-Lokomotive i. d. Chugoky-Bahn (Japan)
gebaut v. d. Hann. Masch.-B.-A.-G. vorm. Egestorff 1910. F.-Nr. 5835

to find a better-suited microcosm more emblematic of the development of the Japanese nation as a whole during the Meiji reign.

The Emperor's son Yoshihito ascended to the Chrysanthemum Throne as the Taishō Emperor, reigning over a nation that had become the most powerful independent nation in Asia, was to gain wide acceptance as a world power within a decade, and possessed a railway system that, but for the narrowness of its gauge and preponderance of single track lines, could be compared on fair terms with many of the busiest, most profitable such systems in the world.

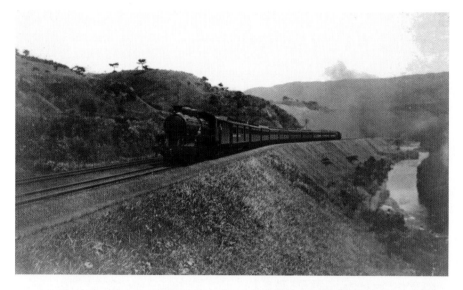

(top left to bottom)
As the Meiji era drew to a close, train ridership was increasing, as were train lengths and train weight. This photo of an express train negotiating the Hakone Pass shows one of the German-built express locomotives handling an express with the assistance of a banking locomotive at the rear of the train. The train length is now ten carriages, the last three of which are first class vehicles, as evidenced by the white stripe just visible at the rear of the train in front of the helper engine.

A very scenic late Meiji/early Taishō view of a freight train, piloted by what appears to be a B6 class locomotive at a tunnel at an unidentified location being watched from the bridge of a roadway by the locals. Note that while the railway bridge is of masonry and steel, the local roadway passes the ravine over a wooden bridge.

Freight tonnage per train also increased at the end of the Meiji reign, and if larger locomotives equal to the task were unavailable, motive power departments coped with heavier trains by using the practice known as *double-heading*. This late Meiji/early Taishō view (postmarked August 20, 1914) shows tandem B6 locomotives running bunker first at the head of a long freight, with a cattle car fourth from the front derived from British design practice. Assuming that both locomotives had been coaled with the same coal at the engine shed and were in comparable states of repair, the fireman in the second locomotive must have been more skillful in his art, as the first engine's exhaust is much sootier with particulate matter: evidence of incomplete combustion.

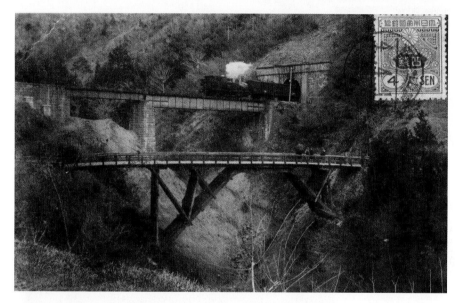

(opposite above)
During the Meiji era, Japan's municipal trolley lines established a widespread practice of decorating their trams to mark special occasions, both festive and solemn, and happily for lovers of crêpe paper and swag, developed that tradition with unabashed glee. The custom was observed by municipal transit lines on a scale and depth unmatched in either Europe or the Americas, adopting the Victorian Western cultural phenomenon of ceremonial motive power decoration and transforming it into something that was to become quintessentially Japanese. This posed photograph records one of the Tōkyō Municipal Railway's tramcars, with both versions of the corporate *shamon* prominently displayed, as decorated in commemoration of the Shinto ceremonies installing the Meiji Emperor in the Shinto Pantheon, which occurred in 1920. As such, it was almost certainly the last Meiji-related railway event to have occurred in the realm. Note the driver posed in his great coat beneath the drapery of imperial purple. The two blue Kiku-no-gomon badges seen over the windows bear the ideographs of a sun surrounded by a crescent moon , which combine to form the kanji "Mei-" of Meiji. The tradition of specially decorating municipal trams can still occasionally be seen on the surviving streetcar lines in present-day Japan. Although the practice has become less prevalent with the gradual replacement of most such lines by subways, Japan is still arguably the best place in the world to observe this near-extinct cultural tradition, directly descended from Victorian times.

(opposite below)
Tōkyō station at night, showing the effects of modernization brought by electric power, with a new motor-car taxi that was destined eventually to replace the venerable jinrikisha in the foreground.

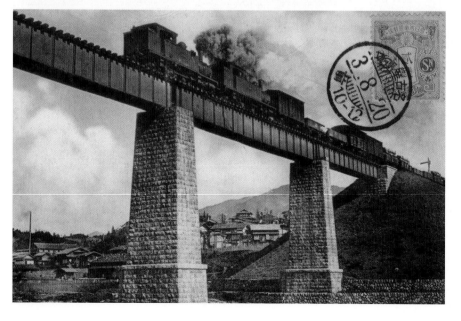

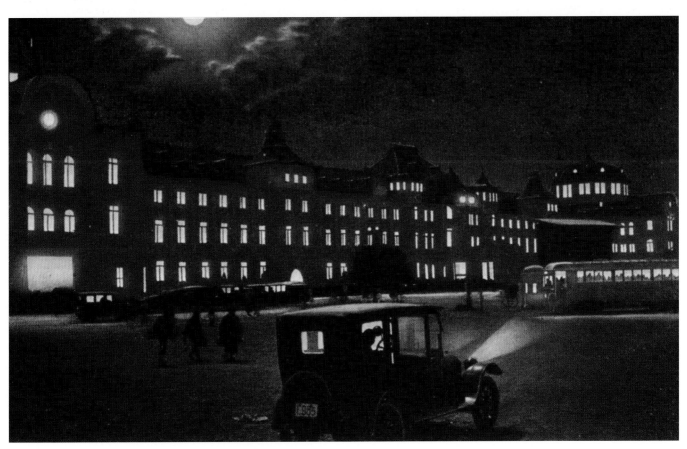

ORIGINAL METROPOLITAN TERMINII OF
PRINCIPAL MEIJI ERA NON-GOVERNMENT RAILWAYS

Hankai/Nankai Tetsudō	Namba (Ōsaka)
Kansai Tetsudō	Minatomachi (Ōsaka)
	Aichi station (Nagoya)
Kōbu Tetsudō	Iidamachi (running rights to Manseibashi)
Kōya Tetsudō	Shiomibashi
Kyōto Tetsudō	Nijō (with Tambaguchi intermediate station and running rights to Kyōto station)
Nippon Tetsudō	Ueno (running rights to Shimbashi via Akabane)
San'yo Tetsudō	Hyōgo (running rights to Kōbe Station)
Sōbu Tetsudō	Honjo (renamed Kinshicho in 1915)
Tōbu Tetsudō	from 1899: Senju / from 1902: Azumabashi, renamed Akasuka in 1909, present day Narihirabashi

WORKSHOP LOCATIONS

IJGR	Kōbe (loco building ceased in 1909)
	Nagano
	Shimbashi/Hamamatsu
	Takatori (moved from Kōbe shops)
	Tsuchizaki
HTTKK	Temiya (later IJGR)
Kansai	Yokkaichi (later IJGR)
Kyūshū	Kokura (later IJGR)
Nippon Tetsudō	Ōmiya (later IJGR)
San'yo Tetsudō	Hyōgo (later IJGR)

GAUGE EQUIVALENTS AND REPRESENTATIVE LINES

576mm = **1 shaku 9 sun**	(Gumma Basha)
600mm	(Chiba-ken, Narita)
610mm = 2' 0"	(Aso, Kishu Mine, Mamurogawa, Musashino Mura, Perry's Gift Railway, Tateyama)
635mm = 2' 1"	(Iwafune Jinsha)
660mm	(Kito Basha)
666mm = **2 shaku 2 sun**	(Yamanashi Basha, Hongo)
737mm = 2' 5"	(Furukawa Basha, Shinagawa Basha)
750mm = 2' 5½"	(Japanese logging railways)
753mm = **2 shaku 5 sun**	(Fuhoku)
762mm = 2' 6"	(Glover Co. demo line, Kinki Nippon, Kurobe Valley, Seibu)
838mm = 2' 9"	(Kamaishi, early Hankai)
914mm = 3' 0"	(Koiwai Kidō, Otaru Tetsudō, Yutoku Kidō, several Kyūshū lines)
1000mm = 3' 3"	(Meter gauge)
1067mm = 3' 6"	(Japanese Standard Gauge, "Cape Gauge")
1372mm = 4' 6"	(Tōkyō, Hakodate, & Yokohama Tramways, Tokyu Tetsudō Setagaya Line, Tōkyō Metro Shinjuku Line, Keio Tetsudō)
1391mm = 4' 6¾"	(Akita Municipal Tramway)
1435mm = 4' 8½"	(World Standard Gauge, Shinkansen, Tōkyō Subway, Keisei, Keihan, Hankyu, Hanshin, Hokusou Kaihatsu, Keihin Kyūkō, Kintetsu, Nishi Nippon, Hakone Tozan)

Gauges shown in bold were based on a traditional Japanese measurement:
1 *shaku* = 10 *sun* = 303.03mm.

IJGR LOCOMOTIVE NUMBERING SCHEMES 1872–1909

1872–1874
(Up to opening of the Kōbe–Ōsaka Line)

Class	Running Number(s)	Builder	1909 Designation
A	10	Yorkshire	110
B	2, 3, 4, 5	Sharp Stewart	160
C	6,7	Avonside	(*none, moved to Taiwan*)
D	8,9	Dubs	190
E	1	Vulcan	150

* * * * * * * *

1874–1891
(Up to opening of the Tokaidō Line)

With the opening of the Kōbe–Ōsaka Line in 1874, locomotives running on the Shimbashi line were assigned *odd* numbers, while locomotives on the Kōbe–Ōsaka–Kyōto and the later Tsuruga–Nagahama-Ōgaki Lines were assigned *even* numbers. Abt cogged locomotives for the Shin'etsu line were also given even numbers, while conventional steam locomotives on that line were given odd numbers. Classes of locomotives were assigned a single letter designation from the Roman alphabet, and after the *Romaji* alphabet had been exhausted, the system was continued in "AA", "AB", "AC", "AD", etc. fashion. Those running numbers for which records remain or have been discovered are as follows:

Shimbashi Line (renumbering):

Class	Renumbered	Builder	1909 Designation
A	10→3	Yorkshire	110
B	2, 3, 4, 5→ 13, 15, 17, 19	Sharp Stewart	160
C	6, 7→ 5, 7	Avonside	(*none, moved to Taiwan*)
D	8, 9→ 9, 11[i]	Dubs	190
E	1→1	Vulcan	150

Kōbe–Ōsaka–Kyōto Line

Class	Running Number(s)	Builder	1909 Designation
F	6, 8, 10, 12	Stephenson (2-4-0T)	120
H	22, 24	Manning Wardle (0-6-0T)	1290
N (L on reb'ld.)	14, 16, 18, 20	Kitson (0-6-0T; 2 rebuilt as 4-4-0s/2 rebuilt as 0-6-0s)	5100/7010
O	2, 4	Sharp Stewart (0-4-2)	5000
Z	70, 72, 74, 76, 78, 80	Dubs	1850

Tsuruga–Nagahama–Ōgaki Line

Class	Running Number(s)	Builder	1909 Designation
Y	54, 56, 58, 60, 62, 64, 66, 68	Kitson (0-6-0T)	1800

Naoetsu–Ueda (later Shin'etsu) Line

Class	Running Number(s)	Builder	1909 Designation
I	59, 77, 79, 81, 83, 85, 87, 190	Nasmyth Wilson	1100
Z	61, 63, 65, 67, 97, 99, 101, 103	Dubs	1850

* * * * * * * *

1891–1909 (with 1909 equivalents shown)

Locomotives were given a running number, in addition to a two-character class designation consisting of a letter and number (*e.g.* A8), carried on a small brass oval plate beneath the running number on cab or tank side. Numbering within a class was not necessarily contiguous.

"A" Classes (four-coupled side tank locomives):

A1, A2, A3, A4, A5, A6, A7, A8, A9, A10

"B" Classes (six-coupled side tank locomotives):

B1, B2, B3, B4, B5, B6, B7

"C" Classes (Abt system geared locomotives for the Usui Line):

C1, C2, C3

"D" Classes (four-coupled tender locomotives):

D1, D2, D3, D4, D5, D6, D7, D8, D9, D10, D11, D12

"E" Classes (six-coupled tender locomotives):

E1, E2, E3, E4, E5, E6, E7

"F" Classes (eight-coupled tender locomotives):

F1, F2

1874 Scheme to 1891 Scheme Conversion Table

1874 Scheme	1891 Scheme	1874 Scheme	1891 Scheme
E	A1	P	D4
A	A2	R	D5 (Beyer-Peacock versions)
C	A3	T	D5 (Neilson versions)
G	A4	AF	D6 (Beyer-Peacock versions)
D	A5	AF	D6 (Neilson versions)
B	A6 & A7	AM	D8
H	B1	AN	D9
Y	B2 (Kitson versions)	U	E1 (Kitson versions)
Z	B2 (Dubs versions)	U	E1 (Vulcan versions)
I	B3 & B4	V	E2
AB	B5	X	E3
AD	C1	AG	E4
AH	C2	AK	E5
O	D1	AL	E6
N	D2	AQ	E7
S	D3		

1891 Scheme to 1909 Scheme Conversion Table

A Classes[ii]	B Classes[iii]	C Classes[iv]	D Classes[v]	E Classes[vi]	F Classes[vii]
A1→ 150	B1→1290	C1→3900	D1→ 5000	E1→7010	F1→9150
A2→ 110	B2→1800[viii]	C2→3920	D2→ 5100	E1→7030	F2→9200
A3→ [ix]	B2→1850[x]	C3→3950	D3→ 5490[xi]	E2→7450	
A4→ 140	B3→1060	C3→3980	D4→ 5130	E3→8150	
A5→ 190	B3→1100[xii]		D5→ 5300[xiii]	E4→7700	
A6→ 160[xiv]	B4→1100[xv]		D5→ 5400[xvi]	E5→7900	
A7→ 160[xvii]	B5→3080		D6→ 5500[xviii]	E6→7950	
A8→ 400[xix]	B6→2100		D6→ 5630[xx]	E7→8100[xxi]	
A8→ 500[xxii]	B6→2120		D7→ 5680		
A8→ 600[xxiii]	B6→2400		D8→ 6150		
A8→ 700[xxiv]	B6→2500		D9→ 6200		
A9→ 860	B7→3150		D9→ 6270		
A10→230			D9→ 6300		
			D9→ 6350		
			D10→5700		
			D11→5160		
			D12→6400		

Note: Arrows indicate the change from the 1891 class designation (shown before the arrow) to the 1909 designation (shown after the arrow), *e.g.* the 1891 scheme's A1 Class was designated Class 150 in 1909.

Francis Trevithick's 1894 Proposed Classification Scheme (not adopted)

A Classes: Small side-tank Engines

B Classes: Side-tank Engines for the Main Line

C Classes: Passenger Tender Engines for the Main Line

D Classes: Large Tender Engines for heavy gradients

E Classes: Large Tank Engines for heavy gradients

F Classes: Large Tank Engines for the Abt System

* * * * * * * *

1909 (to 1928)[xxv]

Lettered class designations were discontinued. A numbering system was adopted that was similar to the one used on the United Kingdom's Great Western Railway. Locomotives for mainline services were assigned four-digit class numbers, the first two digits of which represented the class, and the last two digits of which was the locomotive's identification. Thus loco 6200 was the first loco in the 6200 class, 6201 the second, and so forth. Sub-classes *could* be designated by the third digit, thus loco 6352 was the third-numbered member of the 6350 class. 1912 saw the start of the practice of assigning class ranges of scrapped or withdrawn locomotives (*i.e.*"vacant ranges") to newly-rebuilt locomotives, starting with the 2700 range. The redesignated class assignments of rebuild classes after 1912 are not listed here.

Classes were officially grouped in the following ranges:

Below 999	Two-coupled tank engines
1000–3899	Three-coupled tank engines
3900–3999	Abt system tank engines
4000–4999	Tank engines with four or more coupled axles
5000–6999	Two-coupled tender engines
7000–8999	Three-coupled tender engines
9000–9999	Tender engines with four or more coupled axles

In its application, what emerged from the above-given official ranges is as follows: Tank locos were (with one short-lived exception) given class numbers below 5000.

Class Range	Type
Below 100:	0-4-0T or small 0-6-0T
110–190:	2-4-0T
200–950:	2-4-2T
1000–2080:	0-6-0T
2100–2700:	0-6-2T
2700:	0-6-4T (reassigned class designation on modification)
2800–2850:	2-6-0T
2900–3450:	2-6-2T
3700:	2-6-4T
3800:	4-6-2T
3900–3980:	Abt Tanks
4000–4030:	0-8-0T
4100:	0-10-0T
4500–4510:	0-4-4-0T
4600:	0-4-4-0 tender locos, designated Class 9020 on modification.

Tender locos were given class numbers 5000 to 9850.

Class Range	Type
5000:	0-4-2
5050–5060:	2-4-2
5100–6500:	4-4-0 (Foreign built)
6600:	4-4-2
6700:	4-4-0 (Domestic built)
7000–7030:	0-6-0
7050–7080:	0-6-2
7100–8550:	2-6-0
8600:	4-6-2
8700–8850:	4-6-0
8900:	4-6-2
9000–9600:	2-8-0 (Except 9020 Class)
9020:	2-4-4-0
9700:	2-8-2
9750–9850:	0-6-6-0

Electric locos were given class numbers above 10000 EMUs were classified using a differing syllabic system.

[TANK ENGINES]

Class	Type	Class size	Builder	Introduction
1	0-4-0T	1	Bagnall	1903
5	0-4-0T	2	Baldwin	1898
10	0-4-0T	23	Krauss	1889~1895
40	0-4-0T	2	Krauss	1896, 1911
45	0-4-0T	3	Hohenzollern	1889
60	0-4-0T	7	Hohenzollern	1889, 1894, 1901
100	2-4-0T	1	Nasmyth Wilson	1896
110	2-4-0T	1	Yorkshire	1871
115	2-4-0T	1	Kisha Kaisha	1903
120	2-4-0T	4	Stephenson	1873
130	2-4-0T	2	Sharp Stewart	1875
140	2-4-0T	2	Sharp Stewart	1875
150	2-4-0T	1	Vulcan	1871
160	2-4-0T	6	Sharp Stewart	1871, 1874
170	2-4-0T	2	Kisha Kaisha	1903
180	2-4-0T	1	Atsuta Tetsudō Sharyo	1900
190	2-4-0T	2	Dubs	1871
200	2-4-2T	2	Baldwin	1896
210	2-4-2T	3	Pittsburgh	1898
220	2-4-2T	2	Dubs	1891
225	2-4-2T	1	Kisha Kaisha	1903
230	2-4-2T	41	Kisha Kaisha	1903~1909
400	2-4-2T	4	Nasmyth Wilson	1886
450	2-4-2T	4	Brooks	1897
490	2-4-2T	1	Nasmyth Wilson	1897
500	2-4-2T	61	Dubs	1887~1902
600	2-4-2T	78	Nasmyth Wilson	1887~1904
700	2-4-2T	18	Vulcan	1887~1896
800	2-4-2T	2	Kisha Kaisha	1903
810	2-4-2T	1	Kisha Kaisha	1904
850	2-4-2T	1	Hyogo shops	1896
860	2-4-2T	1	Kōbe shops	1893
870	2-4-2T	14	Nasmyth Wilson	1897–98, 1901–02
900	2-4-2T	26	Schenectady	1898
950	2-4-2T	10	Baldwin	1896
1000	0-6-0T	4	Baldwin	1894, 1896
1010	0-6-0T	4	Baldwin	1895, 1896
1020	0-6-0T	2	Dickson	1899
1030	0-6-0T	1	Avonside	1898
1040	0-6-0T	6	Omiya Shops	1904
1050	0-6-0T	3	Nasmyth Wilson	1896
1060	0-6-0T	2	Sharp Stewart	1896
1100	0-6-0T	14	Nasmyth Wilson	1885~1897
1150	0-6-0T	4	Dubs	1896
1170	0-6-0T	1	Nasmyth Wilson	1900
1180	0-6-0T	2	Baldwin	1900
1200	0-6-0T	9	Nasmyth Wilson	1896
1210	0-6-0T	1	Dubs	1896
1220	0-6-0T	4	Nasmyth Wilson	1897, 1898
1230	0-6-0T	2	Dubs	1896
1235	0-6-0T	2	Baldwin	1896
1255	0-6-0T	1	Pittsburgh	1897
1270	0-6-0T	1	Dubs	1899
1280	0-6-0T	2	Nasmyth Wilson	1897, 1903
1290	0-6-0T	3	Manning Wardle	1873, 1881
1295	0-6-0T	1	Baldwin	1894
1300	0-6-0T	1	Baldwin	1894
1320	0-6-0T	4	Baldwin	1894-1896
1325	0-6-0T	2	Alco	1911
1350	0-6-0T	1	Pittsburgh	1897
1360	0-6-0T	1	Nasmyth Wilson	1900
1370	0-6-0T	1	Baldwin	1903
1400	0-6-0T	21	Krauss	1895~1897
1430	0-6-0T	5	Hannover	1900, 1903
1440	0-6-0T	8	Krauss	1890~1898
1480	0-6-0T	5	Dubs	1895, 1901
1500	0-6-0T	4	SLM (Winterthur)	1895, 1898
1530	0-6-0T	2	Sharp Stewart	1894
1550	0-6-0T	2	Krauss	1904
1630	0-6-0T	3	Maffei	1912
1650	0-6-0T	2	Baldwin	1895
1670	0-6-0T	1	Nasmyth Wilson	1886
1680	0-6-0T	2	Nasmyth Wilson	1895
1690	0-6-0T	2	Pittsburgh	1896
1710	0-6-0T	2	Dubs	1896
1730	0-6-0T	1	Nasmyth Wilson	1896
1800	0-6-0T	13	Kitson	1881, 1896
1850	0-6-0T	35	Dubs/North British	1885~1903
1900	0-6-0T	30	Beyer-Peacock	1896
1940	0-6-0T	5	Nasmyth Wilson	1898
1960	0-6-0T	12	Neilson	1894
1980	0-6-0T	3	Brooks	1897
2000	0-6-0T	1	Maffei	1904
2040	0-6-0T	2	Hannover	1900
2060	0-6-0T	3	Krauss	1906
2080	0-6-0T	2	Nasmyth Wilson	1900
2100	0-6-2T	17	Dubs	1890, 1891, 1898
2120	0-6-2T	268	Dubs/North British Sharp Stewart/Kōbe Schwartzkopff	1898~1905
2400	0-6-2T	75	Henschel/Hannover/Berliner (ex-Schwartzkopff)	1904, 1905
2500	0-6-2T	168	Baldwin	1904, 1905
2700	0-6-2T	2	Cooke	1897
2700[xxvi]	0-6-4T	24	Shimbashi, Nagano, Hamamatsu shops	1912~1914
2800	2-6-0T	7	SLM (Winterthur)	1897, 1899
2820	2-6-0T	12	Brooks	1898
2850	2-6-0T	3	Pittsburgh	1897
2900	2-6-2T	17	Yokkaichi & Takatori shops	1912 conv.
3000	2-6-2T	3	Baldwin	1899, 1900
3005	2-6-2T	1	Alco	1912
3010	2-6-2T	2	Baldwin	1897
3020	2-6-2T	3	Brooks	1897
3030	2-6-2T	5	Baldwin	1894
3035	2-6-2T	4	Kisha Kaisha	1911
3040	2-6-2T	2	Shimbashi & Nagano Shops	1910 conv.
3050	2-6-2T	2	Baldwin	1907
3060	2-6-2T	3	Baldwin	1898
3070	2-6-2T	6	Kisha Kaisha	1911
3080	2-6-2T	2	Nasmyth Wilson	1888
3100	2-6-2T	24	Alco	1906
3150	2-6-2T	4	Kōbe shops	1904
3165	2-6-2T	1	Hannover	1910
3170	2-6-2T	6	Hannover	1903-1904
3200	2-6-2T	24	Beyer-Peacock	1903-1904
3240	2-6-2T	2	Henschel	1904
3250	2-6-2T	4	Baldwin	1893
3300	2-6-2T	24	Baldwin	1890~1896
3350	2-6-2T	2	Brooks	1897
3360	2-6-2T (comp'd)	11	Baldwin	1905, 1906
3380	2-6-2T (comp'd)	4	Hyogoshops	1906
3390	2-6-2T	3	Baldwin	1901
3400	2-6-2T	20	Pittsburgh & Brooks	1896~99, 07
3450	2-6-2T	2	Brooks	1898
3500	2-6-2T	5	Kōbe, Takatori & Shimbashi shops	1909 conv.
3700	2-6-4T (comp'd)	6	Hyogo shops	1907-1908
3800	4-6-2T	4	Dubs	1898
3900	0-6-0T(Abt)	7	Esslingen	1892, 93, 07
3920	2-6-0T(Abt)	2	Beyer-Peacock	1895
3950	2-6-2T(Abt)	10	Beyer-Peacock	1898, 01, 08
3980	2-6-2T(Abt)	6	Kisha Kaisha	1906, 08, 09
4000	0-8-0T	2	Porter	1901

Class	Type	Class size	Builder	Introduction
4030	0-8-0T	3	Baldwin	1895
4100	0-10-0T	4	Maffei	1912
4110	0-10-0T	39	Kawasaki	1913, 14, 17
4500	0-4-4-0T	1	Maffei	1902
4510	0-4-4-0T	1	Maffei	1904

[TENDER ENGINES]

Class	Type	Class size	Builder	Introduction
4600[xxvii]	0-4-4-0	6	Alco	1911
5000	0-4-2	2	Sharp Stewart	1871
5050	2-4-2	1	Baldwin	1896
5060	2-4-2	1	Baldwin	1895
5100	4-4-0	2	Kitson	1874 conv.'76
5130	4-4-0	6	Kitson	1876
5160	4-4-0	20	Brooks	1897
5200	4-4-0	2	Pittsburgh	1897
5230	4-4-0	12	Dubs	1884, 1885
5270	4-4-0	1	Omiya shops	1901
5300	4-4-0	24	Beyer-Peacock	1882, 1890
5400	4-4-0	14	Neilson	1891
5480	4-4-0	2	Hyogo shops[xxviii]	1901–1902
5490	4-4-0	2	Beyer-Peacock	1882
5500	4-4-0	72	Beyer-Peacock	1893~1898
5600	4-4-0	18	Beyer-Peacock	1899, 1903
5625	4-4-0	3	Beyer-Peacock	1899
5630	4-4-0	11	Neilson	1893
5650	4-4-0	6	Sharp Stewart	1898
5680	4-4-0	4	Kōbe shops	1895
5700	4-4-0	58	Schenectady	1897~1906
5800	4-4-0	3	Baldwin	1905
5830	4-4-0	2	Dubs	1898
5860	4-4-0	3	Brooks	1898
5900	4-4-0	28	Baldwin	1897, 1901
5950	4-4-0	11	Rogers	1898
6000	4-4-0	12	Alco (Pittsburgh)	1906, 1907
6050	4-4-0	1	Schenectady	1907
6100	4-4-0	8	Hyogo shops	1903~1905
6120	4-4-0	7	Schenectady	1900 conv.'07
6150	4-4-0	18	Baldwin	1897
6200	4-4-0	50	Neilson	1897, 1900
6270	4-4-0	25	Dubs	1900
6300	4-4-0	24	Alco (Cooke)	1908
6350	4-4-0	36	Hannover	1909
6400	4-4-0	30	Schenectady	1902
6500	4-4-0	9	Pittsburgh	1898, 1906
6600	4-4-2	24	Baldwin	1897
6700	4-4-0	46	Kisha Kaisha & Kawasaki	1911, 1912
6750	4-4-0 (superht.)	6	Kawasaki	1913
6760	4-4-0 (superht.)	88	Kawasaki	1914, 16~18
7000	0-6-0	2	Baldwin	1887
7010	0-6-0	2	Kitson	1873, 1874
7030	0-6-0	4	Vulcan	1875
7050	0-6-2	12	Dubs	1902, 1903
7080	0-6-2	6	Beyer-Peacock	1902
7100	2-6-0	8	Porter	1880~1889
7150	2-6-0	1	Temiya shops	1895
7170	2-6-0	2	Baldwin	1887
7200	2-6-0	25	Baldwin	1890~1897
7270	2-6-0	6	Brooks (2) & Kisha Kaisha (4)	1900, 1905
7300	2-6-0	4	Baldwin	1903
7350	2-6-0	6	Rogers	1902
7400	2-6-0	3	Baldwin	1896
7450	2-6-0	4	Kitson	1889
7500	2-6-0	6	Baldwin	1903
7550	2-6-0	3	Alco (Schentdy.)	1904
7600	2-6-0	6	Nasmyth Wilson	1889

Class	Type	Class size	Builder	Introduction
7650	2-6-0	3	Brooks	1897
7700	2-6-0	14	Beyer-Peacock	1894, 1903
7750	2-6-0	10	Neilson	1893
7800	2-6-0	6	North British	1904
7850	2-6-0	12	Dubs/North British	1898, 1908
7900	2-6-0	4	Kōbe shops	1896
7950	2-6-0	18	Rogers	1897
8000	2-6-0	6	Baldwin	1892, 94, 95
8050	2-6-0 (comp'd.)	1	Baldwin	1895
8100	2-6-0	20	Baldwin	1897
8150	2-6-0	6	Baldwin	1890, 1893
8200	2-6-0	4	Baldwin	1896
8250	2-6-0 (comp'd.)	1	Baldwin	1902
8300	2-6-0	3	Alco (Schentdy.)	1906
8350	2-6-0	4	Baldwin	1894
8360	2-6-0	3	Baldwin	1900
8380	2-6-0	1	Baldwin	1900
8400	2-6-0	4	Rogers	1897
8450	2-6-0 (comp'd.)	6	Baldwin	1893
8500	2-6-0 (comp'd.)	2	Hyogo shops	1905
8550	2-6-0	61	Schenectady/Alco	1899~1907
8600 (temp.)	4-6-2	24	(See Class 8900)	(see Cl. 8900)
8620	2-6-0 (superht.)	687	Kisha Seizo, Hitachi Kawasaki, Nippon Sharyo	1914~26, 28
8700	4-6-0	30	North British Kisha Kaisha	
8800	4-6-0 (superht.)	12	Schwartzkopff	1911
8850	4-6-0 (superht.)	24	Borsig Kawasaki	1911
8900 (ex8600)	4-6-2 (superht.)	36	Alco/Brooks/Rchmd.	1911
9000 (temp.)	2-8-0	8	see Class 9040	(see Cl. 9040)
9020[xxix]	2-4-4-0	6	Alco	1911
9030	2-8-0	3	Baldwin	1903
9040 (ex9000)	2-8-0	8	Baldwin	1893~1898
9050	2-8-0	26	Alco (Pittsburgh)	1907
9150	2-8-0	10	Kōbe shops	1906~1908
9200	2-8-0	47	Baldwin	1905
9300	2-8-0	12	Baldwin	1906
9400	2-8-0	12	Alco (Rogers)	1906
9500	2-8-0	12	Schenectady	1898
9550[xxx]	2-8-0	12	Kawasaki	1912
9580[xxxi]	2-8-0 (superht.)	12	Kawasaki	1912
9600[xxxii]	2-8-0 (superht.)	784	Kawasaki, Hitachi Kisha Seizo, IJGR Kokura Shops	1913~1926
9700	2-8-2	20	Baldwin	1897
9750	0-6-6-0 (superht.)	24	Alco (Schenectady)	1912
9800	0-6-6-0 (superht.)	18	Baldwin	1912
9850	0-6-6-0 (superht.)	12	Henschel	1912

[ELECTRIC LOCOMOTIVES]
(600 V. DC Third Rail)

Class	Type	Class size	Builder	Introduction
10000	C (Abt)[xxxiii]	12	AEG	1911

[ELECTRIC MULTIPLE UNITS]
(600 V. DC Catenary)

In September 1910 the IJGR adopted a new numbering system for all self-propelled passenger stock (electric units as well as steam rail-motors) consisting of an assigned syllable or combination of syllables (according to a syllabic code) and running number series.

The initial syllables assigned were *De* (for Densha "Electric Cars"), *Ni* (for

ARTICLE 29. In the last five years of the term, if the company neglect general maintenance and repairs, the Government shall have the power to demand the company to make all the repairs, and to restore the whole works to completeness, so as to have everything in good order at the time of delivery. In case the company neglect any of the repairs or maintenance pointed out by the Government, or when they are executed differently from the ways as specified by the Government, the Government shall make them good, and the expenses shall be paid fro the income of the company. ARTICLE 30. In the case of Article 27, railway stores, goods, depots, stations, land belonging to them, and beside [sic] every other building, machinery and plant belonging to the railway and necessary for working the railway shall be delivered up together with the railway. ARTICLE 31. In the event of the company breaking or acting against any of the articles in this contract, and "the agreements on the formation of the company," or in case the company neglects to obey the articles, thereby obstructing the public benefits of railways, the Government shall appoint, for the time being, a special committee consisting of shareholders or otherwise, to take charge of the affairs of the company; or, regardless of the term in this contract, the Government may put the whole railway, the buildings, the machinery and plant belonging to the railway and necessary for its working, to public sale, and let other people succeed the company, and take charge of the works of construction and traffic. In this case the company shall be responsible for the loss or gain [that] thereby may be incurred. ARTICLE 32. In working according to the articles or clauses of this contract, and the agreement on the formation of the company, if there arises any dispute or difference of opinion between the Government officials and the company, the Minister of Public Works Department shall be the arbitrator.

RAILWAYS BY REGION

The following list includes Japanese Railways principally of the reign of the Meiji emperor (1868–1912) but in some cases the Taishō (1912–1926) and Showa (1926–1989) emperors, up to a cut-off of about 1945. This list may not be complete in matters of mergers, name changes, and corporate succession, which can be quite complicated. Nonetheless, it serves as a starting point as an assemblage of data (some of which are out of print or not easily obtainable) into one compilation, from which further study may be commenced. Those interested in further detail would be well-advised to consult the excellent Japanese language work *Private Railways of Japan, Their Network and Fleets 1882 to 1991 (Shitetsu-shi Handbook)* by Wakuda Yasuo ISBN 4-88548-065-5.

When using this list, bear in mind:

- Railways are grouped by geographic region, with the exception of those railways nationalized in 1906, where the region is indicated parenthetically in italics after each corresponding railway. Noteworthy military and colonial railways are listed as they were often listed with domestic railways during the Meiji era by texts speaking of railways of the Japanese Empire.

- * indicates that an identified *shamon* (corporate logo) for a railway company is to be found in the *shamon* section of this appendix.

- Parentheticals contain the year of first operation (*not* the date of incorporation or formation) if known, and the name of the successor company by merger or amalgamation (if known or if any), which is indicated by the symbol →. Where given, the course of sale, amalgamation, or merger is indicated and can be determined by referral to the name of the successor to determine if it also has been subject of later amalgamation, with the process being repeated until no further successor name appears. Railways which were nationalized directly subsequent to 1906 without having been subject of sale, merger, or amalgamation are indicated by the notation "→ nat." Name changes, mergers, sale and similar activities after 1940 are generally not included.

- Where a particular railway name has fallen into disuse by virtue of merger, abandonment, etc. and has later been adopted or used by one or more different railway companies, italicized roman numerals in brackets indicate that fact, with the number reflecting the order of usage. e.g. Sōbu Tetsudō [I], Sōbu Tetsudō [II]. The use of [I] with a particular railway name without a subsequent identical name appearing indicates that the railway name was reused later than the end of the Taishō era. Names that have been used by companies in different locales or later reused by different companies with notable variation have no such indication e.g. Sangū Tetsudō, Sangū Kyūkō Tetsudō; Zusō Tetsudō, Zusō Jinsha Tetsudō.

- Popular, abbreviated, contracted, commonly used English language names for railways and "nicknames" are indicated in quotes, e.g. Sagami Tetsudō "Sotetsu;" Ōsaka Denki Tetsudō "Daiki;" Odawara Kyūkō Tetsudō "Odakyu;" Enoshima Denki "Enoden." City tram or trolley lines (Nagoya-shi, Yokohama-shi, etc.) are subsequently listed by their English equivalents "Tōkyō Metropolitan Gov't.," "Nagoya Municipal Rwy." In an effort to clarify matters, certain incorrect English transliterations known to have appeared in print are listed, indicating the proper railway to which the misnomer refers.

- Railway name changes not a result of merger or amalgamation are indicated by the symbol Σ, e.g. Kada Keiben Tetsudō Σ Kada Denki Tetsudō.

- Some commonly used names from the English-language Press of the Meiji-era for government-built sections of line not initially connected to the system that were in currency prior to connection of the line into the contiguous railway network are given in a separate section along with the name of the particular IJGR line of which they formed a part, where known.

- Mining, logging, and industrial railways are listed only if they provided routine or seasonal passenger service, or are historically significant. Failed railway ventures that never laid rails are listed in a separate section. Railways that never had an independent existence in the Meiji period (e.g. the Ise Division of the Dai Nippon Kidō sold in 1920 to the Chusei Tetsudō) are not listed.

- For sake of brevity, "Kabushiki Kaisha" 株式会社, the Japanese corporate designation equivalent to "Inc." or "Ltd.", has not been included in the names.

Government Railways

1. Nihon Teikoku Tetsudō Chō 日本帝国國鐵庁 (*lit.* "*Japan Imperial Railway Government Offices*"), aka Tetsudō Sagyō Kyoku 鐵道作業局 (*lit. "Railway Operations Bureau"*) 1872 *Throughout Japan.* Known variously in English as The Imperial Japanese Government Railways, Imperial Japanese Railways, Imperial Government Railways, Imperial Government Railways of Japan, "IJGR", "IJR", "IGR" etc.*

2. Hokkaidō Kansetsu Tetsudō "Hokkaidō Government Rwy." 北海道官設鐵道 1898 prenat. Hokkaidō*

Railways nationalized in 1906–1907

3. Bōsō Tetsudō 房総鐵道 1896 *Kantō**
4. Gan'etsu Tetsudō 岩越鐵道 1898 *Tōhoku**
5. Hankaku Tetsudō 阪鶴鐵道 1897 *Kansai**
6. Hokkaidō Tankō Tetsudō "HTTKK" "Hokkaidō Colliery & Railway Corporation" 北海道炭礦鐵道株式会社 1880 *Hokkaidō**
7. Hokkaidō Tetsudō [*I*] 北海道鐵道 1902 *Hokkaidō**
8. Hokuetsu Tetsudō 北越鐵道 1897 *Chūbu**
9. Kansai Tetsudō 関西鐵道 1889 *Kansai**
10. Kōbu Tetsudō 甲武鉄道 1889 *Kantō**
11. Kyōto Tetsudō 京都鐵道 1897 *Kansai**
12. Kyūshū Tetsudō [*I*] 九州鉄道 1889 *Kyūshū**
13. Nanao Tetsudō 七尾鐵道 1898 *Chūbu**
14. Nihon Tetsudō 日本鐵道 1883 *Kantō/Tōhoku**
15. Nishinari Tetsudō 西成鐵道 1898 *Kansai**
16. Sangū Tetsudō 参宮鐵道 1893 *Kansai**
17. San'yo Tetsudō 山陽鐵道 1888 *Kinki/ San'yo/ Chugoku**
18. Sōbu Tetsudō [*I*] 総武鉄道 1894 *Kanto**
19. Tokushima Tetsudō 徳島鉄道 1899 *Shikoku**

Chūbu Region Railways
(except Nagoya/Chūkyō railways)

20. Akiba Basha Tetsudō 秋葉馬車鉄道 1902 → Akiba Tetsudō → Sunzu Denki
21. Awazu Kidō 粟津軌道 1911 → Onsen Denki
22. Bukō Keiben Tetsudō 武岡軽便鉄道 1914 Σ Bukō Tetsudō Σ Nanetsu Tetsudō
23. Chikuma Tetsudō 筑摩鉄道 1922 → Chikuma Denki → Matsumoto Denki
24. Chūetsu Tetsudō 中越鉄道 1897* → nat.
25. Echigo Tetsudō 越後鉄道 1912 → nat.
26. Enshū Tetsudō "Entetsu" 遠州鉄道 1909, *Dai Nippon Kidō constituent, see #430*
27. Fuji Basha Tetsudō 富士馬車鉄道 Σ Fuji Tetsudō 1890

28. Fuji Basha Tetsudō [II] Σ Fuji Denki Kidō 富士馬車鉄道 1903
29. Fuji Kidō 富士軌道 1909
30. Fuji Sanroku Denki Tetsudō 富士山麓電気鉄道 1929
31. Fuji Minobu Tetsudō 富士身延鉄道 1913 → nat.
32. Gotemba Basha Kidō 御殿場馬車軌道1909
33. Ihara Kidō 庵原軌道 1913
34. Iiyama Tetsudō 飯山鉄道 1921 → nat.
35. Ina Densha Kidō 伊那電車軌道 1909 Σ Ina Denki Kidō
36. Iwamura Denki Kidō 岩村電気軌道 1906
37. Izu Tetsudō 伊豆鉄道 1907 → Sunzu Denki Tetsudō *
38. Kajikazawa Basha Tetsudō 鰍沢馬車鉄道 1901 → Yamanashi Basha
39. Kanaiwa Basha Tetsudō 金石馬車鉄道 1898 Σ Kanaiwa Denki Tetsudō
40. Katō Tetsudō 河東鉄道 1922 Σ Nagano Dentetsu 河東鉄道 1922
41. Kiso Rinyō Tetsudō 木曽林用鉄道
42. Kitō Basha Tetsudō 城東馬車鉄道 1899 Σ Omaezaki Kidō → Horinouchi Kidō Unyu
43. Kubiki Tetsudō 頚城鉄道 1914
44. Kurobe Kyōkoku Tetsudō 黒部峡谷鉄道 1953— from 1925 industrial line
45. Matsumoto Denki Tetsudō 松本電気鉄道 1932
46. Nagano Denki Tetsudō 長野電気鉄道 1926* → Nagano Dentetsu
47. Nagaoka Tetsudō 長岡鉄道 1915*
48. Nagara Keiben Tetsudō 長良軽便鉄道 1913 → Mino Denki Kidō
49. Nakaizumi Kidō 中泉軌道 1909 Σ Nakaizumi Kidō Unso
50. Nanetsu Tetsudō 南越鉄道 1924
51. Nonaka Kidō 野中軌道 *privately owned* 1898 → Gotemba Basha Kidō
52. Oigawa Tetsudō 大井川鉄道 1927
53. Seinō Tetsudō 西濃鉄道 1928*
54. Shimada Kidō 島田軌道 1898
55. Shinano Tetsudō 信濃鉄道 1915 → nat. *Ōito line*
56. Shizuoka Tetsudō 静岡鉄道 1908* → Dai Nippon Kidō, Shizuoka Division
57. Shōkin Basha Tetsudō 松金馬車鉄道 1904 Σ Shōkin Densha Tetsudō → Kanazawa Denki Kidō
58. Sunzu Denki Tetsudō 駿豆電気鉄道 1906* → Fuji Suiden, etc. → Izu Hakone, Seibu subsid.
59. Tateyama Keiben Tetsudō 立山軽便鉄道 1913 Σ Tateyama Tetsudō → Toyama Denki
60. Tochio Tetsudō 栃尾鉄道 1915
61. Tōsō Tetsudō 藤相鉄道 1913
62. Toyama Denki Kidō 富山電気軌道 1913 Σ Tsuru Basha Tetsudō Toyama shi → Toyama Denki Kidō
63. Tsuru Basha Tetsudō 都留馬車鉄道 1900 Σ Tsuru Denki Tetsudō → sold to Sakamoto Suwamatsu (private investor)
64. Ueda Maruko Tetsudō 上田丸子鉄道 1927 Σ Ueda Denki Σ Ueda Dentetsu
65. Uonuma Tetsudō 魚沼鉄道 1911* → nat.
66. Yamanaka Basha Tetsudō 山中馬車鉄道 1899 → Yamanaka Kidō Σ Onsen Denki → Yamanashi Denki
67. Yamanashi Basha Tetsudō 山梨馬車鉄道 1898 → Messrs. Amenomiya & Ono → Yamanashi Keiben Tetsudō
68. Yamashiro Kidō 山代軌道 1911 → Onsen Denki
69. Yōrō Tetsudō 養老鉄道 1913 → Ibigawa Denki

→ Yoro Denki → Ise Denki
70. Zusō Tetsudō 豆相鉄道 1898 → Izu Tetsudō → Sunzu Denki → Fuji Suiden → Sunzu Tetsudō Σ Sunzu Tetsudō Hakone Yusen Σ Sunzu Tetsudō Σ Izu Hakone Tetsudō

Chūgoku Region Railways

71. Bōseki Tetsudō 防石鉄道 1919
72. Chūgoku Tetsudō 中国鉄道 1898*
73. Geibi (aka Gebi) Tetsudō 芸備鉄道 1915
74. Hagami Tetsudō (Never existed; Mistaken English language transliteration for Hinokami Tetsudō)
75. Hinokami Tetsudō 簸上鉄道 1916 → nat.
76. Hiroshima Denki Kidō 広島電気鉄道 1912* → Hiroshima Gasu Denki
77. Ibara Kasaoka Keiben Tetsudō 井原笠岡軽便鉄道 1913 Σ Igasa Tetsudō*
78. Iwakuni Denki Kidō 岩国電気軌道 1909 → Chugai Denki → Sold to Yamaguchi Prefecture
79. Katakami Tetsudō 片上鉄道 1923
80. Kure Denki Tetsudō 呉電気鉄道 1909 Σ Kure-shi Denki → Hiroshima Kure Denryoku → Hiroshima Denki
81. Okayama Denki Kidō 岡山電気軌道 1912*
82. Onoda Keiben Tetsudō 小野田軽便鉄道 1915 Σ Onoda Tetsudō
83. Saidaiji Kidō 西大寺軌道 1911 Σ Saidaiji Tetsudō
84. Shimotsui Keiben Tetsudō 下津井軽便鉄道 1913 Σ Shimotsui Tetsudō
85. Taisha Miyajima Tetsudō 大社宮島鉄道 1932
86. Tomo Keiben Tetsudō 鞆軽便鉄道 1913 Σ Tomo Tetsudō

Chūkyō Nagoya Region Railways

87. Aichi Basha Tetsudō 愛知馬車鉄道 1908 Σ Owari Denki
88. Aichi Denki Tetsudō 愛知電気鉄道 1912 → Nagoya Tetsudō
89. Atsuta Denki Tetsudō 熱田電気鉄道 1910 → Nagoya Tetsudō
90. Bisai Tetsudō 尾西鉄道 1898* → Nagoya Tetsudō
91. Chita Tetsudō 知多鉄道 1931 → Nagoya Tetsudō
92. Hekikai Denki Tetsudō 碧海電気鉄道 1926 → Nagoya Tetsudō
93. Kihoku Keiben Tetsudō 岐北軽便鉄道 1914 → Mino Denki
94. Mikawa Tetsudō 三河鉄道 1914 → Nagoya Tetsudō
95. Mino Denki Kidō 美濃電気軌道 1911 → Nagoya Tetsudō
96. Nagara Keiben Tetsudō 長良軽便鉄道 1913 → Mino Denki Kidō
97. Nagoya Denki Tetsudō 名古屋電気鉄道 1898 → Nagoya Municipal Rwy.
98. Nagoya Tetsudō "Meitetsu" 名古屋鉄道 1912*
99. Nagoya Tochi 名古屋土地 1913 → Nakamura Denki Kidō
100. Nishio Tetsudō 西尾鉄道 1911 → Aichi Denki
101. Okazaki Basha Tetsudō 岡崎馬車鉄道 1899 → Okazaki Denki Kidō
102. Okazaki Denki Kidō 岡崎電気軌道 1911 → Nagoya Tetsudō
103. Sanki (aka Sangi) Tetsudō 三岐鉄道 1931

104. Seto Jidō Tetsudō 瀬戸自動鉄道 1905 Σ Seto Denki Tetsudō* → Nagoya Tetsudō
105. Shimonoishiki Densha Kidō 下之一色電車軌道 1913
106. Toyokawa Tetsudō 豊川鉄道 1897* → nat.
107. Tsukiji Denki 築地電軌 1917*

Hokkaidō Railways

108. Bibai Tetsudō 美唄鉄道 1914
109. Ebetsu-mura 江別村 1905
110. Hokkaidō Kōgyō Tetsudō 北海道鉱業鉄道 1922 Σ Hokkaidō Tetsudō [II] 1924 → nat.
111. Kikan Basha Tetsudō 亀函馬車鉄道 1897 Σ Hakodate Basha Tetsudō → Hakodate Suiden
112. Hokkai Tankō Tetsudō 北海炭鉱鉄道 1924 Σ Yūbetsu Tankō Tetsudō
113. Horonai (aka Poronai) Tetsudō 幌内鉄道 1880 → Hokkaidō Tankō Tetsudō
114. Iburi Jukan Tetsudō 胆振縦貫鉄道 1940 → nat.
115. Ishikari Sekitan Tetsudō 石狩石炭鉄道 1914) → Iida Nobutaro (private investor) → Bibai Tetsudō
116. Iwanai Basha Tetsudō 岩内馬車鉄道 1905
117. Jōzankei (aka Jyozankei) Tetsudō 定山渓鉄道 1918
118. Kamikawa Basha Tetsudō 上川馬車鉄道 1906
119. Kayanuma Tankō Tetsudō 茅沼炭鉱鉄道 1865 (horse and gravity)
120. Kushiro Tetsudō 釧路鉄道 1892
121. Kushiro Futō Tetsudō (Yūbetsu subsidiary) 釧路埠頭鉄道 1923
122. Kushiro Rinkō Tetsudō 釧路臨港鉄道 1925
123. Rumoi Tetsudō 留萌鉄道 1930
124. Sapporo Sekizai Basha Tetsudō 札幌石材馬車鉄道 1910 Σ Sapporo Shigai Kidō Σ Sapporo Denki Kidō
125. Sapporo Kidō 札幌軌道 1911
126. Suttsu Tetsudō 寿都 鉄道 1920
127. Tomakomai Keiben Tetsudō 苫小牧軽便鉄道 1913 → nat.
128. Yūbari Tetsudō 夕張鉄道 1926

Kansai/Kinki Region Railways

129. Arashiyama Densha Tetsudō 嵐山電車鉄道 1910* → Kyōto Dento
130. Arima Tetsudō 有馬鉄道 1915 → nat.
131. Arita Tetsudō 有田鉄道 1915*
132. Atagosan Tetsudō 愛宕山鉄道 1929
133. Banshū Tetsudō 播州鉄道 1913 → Bantan Tetsudō
134. Bantan Tetsudō [I] 播但鉄道 1894 → San'yo Tetsudō
135. Bantan Tetsudō [II] 播丹鉄道 1913
136. Befu Keiben Tetsudō 別府軽便鉄道 1921 Σ Befu Tetsudō
137. Hankai Denki Kidō 阪堺電気軌道 1911*
138. Hankai Tetsudō 阪堺鉄道 1885 → Nankai Tetsudō
139. Hankyu Tetsudō 阪急鉄道 1921
140. Hanshin Denki Tetsudō 阪神電気鉄道 1905*
141. Hanwa Denki Tetsudō 阪和電気鉄道 1929 → Nankai Tetsudō
142. Hatsuse Kidō 初瀬軌道 1909 Σ Hatsuse Tetsudō → Hase Tetsudō → Ōsaka Denki
143. Hyōgo Denki Kidō 兵庫電気軌道 1910 → Ujigawa Denki
144. Iga Kidō 伊賀軌道 1916 → Sangu Kyūkō

Sangyō Tetsudō 産業鉄道 = Industrial Railway

Sanroku Tetsudō 山麓鉄道 = Mountain foothill railway

Santō 三等 = Third Class

Seitetsujo 製鉄所 = Iron and Steelworks

Sekitan Umpan Kidō 石炭運搬軌道 = Coal-hauling Railway

Sekizai Kidō 石材軌道 = Quarry Tramway

Sen 線 = Line (of railway)

Senro 線路 = Railway or Tram Line

Sen'yō kidō 専用軌道 = Tramway with right of way built on or through private land (*i.e.* by right of easement), *comp. with* Heiyo kidō

Shako 車庫 = Depot, Car barn, Tram depot

Sharyō 車輌 = Rolling Stock

Sharyō Kōjō 車輌工場 = Car Repair Shops

Shiei Densha 市営電車 = City-operated tramway, Municipal Tram/Trolley Line

Shiei Tetsudō, "Shitetsu" 私営鉄道, "私鉄" = Private Sector (*not nationalized*) Railway

Shigai Tetsudō 市街鉄道 = (*lit. City streets railway*) Metropolitan Railway, Street Car

Shin 新 = New

Shindaisha 寝臺車 = Sleeping Car

Shingō 信号 = Signal, signaling

Shingōjo 信号所 = Signal Box, Interlock Tower

Shin-kaisoku 新快速 = New Rapid Service = New Kansai area day kaisoku trains

Shinkansen 新幹線 = New Trunk Line, so-called "Bullet Trains"

Shinkō 進行 = Go, Proceed, All Clear (green signal indication)

Shinrin Tetsudō 森林鉄道 = Logging Railway, forestry railway

Shisen 支線 = Branch Line

Shiteiseki 指定席 = Reserved seat

Shitetsu 私鉄 = *see* Shiei Tetsudō

Shōei Tetsudō 省榮鉄道 = Government Railway

Shokumin Kidō, Tetsudō 殖民軌道, 鉄道 = Light Tramway for Reclaimed Land (*Hokkaidō*)

Shuppoppo シュッポッポ = Choo-choo (children's onomatopoeic name for *train* derived from the sound of steam escaping cylinder cocks and first two exhaust beats of steam locomotive at start)

Shūyūken 周遊券 = Excursion Ticket

Sonin 奏任 = *arch.* Meiji era mid-grade railway employee appointed bureaucratically but with Imperial Assent, *see* Chokunin and Hanin

Sōshajō 操車場 = Marshalling Yard

Shuppatsu 出発 = Departure

Shuppatsu-jikan 出発時間 = Departure Time

Shūten 終点 = Terminus

Suiryoku Denki Tetsudō 水力電気鉄道 = Hydro-Electric Power Railway

Takushoku Tetsudō 拓殖鉄道 = Colonial Railway

Tansen 単線 = Single Track Line

Tankō Tetsudō 炭礦鉄道 = Coal Mining Railway

Tansha 炭車 = (*lit. "Coal car"*) Freight car for carrying coal shipments

Tansuisha 炭水車 = (*lit. "Coal/Water Car"*) Locomotive tender

Tasen Tetsudō 多線鉄道 = Multi-track Railway

Teikoku 帝國 = Imperial, "The Empire" (*often used in Meiji-era corporate names*)

Teiryūjō 停留場 = Halt, Flag-stop Station, Tram or Trolley Stop (*alt.* Teiryujo 停留所)

Teishaba 停車場 = (*arch.* Railway Station *lit. car stopping place*)

Teishi 停止 = Stop (Red signal indication)

Tekkyō, Tetsukyo 鉄橋 = Railway Bridge, Steel Bridge

Tenkōsha 轉向車 = (*lit. "Converted Car"*) Bogie carriage, Passenger Car on trucks (*archaic Meiji usage for non-bogie cars converted to bogie stock*)

Tetsu 鉄 = Iron

Tetsudō 鉄道 = (*lit. "Iron Way"*) Railway

Tetsudō Dōshi-kai 鉄道同志会 = Meiji-era railway advocacy group variously translated as "The Railway Association" or "The Association of Railway Presidents"

Tetsudō Gakkō 鉄道学校 = Railway School

Tetsudō Kōji Sekkei Sankō 鉄道工事設計参考 = (*arch.*) Railway Works Planning Consultation Agency (Meiji era)

Tetsudō Kōjō 鉄道工場 = Railway Shops

Tetsudō Nesshinka 鉄道熱心家 = (*arch.*) Railway proponent, advocate, booster, promoter (of the Meiji-era)

Tetsudō Renraku Kōro 鉄道連絡航路 = Railway Ferry

Tetsudō Yoteisen 鉄道豫定線 = Proposed Railway Line

Tetsudōkyō 鉄道橋 = Railway Bridge

Tetsudōshō 鉄道省 = Department of Railways

Tō 等 = [Ticket] Class (e.g. 1st Class, 2nd Class)

Tōchaku-jikan 到着時間 = Arrival Time

Tokkyū 持急 = Limited Express Train

Tokubetsu-kaisoku 特別快速 = Special Rapid Service train: fewer stops than *kaisoku*

Tokushu Tetsudō 特種鉄道 = Special Railway (usually light or feeder)

Tozan Sen/Tetsudō 登山線/鉄道 = Mountain Line/Railway

Tsuidō 隧道 = Tunnel

Tsūkin-kaisoku 通勤快速 = Commuter Rapid Service Peak Hour Train

Tsūkin-kyūkō 通勤急行 = Commuter Peak Hour Express

Tsuribashi 釣橋 = Suspension Bridge

Unchin 運賃 = Fare

Unchin-bako 運賃箱, Ryōkin-bako 料金箱 = Fare box (as in a tram or trolley)

Untan Tetsudō 運炭鉄道 = Coal Railway

Unyu 運輸 = Transport, Transportation [company]

Zumen 図面 = Plans, blueprint

JAPANESE GEOGRAPHIC LEXICON

As Japanese railways often take their names from the geographic region through which they pass, a basic knowledge of Japanese geographic terms is useful. Japan is presently divided into 47 Prefectures, which are grouped into 8 geographic regions: the three islands of Hokkaidō, Kyūshū (including Okinawa), and Shikoku and (on the largest island of Honshū) the five regions known as Chūbu, Chūgoku, Kantō, Kinki, and Tōhoku. Another system within this framework has created additional smaller regions, of which the principal ones are Hokuriku, Kansai, Sanin, San'yō, Tōkai, and the Tōkyō To or Metropolitan Area. In 1871 Meiji legal and structural reforms abolished old domains and provinces, replacing them with the current prefectural structure. However, certain names of old provinces lent themselves to names used by railways, and to that extent, they are incorporated herein with a notation (*hist.*)

Bantan 播但 = Railway term of regional connotation derived from the former Harima (播磨) and Tajima (但馬) provinces in Hyōgo Prefecture; from first kanji of each name (*hist.*).

Bōsō 房総 = Peninsula on which Chiba Prefecture is located

-bu 武 = Railway name suffix connoting proximity to the former feudal province of Musashi (武蔵) where present day Tōkyō, Saitama, and Eastern Kanagawa are located (e. g. Kōbu, Seibu, Sōbu, & Tōbu Tetsudō).

Cho, -cho 町 = Town, syn. "machi" (smaller than "-shi")

Chū 中 = middle, central, trough, *see* naka

Chūbu 中部 = Region consisting of the Prefectures of Aichi, Fukui, Gifu, Ishikawa, Nagano, Niigata, Shizuoka, Toyama, and Yamanashi

Chūgoku 中国 = (*lit. "Midlands"*) Region consisting of the Prefectures of Hiroshima, Okayama, Shimane, Tottori, and Yamaguchi

Dai, tai 大 = Great, greater

Dō 道 = Way, both in the sense of road or route (*see Tokaidō, Tetsudō*) or way of thought (*Bushi* = warrior: *Bushidō* = "Way of the warrior", "fighting spirit"); also a political/governmental/judicial "circuit"

-etsu 越 = Suffix denoting the area comprising the former Echigo Province used in railway names (e.g., Shin'etsu, Ganetsu)

Gawa, Kawa 川 = River

Goku 国 = see Koku

Hanshin 阪神 = Ōsaka–Kōbe area

Hantō 半島 = Peninsula

Higashi 東 (*alt. "Tō-"*) = East, Eastern

Ho-, Hok- 北 = Prefix denoting north or northern, *see also* Kita

Hokkaidō 北海道 = (*lit. "The North Sea Circuit"*) Second largest and northernmost of the four principal islands of Japan. Compare with "*Tōkaidō.*"

Hokuriku 北陸 = Region consisting of the Prefectures of Fukui, Ishikawa, and Toyama

Honshū 本州 = (*lit. "Main Province"*) The "mainland" or largest island of Japan

Izu 伊豆 = Peninsula south of Mt. Fuji and the city of Numazu

Kai 海 = Sea

Kaikyō 海峡 = Straits

Kanhasshū 関八州 = The eight Kantō Provinces (*hist.*)

Kansai 関西 = (*lit. "Gateway West"*) Ōsaka, Kyōto, Kōbe region

Kantō 関東 = (*lit. "Gateway East"*) Region consisting of the Prefectures of Chiba, Gumma/ Gunma, Kanagawa, Ibaraki, Saitama, Tochigi, and Tōkyō

Keihin 京浜 = Tōkyō–Yokohama district (alt. pron. of last two kanji of each name)

Ken, -ken 県 = Prefecture, suffix for "prefecture"

Kii 紀伊 = Peninsula on which Wakayama Prefecture is located

Kinki 近畿 = Region consisting of the Prefectures of Hyōgo, Kyōto, Mie, Nara, Ōsaka, Shiga, and Wakayama

Kisokaidō 木曽街道 = (*lit. "The Kiso Route"*) Historically, the second principal roadway of Japan, secondary to the Tokaidō, running along the Kiso River Valley

Kita 北 (*alt. "Ho-" "Hok-"*) = North, northern

Ko 子 = Little, lesser

Koku, goku 国 = Land, Country, Province, *see also* Kuni

-Ku 区 = City ward or precinct

Kuni 国 = Country, Province (*in pre-Meiji times*)

Kyūshū 九州 = (*lit. "Nine Provinces"*) The third largest of the islands constituting Japan, the southernmost of the four principal islands, from the nine former historical provinces found there

Machi, -machi 町 = Town (smaller than "–shi" syn. "chō")

Minami 南 (*alt. "Nan"*) = South, southern

Mura, -mura 村 = Village (smaller than '-cho' or '-machi')

Naka 中 = Middle, central, through, *see also* Chū

Nakasendō 中仙道 = (*lit. "The way through the mountains"*) Secondary important principal route between Kyōto and Tōkyō, taking an inland route via mountain passes.

Nan- 南 = Prefix denoting south or southern, *see also* Minami

Nishi 西 = (*alt. "-sai"*) West, western

Noto 能登 = Peninsula on the northern (Sea of Japan) side of central Honshu

Onsen 温泉 = Hot springs, warm springs, spa

Sai, sei 西 = West, western, *see also* Nishi

San 山 = see Yama

San'in 山陰 = Region consisting of the Prefectures of Shimane, Tottori, and that part of Yamaguchi Prefecture facing the Sea of Japan.

San'yō 山陽 = Region consisting of the Prefectures of Hiroshima, Okayama, and that part of Yamaguchi Prefecture facing the Inland Sea.

Shi, -shi 市 = City (larger than "-machi")

Shikoku 四国 = (*lit. "Four Provinces"*) Smallest of the four major Japanese Islands, facing the Inland Sea; from the four provinces into which it was formerly divided.

Shima 島 = Island (*alt. Jima*)

Shimokita 下北 = Eastern peninsula at the northern tip of Honshu

Shinshū 信州 = Nagano prefecture region

Shū 州 = Province

Tani 谷 = Valley

To 都 = Capital, metropolis, metropolitan

Tō- 東 = Prefix denoting East, Eastern, see Higashi

Tōhoku 東北 = (*lit. "EastNorth" i.e. "the Northeast"*) Region consisting of the Prefectures of Akita, Aomori, Fukushima, Iwate, Miyagi, and Yamagata

Tōkai 東海 = "East Sea" region consisting of the Prefectures of Aichi, Gifu, Mie, and Shizuoka

Tōkaidō 東海道 = (*lit. "The East Sea Circuit"*) Historically, the principal road connecting the two most populous areas of Japan (Kansai and Kantō) leading east from the old Imperial capital of Kyōto to the Shogun's capital of Edō (now Tōkyō), following a coastal route; the regions along the Tokaidō road or a route or rail line following the Tokaidō road.

"Tōkyō To" 東京都 or **Tōkyō Metropolitan Area** = Region consisting of the Prefectures of Chiba, southern Ibaraki, Kanagawa, and Saitama under the jurisdiction of the Governor of Tōkyō

Tsugaru 津軽 = Western peninsula at the northern tip of Honshu, straits between Honshu and Hokkaidō

Wan 湾 = Bay

Yama 山 (*alt. San*) = Mountain(s)

BIBLIOGRAPHY

Akai and Katano, *Shitetsu Densha Profile*, Kigei Publishing, 1970

Aoki *et al.*, *A History of Japanese Railways, 1872-1999*, East Japan Railway Culture Foundation, Japan, 2000, ISBN 4-87513-089-9

Auth. Unk., *The Russo-Japanese War*, P. F. Collier & Son, New York, 1904

Baxter, James C., *The Meiji Unification through the Lens of Ishikawa Prefecture*, Harvard, 1994, ISBN 0-674-56466-9

Beasley, William G., *The Meiji Restoration*, Stanford Univ. Press, 1972

Bell, Archie, *A Trip to Lotus Land*, John Lane Co., New York, 1918

Bennett, Terry, *Photography in Japan 1853–1912*, Tuttle, 2006 ISBN 10: 0 8048 36333 7

Bilingual Books, *Chronology of Japanese History*, Kodansha, Tōkyō, 1999 ISBN 4-7700-2453-3

Bird, Isabella, *Unbeaten Tracks in Japan*, Putnam, New York, 1881

Black, John R., *Young Japan*, Turner & Co., London, 1881

Bolce, Harold, *Phases of Railroading in Japan*, Booklovers Magazine, Vol. IV, No. 3, Sept. 1904

Brunton, R. Henry, *Building Japan*, Sandgate, Folkestone, Kent: Japan Library, 1991

Bulletin de la Société Franco-Japonaise de Paris, *Cinquantième Anniversaire de l'Inauguration du Premier Chemin de Fer Japonais*, Vol. 51 (1922)

Busby, T. Addison, ed., *The Biographical Dictionary of the Railway Officials of America*, The Railway Age & Northwestern Railroader, Chicago, 1896

Cantrell, John, *Nasmyth, Wilson & Co. Patricroft Locomotive Builders*, Tempus Publishing, Stroud, 2005 ISBN 0-7524-3465-9

Chamberlain, Basil, *Things Japanese*, Keegan Paul Trench, London, 1891

Chamberlain & Mason, *Murray's Handbook for Japan*, John Murray, London, 1901

Connaughton, Richard, *Rising Sun and Tumbling Bear: Russia's War with Japan*, Cassell, London, 2003, ISBN 0-304-36657-9

Cortazzi and Daniels, *Britain and Japan, 1859-1991: Themes and Personalities*, Routledge, London, 1991

Crow, Arthur H., *Highways and Byeways in Japan*, Sampson Low, London, 1883

Curtis, William Elroy, *The Yankees of the East: Sketches of modern Japan*, Stone & Kimball, New York, 1896

de Fellner, Frederick Vincent, *Communications in the Far East*, P. S. King & Son, Ltd., London, 1934

Demery *et al.*, *Electric Railways in Japan*, (3 Vols.), Light Rail Transit Association, UK, 1983 ISBN 0-900433-95-7

Department of Agriculture and Commerce, Japan, *Japan in the Beginning of the 20th Century*, Tōkyō-Shoin (Japan Times), Tōkyō, 1904

Dyer, Henry, *Dai Nippon*, Blackie & Son Ltd., London, 1904

Engineering, London, *passim*

Engineering News, Chicago, *passim*

Engineering News, New York, *passim*

English, Peter, *British Made: Industrial Development and Related Archaeology of Japan*, De Archaeologische Pers Nederland, Aalst-Waalre, 1982, ISBN 90-6585-012-0

Ericson, Steven, *The Sound of the Whistle: Railroads and the State in Meiji Japan*, Harvard University Press, 1996, ISBN 0-674-82167-X

Everett, Marshall, *Exciting Experiences in the Japanese-Russian War*, Henry Neil, Pub'l., 1904

Faulds, Henry, *Nine Years in Nipon*, Cupples & Hurd, Boston, 1888

Finn, Dallas, *Meiji Revisited*, Weatherhill, New York, 1995, ISBN 0-8348-0288-0

Fox, Grace, *Britain and Japan, 1858–1883*, Clarendon Press, Oxford, 1969

Fujishima Uta, ed., *History of the Enlightened Period of Meiji*, Taisho Kyokai, Tōkyō, 1917

Gerson, Jack J., *Horatio Nelson Lay and Sino-British Relations, 1854–1864*, East Asian Research Center, Harvard University, 1972 (Harvard East Asian Monographs, No. 47)

Gordon, Andrew, *Labor and Imperial Democracy in Prewar Japan,* University of California Press, Berkeley, 1991, ISBN 0-520-06783-5

Griffis, William Elliot, *The Mikado's Empire*, Harper, NY, 1877

Griffis, William Elliot, *Townsend Harris; First American Envoy in Japan*, Houghton Mifflin, 1896

Hare, James H., *A Photographic Record of the Russo-Japanese War*, P. F. Collier & Son, New York, 1905

Hilton George W., *American Narrow Gauge Railroads*, Stanford Univ. Press, 1990 ISBN 0-8047-1731-1

Hirota Naotaka, *Steam Locomotives of Japan*, Kodansha International, Tōkyō, 1972, ISBN 0-87011-185-X

Hirota Naotaka, *The Lure of Japan's Railways*, Japan Times, Tōkyō, Japan, 1969, LCC 72-94927

Hirschmeier, Johannes, *The Origins of Entrepreneurship in Meiji Japan,* Harvard University Press, Cambridge, 1964

Holtham, Edmund Gregory, *Eight Years in Japan*, Keegan Paul Trench, London, 1883

Hoshiyama Kazuo, *Omeshi Ressha Hyaku-nen*, Tōkyō, 1973

Hosokawa, Bill, *Old Man Thunder: Father of the Bullet Train*, Sogo Way, 1997, ISBN 0-9659580-0-0

Imperial Railways Dept., Annual Reports, *passim*

Imperial Railways Dept., General Statistics of Railways in Japan, *passim*

Jansen, Marius ed., *The Emergence of Meiji Japan*, Cambridge Univ. Press, 1995

Japan Gazette, *Japanese Railways Timetable, August 1889*, Yokohama, 1889

JNR, *JNR's 90 Years in Picture*, JNR, Tōkyō, Japan, c. 1962

Kadono Chokyuro, *Japanese Railways*, Transactions and Proceedings of the Japan Society, London, Vol. 5 (1898–1901)

Kamikawa Hikomatsu, ed., *Japan-American Diplomatic Relations in the Meiji-Taisho Era*, Tōkyō, Pan-Pacific Press, 1958

Kashima Shosuke, Correspondence to the Editors, *The Locomotive Magazine*, manuscript, 1904

Keene, Donald, *Emperor of Japan: Meiji and His World 1852–1912*, Columbia, New York, 2002, ISBN 0-231-12340-X

Kodama Riotaro, *Railway Transportation in Japan*, Ann Arbor, Mich., 1898

Kodansha Publications, *Japan, A Bilingual Atlas*, Kodansha, 1991 ISBN 4-7700-1536-4

Kurizuka Mataró, *Nihon Tetsudō Kiyō (Railways and Rolling Stock in Japan)*, Nihon Keizai Hyōronsha, Tōkyō, 1981 reprint

1914 from the author's collection

- Amenomiya Keijiro: *History of the Enlightened Period of Meiji*, Fujishima Uta, Ed., Taisho Kyokai, Tōkyō, 1917 from the author's collection
- Maffei Decapod heavy tank locomotive: [*Henschel-Maffei Locomotive Catalogue*], J. A. Maffei, A. G., Munich c. 1920s from the author's collection
- 6700 Class locomotive: courtesy of Kawasaki Heavy Industries, Ltd.

Epilogue

[none]

- All other photographs and images from the author's collection
- All images appear in their original colors. None have been "colorized" or digitally altered.

FOOTNOTES

PROLOGUE

1 One ri equals 2.44 miles
2 By Japanese custom, a person's surname is his first name, and his given name comes last, exactly the opposite of Western conventions. This book uses the Japanese convention, e.g. Toyotomi Hideyoshi of the Toyotomi family, not Hideyoshi Toyotomi.

CHAPTER 1

1 A shorthand Japanese term for Shōgunate, literally meaning "tent government" from the earliest times when the country was ruled from the Shōgun's military camp.
2 Perry, as a Presidential Envoy, had been quite insistent that he interact and conduct negotiations with a member of the government at the highest level, and found Prince Hayashi acceptable largely because his title was translated "Prince," which in Japan did not necessarily carry the same status that the title did in the monarchies of the West. The title of Prince was an awarded, not inherited, title, used in government as a high honor. The mere title of prince (as opposed to an Imperial Prince of the Blood) was a not as high a title as it was in Europe. In keeping with the nuanced show-of-status diplomacy that often governed traditional East Asian diplomacy of the times, the Bakufu quite naturally wanted to send as low an official to deal with Perry as it could possibly get away with; to bolster the perception that the foreign barbarians were of such inconsequential status as to merit the time and consideration of only a minor functionary. On this score, perhaps the Bakufu got the better of Perry without his even realizing it. One wonders if he would have insisted on negotiating with yet a higher official or a Prince of the Blood if he had understood that the Bakufu had merely sent its Minister of Education on what from the Bakufu's point of view could have been characterized merely as a fact-finding mission to gather intelligence about Western ways and technology.
3 About $1,500,000.00 US dollars. In 1902, the travel writer Eliza Scidmore noted currency and prevailing exchange rates. "The Yen, at par, corresponds to the American half-dollar, and is made up of one hundred sens, which are further divided into ten rins each. The Yen has an average equal exchange with the Mexican silver dollar, which is the current coin and monetary unit throughout China and the Far East. From Hong Kong to Montreal and New York, one talks of and deals in dollars and cents, realizing handsome premiums in the exchange of Canadian or United States dollars for yens or Mexicans." One should keep in mind that writers of the day in the Far East quoting "dollar" prices were, as often as not, referring to "Mexican dollars," and not American dollars. As there are several methodologies for computing the present value of historic currency prices that can lead to truly startling variances in final result, this book

uses the actual price given in the original text.
4 Dutch was the one European language that was understood and spoken among some Japanese of the day in any useful number, due to 200 years of Dutch trade at Nagasaki. As such, it was used as the language for official diplomatic communiqués between Japan and Western powers up to the end of the Tokugawa Shōgunate.
5 The full text of the official translation of the Grant and Conditions is set forth in the section of this Appendix titled "Correspondence Enclosing the Portman Grant."
6 Diplomatic relations between the West and Japan had not yet reached a level where full-fledged Ambassadors had been exchanged, which wouldn't start to occur until the final years of the Meiji era. There were then no Embassies, only Legations; and in place of Ambassadors, there were Ministers.

CHAPTER 2

1 Article III of the Convention of Edō with the Western Powers called for the establishment of Treaty Ports and "lights" in conjunction with those ports, so there was a treaty obligation to fulfill in establishing a lighthouse system.
2 Presumably this was Ōki Takatō, who later served in one of the departments created when the early Department of Civil Affairs and Finance was split in two. Perhaps this was simply a Western Victorian misreading of the kanji for his sobriquet "Minpei" 民平, which can be pronounced Tamihira.
3 Oi Yosuke was also known by the name of Ogasawara Nagamichi. He had been the daimyō of Kokura, in northern Kyūshū.
4 Miaco is Rice's transliteration of the Japanese word Miyako meaning 'the city in which the Emperor resides.' Rice is referring to Kyōto.

CHAPTER 3

1 The same Maejima who was author of the tract on railway estimations.
2 The licensing of stagecoach lines began around 1870.
3 India had started its railway system with a standard gauge of 5' 6", but due to the expense of building on such a grand scale in the years just before the contemplation of the Shimbashi line, opted to allow a system of feeder railways and railways where fiscal returns were expected to be light or modest, to be built to narrow gauge standards.
4 The first such American conversion was completed in 1880 by the Springfield, Jackson, and Pomeroy Railroad, at the time the third longest narrow gauge line in the US, running southeasterly from Springfield, Ohio to the coalfields of Jackson, Ohio, from which was later created the Detroit, Toledo and Ironton Railroad.
5 In the early days of rail travel in Great Britain, almost identical carriage trucks were available for hire by upper-class clients who wished to travel with their horse-drawn carriage, and on payment of an additional fare were usually attached to the end of the passenger train in which the travelers rode, as were corresponding horse boxes if the ticket holder wished to bring his team of horses along: a Victorian version of the present day "Auto-Train." Curiously, by the time the carriage truck for Japan was ordered, the practice had largely died out in Britain.
6 At the height of the Union Pacific Railroad's cash crisis during building of the US Transcontinental Railroad, cross-ties not far removed from rough logs, with only the necessary faces finished, were used in order to save the cost of milling them into uniform and square beams. Similarly ingenious measures would have been appropriate given the tight financial condition of Japan, which was then what we would today characterize as a Third World country, but such departures from British engineering orthodoxy would have been anathema to the average British engineer.
7 At this time, private ownership of land, as we know it in the modern sense and as was recognized by the first Chiken (certificates of land ownership) given out by the new Government starting in January 1871, didn't even

exist, and thus couldn't have given rise to any need of speedier condemnation procedures due to relatively weak eminent domain laws, as has been remarked was the case with later railway building. Land was still feudally held (generally as State lands) at the time of building the Shimbashi line, although certain land, particularly in Tōkyō, classed as bukeji (samurai land) and choji (townsmen's land).
8 Yoritomo was the very first Shōgun of Japan: the founder of the Kamakura Shōgunate.
9 Saiwai Bashi or bridge was located in the southwestern-most corner of the old military parade and drill grounds that stood between the Imperial Castle and the Shimbashi terminal, spanning one of the outer moats or canals that then existed but has since been covered over, in what is now the Kasumigaseki/Hibiya neighborhood. The parade and drill grounds are now Hibiya Park, while the head office of the Tōkyō Electric Company stands roughly were the bridge was.
10 An aria from Offenbach's comic opera "La Grande Duchesse de Gerolstein," a military satire receiving its début in 1867, on this occasion presumably played with the solemnity of a processional march. According to the New York Times of January 19, 1873, the naval band in question was that of the French corvette *Belliqueuse*.
11 The Enryō-kan, a former summer residence of the Shōguns, was the official government reception and banquet hall, also known as the Hamago-kan, predecessor to the famed Rokumei-kan, where important State receptions were held. (Enryō is a difficult-to-translate term meaning something akin to "humble consideration of others" and –kan means "hall." Perhaps it is not too much license to translate the name as a vague approximation of "Hospitality Hall.") It was located in the Hama Rikyu Gardens, a park that still exists today, on the southern border of the Shimbashi terminal complex and later became a state guest residence.
12 In addition to the general illumination, townsfolk were treated to a fireworks and a passenger-carrying gas balloon display on the grounds of Shimbashi station.
13 i.e. from the King of the Ryukyu Islands, as the Okinawan Islands, not yet fully under Japanese sovereignty, were then known.
14 In fact, out of the original 5 locomotive types purchased, the only specimens subsequently re-ordered were the Sharp-Stewarts.
15 Railway workers in Meiji times also carried paper lanterns at night with their names and employee numbers painted on the lantern paper for identification.
16 A social habit that had died out by the 1890s.
17 At that time, the Yen was subdivided into one hundred Sen, a Sen into ten Rin, a Rin into 10 Mō or Mon, a Mon into 10 Shu, and 1 Shu into 10 Kotsu, although the monetary units below the Mō were used only in calculations, as there were no coins below that level.

CHAPTER 4

1 Musha Manka (1848–1941) one of Diak's original assistants who assisted in the Shimbashi–Yokohama survey, and who worked on many subsequent sections.
2 Jishin literally means earthquake. Holtham records that the Japanese of the 1870s used this word to describe upheavals in government administration: a slang term from the Meiji–era that would perhaps baffle a modern day native speaker.
3 In 1867, the Satsuma fiefs were valued at 778,000 koku annually, second only to the Tokugawa domains (5,000,000 koku) and the Maeda clan of Kaga (1,027,000 koku). In 1878, Isabella Bird recorded that an acre of land produced from 30 to 34 bushels of rice annually, depending on the quality of the land.
4 In fact, it is said that one of the reasons for keeping the initial railway line construction in the environs of more cosmopolitan centers like Tōkyō, Yokohama, Ōsaka, and Kyōto was to provide a level of security to the yatoi until a proper assessment could be made as to whether the presence of foreign gaijin would arouse public hostility. In any event, these initial fears were groundless, as no great adverse reaction was met.
5 The address Parkes gave and the Imperial Reply thereto

are set forth in whole in the section of the Appendix titled "Sir Harry Parkes' Address at the Ōsaka–Kyōto Opening."

6 This time, instead of a tree being used, the Imperial Household Agency cleverly disguised a large unsightly piece of manufacturing machinery sitting at the station, using it as the frame over which their replica of Mt. Fuji was built.

7 One of the newly arrived "second wave" of imports; originally a Kitson 0-6-0 engine for freight, it that had been converted quite adeptly to a beautifully proportioned 4-4-0 passenger engine at Kōbe shops; surely one of the rarest events in the history of locomotive rebuilding: a lowly freight engine rebuilt as an express passenger locomotive.

8 Between the opening of the Shimbashi line and the opening of this line, the practice of kneeling before the Emperor had been replaced with that of bowing as part of Meiji modernization efforts. At the opening of the Shimbashi line, Wirgmann noted that the crowds along the line kneeled.

CHAPTER 5

1 Often, available foreign ships to be found in Japanese ports would be chartered by the government for this purpose. There was a shortage of government-owned steamships at that time.

CHAPTER 6

1 Carved stone seals, used in the same fashion as one uses a rubber stamp, that left a characteristic "chop-mark" on a document, and which were often incised with archaic-style characters.

2 A chain is a surveyor's standard unit of measure of ten feet.

3 The locomotives were 0-4-0 tank locomotives manufactured in the UK by Sharp Stewart (probably works numbers 2793, 2794 and 2795), which would be modest by standards of the day, weighing only 18¾ tons. Purcell's diary seems to indicate only two were initially received, but three would eventually be working at Kamaishi.

4 This is further evidence of relatively lax planning. British locomotives were typically designed to run on a coal with high caloric value known as locomotive or "loco" coal, which necessitated importation. Later, British builders borrowed a page from the book of American locomotive builders and designed and built locomotives designed to burn wood as a fuel for "Colonial" railways. Why the person responsible for ordering the locomotives didn't specify a design capable of operating efficiently on a lower-grade fuel such as wood is unknown, leading one to surmise that the ordering decision was left with a Japanese bureaucrat in Tōkyō who didn't have an informed notion of local conditions or simply ordered a "standard design" of locomotive straight from a manufacturer's catalogue without further concern in order to keep costs to a minimum.

5 Mōri Shigesuke (1847–1901) studied railway engineering in the US and later went to England. He started at Kamaishi on his return to Japan, and from there moved to the IJGR, then to the Nippon Tetsudō, where he met with an unfortunate end in an accident in 1901.

6 Holtham did not record whether this was due to the locomotive being defectively built or simply due to it's being unsuited for the line.

7 There is today some confusion about his name in Japan. According to a 19th century biographical sketch of him, Ury derives from the Ury House on the Ury Farm after which young Crawford was named and on which he grew up. At the time of his childhood, Ury House was one of the oldest in the Philadelphia area and something of a landmark. It stood until 1970. Early Japanese writers unfamiliar with that fact, assuming it was mistaken, were convinced that it was the result of the confusion often engendered by the letters "R" and "L" when transliterated into Japanese, which has no native equivalent for the letter "L". They glossed over the name and converted it to the closest known approximation. The mistake has been perpetuated, and one can sometimes see reference to him as Joseph Ulysses Crawford.

19th century American sources all agree that his middle name was "Ury."

8 The first three of which were named appropriately enough Yoshitsune, Benkei and Shizuka respectively after one of the great adventurer-heros from the lore of Japan's 14th century Heikke Wars, his loyal follower, and his wife. Perhaps a rough parallel in English-speaking cultures would have been naming the trio "Robin Hood", "Friar Tuck" and "Maid Marian." All the names of the eight locomotives that were eventually delivered had historic associations with Hokkaidō.

9 One suspects that this service was rendered in conjunction with the government's purchase of the last foreign-built locomotives, among which Baldwin of Philadelphia supplied several. Crawford's son Henriques was soon destined to serve as the Manager of Traffic and Transportation at Baldwin and perhaps used his connections to help his father to obtain the best possible price.

10 Japanese railways observed the British practice of fencing the lines and manning each grade crossing with a gate-keeper who would close gates across the intersecting road upon the approach of any train.

11 Taylor mistakes a device designed primarily to improve traction as being one designed primarily for safety.

12 Because steam drops in pressure as it cools and contracts, in order to obtain the same amount of work out of a cylinder using "recycled" or "low pressure" steam, it was necessary from an engineering point of view to increase the dimension of the low pressure cylinder, thus one cylinder would be larger than the other. Trevithick was evidently so proud of his new locomotive that he designed a cover or casing for the smaller high pressure cylinder that had no real function other than aesthetic, so as not to spoil the symmetry of his new locomotive's appearance when viewed head-on.

CHAPTER 7

1 By the 1880s, the IJGR had standardized its station designs with very utilitarian designs.

2 Atago was a prominent hill, easily visible in Meiji times, in the vicinity of the railway near Shimbashi; now no longer quite as prominent a landmark in the mass of Tokyo's skyscrapers.

3 Professor John Milne, the father of seismology, inventor of a widely used seismograph, and founder of the world's first academic seismological society, The Seismological Society of Japan, making Japan an early world leader in this field. He taught at the Kōbudaigakkō for many years.

4 Gleneagles in Scotland, the famed hotels of Banff and Lake Louise in Canada, Manhattan's Pennsylvania Hotel, and Sun Valley in the US are but a few examples of railway hotel and resort developments that generated tourism revenues for the railways that built them.

5 Alexander Shaw, a Scot missionary for the Church of England built a summerhouse there in 1888, and this seems to be the event that started the town down the path to being a fashionable resort. Another British missionary who was also an expert mountaineer, Walter Weston, climbed many of the neighboring peaks in the 1890s and it was he who gave the Hida Mountains their nickname of "the Japan Alps." Weston is still known as the Father of Japanese Alpinism.

6 Located south of Fukushima on the Nippon Tetsudō mainline.

7 "Pidgin" is the Far Eastern pronunciation of the English word business, as it sounded to Chinese speakers of English. The short-hand business English used by early Chinese traders throughout the Far East to converse with their Western counterparts came to be known as Pidgin English.

8 Oxen were more prevalent in Japan than were horses, and were cheaper to come by. What they lacked in speed, they compensated for in cost and availability. Prior to the Meiji restoration, horses were not commonly used in agriculture, and were generally a military luxury owned by and reserved for only the samurai or higher classes. The per capita horse population of Japan in 1868 was naturally quite lower than that in the US and Europe, and commensurately the cost of a good

horse, not to mention its care and maintenance, was not inconsiderable, well into the first years of the twentieth century. W. E. Curtis commented, "Horses are very seldom seen except in the foreign settlements. You can ride for days through the country without seeing a single horse, either in the villages or on the farms." Even the future King George V of England noted, during his visit in 1881, that during a ceremonial review of troops he had seen 10,000 soldiers, but only one regiment of cavalry "owing to the scarcity of horses in Japan."

9 After the name change, a neighboring line, not to be confused with the Atami line, adopted the Zusō Tetsudō name when it opened in 1898.

10 Lorrimer was correct, 610mm was the gauge before it converted to steam in 1907 and re-gauged to 762mm.

11 Eugen Sandow, the late Victorian era's most celebrated bodybuilder; father of modern bodybuilding.

12 The 1923 Great Kantō Earthquake that devastated Japan altered the geological formation of the area, putting an end to the geyser. Lorrimer was misinformed: there are other geysers in Japan. Atami today is still a popular sea-side resort.

13 Concessions, of course, were not only territorial. They could be commercial in nature as well, such as the right to build a railway line in a particular region, or to operate steam navigation companies along interior rivers.

14 One scholar, writing about the Trans-Siberian Railway as late as 1934, asserted, "Although this railway was originally constructed for goods traffic, no transit [i. e., commercial] goods have ever been transported on it even during the Tsarist rule, because the railway, originally constructed for economic purposes, has always been employed for strategical purposes, to-day even to a greater extent than formerly."

15 The railway around Lake Baikal was not completed until 1905.

16 While the surprise attack on Port Arthur did not completely destroy the Russian squadron there, it was reduced in force to such an extent that every attempt at a sortie was prevented by the Imperial Japanese Navy, with the predictable result of the Russians returning to port and a cat and mouse game of attrition ensued. The next closest Russian fleet of any significant size was bottled up in the Black Sea by virtue of treaty obligations. Moving that fleet through the Bosporus would have violated those treaties, risking both war with Turkey and British entry into the conflict as an ally of Japan. The only available Russian fleet of any size that could have been moved to Korea without risk of serious international repercussions lay anchored in Russia's European naval bases on the Baltic.

17 While the US government officially maintained strict neutrality in respect of supplying either belligerent with military armaments or ammunition, locomotives built to the Korean and Russian gauges were apparently not deemed to be "contraband of war." Moreover, the sympathies of President Theodore Roosevelt and many Americans were favorable to Japan.

18 The Suez Canal route was avoided for fear of a Japanese ambush at that bottleneck and for fear that the British who controlled it would interfere with passage, in keeping with the British-Japanese alliance. A separate detachment sent after the departure of the main fleet later went via Suez.

CHAPTER 8

1 Another American traveler of the era, used to the informality of crossing tracks at backwater American stations, remarked upon the seriousness with which railway authorities viewed station footbridges, which "cross the tracks at every station and their use is enforced, it matters not how remote or unimportant they may be."

2 A kin equals 1.323 pounds.

3 By this time, the exterior appearance of the train was less ornate than at its inauguration. Originally, the coach exteriors were chocolate brown, relieved with gold filigree striping, and kept in a high state of polish. By the time Sanders traveled, the ornate gold striping had given away to a monotone over-all brown.

4 The original class designated the 9550 Class was not superheated. A superheated version was introduced in 1913, becoming the 9600 Class. When improvements were made to lighten the axle load, increase cylinder volume, and improve the firebox, the new class was designated 9600, and the existing 9600 class was re-designated as 9580 class.

EPILOGUE
1 Plans have lately been mooted to restore the roof to its original appearance.
2 Undoubtedly on his way to the Enryokan next-door, which was his guesthouse during his visit.

INDEX

ACKNOWLEDGMENTS

Many people assisted me in the research and preparation of this book, but the following merit particular mention and thanks: John Agnew, New Zealand; Charles Bates, Allen County Museum, Lima, Ohio; Onouchi Makoto, Tōkyō; John Buydos, Dr. Tomoko Steen and Sayuri Umeda, Library of Congress; Dr. Steven Ericson, Dartmouth College; Sr. Jane Gates, Medical Mission Sisters, Philadelphia; Dr. Charles W. Kinzer, Annapolis; Kohashi Noriko, Los Angeles; Komine Hiroyasu, Yokohama; Kenneth Mencz, New York; The National Archives and Records Administration Staff, New York Regional Office; Zoe Rees and Judith Dennison, Birmingham City Archives, UK; and Sakakihara Asakichi, San Francisco.

Among those who have been particularly more generous than I deserve with both their time and assistance are: Kawano Keiko, The Railway Museum, Ōmiya; Terry Bennett, early Japanese photographic authority sans pareil whose assistance, advise, and guidance has been invaluable; Reg Carter, the late librarian of the Stephenson Locomotive Society, UK, who sadly did not live to see publication of this book; and Dr. Aoki Eiichi, one of Japan's pre-eminent railway historians who graciously agreed to review the manuscript and offer comments. Finally, I must give heartfelt thanks to two individuals who helped me verify numerous dates, checked seemingly countless facts, and who offered help when my research abilities were at the limits of what could be accomplished outside of Japan, devoting un-told hours with unwavering enthusiasm and providing encouragement at every turn in the road, Nakagane Jun, Yokohama and Ozawa Tomio, Tōkyō.

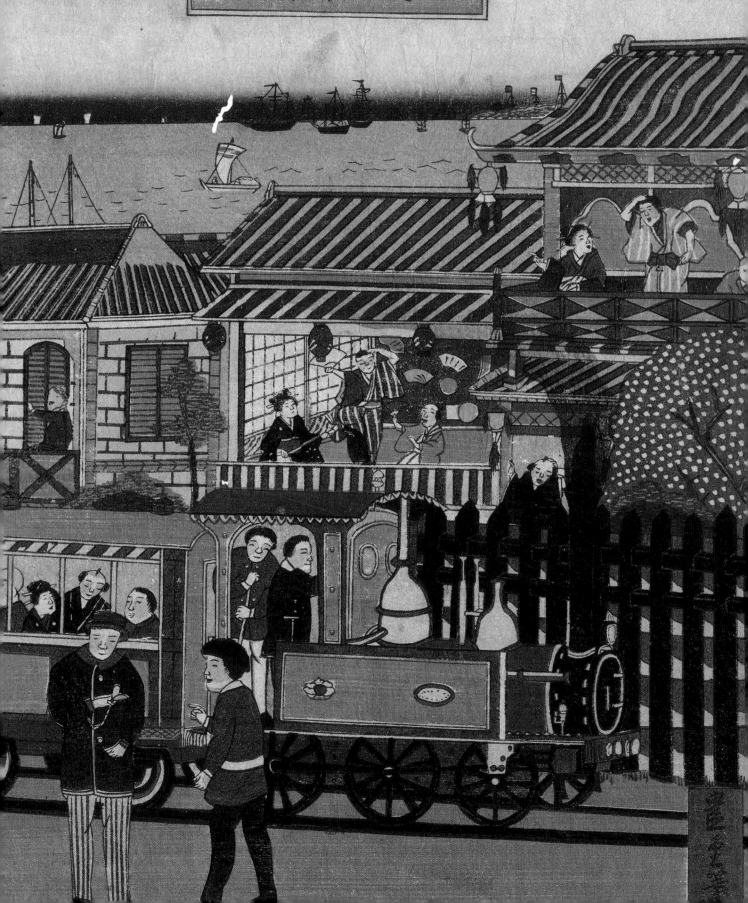

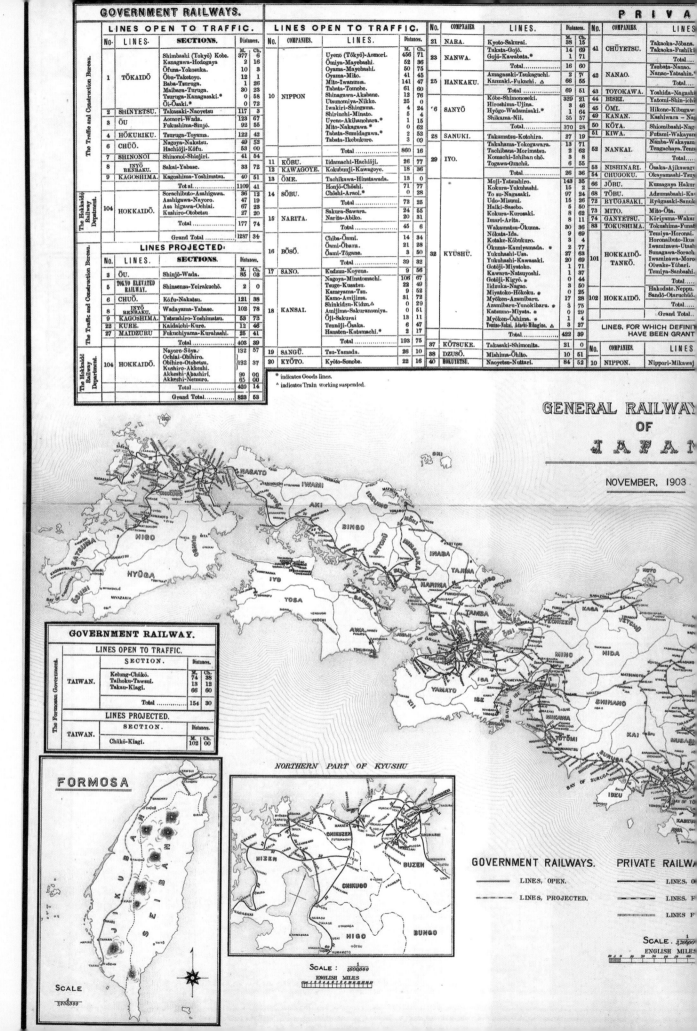

GOVERNMENT RAILWAYS.

LINES OPEN TO TRAFFIC.

	No.	LINES	SECTIONS	M.	Ch.
The Traffic and Construction Bureau.	1	TŌKAIDŌ	Shimbashi (Tōkyō) Kobe.	377	6
			Kanagawa-Hodogaya	2	16
			Ōfuna-Yokosuka.	10	3
			Ōbu-Taketoyo.	12	1
			Baba-Tsuruga.	1	26
			Maibara-Tsuruga.	30	23
			Tsuruga-Kanagasaki.*	0	58
			Ōi-Ōsaki.*	0	72
	2	SHINYETSU.	Takasaki-Naoyetsu.	117	3
	3	ŌU.	Aomori-Wada.	123	67
			Fukushima-Shinjō.	92	55
	4	HŌKURIKU.	Tsuruga-Toyama.	122	42
	6	CHŪŌ.	Nagoya-Nakatsu.	49	52
			Hachiōji-Kōfu.	53	00
	7	SHINONOI.	Shinonoi-Shiojiri.	41	54
	8	INYŌ RENRAKU.	Sakai-Yabase.	33	72
	9	KAGOSHIMA.	Kagoshima-Yoshimatsu.	40	51
			Total.	1109	41
The Hokkaidō Railway Department.	104	HOKKAIDŌ.	Sorashibuto-Asahigawa.	36	12
			Asahigawa-Nayoro.	47	19
			Asahigawa-Ochiai.	67	23
			Kushiro-Otobetsu.	27	20
			Total.	177	74
			Grand Total.	1287	34

LINES PROJECTED.

	No.	LINES	SECTIONS	M.	Ch.
The Traffic and Construction Bureau.	3	ŌU.	Shinjō-Wada.	85	03
	5	TOKYO ELEVATED RAILWAY.	Shinsenzu-Yeirakuchō.	2	0
	6	CHŪŌ.	Kōfu-Nakatsu.	121	38
	8	INYŌ RENRAKU.	Wadayama-Yabase.	102	78
	9	KAGOSHIMA.	Yatsushiro-Yoshimatsu.	53	72
	22	KURE.	Kaidaichi-Kure.	12	46
	27	MAIDZURU.	Fukuchiyama-Kurahashi.	25	41
			Total.	403	39
The Hokkaidō Railway Department.	104	HOKKAIDŌ.	Nayoro-Sōya.	132	57
			Ochiai-Obihiro.		
			Obihiro-Otobetsu.	132	37
			Kushiro-Akkeshi.		
			Akkeshi-Abashiri.	90	00
			Akkeshi-Nemuro.	65	00
			Total.	420	14
			Grand Total.	823	53

LINES OPEN TO TRAFFIC.

No.	COMPANIES.	LINES.	M.	Ch.
10	NIPPON	Uyeno (Tōkyō)-Aomori.	456	71
		Ōmiya-Mayebashi.	52	36
		Oyama-Mayebashi.	50	75
		Oyama-Mito.	41	45
		Mito-Iwanuma.	141	47
		Tabata-Tomobe.	61	60
		Shinagawa-Akabane.	12	76
		Utsunomiya-Nikko.	25	0
		Iwakiri-Shiogama.	4	24
		Shiriuchi-Minato.	5	4
		Uyeno-Akibanohara.*	1	15
		Mito-Nakagawa.*	0	62
		Tabata-Sumidagawa.*	2	52
		Tabata-Ikebukuro.	3	09
		Total.	860	16
11	KŌBU.	Iidamachi-Hachiōji.	26	77
12	KAWAGOYE.	Kokubunji-Kawagoye.	18	36
13	ŌME.	Tachikawa-Hinatawada.	13	0
14	SŌBU.	Honjō-Chōshi.	71	77
		Chōshi-Araoi.*	0	28
		Total.	72	25
15	NARITA.	Sakura-Sawara.	24	55
		Narita-Abiko.	20	31
		Total.	45	6
16	BŌSŌ.	Chiba-Ōami.	14	34
		Ōami-Ōbara.	21	28
		Ōami-Tōgane.	3	50
		Total.	39	32
17	SANO.	Kudzuu-Koyena.	9	56
18	KANSAI.	Nagoya-Minatomachi.	106	67
		Tsuge-Kusatsu.	22	49
		Kameyama-Tsu.	9	52
		Kamo-Amijima.	31	72
		Shinkidzu-Kidzu.△	0	29
		Amijima-Sakuranomiya.	0	51
		Ōji-Sakurai.	13	11
		Tennōji-Ōsaka.	6	47
		Hanaten-Katamachi.*	2	17
		Total.	193	75
19	SANGŪ.	Tsu-Yamada.	26	10
20	KYŌTO.	Kyōto-Sonobe.	22	16

No.	COMPANIES.	LINES.	M.	Ch.
21	NARA.	Kyoto-Sakurai.	38	15
23	NANWA.	Takata-Gojō.	14	69
		Gojō-Kawabata.*	1	71
		Total.	16	60
25	HANKAKU.	Amagasaki-Tsukaguchi.	2	7
		Kanzaki-Fukuchi.△	66	55
		Total.	69	51
*6	SANYŌ.	Kōbe-Shimonoseki.	329	21
		Hiroshima-Ujina.	1	46
		Hyōgo-Wadamisaki.*	1	04
		Shikama-Nii.	35	57
		Total.	370	28
28	SANUKI.	Takamatsu-Kotohira.	27	19
29	IYO.	Takahama-Yokogawara.	13	71
		Tachibana-Morimatsu.	2	62
		Komachi-Ichiban chō.	3	8
		Togawa-Gunchū.	6	55
		Total.	26	36
32	KYŪSHŪ.	Moji-Yatsushiro.	143	35
		Kokura-Yukuhashi.	15	2
		To su-Nagasaki.	97	24
		Udo-Misumi.	15	26
		Haiki-Sasebo.	5	50
		Kokura-Kurosaki.	8	62
		Imari-Arita.	8	11
		Wakamatsu-Ōkuma.	30	36
		Nōkata-Ida.	9	69
		Kotake-Kōbukuro.	3	4
		Ōkuma-Kamiyamada.*	2	77
		Yukuhashi-Usa.	27	63
		Yukuhashi-Kawasaki.	20	69
		Gotōji-Miyatoko.	1	71
		Kawara-Natsuyoshi.	0	44
		Gotōji-Kigyō.*	3	50
		Iidzuka-Nagao.	3	05
		Miyatoko-Hōkoku.*	17	28
		Myōken-Azamibaru.	3	75
		Azamibaru-Yunokibaru.*	0	29
		Katsumo-Miyata.*	1	4
		Myōken-Ōshima.	3	27
		Tomiso-Nakai, Adashi-Mihagino.△	3	1
		Total.	422	39
37	KŌTSUKE.	Takasaki-Shimonita.	21	0
38	DZUSŌ.	Mishima-Ōhito.	10	51
40	HOKUYETSU.	Naoyetsu-Nuttari.	84	52

PRIVA[TE]

No.	COMPANIES.	LINES.
41	CHŪYETSU.	Takaoka-Jōbana.
		Takaoka-Fushiki.
		Total.
42	NANAO.	Tsubata-Nanao.
		Nanao-Yatashin.
		Total.
43	TOYOKAWA.	Yoshida-Nagashino.
44	BISEI.	Yatomi-Shin-ichi.
45	ŌMI.	Hikone-Kibugawa.
49	KANAN.	Kashiwara-Nagano.
50	KŌYA.	Shiomibashi-Nagano.
51	KIWA.	Futami-Wakayama.
52	NANKAI.	Namba-Wakayama.
		Tengachaya-Tennoji.
53	NISHINARI.	Ōsaka-Ajikawaguchi.
54	CHUGOKU.	Okayamashi-Tsuyama.
66	JŌBU.	Kumagaya Hakuraku.
68	TŌBU.	Adzumabashi-Kawabe.
72	RYŪGASAKI.	Ryūgasaki-Sanshin.
73	MITO.	Mito-Ōta.
74	GANYETSU.	Kōriyama-Wakamatsu.
88	TOKUSHIMA.	Tokushima-Funato.
101	HOKKAIDŌ-TANKŌ.	Temiya-Horonai.
		Horonaibuto-Ikushunbetsu.
		Iwamizawa-Utashinai.
		Sunagawa-Sorachi.
		Iwamizawa-Moromi.
		Oiwake-Yūbari.
		Temiya-Sanboshi.
		Total.
102	HOKKAIDŌ.	Hakodate-Neppu.
		Sandō-Otaruchūō.*
		Total.
		Grand Total.

LINES, FOR WHICH DEFINIT[E] HAVE BEEN GRANT[ED]

No.	COMPANIES.	LINES
10	NIPPON.	Nippori-Mikawaj...

* indicates Goods lines.
△ indicates Train working suspended.

GOVERNMENT RAILWAY.

LINES OPEN TO TRAFFIC.

	SECTION.	M.	Ch.
The Formosan Government. TAIWAN.	Kelung-Chūkō.	74	38
	Taihoku-Tawsui.	13	12
	Takau-Kiagi.	66	60
	Total.	154	30

LINES PROJECTED.

	SECTION.	M.	Ch.
TAIWAN.	Chūkō-Kiagi.	102	00

GENERAL RAILWAY OF JAPAN

NOVEMBER, 1903.

NORTHERN PART OF KYUSHU

FORMOSA

SCALE

GOVERNMENT RAILWAYS.
——— LINES, OPEN.
— · — LINES, PROJECTED.

PRIVATE RAILWA[YS]
——— LINES, O[PEN.]
- - - LINES, P[ROJECTED.]
LINES F[OR WHICH]

SCALE.
ENGLISH MILES